LADY TREVELYAN AND THE
PRE-RAPHAELITE BROTHERHOOD

Mervyn Peake: a biographical and critical exploration
The Edwardian Novelists
H.G. Wells
Lord Jim
Virginia Woolf: the major novels
The Life of Joseph Conrad: a critical biography
John Ruskin: No Wealth but Life

Edited
Joseph Conrad, *Lord Jim* (Oxford World's Classics)
Joseph Conrad, *Victory* (Oxford World's Classics)
The Art of Literary Biography
Shakespearean Continuities:
Essays in Honour of E.A.J. Honigmann

Lady Trevelyan and the Pre-Raphaelite Brotherhood

John Batchelor

Chatto & Windus
LONDON

Published by Chatto & Windus 2006

2 4 6 8 10 9 7 5 3 1

Copyright © John Batchelor 2006

John Batchelor has asserted his right under the
Copyright, Designs and Patents Act 1988 to be
identified as the author of this work

First published in Great Britain in 2006 by
Chatto & Windus
Random House, 20 Vauxhall Bridge Road,
London SW1V 2SA

Random House Australia (Pty) Limited
20 Alfred Street, Milsons Point, Sydney,
New South Wales 2061, Australia

Random House New Zealand Limited
18 Poland Road, Glenfield,
Auckland 10, New Zealand

Random House (Pty) Limited
Isle of Houghton, Corner of Boundary Road & Carse O'Gowrie,
Houghton 2198, South Africa

Random House Publishers India Private Limited
301 World Trade Tower, Hotel Intercontinental Grand Complex,
Barakhamba Lane, New Delhi 110 001, India

The Random House Group Limited Reg. No. 954009
www.randomhouse.co.uk

A CIP catalogue record for this book is available from the British Library

ISBN 0 7011 7304 1
ISBN 9780701173041 (from Jan 07)

Papers used by Random House are natural,
recyclable products made from wood grown in sustainable forests;
the manufacturing processes conform to the environmental
regulations of the country of origin.

Typeset by Palimpsest Book Production Limited,
Grangemouth, Stirlingshire

Printed and bound in Great Britain by
William Clowes Ltd, Beccles, Suffolk

Contents

List of Illustrations

Pages xiv and xv
Pages from Pauline Trevelyan's diaries

Insert
Walter Calverley Trevelyan as a young man. Painting by R. S. Lauder. *John Wolseley*

John Ruskin. Photogravure after a lost watercolour by George Richmond, entitled 'The author of *Modern Painters*', 1843. *Ruskin Foundation, University of Lancaster*

Dante Gabriel Rossetti in 1847. Pencil drawing, self-portrait. *National Portrait Gallery, London*

Pauline Trevelyan's journal, *Kenneth Spencer Research Library, University of Kansas, USA*

Two of Pauline Trevelyan's paintings: *Icicles* and *Storm on a Beach*. *Kenneth Spencer Research Library, University of Kansas, USA*

Pauline and Walter Calverley Trevelyan, about 1863. *Reproduced by kind permission of Raleigh Trevelyan*

The Central Hall at Wallington, designed by John Dobson of Newcastle and built in 1853–4. Pauline Trevelyan commissioned William Bell Scott to decorate the Hall with canvases and murals showing scenes from the history of Northumberland. *Copyright © National Trust Photo Library (Andreas von Einsiedel)*

William Bell Scott. Painting by Frederick Bacon Barwell, 1877. *National Portrait Gallery, London*

Thomas Woolner. Pencil drawing by Dante Gabriel Rossetti, 1852. *National Portrait Gallery, London*

Civilization or *The Lord's Prayer*, sculpture of mother and child by Thomas Woolner, installed in the Hall at Wallington. *Copyright © National Trust Photo Library*

The Descent of the Danes: one of the canvases planned in 1856 for the Central Hall at Wallington, and painted by William Bell Scott. *Copyright © National Trust Photo Library (Derrick E. Whitty)*

Bernard Gilpin makes peace along the borders: one of the canvases planned in 1856 for the Central Hall at Wallington, and painted by William Bell Scott. *Copyright © National Trust Photo Library (Derrick E. Witty)*

John Ruskin at Wallington teaching Pauline Trevelyan's friend Louisa Stewart-Mackenzie (Lady Ashburton) to draw. Watercolour by William Bell Scott, 1857. *Copyright © National Trust Photo Library (Derrick E. Witty)*

Algernon Charles Swinburne. Portrait by William Bell Scott. *Balliol College, Oxford, UK/The Bridgeman Art Library*

Jacket: Paintings at Wallington by William Bell Scott. *Front:* portrait of Pauline Trevelyan; *back: Iron and Coal: the Nineteenth Century.* The figure on the left wielding a hammer is a portrait of Sir Charles Edward Trevelyan. *Copyright © National Trust Photo Library*

For Elise and Adèle

Preface and acknowledgements

Whose life is the better of being turned inside out, like an old glove?

Pauline Trevelyan was not conventionally beautiful – she was very small (just over five feet), with striking hazel eyes, a slightly protuberant forehead and a brilliantly sunny smile for people she loved. And 'people she loved' embraced a very wide circle in London, Oxford, Edinburgh and in Northumberland, which was her major home; many of the most famous people in science, literature and the fine arts in the high Victorian period were among her friends. She could be abrupt and direct in conversation: many found her unconventional; some found her formidable or even frightening. She never meant to disconcert people: the abruptness was part of her restless and urgent intellectual curiosity. She wanted, immediately, to know all about any new person whom she met, any new book that she heard of, any new work of art that she saw or any unfamiliar place that she visited. She loved to travel, learn languages and explore European culture.

Her husband, Sir Walter Trevelyan, a distinguished geologist, was much older than Pauline and there were no children, though she would certainly have loved to have had children. They were not ideally matched in terms of their respective outlooks and interests, but he was kind and generous to his brilliant wife, even when he could not agree with her enthusiasms, and they certainly loved each other: her diary puts this beyond doubt. This is an odd kind of love story, but a genuine one.

What would the subject of this biography have thought about the project? On the whole, Pauline did not think well of the kind of biography that has become the norm in the 150 years since her death. When Walter Thornbury published his biography of J.M.W. Turner in 1861, Pauline wrote to her friend Louisa, Lady Ashburton: 'whose life is the better of being turned inside out, like an old glove? besides if men have good in them it is not what other people can write books about.' She complained that 'the coarse jokes & the tricks & the

vulgarity & the varnishing day anecdotes' were given far too much prominence in the book, and that it showed the great artist as a greedy, selfish, miserly, dirty man who became an increasingly secretive and inturned bachelor as he grew older. On the face of it, it is odd that she was quite so cross, since Thornbury's work had been endorsed by none other than John Ruskin, Pauline's 'Master' and close friend.[1] Pauline was not prudish – in her friendship with the young Swinburne she showed that she was unshockable over sexual matters. Presumably the problem was one of decorum: to show a supreme genius as a dirty old man felt, to her, like an act of treachery. An example of the kind of biography that had her wholehearted approval is a big and rather dull life (by Arthur Stanley, Dean of Westminster) of Dr Arnold of Rugby.[2] With its generous quotations from Dr Arnold's letters, this is a narrative in which the biographer barely intrudes, preferring to stand aside and let the central figure speak for himself.

I hope Pauline would have understood that I, too, want to present her in her own words: not on Stanley's monumental scale, but with enough quotation from her unpublished letters and, in particular, from the forty-four volumes of her diary to enable us to hear the acute and often brilliant voice of this remarkable woman, who was largely unpublished in her lifetime.

The major archive sources for this book have been the *Diaries* of Pauline Trevelyan, held at the Kenneth Spencer Research Library at the University of Kansas, and the Trevelyan manuscripts, held in the Special Collections Library at Newcastle University. The Newcastle holdings include the journals of her husband, Sir Walter Calverley Trevelyan, and many collections of private correspondence. An invaluable published source has been Raleigh Trevelyan's *A Pre-Raphaelite Circle* (London: Chatto & Windus, 1978)*. Pauline's spelling in her diaries is individual; for example, 'Maddox' in Ford Madox Brown and 'Rosetti' in Dante Gabriel Rossetti. I have not used '*sic*' or corrected her spelling and capitalisation in my quotations; her words appear as she wrote them.

I am grateful to Robin Dower and the trustees of the Trevelyan Family Papers at the Robinson Library, Newcastle University, for permission to quote from Pauline Trevelyan's unpublished diary, University of Kansas, and from the unpublished Trevelyan papers in

*In my references, Raleigh Trevelyan's book, Pauline's diaries and Sir Walter Trevelyan's journals are abbreviated as *Circle*, *Diary* and *Journal* respectively. Other manuscript sources are identified individually.

the special collections, Newcastle University; to the late Dr Lesley Gordon and to Newcastle University Library for permission to quote from unpublished letters from William Bell Scott, Thomas Woolner and Louisa, Lady Ashburton; to Dr Karen Cook and to the Kenneth Spencer Research Collection, University of Kansas, for permission to quote from the Pauline Trevelyan archive and for permission to reproduce unpublished pages from her diaries and sketch books; to Durham University library for permission to quote from unpublished correspondence between William Michael Rossetti and William Bell Scott; to the Janet Camp Troxell Collection of Rossetti Mss, Manuscripts Division, Department of Rare Books and Special Collections, Princeton University Library, for permission to quote from unpublished letters from Pauline Trevelyan to William Bell Scott; to the Bodleian Library, Oxford, for permission to quote from unpublished letters from John Ruskin; to the University of British Columbia Library for permission to quote from unpublished letters and mss. by William Bell Scott in the Penkill Papers; to Stella Brecknell and the Oxford University Museum library; to the Warden and Fellows of New College, Oxford, who elected me to a visiting Fellowship; to the British Academy for funding my visit to the Pauline Trevelyan archive at the Kenneth Spencer Research Library, University of Kansas; to the library staff of the Literary and Philosophical Society, Newcastle upon Tyne, for their patience and help with my quests for rare Victorian texts; and the Arts and Humanities Research Council for funded research leave. And I would like to thank my agent, Felicity Bryan, who has seen this book through from its inception; Penelope Hoare who as a most kindly and clear-sighted editor has decisively shaped this book from start to finish; Margaret Horneman, Pauline Trevelyan's great-great-great niece, for information about the Jermyn family; Professor Jim Kennedy for his valuable help while I was working in the Oxford Museum; Professor Claire Lamont for information about Sir Walter Scott; Lloyd Langley of the National Trust, Wallington, for information about Wallington; Professor Duncan Murchison for information about Sir Roderick Murchison; Raleigh Trevelyan for sharing his knowledge of Pauline and the Trevelyan family and for his kindness in reading an earlier draft of this book; and my wife, Henrietta, for her unfailing loyalty and support. The dedication is to our grand-daughters, Elise and Adèle Batchelor.

Newcastle, May 2006.

Extracts from Pauline Trevelyan's journal.

Above: Her interest in phrenology: the shape of Sir John Trevelyan's head attracts a rough sketch to illustrate her account of its peculiarities. '*He is like C [Walter Calverley Trevelyan, Pauline's husband] especially in his head which is very curious, benevolence &c being very large firmness and self-esteem ridiculously small.*'

Right: Difficulties with some of her husband's cousins. '*This day I shall never forget from a discovery which I made, and wh[ich] caused me very much unhappiness, and caused me to anathematize all cousins, fat and lean, male and female, for ever and ever. Amen.*'

30th Sunday. to Birk hole church. even Capt J.
who was doing good to please Julia cd not
keep his face grave at the singing — this day
I shall never forget from a discovery which
I made, & wh caused me very much new
happiness. & caused me to anathematize all
fat & lean, male & female
Cousins, for ever & ever Amen #. — by
way of amusement in this dullest of places
I make long journeys to the gardens for the
purpose of constructing nosegays. — I made a
very pretty one today out of fungi & moss —

October

Monday 1st Capt Johnson, after arranging
the Sun dial & regulating it, went away
we were very sorry to lose him he is a
very agreeable, & a scientific man, whom
it is a consolation to have to speak to —
C & I went with L.T.T. to Shafto Crags. which
is a nice place & commands a good view —
there are paths cut out in the side of the hill.
I went to the Moors with Julia & C Adamson
& came home tired. the dear amiable L.T. to
dinner.

CHAPTER I

Paulina Jermyn Jermyn becomes
Pauline, Lady Trevelyan

Married 8 1/2 a.m. in Swaffham Church to Paulina Jermyn Jermyn
– by Rev Mr Casborne

Paulina Jermyn Jermyn was a clergyman's daughter, born at Hawkedon, near Bury St Edmunds, Suffolk, on 25 January 1816. She was the oldest child of the Revd Dr George Bitton Jermyn, who within a year or two of her birth became vicar of Swaffham Prior, near Cambridge, the village in which Pauline was brought up.* Swaffham Prior had the unusual distinction of having two churches, one medieval and the other eighteenth-century, and Dr Jermyn was responsible for both. The vicarage was a charming double-fronted house in pink brick. Built in the seventeenth century, transformed in the reign of Queen Anne and extended again in the 1780s, it was a comfortable place with a big garden and many bedrooms, good for the large family of a well-off gentleman clergyman.

Dr Jermyn was not well-off. He got by with the help of Cambridge undergraduates who paid for board and lodging in the vicarage, but it was a hand-to-mouth existence; Dr Jermyn was never good with money, and both he and his first wife lived in a gently expensive way. She was the beautiful and aristocratic (but hard-up) Catherine Rowland (1792–1828), who bore him eight children (including two who died). The first of these was Pauline, and she was followed by five living siblings: Helen, born in 1818; Hugh, born in 1820; Turenne (Tenny) born in 1822; Rowland (Powley) born in 1824; and her favourite sister Mary (or Moussy), born in 1826. Mrs Jermyn adored her husband and family, but the care of so large a brood on her husband's precarious income was a serious strain on her health. On 15 January 1828 she died of tuberculosis at the age of thirty-six,

*A man of wide-ranging intellectual interests, a geologist and antiquary as well as a clergyman, Dr Jermyn came of an old and distinguished Suffolk family. His uncle, Henry Jermyn, had made voluminous collections for a genealogical history of Suffolk, and Dr Jermyn followed in that tradition. He also wrote an extensive history of his own family.

having had a still-born child, and Pauline was left at the age of twelve to manage the household.

Within the year Dr Jermyn married again; his new wife, Anne Maria Fly, was the daughter of a chaplain to the Royal Household, so it was a most suitable connection, but not one that worked well within the family. Pauline and the new Mrs Jermyn did not get on; Pauline was said to have been 'the despair of her stepmother'. Precocious and independent-minded, Pauline took the view that her younger siblings were her responsibility, and not the responsibility of this intruding woman. And in adolescence Pauline was increasingly odd, socially – she refused to have anything to do with young people of her own age, preferring to wander alone on the fens 'to talk to gypsies and sedge-cutters' or retreating to her bedroom, where her bullfinch was free to fly round the room, perch on the furniture and leave droppings on the curtains. Anne Maria invited promising undergraduates to meet her – among them William Makepeace Thackeray and Edward FitzGerald, young members of Tennyson's circle at Trinity College – but Pauline had nothing to say to them. And while the relationship with her step-mother was sour, its duration was brief; Anne Maria Jermyn died in childbirth just two years after her marriage, and the baby that she bore died within a few weeks of this disastrous event. The family was left motherless again and Pauline, now aged fourteen, once more took charge. The younger children were often a source of anxiety, as well as great joy – her diary for her teenage years is full of games, visits, amateur theatricals (her brothers would never learn their lines) and occasional alarming accidents. In the course of a dressing-up game one of her little brothers 'set fire to his ruff' and was quite severely hurt.

She was educated at home by governesses and tutors. At an early age she learnt Latin, Greek, French, German and Italian, and many of her schoolroom notebooks survive. Italian was her favourite among her studies, and an émigré Italian, the Marchese di Spineto, was employed to teach her. She also had two close contemporaries and confidantes, one of whom was the Marchese's daughter; the other was Laura Capell Lofft, known to Pauline as 'Phluff' or 'Loftus', the daughter of Capell Lofft, the distinguished political writer and man of letters, who lived at Troston Hall near Newmarket.[1]* Laura was

*For a wealthy landowner, Capell Lofft (1751–1824) was a remarkable figure, a Unitarian and an intellectual radical. As a young lawyer in London he contributed to Britain's legislation against the slave trade. After inheriting substantial estates in Suffolk he no longer worked in the law, but remained committed to constitutional, legal and religious reform. Laura inherited his philanthropy and high principles, but not his energy.

a dumpy, unprepossessing, conventional person. Like Pauline, she was an amateur artist (but unlike Pauline she was not much good at it), and she clearly adored Pauline with humble and absolute devotion, never seeking an independent existence. If Pauline was ever embarrassed or puzzled by Laura's dependence on her, she gave no sign of it; her diaries are full of affectionate and untroubled references to this unobtrusive and convenient companion.

Dr Jermyn took a deep interest in the education of his children and was on excellent terms with his brilliant daughter, who had the full run of his library. Her reading was wide and catalysed her literary ambitions: she wrote a great deal of poetry, much of it stimulated by Walter Scott's ballads, and liked to write ghost stories and other such Gothic fragments. Scott was a firm favourite throughout her adolescence. In June 1832, when she was sixteen, Pauline read the first volume of Scott's life of Napoleon,[2] which her father was borrowing for her from a library in Cambridge, and she finished the ninth and last volume of this huge work in January 1833. She seems to have read each of Scott's works as soon as she could lay hands on it and there are scattered references in her diaries to her reading of *Waverley*, *Peveril*, *Ivanhoe*, and so on during these developing years. In September 1832 she recorded Scott's death as though it was a personal loss.

The British Association for the Advancement of Science was founded in 1831 at a meeting for the 'friends of science' held at the York Philosophical Society. ('Philosophy' and 'science' were interchangeable at this date.) The founder, William Vernon Harcourt (son of the then Archbishop of York) outlined the purpose of the Association in a letter to the great mathematician Charles Babbage on 27 August 1831: 'There is no society in Great Britain which has ever attempted, or at least persevered in attempting to give a systematic direction to philosophical research. I am not aware that there is any society which has undertaken to look over the map of science and to say – here is a shore of which the soundings should be more accurately taken, there a line of coast along which a voyage of discovery should be made.'[3] It always remained to some degree a northern phenomenon (the northern and Scottish meetings were particularly well attended), but it was also popular with the gentry. The essentially egalitarian nature of the provincial philosophical societies was not reproduced in the social composition of the Association.

The early meetings were in York in 1831, Oxford in 1832 and

Cambridge in 1833. Samuel Taylor Coleridge, no less, came to the Cambridge meeting in 1833 to see whether this gathering might be a realisation of the concept of the intelligentsia that he had set out in detail in 1830:

> The clerisy of the nation, or national church, in its primary accepta-
> tion and original intention comprehended the learned of all
> denominations; the sages and professors of the law and jurisprudence;
> of medicine and physiology; of music; of military and civil architec-
> ture; of the physical sciences; with the mathematical as the common
> *organ* of the preceding.[4]

The men and women of the Association were – although Coleridge did not recognise it – a national secular church of the intellect.

Pauline's father, Dr Jermyn (1789–1857) was a member of the Anatomy and Medicine Committee of the Association. It was thus at the 1833 meeting in Cambridge that the precocious seventeen-year-old Pauline Jermyn first met Walter Calverley Trevelyan,* who was a member of the Geology and Geography Committee. Trevelyan was brought to Swaffham Prior after the meeting closed. Pauline recorded in her diary: 'Mr Curtis & his friend Mr Trevelyan came to botanise.'[5]

Walter Trevelyan was a fiercely intellectual man, interested in everything (especially scientific things) in the contemporary world. At Harrow he had been a friend of William Henry Fox Talbot (1800–77), who was later to be one of the founding fathers of the science (and art) of photography; Fox Talbot invented 'photogenic drawing' in 1839, and this, improved by the 'talbotype' method, became the foundation of photography of the present day. He discovered a method for taking instantaneous photographs in 1851, and in 1852 developed a means of photographic engraving. Partly through this friendship, Trevelyan, too, took a lifelong interest in photography.†

As an undergraduate at University College, Oxford, Trevelyan was a friend of Charles Lyell (1797–1875), later to be one of the century's greatest geologists. Trevelyan and Lyell were both taught by William

*Always known as 'Calverley' to his family and friends, he is 'Caly' or 'Cal' in Pauline's diaries, and 'Walter' more formally.

†He and Pauline tried to go to every London exhibition of photography, and in the 1840s and 1850s there are numerous references in his and Pauline's diaries to his experiments with new photographic equipment and his expeditions into the snowbound countryside of Northumberland to find spectacular views.

Buckland (1784–1856), Professor of Mineralogy, Reader in Geology and Canon of Christ Church. After Oxford, Trevelyan pursued his studies in Edinburgh, where he knew (Sir) David Brewster (1781–1868), editor of the *Edinburgh Journal of Science*. Through his friendship with Brewster he developed an interest in the geology of the Faroe Islands and spent several weeks there in 1821. His geological findings on this trip made him a well-known and respected figure in the growing geological community.[6]

Edinburgh was Trevelyan's main home and his intellectual base at this date, and his friendships there were of lasting influence. In 1822 he met George Combe (1788–1858), founder (with his brother, the physican Andrew Combe) of the Edinburgh Phrenological Society, and became convinced that phrenology – the study of the bumps of the skull as a guide to personality – was a genuine science. Its central feature was the conviction that the intellect, moral outlook and personality were inherited 'givens'. It followed that phrenology's adherents, like Combe and Trevelyan, were humane and generous in relation to people who had the misfortune to be born less morally and intellectually strong than themselves. Walter's outlook was always selfless and philanthropic, and the friendship with Combe reinforced those characteristics. His faith in phrenology, therefore, though incongruous in a pragmatic and intelligent experimental scientist, cannot be regarded as damaging or harmful.

Both Brewster and Buckland were central to the founding of the British Association. Buckland was the first to read accurately the fossil records in a cave at Kirkdale in Yorkshire, into which hyenas had dragged and eaten their prey, and his findings were published in a book with a magnificently resonant title, which tied together his genuinely important findings and his desire to stay loyal to the Bible's account of the Flood: *Reliquiae Diluvianae, or Observations on the Organic Remains contained in Caves, Fissures and Diluvial Gravel and on other Geological Phenomena attesting the action of an Universal Deluge*.[7] Buckland's and Walter's friend, the Revd Dr William Conybeare, wrote a mock-learned illustrated poem in 1821 about Buckland's findings at Kirkdale. A few lines of this composition give its flavour. Geology at this date was a gentlemanly and light-hearted, as well as learned, pursuit:

> Trophonius 'tis said had a den
> Into which whoso once dared to enter

5

Returned to the daylight again
With his wits jostled off their right centre.
But of all the miraculous caves
And of all their miraculous stories
Kirby hole all its brethren outbraves
With Buckland to tell of its glories.

The verses are accompanied by a striking caricature of Dr Buckland in the hyena's cave at Kirkdale, lighting the scene with a single candle to reveal four living hyenas chewing away at their prey.[8]

Buckland was famous for having identified the first British dinosaur at Stonesfield, near Oxford, in 1824, which he dubbed a 'megalosaurus'.[9] And it was Buckland who established that the curious multicoloured 'beetle' stones, which responded so attractively to cutting and polishing that they were much prized by fashionable ladies of the day as ornamental jewellery, were in fact fossilised turds. He forced concrete through the guts of a dead dogfish and showed that the result closely resembled these faecal fossils – coprolites – in shape.

Initially Buckland wanted to exclude women from the Association. When elected President of the Oxford meeting of 1832 he wrote to a friend: 'Everybody whom I spoke to on the subject agreed that if the meeting is to be of scientific utility, ladies ought not to attend the reading of the papers – especially in a place like Oxford – as it would at once turn the thing into a sort of Albemarle-dilettanti meeting.'[10]*

Membership of the Association was supposed to be restricted to members of philosophical societies. Every major city had its literary and philosophical society, a kind of Open University: philosophy embraced all that we would now call the sciences, while literature embraced what we would now call the humanities. It has been remarked that 'a listing of societies subsumes a roll-call of the major Industrial Revolution areas.'†

Sir John Trevelyan (Walter's father), was closely associated with the Newcastle Literary and Philosophical Society, particularly because his Northumberland friend and neighbour, Sir John Swinburne of

*It was fashionable for society ladies to go to lectures at the Royal Institution, Albemarle Street, in London.

†Manchester (1781), Derby (1783), Newcastle upon Tyne (1793), Birmingham (1800), Glasgow (1802), Liverpool (1812), Plymouth (1812), Leeds (1818), Cork (1819), York (1822), Sheffield (1822), Whitby (1822), Hull (1822) and Bristol (1823).[11]

Capheaton, was its Life President. It was natural, then, that Pauline, as his son Walter's friend and later wife, should involve herself with the British Association when it came into being. Women came to the Association's meetings only as guests or on 'ladies' tickets', and were never full members, but one way or another they were constantly in attendance. In Newcastle in 1838, for example, Sir John Herschel wrote to his wife about a lecture given by Adam Sedgwick (and attended, as we know from her diary, by Pauline Trevelyan):

> Sedgwick, in his talk on Saturday, said that the ladies present were so numerous and so beautiful that it seemed to him as if every sunbeam that had entered the windows in the roof (it is all windows) had deposited there an angel. Babbage, who was sitting by me, began counting the panes, but, his calculation failing, he asked me for an answer; 'but, if what Sedgwick says be true, you will admit that for every little pane there is a great pleasure'.[12]

Some lectures and papers in botany and zoology were closed to ladies on account of the nature of their subject matter, but in general Pauline and intelligent women like her were able to access the lectures of the best scientists* in the country at these annual meetings long before the admission of women to universities. Interest from women was so intense that the Association steadily increased the allocation of space to them. At first they were permitted to attend only the general meetings, and not the 'sectional' meetings at which specialist papers were given, but Charles Babbage urged that they should be given greater access. He thought, rightly, that women would give social cohesion and helpful publicity and popularity to the Association, and they 'became central to the style and success of the British Association, though irrelevant to its manifest purposes and debarred from any formal say in its government'.[13] At the Oxford meeting of 1832, Sedgwick (president-designate for the meeting the following year in Cambridge) was so pleased by the influence that the women had had that he warmly invited them all to the Cambridge meeting in 1833, 'the wives as well as the husbands, under the name of the Members' Philosophical Associates.'[14]

The extraordinary intelligence displayed by the seventeen-year-old Paulina Jermyn at this Cambridge meeting further contributed to the

*The word 'scientist' in its modern sense was coined by William Whewell at the 1833 Cambridge meeting.

pressure for change. John Henslow, a friend and neighbour of Dr Jermyn, wrote to John Phillips (the York curator) saying that Paulina Jermyn's notes on the proceedings in Senate House were far more accurate and intelligent than those made by the reporter officially engaged by the Association. 'The most curious part of the whole was the accuracy with which she had taken down Whewell's tides and Barlow's timber, subjects perfectly new to her. I think after this, there can be no objection to admitting young ladies.'[15]* After the Dublin meeting of 1835, women were attending most of the sectional as well as the general sessions.

In the 1820s and 1830s geology was the most exciting of the sciences. It existed in an extraordinary tension with divinity. Virtually all Fellows of Oxford and Cambridge colleges were in holy orders at this period. Typically, a geologist at one of the ancient universities made more money from the Church than from geology. Buckland's salary, for example, as a Professor of Geology at Oxford was modest (individual colleges were rich, but the university as an institution was poor). For his living he depended on the very handsome salary that he drew as a Canon of Christ Church; he also had the benefit of a beautiful canon's house within the college. At Trinity College, Cambridge, William Whewell was Professor of Mineralogy (1828–32) and of Moral Theology (1838–55). The fact that he could hold chairs in both these subjects tells us a lot about English geology.

William Paley's *Natural Theology* (1802) had sought to accommodate geology with the Bible. The earth's creatures and the history written in its rocks were evidence of God's beneficence as creator. As a living system the earth embodied physical proof that God existed. Creation seemed to display common sense; the functions of such mechanisms as the elephant's prehensile trunk and the barn owl's forward directed eyes were satisfyingly and obviously right. This, the 'argument from design' summed up much eighteenth-century thought about the relationship between God and the natural world. Famously, Paley started his great book with a comparison between the created world and a watch. This was not new – Paley himself said that the analogy was 'not only popular but vulgar' –

*In the family and with close friends, 'Pauline' was customary, but 'Paulina' was her formal name at this date. After her marriage 'Paulina' was used interchangeably with 'Pauline' by her husband in his letters and diaries; otherwise she was Pauline. Her transcripts of these British Association lectures survive in the Special Collections at the Robinson Library, Newcastle University.

and would have been familiar to his first readers.[16] His handling of this traditional analogy is a model of clarity and directness:

> In crossing a heath, suppose I pitched my foot against a stone, and were asked how the stone came to be there, I might possibly answer, that, for anything I knew to the contrary, it had lain there for ever: nor would it perhaps be very easy to shew the absurdity of this answer. But suppose I had found a watch upon the ground, and it should be enquired how the watch happened to be in that place, I should hardly think of the answer which I had before given, that, for any thing I knew, the watch might have always been there. Yet why should not this answer serve for the watch, as well as for the stone? Why is it not as admissible in the second case, as in the first? For this reason, and for no other, viz. that, when we come to inspect the watch, we perceive (what we could not discover in the stone) that its several parts are framed and put together for a purpose, e.g. that they are so formed and adjusted as to produce motion, and that motion so regulated as to point out the hour of the day[. . .] the inference, we think, is inevitable; that the watch must have had a maker: that there must have existed, at some time, and at some place or other, an artificer or artificers who formed it for the purpose which we find it actually to answer: who comprehended its construction, and designed its use.[17]

Paley's *Natural Theology* continued to be regarded as a comforting founding text that reconciled science and religion. In 1806 Coleridge had declared that Paley's writings debased religion to a mere mechanism, and that all thinking men should turn their backs on this tradition forthwith.[18] But Paley continued to underpin the thinking of geologists who sought to reconcile the record of the rocks with the Bible. The created world was evidence of God's goodness.

The young William Buckland was a Diluvianist. He sought to reconcile the teaching of the fossil record with the 'Mosaic' account of the Flood in Genesis 6–9. (Traditionally, of course, the first five books of the Bible, the Pentateuch, were believed to have been written by Moses himself. The King James Bible begins sonorously with 'The First Book of Moses, Called Genesis'.) On taking up his university appointment in geology at Oxford, Buckland gave an inaugural address, 'Vindiciae Geologicae; or the Connexion of Geology with Religion Explained': the earth was formed by a series of catastrophes, of which the Flood was one. In the 'English School' of geology as expounded in particular in Buckland's earlier writings, the study of rocks and fossils told the history of the world before the creation

of man, and Genesis told the history of the world since the creation of man.

The English School continued to accommodate their work with Anglican teaching, unlike Buckland's student, the Scottish geologist Charles Lyell, whose celebrated *Principles of Geology* of 1830–3 treats the record of the rocks as though it and the Bible ought not to have anything to do with each other. Lyell's book is written with endearing directness and common sense:

> Geology is intimately related to almost all the physical sciences, as history is to the moral. An historian should, if possible, be at once profoundly acquainted with ethics, politics, jurisprudence, the military art, theology; in a word, with all branches of knowledge, by which any insight into human affairs, or into the moral and intellectual nature of man, can be obtained. It would be no less desirable that a geologist should be well versed in chemistry, natural philosophy, mineralogy, zoology, comparative anatomy, botany; in short, in every science relating to organic and inorganic nature. With these accomplishments, the historian and geologist would rarely fail to draw correct and philosophical conclusions from the various monuments transmitted to them of former occurrences.[. . .]
>
> The most common and serious source of confusion arose from the notion that it was the business of geology to discover the mode in which the present system of things originated, or, as some imagined, to study the effects of those cosmological causes which were employed by the Author of Nature to bring this planet out of a nascent and chaotic state into a more perfect and habitable condition.
>
> Is not the interference of the human species, it may be asked, such a deviation from the antecedent course of physical events, that the knowledge of such a fact tends to destroy all our confidence in the uniformity of the order of nature, both in regard to time past and future? If such an innovation could take place after the earth had been exclusively inhabited for thousands of ages by inferior animals, why should not other changes as extraordinary and unprecedented happen from time to time?[19]

Partly as a consequence of Lyell's work, Buckland came to disown the diluvial theory of geology, but Adam Sedgwick and William Whewell continued to resist departure from the Mosaic narrative.[20] In 1829 the Earl of Bridgewater left funds in his will for publication of works on the Power, Wisdom and Goodness of God, as manifested in the Creation. The result was a series of beautifully produced books conforming to the doctrine of 'natural theology'. Buckland

was a contributor (in the sixth of the series) and caused some dismay
to his friends because he backtracked on his hard-won struggle with
diluvial theory: he left open the possibility that the Mosaic account
of the Flood was true. His explanation of how God created the world
in six days (as described in Genesis) was ingenious:

> Millions of millions of years may have occupied the indefinite interval,
> between the beginning in which God created the heaven and the earth,
> and the evening or commencement of the first day of the Mosaic
> narrative.[21]

In the second chapter of his book Buckland wrote:

> Geology has shared the fate of the other infant sciences, in being for a
> while considered hostile to revealed religion; so like them, when fully
> understood, it will be found a potent and consistent auxiliary to it,
> exalting our conviction of the Power, and Wisdom, and Goodness of
> the Creator. No reasonable man can doubt that all the phenomena of
> the natural world derive their origin from God; and no one who believes
> the Bible to be the word of God has cause to fear any discrepancy
> between this, his word, and the results of any discoveries respecting the
> nature of his works.[22]

The crisis precipitated by Charles Darwin's *Origin of Species by
Means of Natural Selection,* published in 1859, when the conflict
between biblical teaching and the findings of science became plain
for all intelligent people to see, was long in its gestation. Until that
date Pauline's opinion more or less coincided with Buckland's broad
and genial observation that 'No reasonable man can doubt that all
the phenomena of the natural world derive their origin from God.'

For a wealthy landowner like Trevelyan, there was a good prac-
tical reason for taking an interest in geology, which was that he had
a considerable commercial interest in coal. In 'natural theology' it
was a particular mark of God's providence that iron and coal lay at
levels of the earth at which they were convenient for mining. Trevelyan
was respected as a field researcher whose results were often referred
to in Buckland's publications. At the same time he continued vigor-
ously to support George Combe:

> 12 May 21 Meeting in Evening for forming of 'The Ethical Society'
> for the purpose of prosecuting the study of Phrenology, & for promoting
> the practical application of it to the various duties and relations of life,

or in other words of seeking out and shewing forth the capabilities of human improvement – in Dr Wm Gregory's classroom – address by Mr Combe – attendance of about 40 – 23 of whom joined this evening.

Reference to 'The Ethical Society' marks the fact that phrenologists were liberal and philanthropic in outlook. Trevelyan's social and political convictions – that alcoholic drinks and stimulants were abominable, that war and its weapons were evil – were all compatible with a phrenological reading of the nature of man. So was his influential campaigning against capital punishment. He looked forward to:

the approach of that day when we shall cease to have our streets polluted by the demoralising and disgusting exhibitions of legalised human butchery which has lately been displayed in them; the more absurd in this day when their utter uselessness as a preventive of crime, or as a means of reform, is so well known; and iniquitous and unjust in the extreme when we consider how often the crimes, for the punishment of which they are used, have been caused by our legislators neglecting or withholding from the people that education without which all attempts to prevent crime will ever prove utterly vain and useless. I need not remark how erroneously the teaching of reading, writing, and arithmetic, and occasionally the religious tenets of some particular sect, has hitherto been considered as education, while the moral training or the practical inculcation of true religion has been entirely neglected; it is a melancholy fact that this, with but few exceptions, yet continues to be practically the *ne plus ultra* of education in all classes; when this is the case, we cannot be surprised that good fruit should so seldom be produced by such a system.*

A system of true religious, moral, and intellectual training combined has been commenced in some infant schools; and were this plan generally adopted and continued through the advanced schools until their pupils were fit to enter into active life, we should soon see a great moral change effected in the character of our population; a few years would then do more towards its amelioration than ages of the present unchristian, irrational, and disgusting system of penal laws, with all its

*Pauline was tough-minded about capital punishment. Many years later (January 1857), when she lived at Wallington, one of her diary entries displayed surprisingly little sympathy for a servant on a Northumberland farm who was likely to be sentenced to death for killing her baby: 'Sunday night she went to bed as usual. next morning she refused to get up, and it was found that she had had a child which was found dead between the bed & the mattress – she is very silly – but not silly enough to be got off on that score. she is very cunning & tells many lies & so gets herself into much worse jeopardy. the Dr watched her all night to prevent her committing suicide.'[23]

paraphernalia of fetters and of gibbets, its threats of imprisonment, of exile, and of death.[24]

Walter Trevelyan and Pauline Jermyn were, then, both intelligent and high-minded people. He was immediately impressed by her, as his diary shows:

July 3 1833 Breakfast with Skinner (Jesus). Drove in gig to Dr Jermyns, Swaffham. Two churches in Church Yard, one in ruins with Saxon tower, Norman arches – picturesquely ornamented with Ivy – [. . .]

Dr Jermyn has extensive collections of heraldry &c a taste which has run in his ancestors ever since the time of J 2nd. Of his own he has the histories of the Suffolk families in about 40 vols [. . .]

Some antiquities, an arm bone with armlet of copper found with remains of skeleton & funerary urn &c (Roman) in this neighbourhood – collections of insects, birds [. . .]

Dr Jermyns daughter (a young lady about 17) of remarkable talent for languages & science &c wrote from a memory a full report of the various papers & lectures she heard at the meeting at Cambridge – inherits her father's anterior development.[25]

He was reassured by Pauline's promising skull: in phrenological terms, she was right for him. It would be an exaggeration, but not much of one, to say that Pauline and Trevelyan were brought together by geology and phrenology, and by books like Paley's *Natural Theology* and J.F.W. Herschel's *Preliminary Discourse on the Study of Natural Philosophy* (first published in 1830; we find her borrowing it from a library in Cambridge in January 1834). Herschel's book elegantly balances Paley's. Herschel says there is no point in trying to reconcile Genesis and geology: 'The character of the true philosopher is to hope all things not impossible, and to believe all things not unreasonable.' Science must be 'independent, unbiased, and spontaneous', but the nature of truth is, nevertheless, 'single and consistent'.[26] Sedgwick's *Discourse on the Studies of the University* (originally preached as a sermon in Trinity College Chapel, 1832, and published in 1833) had boldly claimed a central position for the new science of geology in theological thinking (God had created the ancient world that predated man). This produced a violent reaction from both camps: one Henry Cole (a clergyman, not the famous civil servant) ferociously and publicly attacked the sermon for heresy, while John Stuart Mill attacked it for stupidity. Sedgwick survived.

It was unusual for a young woman of the period to be on terms of close friendship with much older intellectual men, as Pauline was with Adam Sedgwick and William Whewell. The relationship with Walter Trevelyan began as another such friendship (Pauline was seventeen and Walter was thirty-six when they first met), but rapidly became a love match.

Trevelyan was a man of striking appearance, with long dark hair and moustaches and a raffish and bohemian style of dress. In middle age, after he had inherited his title and property, contemporaries spoke of him as looking austere and somewhat eccentric,* but as a younger man he was darkly romantic. Pauline was passionate about him; she felt an extraordinary excitement when he was around. Much of her diary for 1833 and 1834 is almost illegible, as though she were deliberately writing in a hand that would make her thoughts and feelings inaccessible to her family.†

Thus, on 14 August 1834, 'drove Mr Trevelyan [and; two other people whose names are irrecoverably illegible] to Cambridge'[27] and the following day, Friday 15 August, 'Mr Trevelyan arrived at 2.00 p.m.' Saturday 16 August was clearly a lovely day spent mostly in his company, though quite what they did together is again almost completely illegible. One can assume that they talked gravely about geology and religion – probably about the contrasting views of Paley and Herschel, and about the ferment of ideas emerging from the meetings of the British Association. They went for long walks, often stopping to look for fossils (when in good health they were both heroic walkers), all the time tacitly acknowledging the feeling that was steadily developing between them. The only bit of that day's events that I can read says, 'Mr Trevelyan very agreeable'.

On Monday 18 August they went for another walk, this time before breakfast. The frequency of his visits increased as the year unfolded (he seems to have visited at least once a week in December) and Pauline uses the diary to draft what seems to be a long, friendly, disarming, but again almost completely illegible letter to him, addressing him as 'my dear sir'. She also says, 'Mr Trevelyan sent a box of fossils.' Early in 1835 he proposed marriage, probably on a

*Photographs of Walter from the 1850s and 1860s bear this out to some extent.

†Somebody has read through the diary, making marginal pencil marks and adding little crosses in pencil. Many of these seem related to references to Trevelyan and their coming marriage, and it appears likely that these pencil annotations are in fact Trevelyan's own, added to remind him, after Pauline's death, of precious moments in the early years of his relationship with her.

visit to Swaffham at the end of January, and on Thursday 12 February she accepted his proposal.

Trevelyan pasted a newspaper cutting into his diary: 'May 21, at Swaffton [sic] Prior, W.C. Trevelyan, Esq., eldest son of Sir John Trevelyan, Bart., of Nettlecombe, Somersetshire, and of Wallington, Northumberland, to Paulina, eldest daughter of the Rev Dr Jermyn.' Paulina, or Pauline, had made a princely marriage for herself.

Walter's diary entries about his marriage and the honeymoon were drily factual:

> Married 8 1/2 a.m. in Swaffham Church to Paulina Jermyn Jermyn – by Rev Mr Casborne – and after breakfast left for London –

The honeymoon was spent in Kent and Sussex, sightseeing and visiting. Trevelyan's diary read:

> May 22 Proceeded to Sevenoaks descending at Hill the escarpment of the Chalk – the Crown Inn has a beautifully situated garden well stocked . . . Walked in Knole Park – prettily formed ground containing some fine green oak & beech.

> [May 24 and 25 Knole Park and the house, Pauline sketched an ancient oak of grand dimensions.]

> May 31st Rusthall

> June 1st Tonbridge Went to Tonbridge infant school about 110 children – well conducted – the more I see of these institutions, the more am I convinced of their great importance & shall be delighted to see them generally established thro the country.

As honeymoons went, this one was fairly sober and displayed an emphasis on learning, self-improvement and good works.

Pauline's account of the marriage was as bald as her husband's. Her diary for Thursday 21st May 1835 read, 'married by Mr Casborne at half past eight'.[28] Her adored younger sister Mary ('Moussy') and her brothers Hugh and Tenny were at the wedding, and among the handful of friends were William Whewell and Professor Henslow from Cambridge. No member of the Trevelyan family was present. The breakfast following the marriage was a prompt morning affair, as the couple left for London at ten o'clock, spent the whole day

travelling and arrived at five-thirty. They had dinner together and thereafter her diary's illegibility casts an impenetrable mystery over the wedding night. It is reasonable to suppose that Walter, who was a kind man and himself very much in love, made sure that this young and completely inexperienced woman was now a happily married wife.

William Bell Scott suggested that the Trevelyan marriage was 'very likely without the passion of love' – in other words, that it was uncon-summated.[29] But against that is the evidence of Pauline's love poems to Walter, which are simple and passionate.[30] A poem called 'Wedded Love', dated 29 January 1836, compares her condition with that of the poet or philosopher, and reflects that the married person is happier. The ambitious individual is blessed by the muses:

> How blest are they at times to shroud
> Their woes beneath the veil of song,
> To launch upon the sea of thought,
> And sweep her boundless waves along.
>
> On them the favouring muse looks down,
> And smiles upon their visions high;
> And they may find a bliss in dreams,
> Denied by stern reality.

The happily married woman, by contrast, has no such ambitions:

> But how should one, supremely blest
> In all the joys of faithful love,
> Delight to turn in thought away
> From bliss that mounts all thought above?
>
> Love sways not a divided heart,
> The jealous muse will reign alone;
> Though hers may be the loftier part,
> Be his and mine the happier one.

A second poem for Walter, written in Rome and dated 21 May 1836, reflects that she loves poetry not for itself, but as a means to communicate love:

> Could love inspire the flowing song,
> How many a verse I'd freely twine;

16

> How sweetly joy should smile along
> All that my heart would breathe to thine!

Renunciation and married happiness are to be preferred to ambition:

> But since no muse will heed my call,
> Nor, smiling, prompt the raptured line,
> Let love's sweet silence tell thee all
> This heart would fondly breathe to thine.[31]

For some eleven years after their marriage – from 1835 to 1846, when Walter's father died – this wealthy, gifted and cultivated pair travelled a great deal. Pauline displayed huge curiosity about the world, especially with reference to its arts, and considerable sharpness. They spent a lot of time in Rome, with two extended visits of several months between their extensive travels to other major Italian cities, and they must have lived in Rome for more than a year all told. The Trevelyans had a number of friends in Rome, including Sir Thomas Acland;* Thomas Babington Macaulay, the historian and politician (who had a family connection to Walter); and Richard Monckton Milnes, later Lord Houghton, the biographer of Keats and friend of Swinburne. Acland and Macaulay both knew Dr Wiseman, the Principal of the English College at Rome, and either one of them could have introduced Wiseman to the Trevelyans.

No intelligent Anglican in the early 1840s could ignore the upsurge of spirituality within the Anglican Church associated with the Oxford 'Tractarians', and any friend of Wiseman would know that he was in close communication with these men. Since 1833, in the aftermath of Earl Grey's Reform Bill, a body of determined and intelligent clergymen, most of them Fellows of Oxford colleges, such as Edward Bouverie Pusey, John Keble and John Henry Newman, had devoted themselves to what one of their followers would later call 'the vital question', which was: 'How were we to keep the Church from being Liberalised?' The answer was to write and publish a series of essays, *Tracts for the Times,* which were devoted in large part to reinforcing the authority of the Anglican Church by appealing to its traditional

*A Somerset friend and neighbour of Walter's father, Acland was the father of Henry Acland, later Regius Professor of Medicine at Oxford and a key figure in Pauline's story.

and historical teaching. The practices and beliefs of the ancient Church were to be restored; the spirituality associated with the early fathers was to be revived; the newly reformed and aggressive liberal state created in 1832 was to be repelled; the revival of ritual, with its pyxes, piscinas, aumbrys, vestments and so forth, was part of the carapace that would enforce the Church's autonomy and re-establish 'the true principles of Churchmanship', which in the impoverished 1830s had become 'so radically decayed'.[32] From at least 1835 the Tractarians had been accused by their enemies of having a secret sympathy with, and in some cases actual membership of, the Roman Catholic Church. Pauline was intensely aware of this and of the associated controversy.

How close did she herself come to conversion to Rome? Her father was an Anglican clergyman and her husband was a committed Anglican evangelical, so there were obvious personal ties to the Anglican fold. And the Roman Church could provoke horror in otherwise rational persons, who sensed 'vast masses of practical evil in the Roman Church, evils from which they shrank both as Englishmen and as Christians, and which seemed as incurable as they were undeniable'.[33] To those engaged in it, the struggle between Rome and the Anglican Church was a matter of life or death, good or evil, depending on one's perspective and persuasion. If Pauline had known Newman well, she would have been tempted to follow him on his path to Rome. Newman's famously seductive personality, with his winningly feminine* grace and exquisitely melodious voice, together with his celebrated history of an agonised personal struggle lived out in full view of his enemies and disciples, would have constituted a massive temptation. Wiseman, a dry, bullying and bureaucratic personality when compared with Newman, had less chance with her.

The Trevelyans' first impressions of Rome were very powerful. On 30 March 1836 they entered Rome by the Porto del Popolo. They visited St Peter's immediately, having arrived for the major celebrations of Easter. Pauline loved the Roman Catholic liturgy. Her diary records her visit to the Sistine Chapel at Easter 1836: 'so much grace dignity & solemnity as would draw feeling & admiration from a

*A contemporary described Newman as 'a graceful high-bred lady . . . with a voice sweet and pathetic, and so distinct that you could count each vowel and consonant in every word'.[34] At this date Newman was an opponent of Wiseman because he was seeking to persuade the Anglican Church to enrich itself by restoring its lost traditional churchmanship and thus bolstering itself *against* Rome. His great public rift with Anglicanism and his consequent conversion to Rome were to come gradually, in 1842–5.

18

Quaker'.[35] The choir sang magically, but her attention was distracted by the behaviour of her countrywomen: 'there was a good deal of crowding at going out and the English ladies behaved abominably – talking laughing jumping over the tops of the benches and striding from one to another in the most hoydenish manner possible'. Pauline insisted on following the fashion of wearing a black dress for Passion Week. They heard the Passion:

> chanted in the most surpassingly beautiful manner – the words of Pilate & our Saviour were very fine and when the Chorus gave the replies of the people it was striking in the extreme – the pause after the words *Consummatum est* had something so overpoweringly awful in it that the recollection haunts one long after – I was equally disgusted & ashamed to hear some English ladies near me going on with their execrable whispers all the time – they also sat still as though they had been stones when everyone else knelt down as well they might – the Pope now uncovered the Cross and chanted *Ecce Unum Lignum* several times [. . .] the very fitting & seemly injunction to wear black on appearing in public in Passion week – the English ladies were the only transgressors in the latter respect and I am ashamed of them.

This Pope, Gregory XVI (reigned 1831–46), was not a man to inflame further Pauline's enthusiasm for the Roman Church. Unlike his successor, the great Pio Nono, he was a repressive figure whose authoritarianism provoked revolt in the papal territories in 1832 and 1838.

Walter did not share Pauline's religious enthusiasm for the services, but he certainly responded to the beauty of the occasions, and was reassured by the fact that reliable friends (including the Aclands) were there too. Pauline did not care whether her behaviour was atypical of the gentry, while Walter liked to fit in. He found the exterior of St Peter's disappointing, but the interior 'is exceedingly grand – the proportions being gigantic & all the ornaments in good keeping & very splendid – the celebrated high altar is I think ugly – not in such good taste as the building in which it is placed'.

> 31st March 1836 Drove to St Peters about noon to see the Pope give the benediction on the crowds assembled on the steps & Piazza before the Church – He was surrounded by Cardinals &c brought on a seat supported on mens shoulders to a balcony (or window) at the centre of the façade of St Peters – & thence gave the benediction with such dignity & grace immediately after which the guns of St Angelos

commenced firing [. . .] in afternoon going again to St Peters we met Sir T[homas] Acland & Mr Fortescue with whom we attempted to get into the Sistine Chapel – P having a black cloak on succeeded but my frock coat caused my expulsion – therefore returned home & having changed it got into the chapel & heard some exquisite singing – Miserere &c.

They had secured tickets for the Easter Mass on 3 April, with a seat for Pauline and standing space near the high altar for Walter. He remarked in his detached, factual way on the chattering tourists who so enraged Pauline: 'About 10 the Pope entered in procession a good military band playing [. . .] noise & bustle from the attending crowds prevented our hearing satisfactorily the singing.'[36] At the major festivals, Christmas 1836 and Easter 1837, they again went to all the Roman Catholic celebrations in the Sistine Chapel and in St Peter's, and during the winter of 1836–7 they became increasingly friendly with Dr Wiseman, visiting him a number of times at the English College, going regularly to hear him preach and inviting him to their own apartments.*

They also stayed in Florence, where they bought a number of paintings, including a Domenichino, a Piero della Francesca (now in an American collection) and a Ghirlandaio, as well as a Della Robbia roundel.[37] In September 1837 Pauline visited San Gimignano:

A very raw cold morning set off early for San Gimignano [. . .] a very small place perched on a high hill looking at first like a large fortress from its number of lofty towers – it was independent during the middle ages & its inhabitants being very pugnacious people conquered a little territory round about them – Dante was once sent as ambassador to this republic – at length however the nobles fell to quarrelling so much among themselves that the inhabitants unable to bear their tyranny any longer gave the town up to Florence. It was during the troubled period preceding this surrender that the quarrelsome nobles built all these towers. They are now all gone but about 12 which make a great show in so small a place [. . .] The cathedral [. . .] is a very old church but the outside has been altered & painted lately & is frightful as may be imagined – but the interior is very good [. . .]

The church is dedicated to Sta Fina [she was born in 1238] a native of this place she was a nasty dirty creature and chose to lie for some

*Walter's diary records a big evening gathering on 8 February 1837, when Wiseman and a number of the fashionable English community in Rome were their guests. He and Pauline continued to call on Wiseman regularly until they left Rome in the late summer of 1837.

years upon a board without ever washing herself or rising up – the consequence whereof may be imagined – they are minutely described in her life & are sufficiently disgusting – she had some miraculous visions – & after her death when her body was *cut* off the board the latter was immediately covered with flowers – her body wrought many miracles – so it seems she was of more use after her death than during her lazy & dirty life – probably a whipping or two & some doses of physic wd have cured her monomania – she died young as might be expected – instances of miserable deranged creatures like this girl being sainted & worshipped wd make one hate the Catholic religion if it were not certain that the Saints (par excellence) of all churches are equally mad – from Luther to the worshippers of Juggernaut.[38]*

They travelled from Elba to Città di Castello, where Walter bought a painting believed to be by Il Sodoma (it is now thought to be by Giutio Lesare Procaccini and is in London's National Gallery).[39]† They were back in Rome for the Christmas Masses at St Peter's, and in the New Year resumed the agreeable sociability of Wiseman and his circle. The son of Edinburgh friends, the Scotts, had joined them in Italy, and Walter and Pauline were showing this boy the sights as far as his health would allow. He was gravely ill and had come to Rome in a last bid to save himself from tuberculosis (as Keats had done in the 1820s). He died aged twenty-one on 10 April 1838. It was a poignant death; his mother had already lost her husband and her two other sons to the same illness.

In April 1838 they were again at all the Masses (for Easter) and were still equably socialising with a whole group of English friends. Walter had bought a carriage earlier in their travels (in Caen in 1835). This had now seen a lot of service, and he replaced it with a more robust vehicle on 18 April. The price was carefully negotiated and noted in the diary.

Walter brought his bride back to England in 1838.

The Trevelyans were originally Cornish, from a Cornish village of the same name. Traditionally the name is pronounced 'Trevillian', and some Trevelyans still use that, while others have taken to pronouncing the name phonetically. Early variants of the spelling of

*Juggernaut, or Juggannath, is one of the names of Krishna. In India a monstrous figure of this deity was dragged in annual procession on a cart. Worshippers were said to throw themselves under the wheels and thus be crushed to death.
†In Florence Walter saw an authentic Il Sodoma and was confirmed in his belief that his painting was by the same artist.

the name include Trevillion, Trevelion, Trevelian and Trevillian. The Trevelyans began to be seriously wealthy in the fifteenth century, when a Sir John Trevelyan married an heiress of the Ralegh family whose dowry included Nettlecombe Court, in Somerset. Nettlecombe, now a field-studies centre, is a very grand Tudor and Georgian sandstone mansion, with its ancient church nestling next to it. In the church is a memorial chapel for Sir John's tomb (1522). Nettlecombe came to Walter with some 20,000 acres of land and substantial property elsewhere in the West Country, including most of the seaside village of Seaton, near Axminster.

Wallington in Northumberland had also come to the Trevelyans by marriage, but more recently. Wallington was originally a castle, and probably existed in the twelfth century as a pele tower, a sturdy squat structure from which landowners could defend themselves from reivers (cattle rustlers) or from hostile incursion by the Scots. The many pele towers and castles that survive in Northumberland are mute witnesses to the violence that prevailed on the borders between Scotland and England for several hundred years. Until the seventeenth century it was not prudent to build a substantial house that was not fortified. Capheaton, the spectacular late-seventeenth-century seat of the Swinburnes, is the earliest house in the region that was built in a style to reflect a more settled and civilised way of life.

Late-medieval Wallington was famous for the hospitality and fierce aggressiveness of its owners, the Fenwicks, who owned the property for 200 years. The Fenwicks built a substantial fortified house round the original pele tower. The story of the Fenwicks was bound up with that of the house of Stuart and the Civil War. As ardent Jacobites, they were unable to accept the outcome of the so-called Glorious Revolution of 1688 (by which James II was deposed). The Fenwick of that date, the third baronet, lost his fortune, his house and finally his life in the Stuart cause. He had bankrupted himself and was forced to sell Wallington to the immensely wealthy Sir William Blackett, a Newcastle merchant.

Sir William Blackett owned Anderson Place, the most desirable big house in the North: desirable because in those troubled times it was secure within a walled city. With its gardens and orchards, it occupied much of the centre of the city of Newcastle. Sir William had the Fenwicks' pele tower and house demolished, and used the stones as a quarry to build a new Wallington, rather conservative in style, based on a quadrangle and built with a great hall and primitive

external staircases. Large though it was, the new house was viewed by Sir William as a shooting box rather than a residence. In the eighteenth century his nephew and heir, Walter Calverley Blackett, had the house extensively rebuilt, with new staircases, Italian plasterwork ceilings and a complete remodelling into a fashionable and elegant modern establishment, fit for stylish entertaining and for the rearing of a large family. Yet Walter Calverley Blackett was a widower and his only child, a daughter, had died, so on his death the property went to his sister's son. It was by this descent through the female line that Wallington became the property of the father of Walter Calverley Trevelyan, Sir John Trevelyan, already the owner of Nettlecombe and some 20,000 acres of land in Somerset.

Pauline's first view of Wallington was on 15 August 1838. She was delighted with the house and its position, though she immediately declared that it needed an 'entrance hall' (her subsequent improvements to the house would remedy that).

Her diary entries were brisk about her first impressions of Walter's family. Julia Trevelyan, his sister, was a 'vecchia ragazza – plain little & ill drest', though Pauline warmed slightly to the fact that Julia was pleased to see Walter, which his mother 'did not show any signs of'.[40] Another sister was 'a fat ugly likeness of Cal in petticoats, though more than 40 years old drest with an affectation of youth & finery ill chosen & worse put on. no cap. her hair not over smooth hanging sloppily down in long curls by her neck &c &c'; and a third sister, who had made a grand alliance with the Spencer Perceval family, was 'peculiarly silly & at the same time a creepy curious body. very like a fattish vampire in appearance. coming down in some of these chilly mornings arrayed in virgin white' (Wednesday 15 August).

The family circumstances were unusual, though perhaps not markedly so by the standards of the gentry of the day; we are still in the world of Regency and Georgian pragmatism rather than Victorian domesticity. Walter's mother, Maria, Lady Trevelyan, had been born Maria Wilson. Her mother, 'Dame Jane' Wilson, was an heiress, being among other things Lord of the Manor of Hampstead. Maria was her favourite child, who inherited a substantial part of her mother's estate in 1818 and would build up her capital so that her personal fortune grew later in her life to yield an annual income of £40,000 (which would translate into a huge sum in today's values).[41] Maria's independence of her husband was thus based on

a solid foundation. Sir John lived mostly at Nettlecombe, the Trevelyan estate in Somerset, while Maria lived mostly at Wallington.

Pauline had ample opportunity to reflect on the eccentricities of Walter's father. This first encounter took place at Nettlecombe:

> Sir J asked us to come into the bookroom where he was. But forgot to ask us to sit down. told us [. . .] that he had sent for a leg of mutton. and gave me the key of the tea chest. but for all this he is very good natured looking. he is like C[alverley, i.e. Walter] especially in his head which is very curious, benevolence &c being very large, firmness & self esteem ridiculously small his forehead is not so good as C's.

It is interesting to find Pauline offering a completely serious phrenological reading of her father-in-law. She was later to laugh at phrenology, but in the early diaries at least she clearly endorsed it. Laughter was needed elsewhere. It required all her resources of wit and irony to cope. The Trevelyans, especially Walter's sister Julia, were disposed to resent this young new bride, the daughter of a penniless clergyman. The grandeur of the Trevelyans was enough to daunt anybody.

Sir John, now in his seventies, had recently found compensation for his difficult marriage in a very young, beautiful and talented woman: Clara Novello, the singer, whom he first saw when she was sixteen, singing with Grisi and Tamburini in Westminster Abbey.[42] Walter got on well with Clara and fully accepted her as his father's companion. This was made easy for him by the fact that he could not stand his own mother, who reciprocated in kind.

Pauline could see that Sir John's deep affection for his oldest son was in danger of being compromised by his formidable wife and strong-willed daughters. Sir John was an old man, estranged from his wife, and the owner of two great houses and estates: the obvious amicable step to take would have been to transfer ownership of Wallington to Walter in order to provide a home for his young bride and for the children they could reasonably be expected to have. Sir John tentatively explored this option, but his wife and daughters were too much for him: Maria was installed in Wallington and had no intention of moving out. Pauline in turn found that living among the Trevelyans, either in Nettlecombe or Wallington, was bad for Walter: when subjected to the strain of his family's oppressive influence, he could behave towards her in a way that she found bullying and insensitive. One diary entry during this unhappy Nettlecombe period reads

simply: 'I cried all day & night.' But at least in her diary she could express herself without restraint. She also had no time for some of the Trevelyans' harmless and grand friends. The Miss Luttrells of Dunster, for example, who visited on 3 August, were 'as old and ugly as their great lump of a Castle'; and a Mrs Woodhouse, who visited on 6 August, 'has a bad expression of countenance, awkward air & atrociously bad manners'.

Clearly many of the Trevelyans felt cool towards this attractive, intelligent and sharp-witted stranger. Did one of them take a peep at her diary? On 30 August 1838 she wrote, 'this day I shall never forget from a discovery which I made, & wh caused me very much unhappiness. & caused me to anathematise all Cousins, fat & lean, male & female, for ever & ever Amen [drawing of a cross]'.

Sir John was proud of his son's reputation as a scientist, and made the journey from Nettlecombe to Wallington in the summer of 1838 in order to accompany Pauline and Walter to the British Association for the Advancement of Science, which was meeting in Newcastle. The meeting was a lavish affair with banquets, balls and receptions, as well as the serious programme of lectures and papers: the citizens of Newcastle were determined to show their proud new city at its best. Pauline wanted to be taken to all the meetings, of course, but had to press Walter hard before he would relent: 'Monday 20th August after several times condemning me to remain at Wall. C at last consented to take me to the meeting at Newcastle provided I kept very quiet all the time.'

She travelled into the city with Walter, Sir John, and a child who was visiting (a young cousin of the Trevelyans called Frederica Perceval, granddaughter of Spencer Perceval): 'an unpleasant rainy drive to NC but even with the bad weather I was much struck with the beauty of the new parts of the town the principal street Grey Street is really a very fine thing at the upper end is a fine column onto which a statue of Ld Grey is to be placed this week.' Walter was astonished by the changes that had taken place in the city of Newcastle while he was abroad: 'Much surprised at the New Town that has sprung up under the hands of Mr [Richard] Grainger [an enterprising merchant and visionary town planner] since I was in the North some of the buildings are very handsome & are built with beautiful stone.'

Newcastle in the 1820s and 1830s was being transformed into a

bold and magnificent city in the classical style. The leading figures here were of humble origins: Richard Grainger (1798–1861) was the son of a Quayside porter who had become a prominent and confident property developer and politician, and the architect John Dobson (1787–1865) was the son of a North Shields market gardener. After apprenticeship to the then leading architect of the city, followed by a further period of training in London, Dobson set up his own practice in Newcastle and rapidly made his mark as an exceptional young talent. With Grainger's broad conception and Dobson's mastery of design, the city centre was steadily being adorned with Grecian squares, elegant curved streets with magnificent classical façades, and graceful public buildings. Today Grey Street is the most notable part of the Grainger and Dobson city plan to survive. The monument that Pauline would see being placed in its key position at the top of Grey Street was in honour of the Northumberland grandee Charles Grey, the second earl (1764–1845), leader of the government that had passed the Reform Act of 1832.

Walter's younger brother Arthur Trevelyan joined the party in Newcastle. He was philanthropic and intelligent, like Walter, but a much more socially relaxed, genial and amusing man than his elder brother. He was always Pauline's favourite among the Trevelyan relations: 'good natured & odd as ever. he made me laugh more than anything has done for a good while past'. Sir John went to the ball given by the city in the Grainger Market in the evening in honour of the Association meeting. He was exceptionally kind to little Frederica, who was taken along to see the sights. The ball was a packed and glittering event, much praised in the local press, but Pauline reported that Sir John found it merely crowded and dingy. She and Walter had clearly decided not to go to it. She preferred the serious side of the Association's work, even the 'statistical section' on 21 August, at which she wanted to hear Robert Owen of Lanark.

Robert Owen (1771–1858) was one of the most colourful and effective industrial reformers of the age. A successful Manchester cotton miller, he bought the New Lanark Mills and made them the practical base for his philanthropy. His 'institution for the formation of character' for the children of his workers made his reputation as a radical educational reformer, and his determination to improve working conditions led him into politics, where he was instrumental in the passing of the Factory Act of 1819. Later he spent a great deal of his personal fortune setting up 'communistic' communities in

Ireland and the United States, and at the time that Pauline met him he had been actively promoting cooperative and social congresses and his 'Equitable Labour Exchange' for some ten years. From a phrenological viewpoint, Pauline found his reasoning faculties 'not very large', but she was nonetheless intrigued. He was:

> An enthusiast of the most sincere description. Owen showed us a large oil painting a view of his projected society which he explained to us [. . .] his plan requires that all the children should be taken from their parents at a very early age and given to the care of nurses – & teachers – I could not make Owen understand the impossibility of bringing most parents to consent to this.

Phrenology provided her with a convenient shorthand method of taking down the personalities of people she observed, and she loyally continued to support Walter's efforts to have phrenology recognised by the Association ('found Cal & Hewett Watson preparing for signature a petition to the general committee to establish a phrenological section').

Although they had ignored the ball, she and Walter visited the market where it had been held. This new structure, recently completed to Grainger's designs, was the biggest covered market in the country and a showpiece of the new Grainger and Dobson town centre. Pauline found it 'prettily illuminated as a promenade [but] crowded to a disagreeable extent'. On the whole, the parties and festivities celebrating the Association meeting did not interest her, although there were further significant introductions, notably to 'Mrs [William] Buckland, a fat good humoured vulgar looking little woman'.* It was the real work of the meeting that engaged Pauline. Her very first introduction to the Association had been a lecture by Whewell on tides, and this kind of topic continued to hold her interest. The lesson from Whewell was that major conclusions could be drawn 'from a small number of observations very accurately made'.

At the meeting Pauline noted the ferocity of churchmen who felt that the authority of Genesis was being threatened by the new science. One speaker 'had come to a conclusion that all the ideas of geologists regarding the lapse of time necessary for the formation of the

*William Buckland's wife, though indeed fat, was a highly intelligent, witty and lively personality, who in due course became one of Pauline's closest friends, despite this unpromising start.

world in its present form were both erroneous and wicked & that almost every rock was deposited at one & the same time one over another just as they are'. In response, 'Sedgwick made one of the best & most temperate yet eloquent speeches I ever heard from him. in which he completely answered and annihilated the arguments, & at the same time proved the perfect accordance of geology & scripture as far as it was necessary that they should agree.' Pauline illustrated the point on another page of the diary with a comic drawing of a devil, with horns and a trident, immediately above an entry about her friend Dr Whewell.

The Trevelyans offered hospitality following the meeting of the Association. This was very much a feature of the gatherings: the gentry would hold house-parties to which selected members of the Association would be invited. Sedgwick, Whewell, Buckland, Sir Charles Monck Middleton of Belsay, Robert Owen of Lanark, Dr Plumptre of University College, Oxford: all these old friends and long-standing acquaintances came out to Wallington. So did two distinguished members of the Association who were new to the Trevelyans' circle: David Brewster, celebrated for his work in optics, and knighted in 1831; and Roderick Murchison, in many ways the grandest of all these figures.* For Walter the excitement of this house-party was tinged with melancholy because the closest of his friends, Buckland, Sedgwick and Whewell, could stay only for a few days.

Regional, diverse and intellectually democratic, the Association brought together gentry such as Murchison and humble figures like the York curator John Phillips. Phillips had been orphaned at the age of fifteen and apprenticed to a surveyor, and had no university education. Instead he had been a zealous member of the Yorkshire philosophical association (thus strikingly demonstrating the function of these eighteenth-century institutions as alternative purveyors of higher education) and, through his formidable hard work, lectures and publications, secured appointment to chairs of geology at

*Murchison had in effect been one of the founders of the British Association for the Advancement of Science, and it was at his insistence that the Association had its regional character, meeting in cities like York and Newcastle instead of confining itself to London and the two university cities (the northern meetings were much better attended than those at Oxford and Cambridge). His book *The Silurian System* (1839)[43] made 'Silurian' a permanent part of the classification of rock strata, and he was to be honoured with a knighthood and later a baronetcy for his services to geology.

(successively) King's College London, Trinity College Dublin and Oxford.*

Sir John Herschel (1792–1871), whose *Discourses* Pauline had read in January 1834, was also at this meeting of 1838. Unlike Sedgwick and the other members of the 'English School', he saw no need for 'perfect accordance of geology & scripture'. He was quite clear that geology and theology were separate activities, and he had advised the young Darwin that this was true. 'Transmutation' – the direct antecedent of 'evolution' – was already in Darwin's secret notebooks (and had been since 1837), but Pauline and her friends were as yet untroubled by that. Some of Darwin's fossils were displayed at the 1833 meeting, and Darwin himself, still at sea with the *Beagle*, was already hesitantly developing the theory that he knew to be dynamite. One of Darwin's mentors was Lyell, who saw 'transmutation' of species as opposed to God's design, and was clear in his work that *succession* of species was indicated by the record of the rocks. Lyell was also clear that Buckland and the other Diluvianists were wrong, that the earth had not been altered by a single catastrophe – the Flood – but had been modified gradually, by slow change over great aeons of time.[44]

Newman was angry that the 1832 meeting of the Association in Oxford had favoured opening up admission to the university to dissenters, and he took the general view that the study of the natural world was likely to lead to atheism: 'It is indeed a great question whether atheism is not as philosophically consistent with the phenomena of the physical world, taken by themselves, as the doctrine of a creative and governing power.' Years later, as a Roman Catholic, he wrote in *The Idea of a University* (1859) that theology and science needed to be connected, but could never be reconciled.[45] Newman, Keble, Hurrell Froude, William Sewell and John William Bowden all saw the Association as making 'a new claim to authority in the affairs of the mind and of the State. That claim could only be met by displacing some other claimant, inevitably a religious one.'[46]

The ferocity with which Pauline's clever male friends quarrelled

*At Oxford Phillips would also become the first director of Henry Acland's new university Museum, an institution with which Walter and Pauline were to be closely involved. Phillips's success had its penalty; he died as a result of falling downstairs at All Souls following a college dinner.

over science and religion had everything to do with money and power: if the Church lost its authority over the origin of the universe, then the state would be tempted to accelerate the reforms that were already under way (stripping Anglican livings of some of their wealth, doing away with pluralism, challenging the comfortable gentlemanly lifestyle that the clergy had traditionally enjoyed) and, as well as losing money, the clergy would lose control of education; the ancient universities would no longer be Anglican strongholds. Chartists, secularists and other radicals were prowling around those bastions of privilege, waiting their turn. Pauline handled this potentially difficult and stressful situation with tact: intellectually she supported the objectives of the Association, but emotionally she was with the Tractarians. For her, science and religion were compartmentalised, and her personal friendships cut across party lines. Buckland and Pusey were both people whom she liked, while William Sewell (a qualified supporter of the Tractarians) and Frederick Plumptre (a cautious supporter of science) she disliked. Further, she and Walter were cushioned by their wealth: they did not stand to lose their livelihoods, as did the dons and clergy in the two warring camps.

During this same year of 1838 Pauline familiarised herself with the landscape where she was to make her permanent home, Northumberland, with its wild beauty and its kind, shy gentry who were to become her friends. First impressions were not promising. On 17 September they visited Capheaton, the Swinburne family seat, which was the large estate next to Wallington: 'A triste looking place. Swinburnes not at home to my great joy.' Quite why Pauline formed this early dislike of Capheaton, and indeed of the Swinburnes, is hard to say. This charming baroque country house, built in 1688, with its elaborately ornate façade and extensive and beautiful park, is still owned and lived in by the family of the poet. Pauline was later to change her opinion of Capheaton completely, partly because she became a close friend of its most famous descendant. Belsay was a different matter: 'next to Belsay where we saw Mrs Monck's sister a simple manner nice girl. the house at B which is new pleased me very much. the outside is a sort of Doric with thick channeled columns is very handsome & so is the hall though that is rather too confined. the library (for the drawing room is not yet finished) is a very delightful room the windows looking over a terrace.' Belsay, which again stands quite near Wallington, is a grand but cold building in

the Greek Revival style, designed largely by its owner, Monck Middleton, in 1810. Middleton had help from the young John Dobson (this was Dobson's first country house). Belsay was gutted because of dry rot and is now a shell. It would have looked splendid on Corfu, perhaps; in Northumberland it looks out of place, but on a fine day the honey-coloured stone columns are decidedly handsome. Its 'too confined' central hall may have stirred Pauline to think about possible improvements to the central space at Wallington.

Still, it was clear that Wallington could not yet be their home. Sir John could not bring himself to settle it on Walter at this date, and it was no place for Pauline to live while Lady Trevelyan and Julia were entrenched there. She and Sir John liked each other well enough, but to live with him at Nettlecombe would be equally difficult, given that it was likely at any time to be invaded by unlovable cousins 'male & female, fat & thin'. Pauline and Walter needed a home of their own. Sir John owned other houses near Nettlecombe, including the manor house at Seaton. On 6 August 1838 Pauline noted that: 'Sir J had last night told us that, if we chose, we might have it to live in.' They dutifully drove through the West Country to the coast. The prospect was not propitious: 'we soon got into Devonshire and passed through some fine country but not exactly of the kind wh I like. immediately near Seaton there are very steep hills & the place itself is situated in the valley of the Axe. close upon the sea. it is a prettily placed small town, just beginning to come into some notice as a watering place. but not as yet in much repute.' In short, it was a dull little place where they found themselves 'small rooms smelling of tobacco at a little public house' and then 'went to find & inspect the *manor house*. it is a placid ugly brick house standing in a sort of street.' It enjoyed views of the sea, 'which however is a nasty dirty concern here & not worth looking at'. They considered the house carefully, but the outcome was not in much doubt: 'on the whole the house is good & might be made all we wanted but the situation by the roadside is an objection too great to be over come'.

Sir John was disappointed: he was often lonely, got on well with Walter and would have liked to have had him living nearby. But Pauline and Walter loved Edinburgh and were part of a warm and stimulating intellectual circle there, so for the next few years that city was their home unless they were abroad. In September 1838 they caught up with their wide circle of acquaintance there, and made

some new friends including, especially, Robert Chambers, the brilliant young journalist. There were still unwelcome family duties, though. 'Sugary' Mrs Blackett, who was related to the Trevelyans, was full of bossy plans for the unmarried girls of the circle, however young: she was even making plans for little Frederica Perceval. Pauline had become fond of Frederica. The diary records that both she and Frederica were weeping when the girl was forced to end her protracted stay with the Trevelyans and go back to her mother.

In May 1839 Pauline read Darwin's recently published journal of the voyages of the *Beagle*,[47] 'the most interesting book we have had for a very long time & extremely well written'.[48] She was reading the revised edition of this extraordinary book and fully understood the implications of Chapter XVII, in which Darwin first proclaimed his great discovery: 'Here, both in space and time, we seem to be brought somewhat near that great fact – that mystery of mysteries – the first appearance of new beings on this earth.'[49] The variations among the species of creatures (tortoises, lizards and finches) on the Galápagos Islands made it clear to Darwin, and to Pauline, that species could *mutate*.*

In September 1840 she was again with Walter at a British Association meeting, this time in Glasgow, loyally supporting Walter's attempts to get phrenology accepted as a science. She agreed to have her skull read by Combe:

> (September 22nd 1840) [George] Combe gave me my temperament. Bilious nervous sanguine with a slight touch of lymphatic – which I think is tolerably correct. Almost every person who gave an opinion differed about mine.

The good news on the phrenological front was that the group at the Glasgow meeting resolved:

> to form a central Phrenological society in London to have a collection of busts & a person to show them and as a place for getting any required information on Phrenological matters. 5s a year to be the subscription. several ladies joined. I did of course. there were a good many names down.[50]

*Darwin was already well on the way to his central observation, namely that the mechanism governing evolution was 'natural selection'. He would record this privately in an essay in 1844, but kept the revolutionary and decisive discovery unpublished and unknown until 1859.

George Combe and his brother Andrew, also a noted phrenologist, had pressed for the inclusion of a phrenological section within the medical sciences at the Edinburgh meeting of the Assocation in 1834. In 1835 Sir George Stewart MacKenzie made a proposal that was more difficult to deal with, that there should be a separate Phrenological Assocation that would meet annually immediately after the Association meeting (thus the enthusiasts would already be gathered in one place). The Trevelyans had earlier tried to get the British Association to adopt phrenology in its formal proceedings, and on their own ground (at Newcastle in 1838) they had made some headway, but the momentum was not sustained.[51] Phrenology was too dangerous for most of the gentlemen of the Association: it threatened the claims of established religion and the functions of government by offering an alternative moral system and pressing for penal and educational reform. But it remained attractive as a source of 'cures' for a range of disorders. Harriet Martineau (1802–76), the celebrated journalist and novelist, suffered from poor health of which her progressive deafness was only one symptom. It was claimed that in 1844 she was cured, by phrenologists, of a condition from which she seemed to be dying. Miss Martineau's symptoms – abdominal pain, loose bowels, tiredness and loss of appetite – resembled those that were bothering Pauline by this date. Walter tried in vain to persuade Pauline that phrenology might in some way cure her.

At the meeting of the British Association in Glasgow in 1840 the young Swiss geologist from Neuchâtel, Louis Agassiz, befriended Pauline and Walter. The Trevelyans accompanied Agassiz and Dr and Mrs Buckland on a 'glacier hunt' in the Highlands of Scotland, which convinced Agassiz that the whole of Scotland had been under ice in prehistoric times and that the current appearance of the Scottish mountains was the consequence of glacial action.[52] Buckland, who had known Agassiz since 1834, was converted to his theory of glaciation after 1838 and supported him at this meeting. The erosion of rocks by glaciers was therefore of great interest to Walter and Pauline.

In the spring of 1841 Walter was encouraged by his cousin, Charles Edward Trevelyan, to stand for parliament as a Whig. The Charles Trevelyans were striking, strong and successful, though not people whom Pauline was likely to adopt as intimates. They were

Evangelicals, members of the celebrated Clapham Sect, and there-
fore part of the first rank of the great in early Victorian London.
Pauline was impressed by them and thought much more of them than
she did of her husband's immediate family, though at the same time
she noted that they had (by her standards) no artistic interests.[53] They
were related by marriage to a figure of substantial cultural signifi-
cance, though: Charles's wife, Hannah, was the sister of Thomas
Babington Macaulay, the famous essayist and historian, who was at
that time MP for Edinburgh and Secretary for War. He liked to hold
court at social occasions: 'Clever, garrulous and amusing' was how
Walter was later to describe him, with the stress on 'garrulous'.[54]
During a visit to London in early 1841 Walter and Pauline were part
of an agreeable circle that included the Bucklands, the Robert
Chamberses and Walter's father (his mistress, Clara Novello, was at
this point in Italy). At the end of June 1841 they travelled to
Switzerland, as guests of Agassiz.[55] They went walking in the hills
outside the town to visit a rock on which Buckland's name was
engraved 'in letters as fat as himself'.

Italy, Greece, Nettlecombe: a leisurely progress towards Wallington

Canaletti has painted the body *of Venice, but Turner has given us her soul*

In late 1841 the Trevelyans were again in Italy. Nothing escaped Walter. Every church, palace, significant work of art, Greek or Roman temple, aqueduct and olive grove was noted in his diary. Pauline continued with her sketching; the 1842 sketches were looser, quicker and less formal than those from her earlier Italian tour. She was becoming increasingly interested in Italian politics: 'La Cittàdina', as her friends in Rome nicknamed her, was clear that her political sympathies lay with republicanism and radicalism when she was in Italy.

After wintering comfortably in Rome, they left the city in March 1842 and travelled in a leisurely manner to Ancona, then took passage by boat to Corfu and arrived in the harbour there on 5 April. Pauline was struck by the strange, exotic, 'Arabian Nights' nature of the scene:

> my attention was occupied with the strange population – Albanians in shaggy cloaks & pistols at their girdles – other Albanians in beautiful costumes – a great deal of white embroidery, & handsome shawls round their waists [. . .] the view from the deck was very beautiful – the town of Corfu in front – with woody hills backed by snowy mountains – rather like Bute [. . .] the mixture of oriental costumes & faces. with the English, & the vulgar English speech one hears about, is very curious & striking, walked through the town, the shops seem good. I was delighted to see Greek tailors & other workmen sitting at their low windows on boards & chattering & laughing with the papers by, as if they had been cut out of the Arabian nights. the low colonnades also are picturesque, the variety of dresses is very remarkable I long to know wh & what they all are. they are almost confined to the men. one sees few women in the streets. went out of one of the gates near which were lounging a fine looking set of men – Albanians employed as an armed police – in shaggy capotes white

35

petticoats embroidered jackets & immense knives daggers & pistols
stuck round in their belts –

Walter set about the prosaic business of finding accommodation:

Looked at several of the Inns and took 2 rooms at Taylor's Hotel, clean
but small – the population Albanian and Greek has a very novel appear-
ance mixed with English Soldiers – the first view of the harbour from
the deck of the vessel, though in some parts wooded with mountains
rising behind reminds me much of the highlands & when I went off
again to the vessel to fetch Paulina I thought the view from the shore
much like that from Rothsay [. . .] I strolled about a little the govern-
ment house is well placed overlooking the bay.

They had introductions to Government House and were soon
invited for the evening:

April 8 Dined at the Palace, Mrs Stuart [sic] Mackenzie reminded
me much of her sister Miss M whom we knew at Rome. It seems a
capital house.

Within a few more days they had been invited to stay in the palace,
so they moved out of their hotel rooms on 11 April.

James Stewart Mackenzie was governor of the island ('Lord High
Commissioner of the Ionian Islands', to give him his full title). Pauline
liked Mrs Mackenzie – 'very like her sister Frances & a very agree-
able well informed person' – and found her husband unobtrusive but
well-meaning: 'the Lord High Commissioner is a very quiet little
man. shy at first but talks very sensibly when he does talk & seems
desirous of doing good here'. The guests invited to meet them were
carefully scrutinised. There was a 'prominent Greek', intelligent and
good-natured, with a disagreeable English wife who had notoriously
bullied her children's governess: 'the lady looks as if she had a very
bad temper, so I don't wonder the Govss was unhappy'. Pauline loved
the setting of this party and thought the Commissioner's job 'a very
fine appointment on the whole the servants look very well in their
beautiful Albanian dresses. the rooms at the palace are both hand-
some and comfortable. well furnished.'

They went to the garrison church with the Stewart Mackenzies (a
far cry from the sublimity of Mass in St Peter's or the Sistine Chapel)
and found it disagreeably smelly: 'the Comrs pew is in the gallery

& the soldiers fill the body of the church below & the heat & close-
ness (in spite of a few windows) is most unpleasant.' Walter's diary
studiously recorded everyone they met – the agreeable, the nonde-
script and the downright nasty: 'April 13 dinner at the palace [. . .]
Met at dinner [. . .] Mr Loundes a Baptist Missionary – Inspector
of the Schools – who has been here about 23 years – & who after
dinner gave prayers & preachment.'[1]

Pauline was appalled by James Stewart Mackenzie's religious
enthusiasms. What Walter referred to drily as 'prayers & preach-
ment' evoked passionate indignation from her:

> the Commissr (for the MacKenzies have all an evangelical twist) thinks
> fit to encourage this person & lets him come to the palace every
> Wednesday, to sing psalms, expound false doctrine, heresy & schism &
> make extempore orations, by courtesy called *prayers*, for the benefit of
> the English part of the house hold & such other persons as choose to
> come & be edified, this is the only one thing I have seen in the admirable
> conduct of the Lord High C wh appears to me wrong – and it is *very*
> wrong – to go to church on a Sunday & belong to the Church – and
> yet in the week to encourage her enemies, persecutors, & slanderers,
> Mr L[oundes] (prejudice apart) is a very nasty sort of sneaking creeping
> looking man – that no creature could for a moment mistake for a
> gentleman – [she then erases a whole sentence, too strong even for her
> private diary presumably] – his wife is not nice either, they have partic-
> ularly good opinions of themselves – Mr Fraser the head of the police
> was here also with an ugly wife [. . .] the psalms & hymns of – Dr
> Watts!!!! Were proclaimed – avoiding even an orthodox version – King
> David's poetry is not good enough for dissenters – & there was some
> very fine nasal melody – then an oration – wh as it was said kneeling
> may be supposed to have been a prayer – then a chapter of the gospel
> *expounded* – then more sweet music – then another oration – al
> extempore – the Lords Prayer itself is not fine enough for the Baptists
> – at least they think their own better – [. . .] The affair was over at
> last, & then there was tea & cakes, &c for self denial in the good
> things of this world does not enter into the list of Baptist missionary
> virtues.

Pauline's judgements were sometimes unaccountable. How could
this acute and sensitive reader of poetry hate the hymns of that great
lyricist Isaac Watts, founder of the strongest and most enduring tradi-
tion of eighteenth- and nineteenth-century English hymn-writing?
But she clearly loathed the whole experience. No wonder she was so
close to converting to Rome during this period.

Staying with the Stewart Mackenzies had one great compensation in their daughter Louisa, whom Pauline met on 14 April: 'one of the nicest girls I ever knew. she is only 14 yet she has more information & is a more agreeable companion than many girls of 20. she is pretty & interesting looking, and has very sweet & modest manners. I am becoming every day more fond of her.' Louisa responded to the love of other women throughout her life and so, in her much less expressive way, did Pauline. Nobody else could compete with Louisa: 'Sunday [. . .] saw Miss Mackenzie [the older sister] for a short time, she is not pretty, but fat & amiable, not so clever as my favourite Louisa.'

As her friendship with Louisa developed, Pauline found that she had more common ground with the Stewart Mackenzies as a family than at first appeared. Sir Walter Scott was a congenial subject: the whole family had read Lockhart's life of Scott, and the group had an animated discussion. Lockhart's *Memoirs of the Life of Sir Walter Scott* had been a huge success with the general public, but Pauline was cool about it, feeling that it was tactless and patronising.[2] She liked her idols to be presented on a pedestal. The Lockhart biography was hardly 'warts and all', but it still managed to annoy her. She clearly felt that the great writer's weakness over money should not have been exposed to public view at all.[3]

All of Pauline's senses were heightened by this visit. She and Walter went on to Athens:

Monday 2nd May to the temple of Theseus to sketch – spent several hours at it [. . .] The whole town is in a stir today merry making [Easter] – nothing but drinking at lemonade stalls dancing singing & playing game. the men usually dance in one place & the women in another [. . .] there seems a great deal of good humoured affection among them. the men kiss one another heartily in spite of their huge moustaches.

They travelled on via Trieste to Venice in July 1842, which they reached after several days at sea. Venice was the climax of this trip. Pauline responded to it in two ways. The first may be seen as a heart-felt reworking of a Romantic's reading of Venice, with Byron's plays and poems* and Samuel Rogers's *Italy* among the sources:

*She was clearly remembering *Childe Harold's Pilgrimage*, and it is obvious that she also knew his *Lament of Tasso*, *Marino Faliero* and *The Two Foscari*.

Sat 23 July 1842 we were not sorry to set off for Venice by the little steamer at 9 in the eveg the night was splendid the moon light lovely & the sea like a mirror – but there were bugs in the beds. & the Captain an ugly old fellow & the steward still older & still uglier kept fidgeting in & out the ladies cabin talking and teasing & waking everybody up – every man in this boat was old and hideous – "antient mariners" every one – passed a most uncomfortable night. about 5 (24th July) Caly called me up to see the towers of Venice – I was sorry he had done so. for, instead of seeing them rising from the ocean they peered over the tops of a sandbank like a dutch town – we crept slowly along for the lagunes are so shallow that it requires great care. a man sounded the depth with a pole every 1/2 minute. the views at first were like Dutch pictures smooth waters, & boats, & mud banks [. . .]. And it was not till fairly opposite the city that the full beauty & magic of the ocean Queen broke at once upon us – and then indeed while one sweeps before palaces, and gardens, and porticos, & stairs, and sculptured magnificence, the scene more than realises all those dreams that Venice more than any other place in the world has long ago inspired – then one after another all those buildings so well known so often imagined, rise beside, before & round us – St Georges island – S Marks – the Ducal Palace – Sta Maria della Salute, the fatal columns the wide piazza – one knew not which way to look – for all is beautiful all is of the past – that strange mysterious Venetian past. where all that is gay & festive, song & revelry & carnaval & procession, blend with torture & tyranny – midnight murder & hopeless imprisonment – where Tassos verses echoed over moonlit waves – where Titian made beauty immortal – where 'Cupids rode the lion of the deeps' – & where Carrara – Carmagnola Faliero & hundreds, ever the best & the bravest of this ungrateful city, sunk into their bloody tombs & Foscaris broken heart found repose. in the grave – such a strange mixture of feeling comes over me at first sight of Venice – admiration, and pity – indignation at her crimes, sorrow for her degradation – that one seems in a confused dream – not in a living city of this world & this age. the morning was cloudless, the pure pale sky & the cool tints of this early hour were like Canaletti's best pictures – and as, leaving the steamer, we floated silently over the still canals, we met boats laden with splendid fruits coming from the mainland with brilliant colours reflected in the water – 4

The second of Pauline's reactions to Venice was strikingly modern: a huge enthusiasm for Turner. In fact her views coincided precisely with the views of Ruskin – whom she had not yet met, and who had not yet published any of his great work on Turner.

Ruskin would shortly be comparing Turner and Canaletto in

terms that chime exactly with those used in Pauline's diary. Pauline wrote:

> while a streak of sunshine, like burnished gold, broke through the cool blue shadows here & there, we had before us another proof of the truth of Turners matchless paintings – Canaletti has painted the *body* of Venice, but Turner has given us her soul – he has seized the poetical phase of every scene, not the less true because it is poetical, his is truth to nature in her fantastic loveliness – Canaletti represents her in her everyday soberest attire.[5]

It is almost as though Ruskin had remembered a conversation that he had had with her and was quoting it. Pauline had seen the London Canalettos and knew well two of his biggest canvases of Venice, which hung in a castle in Northumberland within a couple of miles of Wallington. Little Harle Castle was the home of the Anderson family, friends and neighbours of the Trevelyans.[6]

Pauline also revelled in the dark Gothic of St Mark's basilica and condemned the huge Palladian church, Sta Maria della Salute, in terms that again precisely anticipate Ruskin's rapturous advocacy of Gothic and dislike of the Renaissance:

> [On St Mark's basilica] a few narrow streets soon brought us into the most beautiful piazza that ever I saw. the most uniform, the most stately, on three sides – and on the fourth – the domes & pinnacles, and gilding, & mosaics & sculptures, of S Marks – we saw no church or mosque in Greece so entirely oriental in its character as this. and not only its general character, but its details are most beautiful. the statues the pinnacles the mouldings & capitals are beautifully executed in the richest gothic-byzantine style – but it is principally in the effect of its dark rich gorgeous interior that it excels all other churches – the whole place is very dark – and very richly covered with old mosaics mostly on a gold ground – so that wherever a gleam of sun comes through the narrow windows, the effect is most brilliant –
>
> [On Sta Maria della Salute] went first today (Tuesday July 26) to Sta Maria della Salute – of the most conspicuous objects in Venice, painted a thousand times by all the artists of v – it is said to be built on 1,200,000 piles, it is a most florid building both within & without, of the taste of the 17th century (it was finished 1631) but it is good, of a bad style – the dome is fine, the high Altar is a very rich thing.[7]

It is as though in her diary Pauline is predicting Ruskin's influential view that Gothic and medieval art were robust and honest, while

Renaissance art was the product of a decadent and evil culture: a persistent theme of Ruskin's great books on painting and architecture, *Modern Painters* (1843–60), *The Seven Lamps of Architecture* (1849) and *The Stones of Venice* (1851–3).

Their crossing back to England in the autumn of 1842 evoked one of Pauline's characteristic diary entries:

[30 October 1842] steamer for London – it was very crowded – found that though Caly had taken a bed for me 2 children were put into it – the cabin not large enough for more than 8 had 16 people in it & packages innumerable – the men's cabin was also crowded, floor and all with both sexes – every lady grumbled one party of mama & daughters who had both the best beds were furious & scolded the stewardess till she almost cried & til everyone pitied her. – we had scarcely set off before some of the people got sick & the two children in my bed were among the first. 3/4 of the ladies were ill. but still I was so much amused by the ridiculous scene that I rather enjoyed the time – & laughed all night – it was very smooth and I did not pity the ill people because they had no business to be ill – some lamented some scolded – some advised – one was sure we were in danger & begged the Captain might be called when she was assured it was only a little ground swell – she 'wished with all her heart the ground wd leave alone swelling for it was very disagreeable & she was sure, dangerous' – another was sure no harm cd come as her friends had been to church for her safe passage – another had an Uncle an Admiral who had been in the navy 46 years and therefore she must know something about these things, and she always made it a rule to take a 'stiff northwester' when it was rough & she recommended it accordingly, and the remedy was popular – another had been round the cape & was not sick in the bay of Biscay & it was really provoking to be sick here. but she believed this was an old boat. & old boats always do make people sick – one lady had a number of birds in cages on deck and she sent numerous messages about them hoping the Captain wd attend to their comfort himself anxiously hoping they – dear things – were not suffering.[8]

Back in England, Pauline and Walter travelled to Nettlecombe where they settled for the winter, seeing a lot more of Sir Thomas Acland and his family. Pauline became increasingly attached to them: 'Mrs Acland is a very sweet gentle person – & Henry Acland [the future Regius Professor] is delightful.' She and Walter were both firm supporters of the building of railways, and the Aclands were equally enthusiastic. Pauline applauded the energy with which Sir Thomas tried to benefit the men working on the new railway line to Exeter.

She wrote in her diary for 5 April 1843 that the railway workers were rough, dirty strangers, 'who everyone else treats as outcasts & heathen, and no-one tries to convert'. But Sir Thomas Acland was 'endeavouring by saving them from want to keep them from crime'. His efforts on their behalf were munificent:

> Sir Thomas gives to as many as choose to come for it a plentiful dinner every day – he is providing cottages for them to live in while they are in &c this neighbourhood – and a respectable shop – to prevent their being (as usual) cheated by extortionate retailers – out of most of their hard earned wages – he is also making strict rules to preserve order & discipline among them – he expressly invites them to the chapel, and reserves seats for them – and shows by every means in his power that he takes an interest in them and that good conduct will not go unrewarded. Ld Ebrington* on the contrary after throwing all manner of frivolous obstacles in the way of the company & making himself as obnoxious as possible – when the railways labourers appeared laid in a stock of guns & ammunition – Sir Thos Acland bought up provisions & comforts for them.

In May 1843 Walter and Pauline were in Edinburgh, partly because of the schism between Puseyites and the opposite faction opening up in the Church of Scotland. The Revd Dr Chalmers, whom they knew and admired (Robert Chambers was a mutual friend) had done excellent work for the poor in Edinburgh, but was now attacking the Puseyites. Pauline was torn, of course, between the two sides.[9] From Edinburgh they were soon in Oxford again, Walter's diary recording his usual helpful and temperate account of dates, people, visits, lectures, concerts and sightseeing:

> 22nd May to Oxford
> 23 Called on Dr Plumptre Master of Univ & Forbes of Brasenose then on Mrs Buckland and we went to the Drs lecture on faults &c. a very small class compared with what I remember – then with Forbes to New College chapel – where the music was very fine – Sir Joshua's window continues I think to fade.†

Oxford was white-hot with the Tractarian controversy. Pauline's own sympathies were clear. The contrast between her respective responses to William Sewell and John Henry Newman is marked:

*Lord Ebrington was a neighbour, who was in more or less continuous political rivalry with the Acland family. Pauline's diary reflects the Aclands' habit of demonising this man.
†The Reynolds window, which dominates and disfigures the otherwise magnificent antechapel of New College, Oxford, remains an eyesore to this day.

28th May 1843 to St Marys to hear Mr Sewells* sermon. very cautious & cautionary – he being ill his brother read it. it was very admonitory against visiting Popish country. talking with Popish friends or reading popish books. in short one wd think he had very little confidence in his own faith, which needed so many defences of blindness, deafness and unlocomotiveness – [. . .]

29th May 1843 to St Marys again to hear Mr Newman preach. was greatly delighted more even than I expected. his quiet gentle manner and soft silvery voice like nothing I ever heard before – audible in every part of the church – (indeed one might hear a pin drop it was so quiet) all gave great effect to the purest English & unstudied eloquence that ever were composed. the service was beautiful – it was on Xtian Nobleness.[10]

Pauline knew that Newman was under extreme pressure at this time, and that his famous 4.00 p.m. sermons at St Mary's were the platform from which he could fight back. Since the publication of Tract No. 90, in 1841, Anglicanism in general, and the authorities of the University of Oxford in particular, had turned violently against Newman, who had dared to propose that the Thirty-Nine Articles of the Protestant Church were in fact compatible with the teachings of the Roman Church: his Tract was charged 'with false doctrine, with false history, and with false reasoning' and with being 'dishonest and immoral'. All members of the university at that date were required to subscribe to the Thirty-Nine Articles, and in March 1841 the heads of the colleges collectively condemned Newman's Tract as being inconsistent with the observance of the university's statutes. In 1842 Newman's position was becoming untenable: he was still vicar of St Mary's Church and a Fellow of Oriel, but he had founded a semi-monastic community at Littlemore, near Oxford, and his enemies in the university were branding him as a Roman Catholic and seeking to drive him out.[11]

These issues were so heated at Oxford at this date that even Walter,

*The Revd Dr William Sewell of Exeter College and later Warden of Radley, well known in Oxford for the violence of his opinions, was a nominal supporter of the Tractarians, but fearful of Rome and therefore opposed to Newman, by this date. The requirement to conform to the Thirty-Nine Articles of the Anglican Church was specifically designed to exclude Roman Catholics and dissenters (and all other non-Anglicans) from the university. There was a more sympathetic side to Sewell, though. In the university vacations he was a neighbour of Charles Swinburne, the father of the poet, on the Isle of Wight, and a few years after this date he befriended the young Algernon Swinburne and tried to encourage the boy in his writing of poetry, while his father, a somewhat severe naval man, took the view that this activity was unmanly and a waste of his son's time.

that pious non-partisan churchman, found himself caught up in them. He pasted into his diary a newspaper cutting quoting a complaint from *The Dublin Statesman*, to the effect that he had been supporting the Tractarian cause by displaying popish church trappings to susceptible Anglicans. At a meeting of the Oxford Architectural Society on 7 June Walter had shown sketches from churches in northern France (made on his and Pauline's recent travels), which included 'double fonts'. The unnamed columnist foamed at the mouth over this: 'what businesses have our architectural bishops and clergy to go a whoring after these things?'

On Saturday 10 June 1843 came what we may regard with hindsight as a high point of this visit to Oxford: Pauline's first meeting with John Ruskin, at a breakfast party in Dr Buckland's house in Christ Church:

> Mr Ruskin a real hot disciple of Turner the painter, with whom I got on very well in our mutual admiration of that noble genius. he is an out & out Turnerist, for he admires 'the flash casting her cargo overboard' as the very finest of Turners works – and thinks the Temeraire rather dull. he says no one can understand Turner who has not seen *all* his work. Every one he says is an epic poem complete in all its parts – he is an 'ingenui vultus puer' and I liked him,* after hearing long histories from Dr B about some creatures called Trigla who walk with their fins, we got away at last & started for Salisbury.[12]

For Turner's young champion to call *The Fighting Temeraire*, of 1838, 'dull' is, on the face of it, astonishing. Did Ruskin mean it, or was he just saying it for effect? Later in the friendship Pauline would regularly tease Ruskin over the quirkiness and perversity of his declared judgements. The painting that Pauline and Ruskin warmly agreed on admiring at this first meeting was of course *Slavers Throwing overboard the Dead and Dying – Typhoon Coming On*, normally known for short as 'The Slave Ship'. This masterpiece was to become Ruskin's property in 1844 as a New Year's gift from his father. It was chosen by Ruskin as a central exhibit in his discussion of Turner in *Modern Painters*, I (1843):

*Walter recorded the same breakfast in his diary, but made no mention of the fact that Ruskin was there; to him, this clever young man was just another student among Buckland's guests.

I think, the noblest sea that Turner has ever painted, and, if so, the noblest certainly ever painted by man, is that of the Slave Ship, the chief Academy picture of the Exhibition of 1840. It is a sunset on the Atlantic, after prolonged storm; but the storm is partially lulled, and the torn and streaming rain-clouds are moving in scarlet lines to lose themselves in the hollow of the night. The whole surface of sea included in the picture is divided into two ridges of enormous swell, not high, nor local, but a low broad heaving of the whole ocean, like the lifting of its bosom by deep-drawn breath after the torture of the storm. Between these two ridges the fire of the sunset falls along the trough of the sea, dyeing it with an awful but glorious light, the intense and lurid splendour which burns like gold, and bathes like blood. Along this fiery path and valley, the tossing waves by which the swell of the sea is restlessly divided, lift themselves in dark, indefinite, fantastic forms, each casting a faint and ghastly shadow behind it along the illumined foam.[13]

If Ruskin used the same kind of eloquence about this painting in conversation over breakfast, it is not surprising that Pauline was so enchanted by him. When she read *Modern Painters I*, published in that same year, she responded with a passionate enthusiasm which was strengthened by the fact that she had met the author during the summer. For her, it expressed 'everything about Turner I ever felt, or even did not know I felt.'[14] Pauline had already made friends with Turner, and had called on him in London in his 'wonderful old house – where the old woman with her head wrapped up in a dirty flannel used to open the door'. Inside, Turner's house was a decaying and shabby treasure trove:

where on faded walls hardly weather tight – and among bits of old furniture thick with dust like a place that has been forsaken for years, were those brilliant pictures all glowing with sunshine and colour – glittering lagunes of Venice foaming English seas and fairy sunsets, all shining out of the dirt and neglect, and standing in rows one behind another as if they were endless – the great Carthage at one end of the room – and the glorious old Temeraire lighting up another corner – & Turner himself careless & kind and queer to look upon – with a certain pathos under his humour, that one could hardly miss. The Man & the place were so strange and so touching no one cd forget it all who had ever seen & felt it.[15]

She had been an 'out and out Turnerist' independently of Ruskin and his writings for several years, and she wrote detailed and loving notes in her diary of all the Turner paintings on display at the Royal

Academy that summer of 1843. Only Turner could have imagined the Venetian scenes (also passionately defended by Ruskin): 'warm rich sunny airy – with music in every wave and life in every sunbeam'. She displayed an instinctive affinity with Ruskin in the huge praise that she lavished on the Turners and in the contempt that she heaped on Daniel Maclise:

> 'The Actors' reception of the Author' from Gil Blas, is one of Maclise's gorgeous & laborious paintings – the exuberant detail & careful finish, done to the minutest particular is like his usual richness – the whole is hard & the subject vulgar. it hangs put beside Turners glorious inspiration of Venice – and many a critic turns with a glance of contempt from that splendid thing to extaziate on the painting of Maclise's nutshells – this picture is always surrounded with admiring multitudes who cannot tell what most to admire – in its truth & its finish.[16]

The year of 1843 was one of religious crisis in Oxford. It focused on Newman and the Tractarians and the whole vexed question of the extent to which the Anglican Church could tolerate the adoption of what appeared to be Roman practices and convictions. In March Newman's associate Dr Pusey* preached a sermon that appeared to endorse the Roman Catholic doctrine of transubstantiation. The university authorities punished him by suspending him from preaching for two years. This was a major political error on their part: Pusey was obstinate and resourceful; he was determined to stay in Oxford and within the Anglican Church, and he effectively created a split within Anglicanism. 'Puseyism' now had a martyr and a cause within the Anglican Church, and Pauline joined it. She recorded in her diary her sympathy with Pusey when the excitement about him was at its height (early in June 1843), and part of her disagreement with her mother-in-law was that she, Pauline, was a Puseyite. On a miserable visit with Lady Trevelyan and Walter to Harrogate, she noted the conversations in the hotel:

> [23 July 1843] & there are grumblings about hot plates – negotiations about getting cream enough – and no more macaroni. Mr Archdale declares the dinner yesterday was 'an insulting dinner, yes! Ma'am I repeat I, that dinner was an insult!' Then Mrs & the Miss Finley & Lady T discuss Irish affairs – & harry, burn & roast Popish priests from

*Newman, with many of his friends, would be received into the Roman Church in 1845. With Newman gone, Pusey became the central figure within the high-church branch of Anglicanism.

morning till night – Mrs F generally observing in conclusion that Puseyites are quite as bad, and deserve even worse if possible – sometimes it passes all endurance. happy am I if they keep to abusing the dinners & let Papists alone [. . .] Miss Finley stoutly maintains that all the murders are paid for by the Priests – that people who are sober are always in mischief, that Raphaels frescoes are poor things not worth the trouble of preserving – of all horrid places and vile societies I never met with any as bad as this.

Walter's mother often went to Harrogate to take the waters. This visit took up most of July 1843, and Pauline and Walter reluctantly accompanied her for part of it, Walter dutifully referring in his diary to his formidable parent either as 'Lady T' or 'the mater'. He distanced the vexations of doing his duty by his mother by filling his diary with facts. Pauline, more dangerously, used her diary to give vent to her opinions.

To align oneself with Pusey was to oppose the power of the heads of Oxford colleges, people like the correct and procedural Dr Plumptre.* Similarly, to align oneself with geology had been to challenge the authority of the established Church, and to align oneself with Ruskin was to throw off the dead weight of Sir Joshua Reynolds and the Royal Academy in favour of radical new painting. Yet there are cross-currents within these sympathies. Although Pauline had nearly become a Roman Catholic herself, she had now hardened in her high-church Protestantism and at times censured the 'perversion' of converts to the Roman Church.

During the years in which Edinburgh was their base, the Trevelyans kept in constant touch with the Chambers brothers. Robert Chambers was to rock the theological and geological worlds in 1844 with his anonymous *Vestiges of the Natural History of Creation*.[17] This work provoked outrage among many of Pauline's old friends in the world of geology: Herschel condemned it as unfounded and mischievous speculation, and Sedgwick declared in a review that 'unmitigated contempt, scorn and ridicule are the weapons to be used' against this dangerous book.[18] The anonymity was retained in all editions until after Chambers's death in 1871. His name did not appear on the title page until the edition of *Vestiges* published in 1884. Those suspected

*Walter, of course, felt differently about this man: University College was his undergraduate college, Plumptre was its Master, and Walter was on cordial terms with him.

at the time of having written this extraordinarily bold work included the Prince Consort, Lyell (in which case, of course, it would have had to be taken seriously), Combe, Thackeray and Harriet Martineau (in which case it could be ignored as eccentricity or journalism). There was also a lively rumour to the effect that it might have been by a society lady, and Pauline's was one of the names canvassed.[19] This thought gave comfort to *Vestiges'* enemies, because the book could then be dismissed as the speculation of an upper-class amateur bluestocking. Chambers tried to keep his authorship secret, but many of his friends and associates guessed that it was his book, and he was inclined to give the game away by sending copies of revised editions of *Vestiges* to trusted colleagues (he would reveal himself to Darwin in this way in 1846). Pauline was a close friend and an exceptionally intelligent and penetrating one. Most of the major geologists of the day knew within a year or two of publication that Chambers was the author, and Pauline would certainly have known. She was broadly sympathetic to the intellectual position of the book, despite the hostility towards it of her distinguished friends.

Chambers, a fluent journalist whose insights and audacity beguiled a generation of thinking Victorians, wrote:

> The Creator [. . .] is seen to have formed our earth, and effected upon it a long and complicated series of changes, in the same manner in which we find that he conducts the affairs of nature before our living eyes: *that is the manner of natural law.* [. . .]
>
> The whole of nature is a legitimate field for the exercise of our intellectual faculties; thus there is a connection between this knowledge and our well-being; and that, if we may judge from things once despaired of by our inquiring reason, but now made clear and simple, there is none of Nature's mysteries which we may not hopefully attempt to penetrate.[20]

Robert Chambers may have had a personal motivation for his interest in the mutation of species, since he himself was a mutation. He was born with six digits on his hands and feet. The additional fingers were cleanly removed when he was a baby, but the additional toes were operated on clumsily and only partially successfully. As a result, Chambers was a reclusive schoolboy, unable to join in the activities of other fit boys, and spent all his time reading. This, together with his habit of prodigious hard work, would serve him well during his professional life.

Officially, Pauline's friendship with Robert Chambers was one in

which she, and not he, was the writer. Several of Pauline's poems, short stories and essays were first published by Chambers in *Chambers' Edinburgh Journal*.

After Pauline's death and the subsequent deaths of Walter and of the second Lady Trevelyan, David Wooster (Walter's assistant) carried out Walter's wishes by editing Pauline's writings for publication as *Literary Remains*. (Walter had left money in his will for this purpose.) As a poet, she was restless, fluent and multi-faceted, though technically conservative; while, as a critic and essayist, she was robustly independent and lively. Her love poems belong to the years of Walter's courtship, and show signs of having been corrected for publication soon after their marriage.

Her religious poems merit a pause, given that they are written by Ruskin's pupil. A poem called 'Dawn', written in Rome on 5 August 1836, remarks on the relationship between Christianity and ignorance. Despite Pauline's known sympathy for the Roman Catholic Church, it seems that Christianity is here overlapping with Roman Catholic superstition in her mind:

> But, hark! Slow peals along the gale
> The convent bell from yonder tower!
> Religion's voice awakes the vale,
> And softly claims the nascent hour.
>
> And thus it was in olden days,
> When mental darkness reigned supreme;
> The cloister nursed the feeble rays
> Which since have burst the gloomy dream.
>
> When night and silence all concealed,
> Within its pale the voice began
> Which told of *knowledge,* and revealed
> The noblest destinies of man![21]

This is in a way sternly progressive: religion used to think it had all the answers, but now it is in retreat. However, Pauline wrote in an optimistic vein that anticipates Tennyson's 'Who loves not Knowledge?' rather than Arnold's sense that faith was abandoning mankind with a 'melancholy, long withdrawing roar'.

Her many debates with Ruskin over Catholicism, and her friend-

ship with figures prominent in the Oxford Movement, lie behind 'Sunset Thoughts' of January 1848. It is a poem about Romanticism and Christianity: to respond to a beautiful landscape for its own sake is not enough, and we need to recognise the higher (Christian) thoughts that such a landscape inspires:

> Once more, dear maiden! look once more,
> Look higher, deeper still!
> To pagan sage, to slave untaught,
> Comes many a peaceful sunset-thought,
> Their darkened hearts to fill:
> But on thy pure and thoughtful brow
> Has Christian nursing set its seal,
> And higher thoughts than rest or bliss,
> Must wait upon a scene like this,
> And rouse thy heart to feel.[22]

Pauline also wrote two narrative poems about painters in the 1840s, inspired by her visits to Italy and composed well before she had read William Bell Scott's *Poems of a Painter* (1854) or Robert Browning's 'Andrea del Sarto' (about the failure of mechanical skill to match up to the artist's inner vision) and his 'A Grammarian's Funeral' (in which a scholar's legacy is in the talent of his pupils). In her poem 'The Scholar's Work', written in July 1848, an old artist and teacher sees the triumph of his youngest pupil:

His scholars went unheeded forth, and now he mused alone,
While o'er his silvery locks the glow of rosy sunset shone –
He bore a name the world reveres – a master in his art;
He gazed upon a scholar's work – deep joy was in his heart –
'And thus,' as last he murmur'd low, 'is my life's prayer fulfill'd –
Not Lord as my vain heart foredoom'd, but as Thy wisdom will'd! [. . .]
All that my youthful dreams desired, my manhood's labour sought,
All that I strove in vain to do, a boyish hand has wrought!
When praise resounded in my ear, and laurels crowned my brow,
I turn'd aside to weep and dream – of all I look on now!
Nor pride, nor joy, could ever veil the gulf that still remain'd
Between a true and perfect art, and all that I attained.
In madd'ning glimpses, on my soul, ideal beauty shone,
Like dreamland music, dying, as we waken to its tone.
For ever sought – for ever miss'd – how doubly dreary seemed,
All that my hand could paint, beside the glories that I dream'd;
And now my youngest scholar's hand has grasp'd the long-sought prize –

Has chain'd the dream, has caught the tone, has scaled the airy skies!
I toild along the stony path, midst storms, and fears, and night,
He stands in all his pride of youth, at once upon the height![23]

The subject is like that of Frederic Leighton's first Royal Academy picture exhibited in 1855, his huge canvas *Cimabue's Celebrated Madonna is Carried in Procession through the Streets of Florence*, bought by Queen Victoria, no less, for the substantial sum of £600. In Leighton's painting the significant figure is Cimabue's pupil, the boy Giotto, whose skill will soon eclipse that of his master.

Among her other long poems 'The Dying Artist', written at Nettlecombe in July 1847, is a decidedly dark view of the destiny of the artist:

> So ends a life of toil!
> I stand alone, by the dark River's wave;
> I have poured out my life of life – for what?
> To win dark restless thoughts and an unhonoured grave!
>
> I knew the price I paid;
> How many happy links my choice must sever,
> How much of joy and kindliness and mirth;
> How many precious things I left for ever!
>
> But still I falter'd not;
> A glorious light shone down upon my dreams –
> Pure art enwrapped me in her charmed veil,
> And her low voice I heard, calling like distant streams!

This artist has sacrificed love and normal human relationships to his dedication to his art:

> And some look'd on in scorn,
> And kindlier spirits sorrow'd for my lot,
> And pointed to a smoother, sunnier path,
> Where beauty dwelt, but such fierce toil was not.
>
> It was no path for me –
> My course was onward, and I must away;
> Though toil and sorrow gather'd more and more
> About my hopeless task, I might not stop nor stay!

And now the end is come,
I pass from earth with heart unsatisfied,
 With yearnings unfulfilled, with restless thought,
Without one mighty work to tell I liv'd and died!

 Oh, Art, too dearly lov'd!
A fatal passion thou hast been to me;
 Sorrowing and toiling, slighted and reprov'd;
Oh! what is there on earth I have not lost for thee?

The poem anticipates the end of Browning's 'Andrea del Sarto'. In the Browning poem, Andrea – if given a chance to paint a fresco in competition with Raphael, Leonardo and Michelangelo – would again make the mistakes that have blighted his life. Pauline's fictional artist is similarly doomed to repeat his mistakes. He is trapped in a circle of failure:

 And yet if life were new –
 Could I but stand again on youth's green shore,
 I know my captive steps would surely tread
 The same steep path I slowly climbed before.[24]

Pauline's great love of travel and her talent for writing about it are revealed in some of the pieces that she wrote for the Chambers brothers, especially 'Landing at Lisbon':[25]

The roads are swept, and even now and then watered, and some sort of draining is effected; but in the older ones prevails the primitive usage of emptying everything out of the windows, so that before every house is a mass of the most disgusting dirt, and a smell which defies description [. . .] The dirt of Lisbon, however, is yielding to the march of improvement. No house is now allowed to be built without drains.

After the misery of Harrogate in July 1843, Walter and Pauline went back to their beloved Edinburgh. Robert Chambers had been conducting an experiment on a toad to test its powers of hibernation. Walter thoughtfully noted that the experiment was not successful: '5th September [1843] Breakfast with Chambers – afterwards he dug up the remains of a toad which had been buried in his garden in a frozen state last winter – but probably dead at the time.'

The term 'Puseyite' was by this date contemptuous shorthand for Oxford Tractarians and Edward Bouverie Pusey's immediate

followers. Pauline made fun in her diary of an acquaintance who was unaware of her affiliation:

> Good natured soft Major M set us all into fits by his innocent questions about Puseyism and saying very gravely that he had never to his knowledge met with a real Puseyite to talk to.[26]

Throughout this period Pauline was in pain. Even as early as 1842 Walter's diary regularly reported that 'Paulina' was unwell and unable to accompany him. Her disorder defied all medical intervention. She displayed a cheerful stoicism and a refusal to complain about her illness, which compare ironically with the anguish expressed by some of her male friends: Ruskin was thought to suffer from consumption, kidney stones and incipient blindness (all of these illnesses were imaginary, or psychosomatic); and Thomas Carlyle, who became a close friend after 1860, famously suffered from sleeplessness and nervous debility, which enabled him completely to ignore his wife's real illnesses and suffering. Pauline would not allow her illness to stop her travelling, painting and seeing her friends, and she referred to it regularly in a matter-of-fact way in the diary − frequently the entries reveal that she has spent several days in bed, that she has pain, that she is unable to go out. Her habit in her diary was to make pencil notes of events as they happened as aides-memoires and then to write up the notes into a narrative in the privacy of her room in the evening. When she was ill the diary contains only the pencil notes, for the writing up was beyond her.

Meanwhile Sir John Trevelyan, Walter's father, was becoming increasingly fragile. Clara Novello had made an advantageous marriage and was therefore no longer available to him. He was anxious that there should be an heir. Walter and Pauline had now been married for ten years with no sign of children, and this made him restless. He wanted Walter to pay closer attention to both the Wallington and the Nettlecombe estates. Walter made an effort in the course of 1845, but it was in a sense reactive − his mother was destroying the planting that he had carried out at Wallington, as he discovered in October 1845:

> endeavoured to put a stop to the devastation Lady T is committing on many of the fine trees by cutting off their hanging branches & tho I have been too late to save some of those which were most ornamental

near the house [. . .] in evening had a storm for my interference about
the unfortunate trees.[27]

But Walter and Pauline were addicted to travelling, and in the
spring of 1846 they made an adventurous visit to Portugal (as
recorded in one of Pauline's stories written for Robert Chambers).
Sir John died while they were abroad; Walter had unknowingly
succeeded to the baronetcy on 23 May 1846.

The new Lady Trevelyan kept up her former enthusiasms and inter-
ests. She continued to keep in touch with what Mrs Buckland called
the 'papistical animals' (her fellow Puseyites). Mrs Buckland, now
living in the Deanery at Westminster, wrote teasingly: 'I cannot fancy
my dear humble modest Mrs Calverley turned into My Lady. You
will be like the old woman in the story book who fell asleep and,
meanwhile having her petticoats cut round about, then cries out:
"Surely 'tis not true!"'[28]

Nettlecombe was now officially the home of Pauline and Walter,
but it did not suit them – Walter's sister Julia was installed there,
and his formidable mother was still at Wallington. In 1848 Walter
found that his mother was quarrelling with the owners of a neigh-
bouring estate (the Monck Middletons of Belsay) and encroaching,
quite improperly, on their land, and that she was again interfering
intolerably with the management of the house and grounds, despite
the earlier 'storm'. The relationship between mother and son now
broke down entirely. Walter resorted to legal threats; his mother
moved out of Wallington and leased a house nearby. 'Not pretty,' she
is quoted as saying, 'when one's mother is seventy-seven.'[29]

Meanwhile Walter and Pauline had been in increasingly close contact
with Ruskin, and they heard in detail about the plans for his marriage
to Euphemia Chalmers Gray. From the outset, Ruskin was inclined
to treat the decision to marry Effie as though she, and not he, had
been the driving force: he told Henry Acland that 'the young Scotch
Lady checkmated me'.[30] This ill-fated match took place at
Bowerswell, near Perth, on 10 April 1848. This was the Gray family
home, but it had formerly been lived in by Ruskin's grandparents,
and indeed his grandfather had committed suicide there. For this
reason Ruskin's parents refused to go to the wedding. The same day
the Chartists marched on London. William Buckland had Westminster
Abbey and its precincts fortified against the possibility of a full-scale

revolution in London like those that were rocking many capital cities in Europe in 1848.[31]

Despite the extremely dangerous political situation in France, Ruskin could not bear to stay away from Europe in the summer, and the newly married John and Effie went to Normandy on their honeymoon. Effie soon became aware that her husband was more interested in recording ancient buildings than he was in her, but she worked hard at the marriage.

Wallington was now empty, but it was not until 1849 that Pauline and Walter brought themselves to make the great decision to live in Northumberland. And within a year Pauline's health was giving cause for anxiety. Her condition bewildered her medical advisers. One particularly terrible phase of the illness took place in Edinburgh, where she was treated by two famous physicians, Dr Simpson and Dr Syme (intense professional rivals, as it happens) early in 1850. But by the summer of that year she was feeling well enough not to need direct access to her Edinburgh doctors, and she and Walter spent the rest of 1850 at Wallington, now their home and the place they were both rapidly learning to love. Her devoted childhood friend Laura Capell Lofft spent much of the year with Pauline in case she needed care while Walter was away at his various duties. They had constant bulletins from the most valued of their friends. Effie Ruskin had persuaded John that they should spend the winter of 1849–50 in Venice, where he researched valiantly for what would in due course be published as *The Stones of Venice*. Effie continued to send affectionate letters to Pauline – clearly she valued their friendship and wanted it to become closer than it was – and when the Ruskins returned to London the relationship progressed. The Ruskins spent another winter in Venice (1851–2), again at Effie's insistence so that Ruskin could complete his work, but also so that Effie could separate Ruskin from his possessive parents and have a second valiant attempt at making something of her empty, doomed marriage. Pauline liked Effie, both for Ruskin's sake and for her own, and if she knew of the problems in the marriage she would certainly have hoped that the Ruskins would be able to overcome them.

William Buckland, the great geologist and now Dean of Westminster, had become mentally deranged in 1849 and there are several sad letters to Pauline from his wife in the course of 1850. Pauline regarded Mrs Buckland as an old and precious friend and responded compassionately to her anguish. But by February 1851

Pauline was once more in Edinburgh and was again very seriously ill. She had to have further surgery:

> Feb 19 Simpson and Syme came chloroformed me & then opened my side & took out 20 ounces of stuff. I was stupid & sick with chloroform but otherwise better

> 24 Feb wrote out my first article for the Scotsman [of four]
> Feb 25 Caly to Newcastle Assizes.

Walter had been appointed High Sheriff of Northumberland, and for this reason had to make regular trips to Newcastle from Edinburgh in order to dispense justice. For a man firmly opposed to capital punishment it was often a painful duty.

Pauline was commissioned to review the exhibition at the Scottish Academy for *The Scotsman* and, despite her pain and weakness, took great trouble and was writing her reviews in the worst crisis that her health had so far suffered:

> 28 Feb better get to the Exhibition for two hours

> Feb 28 Simpson & Syme called said they would perform iodine operation next Tuesday

> March 5 Syme & Simpson gave me chloroform & then injected iodine into my side, when the chloroform passed away the pain was dreadful. had leeches & opium C was telegraphed & came by special train

> March 6 stupid and sick all day with opium, but pain relieved

> April 28–30 all these days very ill in bed this illness more unpleasant than any I ever had.[32]

In the middle of all this, Walter's mother died. Because of her ferocious quarrel with Walter over Wallington, she had resorted to systematic vindictiveness when making her will and had arranged to leave nothing to Walter from her huge estate. She even tried to deprive him of a collection of geological and other 'curiosities', which in fact had been left specifically to him by his grandmother, Dame Jane Wilson, but rather than contest the will, Walter bought this item back from the executors. He went to her funeral on 11 April and returned to find Pauline already rallying and showing an improve-

ment in her health. She had succeeded in bringing two friends, Louisa ('Loo') Stewart Mackenzie and Effie Ruskin, together. Loo called on Effie in London, and Effie wrote enthusiastically to Pauline about Miss Mackenzie's beauty, power and depth: 'I shall deem myself happy if she likes me half as much as I am sure I should like her.' Pauline wrote happily to Loo that 'Effie is *quite* as much delighted with you as even I could wish.'[33]

The Oxford Museum

An epoch for good in the Education of the Clergy and Gentry of England

The stories of geology, theology, Ruskin, Acland and the Trevelyans are all united with each other in the story of the building of the Oxford Museum in the 1840s. Henry Acland was educated at Harrow and then Christ Church, and was later Fellow of All Souls and Student of Christ Church. A few years older than Ruskin, he had become Ruskin's closest friend when the two young men were Christ Church undergraduates, and the friendship lasted for most of the century. At the time of the founding of the museum, Acland was still a young man, working enormously hard at his own medical practice in order to maintain his growing family. As a Reader and subsequently as Regius Professor, he was a senior figure at Oxford, but because of its archaic Church- and college-dominated structure, the university's professors were badly paid.

The creation of the university museum was the product of the determination of this brilliant, well-connected, dogged and hard-up young man. The sciences in Oxford in the early nineteenth century were represented by long-established university professorships, but except for medicine they were not offered on undergraduate degree courses and therefore had little support. The classics, mathematics, philosophy and theology (the traditional training for the Anglican clergy) had a stranglehold on college teaching. In 1847 Acland, aged thirty-two, set about changing all that. The meeting of the British Association for the Advancement of Science in Oxford in the summer of that year was his opportunity to canvas support among all the senior natural scientists in the country for the creation of a proper building for the sciences in Oxford. He was persuasive and person-able, and by the time the Association meeting had ended, he had secured enough support to be sure that he could succeed.

For an Association meeting to be held again in Oxford – strong-hold of the Anglican establishment – was in itself significant. One

of the major debates was over Robert Chambers's *Vestiges of Creation*. By 1847 the anonymity surrounding this book had become paper-thin. Chambers himself came to the Oxford meeting and was subjected to brisk and merciless criticism. A whole session was devoted to an acrimonious discussion of *Vestiges*, and Samuel Wilberforce, the Bishop of Oxford and a lively senior member of the Association, condemned the book from the pulpit of St Mary's Church. The attack was effective, and Chambers's work was widely seen as having been damaged by this authoritative denunciation.*

In October of that year Acland moved with his growing family into a house in Broad Street, Oxford. His was not an easy life. His university teaching appointments were relatively undemanding, but to earn his keep and support his family he worked hard and continuously at the coal face of medical practice. He had the largest consulting practice in Oxfordshire. Rail connections between the city and the outlying towns were not good, and typically he would travel by carriage over the rough roads (sometimes as much as seventy miles in a day) to see his patients. Often he did not begin these country rounds before four o'clock in the afternoon and would not be home before midnight. He was also physician to the Radcliffe Infirmary and thus responsible for the general health of the city. There were two cholera outbreaks, in 1849 and 1854,† which were particularly burdensome to him in this role. And, of course, his expertise was sought out by senior figures in the university and by the gentry. 'No one of any respectability thought of dying without seeing Dr Acland.'[1]

His biographer points out that Acland's unassailable social position greatly helped him in his campaign for the founding of the Museum:

A member of one of the oldest families in the West, with the prestige of two such foundations as Christ Church and All Souls to back him,

*There is an irony for Wilberforce in the fact that the founding of the Museum was, in effect, initiated at this 1847 meeting. The third Assocation meeting in Oxford – attended by Pauline and Walter – would take place in 1860 in the completed Museum. At this meeting another ferocious attack from Wilberforce, this time on Darwin's *Origin of Species*, famously backfired.

†Acland wrote major, conscientious reports on the cholera epidemics of the period. The Trevelyans took a keen interest in his report on the epidemic in Oxford of 1854,[2] which did much to improve the drainage and water supplies in the city, though Acland did not identify the crucial point about cholera – that it was water-borne. He ended his discussion by leaving open the question of whether water or 'miasma' was the source of infection, but he was absolutely clear in his observations on the connection between certain practices and incidents of the disease. Oxford Prison, he noted, discharged its sewage into a former millpool behind the prison, and drew its drinking water from the same pool. The high number of prisoners who died during the epidemic told its own story.

the intimate friend of the Parliamentary representatives of the University, the disciple and protégé of the leading men of science in Europe, himself the exponent of the new learning which was winning an entry into the citadel of conservatism, he could afford to go his own way regardless of criticism and remonstrance.[3]

Acland often stayed in Wallington for periods of recuperation from his exhausting work in Oxford. At times Oxford nearly killed him. Ruskin visited Acland in June 1851 and wrote immediately after the visit to express a real anxiety, shared by all Acland's close friends:

> I was going to write to your wife about you but I don't like to frighten her [. . .] but I *will* frighten her unless I hear that you are going to leave Oxford directly. You cannot work less if you stay there – or if you do, it will be at the cost of continual vexation and annoyance – just as bad for you as work. I never saw such a life as you live there – you never were able so much as to put a piece of meat in your mouth without writing a note at the side of your plate – you were everlastingly going somewhere and going somewhere else on the way to it – and doing something on the way to somewhere else, and something else at the same time that you did the something – and then another thing by the bye – and two or three other things besides – and then – wherever you went, there were always five or six people lying in wait at corners and catching hold of you and asking questions [. . .] I am perfectly certain you cannot stay in Oxford – nor continue your profession at present. You must give up for an entire year.[4]

Another friend, a Dr Latham, endorsed this. 'You are beset with a legion of little amiable devils, bespeaking your health and strength for their various virtuous impracticabilities and twaddlements. You must get rid of them either by flight or by force; you cannot remain in Oxford.'[5]

For the establishment of his Museum, Acland sought the support of the great William Buckland, who had done so much to pioneer science in Oxford. But by the 1840s Buckland had come to hate the university and everything about it. To Acland he wrote in 1847:

> Some years ago I was sanguine as you are now as to the possibility of natural history making some [headway] in Oxford, but I have long come to the conclusion that it is utterly hopeless. The idle part of the young men will do nothing, and the studious portion will throw their attention into the channel of honours and profits which can alone be gained by the staple subjects of examination for degrees and fellowships. At

present it is a detriment for a candidate to have given any portion of his time and attention to objects so alien from what is thought to be the proper business of the university as natural history in many of its branches.

However, Acland found welcome support in an unexpected quarter. Given the position of the Tractarians on the natural sciences, Dr Pusey was the last person to be expected to offer encouragement. When asked whether he and his friends seriously discouraged the teaching of natural science, Pusey replied truthfully: 'It is so. We notice that it engenders in those we know, a temper of irreverence and often of arrogance, inconsistent with a truly Christian character.' But there was a gentlemanly mutual respect and liking between Pusey and Acland, which was reflected in Pusey's further remarks: 'The desire to possess such knowledge and the power to attain to it are alike the gift of God. They are to be used as such: while you discharge your duties in that spirit you may count on my assistance whenever you need it.'

In 1849 Acland had formed an influential group of colleagues (which now included Buckland, who had by this time reconsidered his view), proposing to the university that it should build a museum for the advancement of the natural sciences. The group had its beginnings in the lodgings of the Warden of New College (a Dr Williams) on 9 May 1849. The wording of the proposal was careful and cogent. The present provision of lecture rooms for natural science in the university was inadequate and, further, 'it would be consistent with a philosophical view of the connexion of the natural sciences that all the materials explanatory of the organic beings placed upon the globe shall be arranged in distinct departments under one roof, together with fit accommodation for preparing, studying, and lecturing on the same'. What the eighteenth century knew as natural philosophy, and the nineteenth century was calling natural science, were to be bound together within this philosophical view. In the end, the project was made possible by the release of a very large sum of money (some £60,000 from the Press's virtual monopoly of Bibles and prayerbooks), which had built up over the years at the Clarendon Press. By 1853 the university had agreed to vote £30,000 of that cash for this project, despite vigorous protest from those who claimed that the money earned from 'the privilege of printing God's Word', should not be spent on science. The essential physical features of the

Museum were arrived at in 1854 when a Delegacy was appointed to work out the details 'with particular reference to the principle of constructing a building surrounding three sides of an area, which should be covered in and applied to the purpose of a general museum, receiving light from the roof'.[6]

From the outset, the Delegacy was probably thinking in terms of Gothic. The Greek-style Ashmolean Museum and Taylorian Institute, designed by C.R. Cockerell and built 1841–5, was regarded by the Delegacy as a failure. G.E. Street, the diocesan architect for Oxford, made a provisional Gothic design, and pointed out that the Gothic was peculiarly suited to a museum of science because that style 'took nature and natural forms for her guide and her ornaments' and 'where nature is to be enshrined, there especially ought every carved stone and every ornamental device to bear her marks and to set forth her loveliness'.[7]

To take nature as the guide was, of course, a central Ruskinian doctrine. There has been much discussion of the extent to which Ruskin was involved, but to me it seems clear that Ruskin was informally (but closely) involved throughout. Acland would certainly not have embarked on a major architectural commitment without discussing it with the man who was both a close friend and the country's leading writer on architecture. Further, it is certain that they would both have discussed the project with Pauline, given her absolute sympathy with their beliefs and ambitions, her well-known generosity as a patron and her deep commitment to science. Ruskin's writing on the Gothic was clearly setting up echoes in Oxford. It is apparent that from the beginning Acland was steering his committee very hard indeed. When one considers the eventual outcome of the competition – a building by Deane and Woodward in the Gothic style – it cannot be coincidence that Acland was one of Ruskin's closest friends; that Ruskin greatly admired the work that Benjamin Woodward, the brilliant junior in the partnership, had carried out in Ireland (especially at Trinity College Dublin); and that Acland had known and trusted Sir Thomas Deane since the 1830s.[8] It is not clear where the idea of the enclosed glass-covered court came from. Sir Charles Barry had been invited at an early stage to give his expert advice on the project.* In one sense it was an obvious concept for its

*Charles Barry, architect of the Houses of Parliament, was also the architect of the redesigned Hunterian Museum of the College of Surgeons, a building in which toplighting and galleries were the key features. Barry's grand and ambitious building was opened in 1837. The delegates invited him to be one of the experts to cost the new Museum. (It was the design of Barry's son, Edward,

date, and the Delegacy must have been leaning towards a glass roof when it asked the London architect Lewis Cubitt, who had just built King's Cross Station, to make a preliminary design on which the costing of the proposed building could be based.[9] One of the delegates who survived until 1911 said that the suggestion for a glass roof came from Dr Pusey's brother.[10] The Crystal Palace of 1851 had triumphantly shown how effective and cheap a big glass and iron structure could be as an exhibition space. The Oxford men also knew about the glass roofs of existing museums.

The decorative features of the Museum had to be funded from sources outside the university, the delegates having agreed to pay only for the building, not for the interior or exterior decorative sculpture. Money had to be found from other sources for the sculptures of famous scientists through the ages that adorn the interior of the building, for the capitals illustrating the plant and animal kingdoms and for the leaf and animal decorations of the exterior windows. The Queen paid for five of the figure sculptures inside the Museum; Ruskin paid for much of the exterior decoration; and distinguished individuals paid in various sums for other parts of the decorative scheme.

The Trevelyans were crucial here. They were famously wealthy, well connected and philanthropic, and if they were seen to be willing to contribute to the Museum, others were bound to follow. Pauline helped the Pre-Raphaelite sculptor Thomas Woolner towards his first major commission, the figure of Bacon that stands immediately inside the entrance to the Museum. Woolner complained about his payment for this piece, but it was a principal feature of a high-profile new building and it did him no harm. There is substantial correspondence between Walter and John Phillips, the Museum's director, showing how closely involved the Trevelyans were with the whole project between 1854 and 1857. It is not clear how much Phillips welcomed

that came second in the architects' competition to win the contract.)[11] The Hunterian Museum also inspired a building very close in spirit to the Oxford Museum, namely the Museum of Practical Geology in London's Jermyn Street, designed by James Pennethorne. A central purpose of this museum was to demonstrate the close links between scientific knowledge and a thriving economy. Science was moral, defensible and useful. When Prince Albert opened this building in 1851, he praised it in terms that brought together God, the Empire, geology and prosperity:

> It is impossible to estimate too highly the advantages to be derived from an institution like this, intended to direct the researches of science, and to apply their results to the development of the immense mineral riches [the great Midlands coal deposits] granted by the bounty of Providence to our isles, and their numerous colonial dependencies.[12]

the interventions of this distinguished gentleman from Northumberland and his brilliant and determined wife, but he would certainly have welcomed the money and the connections they brought with them. Acland, Woodward and Phillips all understood the kind of influence that the Trevelyans could wield.

By 1853 Ruskin had published his hugely influential studies of architecture, *The Seven Lamps of Architecture* and *The Stones of Venice*, and was exercising as much power in the field of architectural style as he was in that of painting. He had inspired the Pre-Raphaelite Brotherhood* and was now creating Victorian Gothic.

At Oxford, after much debate, two sets of architects proposed detailed designs: one came from Edward Barry (who can be assumed to have had inside knowledge since his father, Charles, had been brought in for expert advice at an earlier stage), who proposed a classical design; the other was from Deane and Woodward of Dublin, who had built the library of Trinity College in what was clearly Ruskinian Gothic.

With vigorous steering from Acland, the Gothic design from Deane and Woodward won the competition, and the result is the Museum that we see today opposite Keble College. In practice the junior partner in the firm, Benjamin Woodward (1816–60), was the architect in charge. The advertisement for the Museum was confident about the use of a medieval church style for the sciences; it was to contain teaching collections for 'Astronomy, Experimental Physics, Chemistry, Mineralogy, Geology, Zoology, Anatomy and Physiology, and Medicine [. . .] and the completion of such a design in Oxford may be expected, by God's blessing, to form an epoch for good in the Education of the Clergy and Gentry of England'.

The advertisement happily elides any difference that we moderns may feel between the clergy and the gentry, and displays no strain over the fact that much of this medieval structure was to be built in glass and iron:

> The design is Gothic of the Thirteenth Century. The plan is simple: a
> Quadrangle surrounded by a Cloister of two stories, with open Arcades

*Three brilliant young artists, William Holman Hunt, John Everett Millais and Dante Gabriel Rossetti, initiated their secret 'Pre-Raphaelite Brotherhood' after reading Ruskin's *Modern Painters*, vol. 1, in 1847 (see Chapter 5 below).

giving access to the several apartments on each floor. The Quadrangle itself is roofed over, to form a space of the exhibition of the collections in scientific order.

A central principle for Ruskin was that buildings should express the creativeness of the artisan. The decorations of medieval buildings (Chartres, for example) were, for Ruskin, their most animate and humane feature, because they were the most democratic. When a medieval craftsman was carving, Ruskin believed, medieval society was at its creative best and there was no visible power difference between the architect and the artisan, the employer and the worker, capital and labour; in short, in the medieval world the economic and social conflicts that dogged Victorian life and were anathematised by Marx and Engels had already, in a sense, been solved.

Ruskin wrote a long letter about Gothic to Acland (Acland quotes it in full in his book of 1859 about the Museum). Ruskin said that Gothic needs workmen who did not yet exist, because the craftsmanship that took 800 years to mature had been allowed to lapse. Ideally, for the decorative work on the Museum, they should use workmen 'As we have yet to create them: men inheriting the instincts of their craft through many generations'.[13]

> Your Museum at Oxford is literally the first building raised in England since the close of the fifteenth century, which has fearlessly put to new trial this old faith in nature, and in the genius of the unassisted workman, who gathered out of nature the materials he needed [Ruskin is referring here to the O'Shea brothers – stone-masons – and their carvings from life].[14]

The Museum was to have had painted frescoes: Arthurian battle scenes on the lower walls and detailed plant and flower patterns on the upper wall. A very large design for one of these frescoes, representing a medieval battle scene of some kind, has survived and hangs in the Museum. The artist is unknown, but may well have been the Newcastle artist (and Pauline's friend) William Bell Scott; it is in his style, and Pauline was urging him to contribute to the decoration of the Museum. If those frescoes had been carried out, the comparisons between the Museum and Wallington would be much closer. Both buildings would have been embodiments of two kinds of history: the written and painted recorded history of England and the history of the earth in the record of its rocks. Pauline wanted Bell Scott to make

his mark in Oxford by working both for the Museum and for the Union building (also by Deane and Woodward), which was completed slightly earlier than the Museum and decorated by Rossetti, William Morris, Val Prinsep and others. But Pauline was not offering any money for this and it was not realistic for Bell Scott to leave Newcastle and work for no payment in Oxford.

Ruskin was opposed to the plans for coloured decorations because he thought the decorative schemes for the Museum should be allowed to evolve slowly. In his letters to Acland, published in *The Oxford Museum* in 1859, he pleaded for experiment and thought before introducing colour decoration into the interior of the Museum, and on 11 November he wrote to the Trevelyans referring briefly to Acland and the Museum: 'The museum is by no means so satisfactory in the way of colour, and Henry is in an excited state about it. Mrs Acland wants him to let it alone. – So do I, rather.'[15]

Ruskin hoped that Rossetti and Millais would design windows, but unfolding events caused a breach between Ruskin and Millais, while Rossetti instinctively disliked working to another man's prescription, especially if that other man was Ruskin.

Ruskin disliked the Crystal Palace and disliked railway stations, but he clearly made an exception for the glass roof of the Museum. It is possible that he was won over to it because of Pauline's plans for Wallington. Acland of course knew that Pauline was having a central court built at Wallington and that she was planning to have a partially glazed roof, to give daylight and to enable the display of works of art and – at the early stage of planning – Walter's geological specimens and a collection of stuffed birds commissioned from Hancock. In other words, until a late stage the hall of Wallington would have displayed science as well as art. And yet the Oxford Museum is medieval in inspiration, as Wallington is not; and if one walks round Oxford looking at the buildings, the models for the Museum are in a sense all around: the quadrangles of the medieval colleges (but in this case covered in glass). It is an 'edifice harmonising with the collegiate associations of Oxford', as Acland put it in one of his many leaflets in the campaign for the Museum.[16]

Pauline had been approached to advise about the plants and flowers for the capitals in the new Oxford Museum. She in turn commissioned a series of drawings from Bell Scott, and sought ideas for the capitals in Ruskin's works. She designed a capital herself: 'Passion

flowers' were her first idea.* Her capital as executed has fritillaries, poppies, tulips and passion flowers, with birds and small animals between the blossoms. It is not clear how faithful the capital is to Pauline's design. The O'Shea brothers, stone-masons of genius who had been brought over from Ireland by Deane and Woodward, did not like working from drawings, and preferred to take examples of live plants from the Botanical Gardens in Oxford and carve directly from nature.

Given that the Wallington project was to be a museum as well as a place to display works of art, Walter recruited a curator, David Wooster, whom he had met in 1852 when he was in charge of a small museum of geology at Ipswich. Walter was impressed by this young man's abilities, and by early 1855 Wooster was living at Wallington. Pauline was not enthusiastic. David Wooster was a shy and serious person with drooping moustaches and indistinct speech, no wit, no conversation and no social skills. She wrote to Louisa Stewart Mackenzie: 'I have had to give in, but he is not the sort to meet every morning at breakfast.'[17] Visitors to the house (such as Augustus Hare, the topographical writer and memoirist, who visited in 1861 and again in 1862) were puzzled by Wooster. Hare wrote that the curator came to the house 'to arrange the collection of shells' and thereafter 'he has never gone away'.

> He looks like a church-brass incarnated, and turns up his eyes when he speaks to you, till you see nothing but the whites. He also has a long trailing moustache, and in all things imitates, but caricatures, Sir Walter. What he does here nobody seems to know; the Trevelyans say he puts the shells to rights, but the shells cannot take four years to dust.

After a time Wooster became Walter's secretary, personal assistant and librarian. Augustus Hare again: 'the library here is delightful, full of old topographical books and pamphlets; and sleek Mr Wooster, with whites of his eyes turned up to the skies, is always at hand to find anything you want.'[18] What did Walter see in this cautious and correct young man? Wooster could share all his hobbies and pursuits, became skilled in photography and would be out with

*Pauline's involvement with the latest innovation in Oxford and with Ruskinian high culture coexisted with the homely and urgent business of sorting out a quarrel among the servants: (16 January 1857) 'This morning we saw all the maids. & discussed [with] the cook & dairy maid on keeping the peace – I looked over *The stones of Venice* with a view to designing a capital of Passion flowers for Oxford.'

Walter in all weathers on photographic expeditions; he enthusiastically adopted Walter's passionate opposition to alcoholic liquors, and would make his own Temperance speeches to the inhabitants of villages on the Wallington estate (one can imagine how the villagers felt about that). As he became more confident about his position in the household Wooster took to imitating Walter's mannerisms and appearance: his hair became longer and his moustaches were styled like Walter's. Wooster had no private life. He was devoted to Walter, and Walter was comfortable with him. Pauline, at first, found David Wooster an intrusion, a social liability and something of a joke, but as time passed she accepted that he made her husband happy and became reasonably fond of him. But she never tired of making jokes at his expense.

The Wallington scheme further demonstrated Pauline's independence of those grand and daunting Trevelyans down at Nettlecombe, and her new-found authority in the family was felt again over the question of Walter's decision that Wallington should be left to someone other than the next direct heir. Neither Walter nor any of his next three brothers (in order of seniority) had sons.

Walter's fourth brother Alfred Wilson Trevelyan had married an Irish woman, and his son, Alfred Wilson Trevelyan (1831–91), the sixth baronet of Nettlecombe, was brought up in Ireland as a Roman Catholic. Walter's cousin Charles Edward Trevelyan, working at the Treasury, was effectively in charge of the relief measures in Ireland at the time of the potato famine. He was sharply criticised in the press for allowing the Irish to starve, by doing too little too late, and the received view of him until recently has been that he exercised the early Victorian doctrine of laissez-faire in a manner that was highly culpable, if not murderous: 'Trevelyan believed the Irish famine was the judgement of God on an indolent and unselfreliant people.' This view of the matter was put about in an influential essay in the early 1960s. However, a recent substantial revisionist study argues that the demonising of Trevelyan over the Irish famine was completely unjust. His view was that the landlords, and not the people, were to blame. Many of the landlords were absentees, who shirked their responsibility and made no attempt to diversify the use of their arable land in order to compensate for the failure of the potato crops over successive years.[19]

While on official business in Ireland, Charles Edward befriended

Alfred Trevelyan's widowed mother (Alfred was a posthumous child) and tried to persuade her that the boy should be educated at an English public school. Walter and Pauline also tried to persuade Alfred's mother that their heir should be brought up in England; Walter wanted him to go to Cambridge, but no progress on this was made. Charles Edward continued to try to broker some kind of satisfactory agreement over Alfred's education and eventually his mother allowed him to go to a good boarding school in Limerick and then to Trinity College Dublin.[20] Alfred was still too Roman Catholic and too Irish to inherit the whole of the Trevelyan property, in Walter's view (and perhaps in Pauline's as well), but it was also Walter's rather austere view of the public responsibility of landowners that caused him to divide the estate. He is on record as saying that he felt it was 'bad for the country for any one individual to hold such sizeable possessions so far away from one another'.[21] In the event, Alfred Wilson Trevelyan had six daughters but no sons, so Walter's fear that the Nettlecombe estate would be permanently lost to Rome was unfounded. Pauline was fond of Alfred, but she preferred the brilliant young George Otto Trevelyan, son of Walter's cousin Charles Edward. Walter duly decided in 1863 to leave Wallington, which was not entailed, to Charles Edward.

The early friendship with Ruskin

He said he was very proud of his scholar & in fact I came to such
glory that . . . I shall stand upon my head for the rest of my days

In *Praeterita*, the beautiful but highly selective and fragmentary auto-
biography written during the 1880s when Ruskin was in poor physical
and mental health, the great critic recalled his closest woman friend:

> I have no memory, and no notion, when I first *saw* Pauline, Lady
> Trevelyan [it was 1843]; but she became at once a monitress-friend in
> whom I wholly trusted, – (not that I ever took her advice!) – and the
> happiness of her own life was certainly increased by my books and me.
> Sir Walter, being a thorough botanist, and interested in pure science
> generally, did not hunt, but was benevolently useful, as a landlord should
> be, in his county. I had no interests in county business at that time; but
> used to have happy agricultural or floral chats with Sir Walter, and
> entirely admired his unambitious, yet dignified stability of rural, and
> celestial, life, there amidst the Northumbrian winds.[1]

There is a certain adamantine egotism about this: to say that his
work had enriched Pauline's life was certainly true, but it is dismay-
ingly self-regarding in this context, and 'monitress' is a very odd
word with which to sum up such a deep and warm friendship. Was
it that by the time he wrote *Praeterita*, Ruskin was so damaged
emotionally and sexually that he was wary of expressing love for any
woman, however equable and mutual that feeling had been? Or was
it simply that this outrageously headstrong genius could not really
take any rebuke or advice, however well meant? Ruskin had always
been violently self-willed and fond of power. Nobody was allowed
to infringe on his absolutism. Pauline loved and cared for him, but
she was certainly capable of plain speaking when she thought he was
being spiteful, silly or sentimental in his preferences as a critic, or
violent and uncontrolled in his political and religious opinions.

For three years or so after her first meeting with him in 1843,
Pauline seems to have had relatively little contact with Ruskin, but
by 1847 she was one of his warmest disciples. She learnt a great deal

from him, both in intellectual and practical terms. He was an encouraging but firm teacher, attending closely to the development of detailed technical skills, particularly drawing. His teaching methods were derided by Bell Scott, but for Pauline they worked well. In March 1849 he wrote to her about a sketchbook that he had recently received from her:

I am sure you must feel yourself that you are advancing in knowledge as well as power – [not] a feeling you had enough of always: you must however draw larger and carry what you do farther: You draw rocks well and will draw them perfectly as soon as you can round them: the next time you have a torrent bed to draw, get some large round masses in front of all: not *wet* and see how thoroughly you can express their curvatures: it is better for this purpose at first to take them out of the sun, as otherwise the light & shade alters before you can finish it. Do again & again until you succeed – in light and shade: and when you have rounded the stone thoroughly put on any stains & lichens they may have, in colour *if you like* – taking care not to interrupt the form. Painting a spotted and knotty apple is good practice: Do the same with trunks of trees, choosing smooth ones – birch – beech – & young pine. You can bring home some stones with you and paint them in your leisure realising them as far as you can. Together with this work make memoranda from nature for chiaroscuro *only*, and for *colour* only.

When you work for colour – get *that* true, though people may not know whether the red or brown thing you paint be a cow or a bunch of fern – never mind its form, but have its colour true at any cost. You cannot get both in a study from nature. You must think of one at a time. So for light and shade – make scrawls of the shapes of things, but mark *carefully* their relations of shade to the sky and to each other. You will thus study form, shade, & colour on separate bits of paper: Of course if you want a likeness of a place, you must mix them as you can: but when you go out to *learn to draw*, keep them separate.[2]

The years of travel since her marriage had clearly been a revelation for Pauline and a period of great happiness. The Trevelyans went everywhere in Italy and saw everything, bought a number of significant works of art to take back to England, had their portraits painted and took notes everywhere.[3] Pauline also made a large number of excellent sketches in watercolour and pencil. They survive in two sketchbooks, one with large and ambitious paintings, and the other smaller book for rapid notes; they cover 1836–8 and 1842–3 respectively. There are many scenes from Rome, Venice, Elba, Piraeus, and so on (Pauline particularly enjoyed sketching the picturesque Italian

and Greek fishermen and their boats) and, once back in England, her sketchbooks include a large number of images of Oxford. So far so conventional. But there are also sketches that are completely different in mood. The eighty-seven sketches in the 'large album' of 1836–8 are far more finished than the forty-seven in the 'small album' of 1842–3. The latter sketches cover the dates at which she met Loo and Ruskin (in 1842 and 1843 respectively).

Did Ruskin rework some of these paintings? The large album has a note from a descendant of Emma Wyndham, Walter's niece, saying that where there are two sketches of the same subject, the more sophisticated may be by Ruskin. If Ruskin did rework them, it was some years later; it is possible that Pauline showed him these albums in 1847 or so, and he could then have reworked a couple of sketches to show her the kind of landscape painting he admired. There is a drawing of an egg, carefully shaded, in the small album of 1842–3, which is absolutely consistent with Ruskin's method of teaching drawing. Although Pauline met Ruskin in 1843, she seems not to have had drawing lessons from him until several years later, so it is possible that she was using up spare leaves in this sketchbook for drawing exercises set by Ruskin in 1847.[4] She was a conscientious pupil. She felt free to laugh at times at the close detail with which he wanted her to work, but she understood and valued the teaching that he gave her, and was in any case an intuitive and accomplished watercolourist (and had been since her teens).

The relationship was not all one-sided. Ruskin learnt a great deal from the Trevelyans. Much of his knowledge of geology was developed through his friendship with Pauline and Walter. He also gained some religious flexibility, a willingness to laugh at himself and the personal experience of what it was to love someone who put up with constant pain. The tantrums and intolerance that marked some of his early writing were ameliorated by his friendship with Pauline, and he was willing to listen to her criticism of his work. And he admired the landscape in which she lived: 'I shall not call your county hideous,' he wrote from Venice (27 January 1850). 'There is a wildness about those Northumbrian hills which might seem to deserve the ill name [. . .] but I love that dreary northern look with all my heart.'[5]

Ruskin was a troubled soul in the late 1840s and 1850s, for religious questions haunted him. Like so many fundamentalist Protestants who grounded their faith in patient daily reading of the

Bible, he fretted over the impact of geology on the Mosaic history of the beginning of the universe. His pamphlet about the Church of England, *Notes on the Construction of Sheepfolds*, caused anxiety to his friends, and Ruskin wrote to Henry Acland on 24 May 1851 partially in explanation and exoneration. It is clear that he felt his faith was being actively threatened by the sciences:

> It is said that 'the Just shall live' and that 'We' (meaning all Christians) 'walk by faith.' Now very surely the World at present neither lives nor walks by anything of the kind, and therefore to move mountains is very impracticable indeed. You speak of the Flimsiness of your own faith. Mine, which was never strong, is being beaten into mere gold leaf, and flutters in weak rags from the letter of its old forms; but the only letters it can hold by at all are the old Evangelical formulae. If only the Geologists would let me alone, I could do very well, but those dreadful Hammers! I hear the clink of them at the end of every cadence of the Bible verses – and on the other side, these unhappy, blinking Puseyisms; men trying to do right and losing their very Humanity.[6]

From his viewpoint, Pauline herself was guilty of 'blinking Puseyisms' (Ruskin's 'blinking' perhaps referring to one of Pusey's chosen personal disciplines, that of custody of the eyes), while Acland was guilty of encouraging the 'dreadful Hammers' of the geologists who were seeking to establish the true history of the earth. So this letter may be said to put Ruskin in friendly tension with these two friends and allies.

In the course of 1852 Pauline and Ruskin corresponded about religious matters. The tone was friendly enough, but the content was potentially explosive; they disagreed fundamentally about the Oxford Movement and Pusey, and very substantially about the Church of Rome. Ruskin hated it, Pauline was decidedly sympathetic to it, both from personal conviction and, now, through family loyalty: her sister Mary Jermyn (Moussy), ten years younger than Pauline, had married the Revd J.C. Hilliard in 1848. He was a Puseyite and later for many years rector of Cowley, near Uxbridge.

From London, 31 Park Sreet, on 1 March 1851, Effie Ruskin wrote to Pauline about her husband's new publications: he 'is very busy now with his second volume of the Stones, his first comes out today as well as a Pamphlet upon some ideas of Church Government which he calls "Notes on the Construction of Sheepfolds." I am afraid you will not like it but be sure and read it and tell us exactly what you

think of it.'[7] Pauline did indeed read *Notes on the Construction of Sheepfolds,* and was not happy with it. 'I think it is weak,' she wrote to Louisa Stewart Mackenzie, 'I don't think it is in any way worthy of him [. . .] It is a thousand pities he should go out of his own line, unless he has something better to say.'[8] We can be sure that in his *Sheepfolds* pamphlet she liked neither Ruskin's observations about the Puseyites, nor his virulent hostility to the Church of Rome. And he made matters worse in his letters to her about *Sheepfolds,* which did more than just tease: he treated her deepest beliefs with offensive lightness.[9] He wrote from Venice on 22 September 1851:

> So I am to fight out my quarrel with the Pope – am I – without saying anything about any body else. Well, but then, are you Tractarians going to be quiet? You say you are down – I had no idea of that – I thought you were in great strength and that there was a Tractarian curate – or rector in at least three parishes out of seven over the whole country [he knew that 'Moussy' Hilliard's husband was such a clergyman]: I know that all my Oxford friends – with one exception,[10] are divided between Tractarianism & liberalism – and are determined to let the Catholics have it all their own way, either because they love them – or because they don't care about religion at all. Such members of parliament as they make! the men whom I used to have hot suppers with.[11]

Ruskin assaulted the Puseyites and the Church of Rome as though the one inevitably led to the other – Pusey being like a treacherous officer who leads his men helplessly into the enemy camp:

> Now, one could put up with Puseyism more patiently, if its fallacies arose merely from peculiar temperaments yielding to peculiar temptations. But its bold refusals to read plain English; its elaborate adjustments of tight bandages over its own eyes, as wholesome preparation for a walk among traps and pitfalls; its daring trustfulness in its own clairvoyance all the time, and declarations that every pit it falls into is a seventh heaven; and that it is pleasant and profitable to break its legs; – with all this it is difficult to have patience.[12]

The *Sheepfolds* pamphlet was a declaration of war. The question of Roman Catholic aggression could not be put to one side as irrelevant to secular affairs:

> By our definition of the term Church, throughout the whole of Christendom, the Church (or society of professing Christians) *is* the

State, and our subject is therefore, properly speaking, the connection of lay and clerical officers of the Church; that is to say, the degrees in which the civil and ecclesiastical governments ought to interfere with or influence each other.[13]

A well-governed Church, like a well-governed state, depended upon strong 'monarchical' leadership ('of all puppet-shows in the Satanic Carnival of the earth, the most contemptible puppet-show is a Parliament with a mob pulling the strings').[14] Both branches of the Protestant Church, the Evangelical and the high, were urged to find within themselves enough 'monarchical' leadership to enable them to take joint action against Rome:

> I believe that this state of things cannot continue much longer; and that if the Church of England does not forthwith unite with herself the entire Evangelical body, both of England and Scotland, and take her stand with them against the Papacy, her hour has struck. She cannot any longer serve two masters; nor make courtesies alternately to Christ and Antichrist.[15]

Pauline was reluctant to take Ruskin on over the main issues, but she could tease him over minor aspects of the dispute. When he had complained of the Pre-Raphaelite Brotherhood's Roman practices and images in the first of his letters to *The Times* about the young painters (13 May 1851), Ruskin wrote:

> Let me state, in the first place, that I have no acquaintance with any of these artists, and very imperfect sympathy with them. No one who has met with any of my writings will suspect me of desiring to encourage them in their Romanist and Tractarian tendencies. I am glad to see that Mr Millais' lady in blue is heartily tired of her painted window and idolatrous toilet table; and I have no particular respect for Mr Collins' lady in white, because her sympathies are limited by a dead wall, or divided between some gold fish and a tadpole.[16]

It was this letter, rather than the pamphlet, that Pauline referred to when she wrote about Charles Allston Collins's *Convent Thoughts* and Millais's *Mariana*. She complained that in Ruskin's mind:

> Mr Collins may not paint lilies in a convent garden, but the serpent is supposed to be hid under the leaves; and Mr Millais cannot decorate Mariana's room in the Moated Grange, with some indications of the

faith of her country, but the author of Modern Painters finds the Pope behind the curtain.[17]

This was not wholly fair. Ruskin was the most important of the champions of the Pre-Raphaelite Brotherhood. It is true that he expressed anxiety about the painters' 'Romanist and Tractarian tendencies', but this was clearly a minor point; what was important, for Ruskin (and clearly true as a general statement about these young artists), was that 'Pre-Raphaelite' was a silly *nom de guerre* since it detracted attention from what they were actually doing. 'Antique painting' was not the point: 'They know very little of ancient paintings who suppose the works of these young artists to resemble them.' The young men were interested in returning to the past 'in this one point only – that, as far as in them lies, they will draw either what they see, or what they suppose might have been the actual facts of the scene they desire to represent, irrespective of any conventional rules of picture-making'. In his next letter to *The Times,* on 30 May 1851, Ruskin withdrew the observation about 'Romanist tendencies' and added a passage of resonant praise, which – coming from the most powerful critic in the land – gave the young painters a sense of huge horizons opening before them:

> If they do not suffer themselves to be driven by harsh or careless criticism into rejection of the ordinary means of obtaining influence over the minds of others, they may, as they gain in experience, lay in our England the foundations of a school of art nobler than the world has seen for three hundred years.[18]

Early in 1853 Pauline and Walter were in London, partly for Pauline's health. It was a very harsh winter, and news reached them that Wallington was cut off by snow, so they stayed on at 3 Porchester Terrace instead of attempting to go home to the North. For 15 February Walter's diary entry reads, 'Dined with Ruskens.' Walter seldom spelt Ruskin's name correctly. He was invariably polite to the great critic, but the diary entries about him are never warm or intimate. Typically the end of a visit from Ruskin would be noted simply as 'Rusken went'. On this occasion, though, Walter was interested in Ruskin's collection, including his 'drawings and etchings of Turner. Casts from Venice and Verona of mediaeval work.' Pauline wrote to Louisa Stewart Mackenzie about the same visit, in some excitement, since this was the first time she had seen Ruskin for a considerable

while. Because he guided her knowledge of art and had advised on her own painting, she always referred to him as 'Master'. 'I am so thankful to find that I can worship him so entirely as ever – and also that he is as kind and loving as ever – what a blessing *that* is, when one has been several years without seeing one's idol.' She was always nervous about Ruskin's attitude to her work, since he could be peremptory (he told her sharply not to 'Preraffaelitise'), but on this occasion he approved of what she had done, 'which was an immense relief to me'. She had shown him some of her drawings: 'Oh what a fright I was in – for he said he expected great things of me – & I was afraid when he saw what I had done he would think I was a shocking bad scholar.' His reaction to her work was a huge comfort: 'He was not the least disgusted – but quite the contrary – and said he was very proud of his scholar & in fact I came to such glory that [. . .] I shall stand upon my head for the rest of my days.'[19] Contact with Ruskin was delightfully frequent during this stay in London. They saw the Ruskins again on 22 February, when Pauline had lunch with Effie and then spent the whole afternoon sitting (metaphorically) at her Master's feet.

On 28 February Pauline went to stay at Herne Hill, without Walter, and found her quiet friendship with Effie intensifying and the ability to laugh at Ruskin's crotchets and eccentricities becoming correspondingly easier:

> The Ruskins were very kind to me & very nice, and took great care of me – my Master gave me Albert Durer curious woodcuts of the apocalypse etc. to look at, & many wonderful prints by him wh took me all the evening to look at – we had tea at 6.00 and went to bed early
>
> March 1 a terribly cold snowy day cd not go out had Turners to look at & Mrs Beryls things & lots of Master's things, Swiss beauties & others, also Albert Durers again Master to London to church E & a friend of hers played very nicely She was rubbing the dirt off an old Madonna.

In the privacy of her diary Pauline felt free to criticise 'Master's' dictatorial manner and inflexible opinions: his 'heresies about music', for example (he preferred 'Home, Sweet Home' to Beethoven), and his prudishness over sexual matters (Pauline herself was very open-minded about such things): 'his theories about novels – married people – Thackeray etc – excessively queer & funny – he was very quarrelsome today'. Ruskin condemned both Thackeray's fiction and

his personal life: *Vanity Fair* was notorious for having a loose woman (Becky Sharp) as its central figure, and Thackeray was well known to have a mad wife and to console himself with other women.

Ruskin's parents were very conscious that they were entertaining 'Lady Trevelyan' and were inclined to be obsequious. Vainer gentry would have found them cloyingly over-attentive, but Pauline took the old people at face value and simply felt that she was 'very lovingly received'. She was always prepared to see the best of every situation where John Ruskin was concerned. She and Ruskin went back to London from Herne Hill to see another private collection of Turners, and on the following day over breakfast she listened (patiently) to reasons for his dislike of the Crystal Palace. Later in the month of March she went back to Herne Hill to look at missals with him, and in early April 'with J[ohn] & E[ffie] to London to Exeter Hall to hear Mendelssohn's *Lohgesang* and Mozart's *Requiem*. Millais with us. It was most delicious. The *Lohgesang* is a noble inspiration. the way in which it is worked up to the highest pitch of imagination is astonishing.' By contrast, Ruskin greatly disliked Mendelssohn's music, probably because Effie admired it.

Pauline did recognise, of course, that she was constantly learning from her contact with her adored 'Master'. Maybe the pleasure of having his company without having Effie busily displaying her social skills (Pauline was fond of Effie, but found her provincial and pushy at times) outweighed the vexation she must have felt at what Ruskin said. For example, she quotes without any comment Ruskin's opinion of female painters:

> 3 April Effie too ill & tired to come down. Master & I breakfasted together. he thinks perhaps the reason why there has been no *great* female painter is that the greatest of all requisites is intense self government & self denial. Feeling they have & power – remains to be seen whether they can exercise self restraint.

If anyone was a mistress of self-government and self-denial, Pauline was, whereas Ruskin was incapable of either. But she kept such reflections out of her diary. She simply loyally narrated the great man's pursuits and interests:

> He is making a translation of the epistle to the Romans, his questions as to the meaning of 'glorying in man' – his ideas of education, of science causing humility & scholarship making people conceited. He

& I went to Denmark Hill & there went with the old people to church. a hideous modern church. they are going to put a good apse to it. fight about the *Deus* at dinner [the details of the fight were not given, but if the issue was over the use of the Latin word for God, then it is likely that Ruskin was airing his violent hostility to the Church of Rome] [. . .] Caly came & staid all night.

Ruskin gave her helpful technical advice the following day, 4 April.

Master took me to his rooms & showed me the way he gets the soft delicate shades in his capitals without washing in & out. it taught me what I have long been wishing to know. he showed me how Turner put in his skies, so frankly & at once. *no* putting in & taking out again. the greys put first generally. the tint below always having reference to what is to come over it. he showed me how Hunt does his grasses. he showed me how Turner does his grand sky in 'the Alps.'

Pauline no doubt hoped this would be the first of many lessons with 'Master' while she was in London, but instead Ruskin decided that she should go to William Henry Hunt for tuition. He did, though, show her some exhilarating page proofs that had come in for his approval: 'saw the 1st chapter of the new vol of *Stones of Venice* in print it is grand'. And as usual she visited the studios of the young artists: 'April 5 we all went early to Millais to see his new pictures, most glorious things they are. the colours of one is more subdued than usual.' The new painting she singled out for praise was *The Order of Release*: this striking and painstaking canvas shows a Highlander, who has been imprisoned for his part in the 1745 rebellion, being released from prison by the intervention of his wife, who has persuaded someone in authority to pardon him. Effie was seeking release from her unsustainable marriage when she modelled for the Highlander's wife. Millais knew that her marriage to Ruskin was unconsummated and that she was trying to escape from it, and by the time he made this painting he was deeply in love with her. Millais's view of his role in this was chivalrous and idealistic: he was seeking to release this damsel from imprisonment by a man whom the lovers both now saw as a perverted monster. Pauline did not remark on the fact that Effie was the model for the wife, though anyone who was a friend of the Ruskins would clearly have known.

William Henry Hunt (1790–1864), affectionately known as 'Bird's Nest' Hunt, was famous for his finish and his careful and startlingly

realistic portrayals of fruit, flowers, nests and birds' eggs. He had taught John Ruskin, so for Ruskin to recommend him as a teacher to Pauline shows how highly he regarded Pauline's talent. On 6 April Pauline went to Hunt's studio to see his paintings. Hunt was only five feet tall (exactly Pauline's height) and had severe scoliosis of the spine. He also had a large family to support, so the income from teaching was helpful. Pauline took to him immediately: 'he is quite a little cripple but has bright eyes & white hair, he consented to teach me for love of Mr Ruskin.' On 8 April Pauline went to hear the Mozart and Mendelssohn programme all over again and enjoyed it even more the second time. Illness could not stop her continuing to go out with her friends: (19 April) 'with J & E Ruskin to Ellas Concert, where vieux temps – Piatti & Klaus – played quite divinely – was very happy with Master – met Loo & others – had my purse stolen, or lost it'. The constantly enchanting Loo was part of Pauline's London social circle. Whether Pauline was fit or in pain, whether her purse was lost or stolen, did not matter in such company as that of Loo and Master.

Pauline found plenty to sympathise and agree with in Ruskin's attitudes to art, but where she disagreed – about his bullying and censoriousness, for example – she had the courage to stand up to him and tell him he was wrong:

> April 27 to Hunts for my last lesson – he was very amusing about his womankind who never wd stick to drawing [. . .]
>
> Went out to Denmark Hill to dine with old Mr Ruskin [. . .] & Mr and Mrs Pritchard, M.P. & Millais, it was heavenly. Millais told me himself he is only 24 in June. & about the mean way the Academy treated him. & Mr Windus buying all his things of a dealer – not one from himself. Mr Ruskin showed me a very nice letter from Lear, whom the acad have horribly ill used this year, a very good letter. talked to Master about being savage at people in his books. he vows he is not. that he ought to be ten times more so. that he wd like to say [Thomas] Creswick [RA, 1811–69] is a wretch who ought to sweep a crossing instead of painting & so on & he does not.*

Although she saw little of Ruskin between 1850 and 1853, Pauline

*Ruskin had offered muted praise for Creswick's realisation of the natural world in 'On the Truth of Vegetation' (*Modern Painters*, I, 1843): 'I am very far from calling Creswick's good tree-painting; it is false in colour and deficient in mass and freedom, and has many other defects, but it is the work of a man who has sought earnestly for truth: and who, with one thought or memory of nature in his heart, could look at the two landscapes, and receive Poussin's with ordinary patience?'[20]

never stopped reading his work and thinking about him. On 2 January 1851 she received from him her copy of *The King of the Golden River*: 'got the Golden River a fairy tale by my beloved Master – a most exquisite little book full of feeling, & beauty'. A few days later she sent her sister Moussy 'stamps 6s' so that she could buy her own copy of the book.[21] As far as painting and the fine arts were concerned, Ruskin expected (and got) obedience in his relationship with Pauline. This was typical of his relationships with women artists. He was often generous and encouraging to them as individuals, though he was inclined to dismiss women as a group, when it came to painting. He wrote to a young woman who had approached him for encouragement in 1858: 'Dear Miss Sinnett, I am quite delighted with your sketches [. . .] You must resolve to be quite a great paintress; the feminine termination does not exist, there never having been such a being as yet as a lady who could paint. Try and be the first.'[22] No such being as a lady who could paint: the same opinion in a different form was sent to Anna Blunden (1829–1915) in a letter of 1859: 'You will never be a great painter – but no woman has ever been a great painter yet – and I don't see why you should be vexed because you are not the first exception.'[23] This was his attitude to women artists in Pauline's lifetime. He encouraged Pauline herself, but often with demands that were actually a form of constraint. Notoriously, he bullied Lady Waterford (1818–91) of Ford Castle, a wealthy amateur artist who also lived in Northumberland. Here the bullying was subtle: ostensibly he urged her to show a proper ambition, but in practice he condemned her to a constant consciousness of failure because the standards he set were too high for her. He told her to emulate Titian, no less: 'make that your perpetual mark – and don't let anybody insult your power by telling you to stay content with what you can do now'.[24] And he declined, deliberately, to introduce these two women to each other. After Pauline's death, Lady Waterford wrote sadly to Ruskin regretting that she and Pauline had never met. They would certainly have liked each other and learnt from each other, and they would also, very probably, have joined forces in opposition to Ruskin's exacting tuition. If Ruskin himself suspected such an eventuality, that would have been sufficient reason for him to keep them apart.

It is a mark of the importance of Ruskin in Pauline's life that she postponed work on the central hall of Wallington (her great project) so that the Ruskins could visit in June 1853. Pauline had conceived the

transformation of Wallington as soon as she and Walter came into possession of it, but the work was delayed for several years for contingent reasons: Walter's mother regarded Wallington as her own home and it was difficult to start work on the house while she was still alive; and then, following her death in 1851, Pauline had periods of illness. The essential scheme was to enclose the inner courtyard (a dark, dank and weed-grown rectangle) and turn it into a big, well-lit and handsomely decorated space. It would be a salon for sophisticated entertainment and a space for the display of works of art and geological specimens.

Early in 1852 we find Pauline commissioning John Dobson, the celebrated Newcastle architect, who had designed many of the best streets in the city as well as a number of attractive country houses in the region. On Monday 12 January 1852 'Mr Dobson the Architect came with his Clerk to plan the covering in of this house with a flat roof.'[25] Dobson and his team haunted the house for two or three weeks. Dobson worked steadily on the commission through 1852 and the early months of 1853, so that by the time of the Ruskins' visit the scheme was complete. Pauline's diary does not record detailed discussion of the plans during this week though – her guests preferred to be out of doors as much as possible. On the day the Ruskins were expected, Pauline went to one of the picturesque corners of the Wallington estate, Rothley Mill, to prepare a sketch with which to impress Ruskin: 'settled what it wanted & mean to do it right'. Soon after her return from this sketching expedition her guests arrived. Ruskin was in poor health with a heavy cold, but the young members of the party were in high spirits. John Everett Millais declared that he 'had never seen a clear stream nor a wild country before & he was so happy it was very pleasant to see him. They were all very nice. Got a fine night [wind] blowing again this evening.'

The following day, 23 June, it was beautiful weather and Pauline was happy to be able to show Northumberland 'looking its best. Millais was in high glee with everything he saw. Water and distances and plants and the lilies in the ponds – took him to the Wildwoods.' The visitors were impressed by the house (as who could fail to be) and by its works of art: 'He [Millais] and Mr Ruskin were much struck with our Paolo & Francesca.'*

*This plaster group by Alexander Munro (1825–71) had been shown at the Great Exhibition of 1851. Munro had been fired with enthusiasm for Dante's story of these doomed lovers by his close friend Dante Gabriel Rossetti. Pauline became fond of Munro and often invited him to Wallington. She commissioned an oval medallion portrait of herself, which is set into a wall in the central hall at Wallington.

After dinner they drove out in a carriage to a high and beautiful part of the county, and the ladies rode ponies while the men (Ruskin and Millais) walked: 'the moors looked well & the burnie beautiful. Millais was in raptures. He said he never could have fancied anything so fine. The lapwings & curlews pleased him too.' The weather changed in the course of this walk; they were caught in rain and took refuge with the wife of one of Walter's tenant farmers. And unfortunately the first day and a half of beautiful weather were all that the visitors were to have; for the rest of the visit, the weather was wild and unwelcoming. Ruskin had clearly recovered from his cold, since he read Wordsworth in the evening (*The Excursion,* no doubt, because that is the text that he takes as his major source of quotations from Wordsworth in all five volumes of *Modern Painters*). Effie and Millais were in love with each other at this time, and were both nourishing a secret hatred of Ruskin: they must have loathed having to listen to him read.

Friday 24 June was 'a dull rainy day', and Ruskin visited Walter's museum. Walter took time and trouble to display the best items in his collection of minerals. Pauline went with them and enjoyed it, as she always enjoyed the company of intelligent men discussing things that interested them. Ruskin may have become impatient with Walter's exhibition (he liked to be the one pointing out beauties in the natural world), but today the teacher was among the pupils. Pauline was extremely fond of Effie by this time, and also sought out her company. They spent a good deal of time together in Pauline's sitting room.

Pauline's adored Loo and John Everett's brother, the good-natured William Millais, arrived to make up the party later in the day. Ruskin could never really get on with Loo, but was willing to give her drawing lessons. Pauline was wretched over the disappointing weather: 'It rained very much all day but in the eveng it cleared. Effie and I went to the garden. The gentlemen all walked up Whelpington valley. Mr R admired it much, but said it was not a good place for me to study in as the trees are scrubby & he thinks I am too fond of scrubby trees. – Effie looked lovely with some stephanotis in her hair (Swiss Rhododendron) – William Millais sang beautifully in the evening.' If Pauline was aware of the tensions in the party, she did not refer to them, though the evidence was right in front of her. Effie and Millais were forced into Ruskin's constant company, of course, and the strain began to show: 'Mr Ruskin read *The Tempest*. John Millais has a bad headache.'

On 25 June the weather was better, the Millais brothers 'went to Rothley and the moors to fish' and Pauline had Ruskin to herself and walked with him by the Wansbeck (which flows past Wallington): 'Mr R and I had a nice walk by the river and looked out some bits to sketch.' In the afternoon the whole party went to Shafto Crags, part of the Wallington estate: 'Effie and I stayed at the farm.' Effie was always the lady opting for quiet pastimes, while Loo was always the tomboy. Loo, Walter and Ruskin climbed the crags. On the way back to Wallington Loo's characteristic recklessness caused trouble. 'Coming home Loo who was driving whipped one of the horses and they tried to jump over the fence it was very dangerous – however no one was hurt except the horse.' That evening Effie was the one to show signs of strain: 'John Millais did me a delightful portrait of Mr Ruskin, very like and perfectly done – Effie was ill with a sick headache and staid in bed.'

Effie's indisposition continued on the Sunday, 26 June:

Effie ill and not down. All but the ladies to morning church and we all in the afternoon – afterward to the gardens & got caught in the rain – Millais gave me a beautiful drawing of Calverley. Mr Ruskin says ours is a very nice copy of Liber Studiorum [Turner's famous volume of studies, always commended by Ruskin as a teaching aid] as all the more important & rare ones are fine impressions – Millais works more rapidly than anyone I ever saw – for these sketches he uses no body colour but leaves all his high lights –

27 June A showery morning so the PRB s [Pre-Raphaelite Brethren] who were to have gone to the moors, gave it up W Millais afterwards did a pretty drawing on the river J Millais began a drawing of Effie which promises pretty well. My master began a very sweet study of a holly and hawthorn from my window for Mr Collingd* who had come to luncheon. In the afternoon Loo & Caly Mr Ruskin and I went to Capheaton.

At Capheaton Sir John Swinburne, the poet's grandfather, had a small but excellent collection of Turner drawings. Ruskin was '*delighted* with the Turners. especially the tree drawings in one of the Rhine views, and the view of Bonneville in Savoy. He was quite surprised to see such drawings, so well preserved & so well selected.'

*The Collingwoods, of Dissington Hall, a substantial house that stands a few miles outside Newcastle, were the Northumberland family made famous by Admiral Collingwood of the Napoleonic Wars.

28 June showery day but lovely morning The Millais did not go to
the Moors but Wm M went to the river to do another sketch there.
John M went on with his drawing of Effie & my master finished his
study of the hawthorn and holly & gave it to me. In the eveg it rained
& we had showers & gleams & rainbow again, & a very fine sky –
Millais did another sketch of Effie for me Very pretty to see how he
put in his tints so frankly & freely – at once, with – a little brush &
fine clear colours. he is very good natured about letting one look over
him. Loo & Caly took a ride in the evening.
 29 June the wind had increased to a heavy gale the leaves were
coming down in showers & my garden looked deplorably wretched.
The Ruskins & Millais' went away to Scotland – Loo & Caly went with
them in the dogcart for a few miles.

This visit to Wallington, although it had lasted just a week,
strengthened and enriched Ruskin's feeling for Pauline. He wrote to
his father from Jedburgh the day after the party had left Wallington:
'She and Sir Walter are two of the most perfect people I have ever
met with – and Sir Walter opens out as one knows him, every day
brightly. Lady T kept us laughing all day long.'[26]

The Ruskin party went on to Scotland. Ruskin had two purposes in
making this visit – to prepare the lectures on architecture and painting
that he was due to give in Edinburgh later in the year, and to have
his portrait painted by Millais. Ruskin, Effie and the Millais brothers
travelled by coach and train to Stirling and then stopped at
'Glenfinlas' (Glen Finglas as it is called today), Brig o' Turk, in the
Trossachs. They meant to stay only for one night, but in the event
lingered in this part of the Highlands for some two months. Ruskin
and Millais were captivated by the beauty of the place, and after
roaming the landscape for a day or two, they settled upon a beau-
tiful mountain stream in which a commission from John James
Ruskin (the writer's father) was to be carried out: namely, the painting
by John Millais of a portrait of Ruskin. This portrait was to be
faithful in every particular to the principles set out in Ruskin's
Modern Painters. The painting that Millais executed represents a
kind of intellectual loop. Millais, Holman Hunt and Rossetti had
been inspired by Ruskin's writings to establish the principles of the
Pre-Raphaelite Brotherhood: absolute fidelity to the object in front
of the eye, freedom from academic rules of composition, detailed
and painstaking representation of the natural world. Having in effect

shown the Brotherhood how to frame their doctrine, Ruskin, with the aid of his father's money, now wanted a painting that embodied the consummation of that doctrine.

On 3 July Millais wrote to William Holman Hunt about the project, namely 'to paint Ruskin's portrait by one of these rocky streams', but added, 'I feel quite done up.' He was not in a mood for work: 'Although this place is so beautiful and William is with me I feel very lonely and miserable; there is something depressing about these far stretching mountains, everything looks wild and melancholy and one cannot help feeling you are very far from your other friends.' What Ruskin actually wanted, as he wrote to his father, was a *pair* of portraits, 'me beside the stream, and Effie at Doune castle – two companion pictures'; the squire and his lady, the gentleman and his wife, both to be in the distinctive lunette shape that Ruskin and Millais agreed upon for the Ruskin portrait (the lunette was in fact based on the shape of a window at Doune Castle). Millais's plans for the painting were clearly less ambitious than Ruskin's at this stage. He continued to feel 'seedy', as he wrote to his friend Charles Allston Collins, and was thinking of the portrait as 'small' and simple and therefore manageable.[27] He had come to the Highlands for a rest and a holiday, not primarily to work.

At Glen Finglas, Ruskin, Effie and Millais stayed at first in a hotel and then in a small rented cottage (the hotel was very expensive). William Millais stayed on in the hotel, and on 25 July Henry Acland, who was visiting Edinburgh, came over to join the party for a few days and he too stayed in the hotel. The weather for the whole of July had been a matter of daily and relentless rain, so Millais was unable to make a start on his painting until 28 July, and he then managed only an inch or two of leaves. Further progress was made, but painfully slowly, during the month of August. The ostensible reason for the delay on the painting was the continuing wet weather, but there was another cause: Millais was in a state of depression and nervous anxiety because he and Effie were falling in love with each other, and the strain for the lovers of being trapped every day in Ruskin's company was almost too much for them to bear. (For Millais there was the additional strain that he was Ruskin's 'friend' and his guest.) Millais confided his pessimistic state of mind to Holman Hunt: 'Here I am at 24 years of age sick of everything, after having won the artistic battle and certain to realise a respectable compe- tence as long as I can use my eyes, and yet I don't believe there is a

more wretched being alive than the much envied J.E. Millais.'[28]

Ruskin must, surely, have noticed that Millais was behaving oddly, in at least one respect: Millais abruptly moved out of the cottage that he and the Ruskins were sharing and went to stay in the hotel with his brother for a few days, then equally abruptly moved back into the cottage. It was as though he could not bear to witness the Ruskin marriage at close quarters, but at the same time (and with equal force) could not bear to be apart from Effie, whatever the circumstances.

By October, Millais was in a near-hysterical state and incapable of work, and Ruskin was sincerely worried about him. He wrote to his mother that Millais was 'all excitement, sometimes depressed, sick and faint as a woman, always restless and unhappy. I think I never saw such a miserable person on the whole.' Obviously Millais could not talk about the deepest reason for his unhappiness – his passion for Effie – but his friend Holman Hunt was about to leave the country for the Holy Land and this was an additional and, so to speak, legitimate reason for Millais's listlessness and distress. 'God knows I will miss you,' Millais wrote to Holman Hunt on 20 October, 'but I suppose you are doing right in leaving this country, which is getting more and more gloomy.' He was full of self-pity: 'I am almost glad that I do not see you start as I believe I should groan myself into a fever.' Ruskin himself wrote to Hunt on the same day: 'Here is Everett [as he always called Millais] lying crying upon his bed like a child – or rather with that bitterness which is only in a man's grief – and I don't know what will become of him when you are gone.'[29] The painting, of course, was not progressing and after a few more days Millais declared that he could not go on. John James Ruskin was very annoyed to find that the cherished portrait was nowhere near completion, and it needed all Ruskin's tact and persuasiveness to calm his father down. The painting would be completed the following year. The party could not stay on in the Highlands. Ruskin had to go Edinburgh to give his lectures.

Meanwhile, back at Wallington, Pauline and Walter moved out of the main house so that the builders could move in and the long-delayed building of the central hall could take place. They moved just a few yards, to the Garden House. They processed down there 'patriarchally carrying our treasures – *Liber Studiorum* prints &c – hung them up and came back'. Ruskin and his teaching remained

very much in Pauline's mind during this month. On 16 July: 'went
to the River and drew in the subject wh Master advised me to paint',
and later the same day she was reading *The Stones of Venice*. The
effect of the builders' work on the main house was to make it look
like a Romantic ruin, and Pauline was obviously rather intrigued by
this unintended instance of the picturesque: (17 July 1853) 'to church
and walked back to Wallington which looks inside like a ruined
[Abbey] the court full of halfruined arches, & closed up doors like
a deserted cloister. the roses very beautiful.'[30]

Ruskin kept in touch from the Highlands, writing Pauline a number
of letters describing the pleasure of his visit to Glen Finglas (despite
the weather). Their favourite mutual quarrel inevitably reared its
head: 'I am heartily glad you like the second volume of Stones: I am
nearly sure you will be pleased with the third – which is more general
in its subjects.' (One of Ruskin's holiday tasks in Scotland was to
make the index to this volume.) 'Cardinal Wiseman will like it too
– as there is plenty of abuse of the reformation in it.'[31] Ruskin knew
that Pauline and Walter were friends of Wiseman, and enjoyed teasing
her about that.

The friends met again in November, when Pauline went to Ruskin's
lectures in Edinburgh, which later became his *Lectures on
Architecture and Painting*. She visited galleries and resumed contact
with her circle of Edinburgh friends, especially Robert Chambers.
Fine art was clearly in a commanding position among her interests
now, although she never abandoned geology, and Ruskin, of course,
was to have a steady developing interest in geology. She was feeling
unwell some of the time during this stay, but did not allow that to
interrupt her social and intellectual round:

> My master had been today. Loo came in, & went with us to the lecture:
> had a great fuss about a ticket, which made us rather late. – got pretty
> good seats, the lecture was very excellent, on divisions of architecture,
> and the superiority of the Gothic to the Greek in strength of construc-
> tion, in meaning, in beauty & in ornament There were large drawings
> of beautiful things – bits of gothic & a bunch of oak leaves & a deli-
> cious *Greek* leaf – the place was crowded to excess.

On 2 November there was another dinner party with the Ruskins,
and further evidence (which Pauline again noted without comment)
that something was amiss with Millais when Ruskin was around:

November 2 1853 Mr Ruskin called early and was delightful as usual
– we went out walking & paid some visits – then we dined at the Ruskins
[. . .] Master was delightful. Millais was ill with a headache.

There was yet another dinner party on 3 November at the home
of Walter's friend George Combe, the phrenologist: 'dined Combes
– met Robt Chambers – Coxes – &c a pleasant party but not bril-
liant'. Pauline had done loyal service to the Combe family. George's
brother Andrew had died in 1847, and George wrote a dutiful biog-
raphy of him. Under some pressure from Walter and from her friend
the physician John Brown, Pauline had agreed to write a review of
this work and Robert Chambers had published it.* It was a pleasure,
then, to catch up with these friends, but that company paled in
comparison with the glamour of being with Ruskin in the glory of
his triumphant first lecture. Not all of the lectures were triumphs.
Ruskin was ill after the second one and the remaining two had to be
postponed from 8 and 11 November to 15 and 18 November. Pauline
greatly enjoyed the first of these two lectures, but afterwards she and
Ruskin had a sharp disagreement about Christianity (presumably her
Puseyism was again the issue). 'She got very angry,' said Ruskin, 'and
declared that when she read me, and heard me, at a distance, she
thought me so wise that anybody might make an idol of me, and
worship me to any extent, but when she got to talk to me, I turned
out only a *rag doll* after all.'[33]

On 6 and 7 November Pauline was ill in the Edinburgh lodgings
that Walter had taken and was 'on the sofa part of the day', while
Effie and Ruskin were indisposed as well: (8 November) 'Effie sent
word she was ill, but wd come to see me if she could. Master so ill
he could not lecture having caught cold after the last one.' The
following day Pauline was well enough to go calling: (9 November)
'went late to see Master. his voice very bad still He lent me his 3d
vol [of *Stones of Venice*] & settled about the balcony we are to have
at Wallington – Found he had been intending me to have his books

*George Combe, *The Life and Correspondence of Andrew Combe, M.D.* (1850). Pauline's review
is included in her *Remains*. A stoic herself, she had been impressed by the resolution displayed
by Andrew Combe as death closed in on him:

> The winters of 1845 and 1846–7 he spent in Scotland; his strength was rapidly declining,
> and he underwent severe shocks of illness, but he still devoted the intervals of partial improve-
> ment, to the consideration of important subjects, and the occasional writing of short articles,
> and long letters, on education, on the management of the insane, and on medical subjects.[32]

as gifts & I never got them.' She had been writing to Ruskin about Dobson's designs. He did not much like them – too Palladian for his taste – and recommended that an early Venetian Gothic/Byzantine balustrade from the cathedral on Murano should be imitated for the first-floor balustrade in the hall, in order to balance the classical arches above and below. Ruskin's sketch of the Murano balustrade in *Stones of Venice,* volume 3, was used as the basis of the design.

Ruskin had lost his voice, which had led to the lecture scheduled for 8 November being deferred. For Pauline the delay simply meant a prolongation of this delightful visit, and of the Master's irresistible company:

> November 11 1853 Loo came to breakfast with us Mrs J Mackey came to say goodbye before going to Durham she was very pleasant. A great many people called & kept us till late. C & I went to see the Etty's & other pictures in the Academy. They are well hung now & look well. the Ettys splendid. paid a lot of visits [. . .]

William Etty's paintings of partially clothed women were considered queasy and indecent by many commentators of the day, but Pauline was unshockable, as usual.

> Friday 18th November 1853 [. . .] Tea at Master's – & then to lecture, went a whole hour before hand & sat there – had much interesting talk while we waited with Sheriff Jameson. who is really delightful.[. . .] Master's lecture was glorious. his contrast of the 12th & the 19th centys splendid. & comparison of Nelson & St Louis and all he said about the PreRaphaelites perfect.[34]

The last of these Edinburgh lectures, with its powerful advocacy for the Pre-Raphaelites, showed Ruskin recovering his form. Not all his audience liked his style as much as Pauline did. His elocution annoyed a journalist reporting the lecture for the *Edinburgh Guardian*: he could not pronounce the letter 'r' clearly, and tended to chant or intone his lectures. 'His dress and his manner of speaking [. . .] are eminently clerical,' this writer complained.[35]

These were important lectures. In them Ruskin set out to alter the taste of a generation and to achieve a revolution by ensuring that, by contrast with the old gentry, who had liked to collect Renaissance or classical art on their Grand Tours of Europe, the new middle class would buy *modern* painting and would also insist on modern (which

for Ruskin in the 1850s meant neo-Gothic) architecture. He urged the citizens of Edinburgh to tear down their elegant classical New Town and rebuild it in the Gothic style: 'Introduce your Gothic line by line and stone by stone; never mind mixing it with your present architecture; your existing houses will be none the worse for having little bits of better work fitted to them.'[36]*

The lectures were designed both to provoke and to entertain, with striking visual aids introduced at key moments to illustrate the contrast between the Gothic and the Greek realisation of an ash branch, and the naturalistic delineation of the head of a lion (in a beautiful drawing that he had commissioned from Millais) compared with the stylised and lumpen 'Grecian sublimity of the *ideal* beast, from the cornice of your schools of design'.† Underlying the lectures, and probably contributing to Ruskin's problem with his throat, was the tension within the Ruskin marriage. The fourth of the lectures, 'Pre-Raphaelitism', heaped praise upon Millais, who by this time was Effie's secret 'swain' and had come to regard Ruskin with contempt and loathing. In the lecture Ruskin takes on hostile critics who had claimed that the Brotherhood's work was 'out of drawing' by reminding them that since his admission to the Royal Academy schools as a ten-year-old prodigy, Millais had 'literally encumbered himself with the medals given as prizes for drawing'.[37] Ruskin was perhaps, as his enemies later claimed, trying to rid himself of Effie by bringing her into inflammatory proximity to Millais; praising Millais as an immortal genius, second only to Turner, may have been part of the plot. Effie was certainly miserable. It is sad to see that throughout this visit to Edinburgh Pauline remained oblivious to this situation, and that her fondness for Effie was steadily increasing.

The end of the Ruskin marriage came in April 1854. Effie arranged to return her keys and wedding ring to Ruskin, and took a train to her parents' house in Scotland. The relationship with Millais was still secret, but the relief to the lovers now that Effie had successfully made the break with Ruskin was obvious to all their friends. The loss of Effie as a friend was a wrench that made Pauline ill. At first

*The lectures managed to display the Gothic as being compatible with the practices of the Pre-Raphaelites. To read the four Edinburgh lectures together is to see that, for Ruskin, the 'Gothic' in architecture and the 'Pre-Raphaelite' in painting both seek to define the modern by rediscovering and restating the innocence, strength and virtue of two kinds of medieval art.
†Ruskin was always an enemy of Henry Cole's national Schools of Design.

she took Ruskin's part entirely. On 28 April 1854 she received a letter from Effie:

> telling me she had left Herne Hill forever. intends to annul her marriage on the score of its never having been consummated, & abusing her husband horribly, calling him all manner of names. Indeed she abused him so furiously that she defeats her own object, for no one could believe it. The treachery with which she acted plotting all this for a month and behaving to him just as always bidding him goodbye as if all was right, when she knew he would next day receive a summons to answer to her accusations seems to me utterly dreadful. & incredible. how she can have been so far perverted. this letter made me very ill, & of course I could not sleep.[38]

It is interesting that at the moment when she wrote this, Pauline recorded the central fact about the annulment – 'the score of its never having been consummated' – without comment, but was nevertheless absolutely clear that Effie's actions were completely wrong. However, on 23 May she did allow herself to blame Ruskin a bit: 'got Master's letter explaining his affairs. there was little in it but what I knew before. He seems to have had a miserable time of it for a long while, indeed he had no real need of a wife, he only married for amusement. he wd have been far happier with his father & mother & ought not to have married at all, I think.'

The Pre-Raphaelite Brotherhood and William Bell Scott

A certain fire and poetic feeling, which attracts and interests us

The key figure in any discussion of the Pre-Raphaelite Brotherhood is Dante Gabriel Rossetti, the painter, poet and visionary. Born in London in 1828, the son of Gabriele Rossetti (political activist and Dante scholar), Dante Gabriel was the centre of the Rossetti galaxy (among his siblings were the poet Christina and the critic William Michael). His father had been deeply involved in Italian resistance to Austrian domination, and it was for this reason that he had to leave Italy and settle in London. From 1830 until his retirement through ill health in 1847, Gabriele was Professor of Italian at the newly created King's College, but this brought in very little money and for years the family was kept afloat financially by the selflessness of William Michael Rossetti, who had a boring but secure career in the Revenue Office. Until he began to earn as a painter in the mid-1850s, Dante Gabriel was ruthlessly willing to live at his brother's expense. Unlike their father, he took very little interest in politics, although among his earliest poems are one or two that applaud his father's cause of resistance to the Austrians.

Rossetti was trained in drawing from 1841 and entered the Royal Academy Schools in 1845. He was to be one of its least diligent and orthodox pupils. Its methods – especially the eighteenth-century training of 'drawing from the antique' – repelled him, and in 1847 he sought private tuition from a slightly older but very similar artist, Ford Madox Brown. Rossetti wrote a fulsome letter to Brown: 'Since the first time I ever went to an exhibition (which was several years ago, and when I saw a picture of yours from Byron's *Giaour*) I have always listened with avidity if your name happened to be mentioned'; and he asked for Brown's 'invaluable assistance as a teacher'. Brown took this letter as an insolent student's mockery and went round to the Rossetti house armed with a stick in order to teach the young man some manners, but Rossetti's ardent and genuine admiration

showed Brown that he was mistaken, and he took on Rossetti as his first pupil.[1] The friendship was lifelong; while other young men were competing aggressively with each other for fame, Rossetti was generous within his masculine circle, and one of his most attractive features was his lasting loyalty to the friends of his young manhood.

Although only twenty-seven himself when they met, Ford Madox Brown was a far more learned and scholarly artist than Rossetti. Under his influence, Rossetti immersed himself in medieval and early Renaissance European painting, and at the same time his literary tastes were formed: recent and contemporary poets, especially Browning, Shelley, Coleridge and Blake. (In 1847 he had the extraordinary good fortune to buy, from a member of the British Museum staff, one of Blake's notebooks for ten shillings, which he borrowed from his brother William Michael.) Rossetti's formal training (and professional identity) was that of a painter, but from young manhood he was also writing poetry. His contemporaries saw him as an inspirational and visionary poet, like the Romantics whose work he read so eagerly. Holman Hunt observed him writing. Once Rossetti was 'engaged in the effort to chase his errant thoughts into an orderly road, and the spectral fancies had all to be kept in his mind's eye, his tongue was hushed'. He was a man possessed: 'he rocked himself to and fro, and at times he moaned lowly, or hummed for a brief minute, as though telling off some idea'. Not a sociable visionary, clearly: 'he would often get up and walk out of the room without saying a word'.[2]

The year of 1848 was one of revolution in the whole of Europe: the French expelled their monarch (who fled to England), Venice declared itself a republic and other Italian city-states rose against Austria (just as Rossetti's father had hoped). In Britain the year was marked by the culmination of a period of deep political unrest characterised by extreme rural poverty and serious organised political action on the part of the industrial working class. Rossetti, now twenty years old, was stirred by a painting exhibited in the Academy and executed by a man who had until recently been a fellow student, William Holman Hunt. The painting was from Keats's 'The Eve of St Agnes'. With characteristic impetuosity and an extravagant flow of flattering praise, Rossetti made contact with Holman Hunt. The two young men took to each other immediately. Ford Madox Brown was off to witness the artistic life of revolutionary Paris at first hand for a few months, and Rossetti transferred his hero-worship and

appetite for discipleship into a desire to become Hunt's pupil, which was scarcely practicable, given that they were both penniless students. But with this, another lifelong friendship was established, and Holman Hunt's closest intimate and ally among the Royal Academy students, John Everett Millais, became Rossetti's friend as well.[3] Keats was a passionately shared enthusiasm. The young men joined a circle of students who encouraged each other in sketching and drawing. An early Rossetti drawing of Keats's 'La Belle Dame sans Merci' (March 1848) attracted admiring comments from this group: Holman Hunt thought it beautifully designed, while Millais recommended that it should be worked up into a painting.

The three young men responded to the revolutionary fervour of the time by deciding to overthrow the established order in the regimented and authoritarian world of the Royal Academy Schools. Copying from earlier painting or from classical sculpture was fundamental to the Academy training, and the process was intolerably slow – it took some six years. The fifteen *Discourses* of Sir Joshua Reynolds, delivered as lectures to Academy students between 1769 and 1790, were the first attempts in English to establish a philosophy of art and of art teaching. They remained the text that underlay art teaching among the older generation in the 1840s.[4] The examples of great art urged on his students by Sir Joshua varied (the *Discourses* were delivered over twenty-one years), but *Discourse V*, which upholds Raphael, Michelangelo, Salvator Rosa and Poussin, may be taken as identifying a body of great art in the grand style to which Sir Joshua would remain faithful. (Raphael is upheld as the supreme genius here and elsewhere in the lectures, but in a much later lecture, *Discourse XV*, Michelangelo has pride of place.) It was probably because of the insistence of so many of the *Discourses* on the supremacy of Raphael that the Pre-Raphaelite Brotherhood chose their *nom de guerre*, as Ruskin styled it.

Ruskin's *Modern Painters* (1843–60) provided the Victorians with a body of art criticism that effectively challenged, disposed of and replaced the *Discourses*. Hence the eagerness with which the Pre-Raphaelite Brotherhood embraced Ruskin's teaching. The Brotherhood seems to have come into being towards the end of this momentous year of 1848. The composition of the group was based on friendship rather than genius, although there were men of genius aboard. Rossetti, Millais and Holman Hunt formed the nucleus. Millais had been recognised as a prodigy at the Royal Academy

Schools at the age of eleven, and was a much more orthodox figure than Rossetti, being magnificent to look at, with a breezy upper-class style that contributed to the steady rise of his reputation and fortunes. Holman Hunt came from a humbler background and was a dogged and ambitious worker. He embodied another kind of English ideal, that of the self-made man. To join the three central figures Rossetti recruited a sculptor, Thomas Woolner; another painter, James Collinson; an aspiring painter, Frederick George Stephens, later primarily an art critic; and his brother William Michael Rossetti, who was not an artist at all, but was to be a patient and loyal chronicler of the group. Ford Madox Brown, the painter with whom Rossetti had studied and a man from whose methods the Brotherhood had learnt a great deal, was not invited to join. Holman Hunt thought Brown too old, and Dante Gabriel Rossetti was probably relieved not to have his former teacher in on the conspiracy (if only because part of the point of the Brotherhood was to defy the authority of all teachers).

The poet Christina Rossetti was effectively an additional member of the Brotherhood, both because she was very close to her brothers and because of her odd, unhappy relationship with the painter James Collinson. A shy, dumpy figure, Collinson was a Roman Catholic. He proposed marriage to Christina, but she turned him down because, as a devout Protestant, she could not consider a man of his faith. He then converted to the Anglican Church, proposed again and Christina accepted him. It is not at all clear that she felt any passion for him, but she certainly wanted independence from her family and was extremely anxious to avoid the fate of educated young women with no money in the period – that of becoming a governess. Collinson wavered and procrastinated, then converted back to the Roman Church, and Christina's hope of independence was dashed – the engagement was broken off.

The shared enthusiasm for Keats that had brought the young men together was further inflamed, in the summer of 1848, when Richard Monckton Milnes (literary aristocrat and friend of Tennyson) created a sensation with his *Life, Letters and Literary Remains of John Keats*, and the painters began eagerly seeking out subjects from this newly rediscovered poet.[5] In response to the stimulus of this book, and to follow his *Eve of St Agnes*, Holman Hunt embarked on his ambitious canvas of *Isabella and the Pot of Basil*.

The Brotherhood had it first recorded meeting on 31 December

1848. In its original state it lasted from 1848 to 1854. The first painting signed with the mysterious initials, 'PRB' – Dante Gabriel Rossetti's *The Girlhood of Mary Virgin* – was exhibited at the Free Exhibition in 1849. To exhibit here was an astute move: paintings exhibited in this way attracted attention and reviews, and did not run the risk of rejection by what Rossetti regarded as an inherently hostile institution, the Royal Academy (Holman Hunt and Millais exhibited their first PRB paintings at the Academy). Rossetti's *Girlhood* painting was sold for a good price to the Anglo-Catholic patron Lady Bath, to hang at Longleat. In this same year Rossetti sent his poems to William Bell Scott, and from that point onwards the two men developed a strong and lasting friendship; had they met earlier, Bell Scott would certainly have been a member of the original Brotherhood. To extend their knowledge of painting, he and Holman Hunt made an extended visit to Paris and Brussels in 1849. In Brussels in particular, paintings by Van Eyck and Memling fed Rossetti's imagination and stimulated him to paint *Ecce Ancilla Domini!* ('The Annunciation', first exhibited in 1850). The young artists also produced a periodical, *The Germ*, which ran for just four issues in 1850 (William Bell Scott published several rather good poems in it, at Rossetti's invitation). Meanwhile, in 1850 Rossetti met for the first time the beautiful and gifted painter and model Elizabeth Siddal; a more or less serious affair commenced, and Lizzie Siddal in due course became his wife.

The Brotherhood, though, unravelled: in 1850 James Collinson wrote to Rossetti to say that, as a sincere Catholic, he could no longer adhere to the tenets of the Brotherhood (because Catholics were forbidden to join secret societies); then Woolner went to Australia in 1852 and Holman Hunt travelled to the Holy Land in 1853 for his religious paintings. In the same year John Everett Millais defected by becoming an Associate of the Royal Academy (the whole point of the Brotherhood, as a bunch of rebels, had been their entrenched opposition to the Academy). For Rossetti the Brotherhood had represented King Arthur's Knights, and now they were going their separate ways: he quoted Tennyson's 'Morte d'Arthur', 'So now the whole Round Table is dissolved' (in a letter to his sister Christina on 8 November 1853).[6] Later Rossetti was to create a second brotherhood, less formal but just as potent, through his friendships from 1856 with two younger men, William Morris and Edward Burne-Jones. In 1857

this trio became the nucleus of a second group, the artists who under-
took the celebrated Oxford Union murals: Rossetti, Burne-Jones,
Morris, John Hungerford Pollen, Arthur Hughes, Valentine Prinsep
and John Roddam Spencer-Stanhope. To these names should be added
the sculptor Alexander Munro, who made a stone tympanum relief,
after a design by Rossetti, for the entrance to the Oxford Union
building.

'We few, we happy few, we band of brothers': this triumphal
summons to heroic and chivalrous young manhood, from
Shakespeare's *Henry the Fifth* (a play that was immensely popular
at this date), together with Sir Walter Scott's revival of Malory's
stories of King Arthur and his Knights of the Round Table, coloured
the meaning of 'Brotherhood' both for these young men and for the
Victorian public at large; and since Tennyson had taken up the
Arthurian stories in his early poems (including 'The Lady of Shalott',
'Morte d'Arthur' and 'Sir Galahad'), an ideal of 'brotherhood' based
on Malory had re-entered the culture with a renewed vitality. Prince
Albert, as Chairman of the Royal Commission of the Fine Arts, had
asked William Dyce for a decorative scheme based on the Knights of
the Round Table for the Queen's Robing Room in the new Houses
of Parliament; Dyce had been working on the scheme since 1849. His
design displayed manly virtues and Christian selflessness among
Arthur's knights. The Oxford Union took a more romantic and
sensuous view of the story of King Arthur (Guinevere had more of
a role than she had in the Dyce paintings), but the male relationships
and the key concept of 'brotherhood' were still conspicuously present
in the Oxford decorations.[7] And brotherhood was part of the point
for this lively group of young artists: Morris and Rossetti and their
friends all had immense fun while they carried out the murals.*

Pauline Trevelyan met Rossetti through Bell Scott in the mid-1850s,
and the Oxford Union scheme was developing concurrently with the
Oxford Museum, so it was natural that she should take a lively
interest in the young painters' doings. She recorded in her diary the

*Pauline Trevelyan and Rossetti both wanted William Bell Scott to contribute to the Oxford
Union, and had he done so, the links between that masterpiece of Victorian Gothic and the
Wallington scheme would have been much closer than they are. But he declined in a letter to
her of 2 July 1857: 'The whole thing to an accomplished artist of any school in the world must
have the aspect of an enormous lark. Rossetti wanted me to undertake one yesterday – he is
shortly going down to start, but I really could not stand it, and declined to come within their
magic circle.'

progress of the painting in the Oxford Union and of the building of the Museum – both projects were encountering difficulties:

> The Union is going on slowly. two or three of them are here – Mr Stanhope – Jones – Morris – Hughes, &c. They are seeing now them-selves that the tremendously dark strong colours in the roof injure the pictures, especially Rosetti's & other delicate ones – & I am sorry to say that they are also finding that the work won't last. much of it even now gets scaling off – & the rough surface catches dust in lines. & makes seams on ladies faces &c. it is looking very beautiful now, for the room is further finished & some of the Scaffolding is away. The members of the 'Union' society have been paying the bills. and looked rather blue at paying above £300 for a *gratis* work – and having it constantly thrown in their teeth that it was gratis & a handsome present to the Society – the new Museum is nearly at a stand still. the work men taking Xmas holiday but they talk of getting to work again on Monday.

Despite her misgivings, she was struck by the visionary nature of the Oxford Union scheme and wrote Bell Scott a detailed letter describing it and urging him to visit them:

> [12 November 1857] about the Union frescoes – as soon as I got well of my cold – I went there every day. for it was most delicious to see them going on – they will be very fine and striking *I hope they last* – they are very high up – at the top of a lofty room – first there is a pretty high range of bookcases. then a gallery on a level with the upstairs rooms. above that another range of book cases – then the frescoes & then the high pitched roof. which Mr Morris painting in *dark* colours & with that sort of northern grotesque of twining serpents etc – very ugly – unnecessarily ugly I think – but some of the frescoes are most noble things – In one corner Launcelot is sitting fast asleep – and the Queen & her apply tree occupy the middle of the picture, in the other corner the Holy maiden of the Grael is kneeling. & there are a circle of the most lovely angels heads round her. I don't think anyone ever invented more divine ones & angels below pulling the bell (as in the Tennyson [the finding of the Grail in Tennyson's 'Sir Galahad']) [. . .] Hughes has painted Arthur conveyed away in the boat, over the moon-light lake & Sir Bevedere throwing Excaliber back into the water [from Tennyson's 'Morte d'Arthur'] – I like it very much. but Mr Ruskin does not;* he thinks it is not decorative enough and that a moonlight & an

*Ruskin was bound to prefer Rossetti to Hughes. Ruskin loved and admired Rossetti extrava-gantly at this date (his ardour was too cool later) and he declared Rossetti's Arthurian Oxford fresco 'the finest piece of colour in the world'.

effect of light was not suitable. Which perhaps is true. but it seems needful to complete the story, & the quiet of it seems to me pleasant & resposeful among all the blue skies, redhaired ladies and sunflowers [. . .] but you really must run down & see it. for it is so fresh and unlike other things, and so characteristic, and so queer – that it excites and delights one immensely.

It was in the summer of 1857 that William Morris and Dante Gabriel Rossetti encountered a beautiful young woman, the daughter of an ostler (as tradition has it), called Jane Burden. She was to become both Morris's wife and (many years later) Rossetti's mistress and a major inspiration for his work in both poetry and painting during the 1870s.

Dante Gabriel Rossetti dubbed Bell Scott 'Scotus' after Duns Scotus, the medieval theologian and philosopher who was actually Scottish but whom the Trevelyans liked to claim as a 'Northumbrian'. He is among the famous men of Northumbria depicted by Bell Scott on the lower spandrels, at Wallington. The sobriquet became Pauline's favourite nickname for him. Dante Gabriel stayed with Bell Scott in Newcastle in 1853 (having come to the North partly for his health and partly to paint) and the two men travelled out to Hexham, 'that charming, old-fashioned, ancient place', where they both painted. Rossetti was seeking a setting for his painting of a rustic lover finding his former mistress, who has been working as a prostitute in London (the subject developed into his famous unfinished painting, *Found*)[8] and Bell Scott painted an excellent watercolour called *Hexham Market-Place*, showing the innkeeper's daughter sitting in the window of the inn in which he and Rossetti stayed. Prostitutes were the last word in daring as topics for art in Bohemian circles during the 1850s, and the subject of *Found* was suggested to Rossetti by Bell Scott's poem on the theme, 'Rosabell', which was published in his *Poems of a Painter*. The model, Fanny Cornforth, was Rossetti's mistress at this date, and this large, simple, beautiful woman was to be the sensuous focus of some of his most celebrated images of women in the late 1850s and early 1860s: *Bocca Baciata* ('The Kissed Mouth') is perhaps the most flagrantly enticing of these erotic paintings.

Well before she met William Bell Scott, Pauline had reviewed his biography of his brother, David Scott. This book brought out all her sympathy and intelligence.[9]

We see a mind perpetually at war with the world and with itself – weary, self-torture, finding no resting-place, catching occasionally, as it seems, a glimpse of some more safe and quiet path, but never finding the entrance to it, and sinking, at last, exhausted by the burden of existence, at an age when others are only reaching the middle of their career. From the first page of his life to the last, it is little else than a scroll 'written within and without, with lamentation, and mourning, and woe'.

She was very good on David Scott's self-centredness. In due course she would identify exactly the same quality in Bell Scott himself:

There was in his mind a gigantic overshadowing image of himself, round which everything was grouped; by its relations to which everything was judged, and generally found wanting; and to which everything must yield. There does not seem [. . .] an attempt to put himself fairly in the place of any other, or of the public, and to look from any other than his own peculiar point of view, on whatever question was before him. [. . .] How many a genius as brilliant as his own has calmly and cheerfully accepted far more adverse circumstances, has worked on towards its own great ends without one murmur against destiny, and drawn nourishment and strength from the hardest trials that beset its way! But with poor David Scott, it was far otherwise: his constitutional melancholy only grew darker as the years went on – past trials, instead of furnishing strength and hope for future warfare, were a source of bitterness to be morbidly dwelt on through life; and instead of moulding circumstances as they arose, and making them minister to the wants of his genius, he met them in a spirit that made all things antagonistic.[10]

She summed up with compassionate but unsparing clarity: 'The insatiable *me* sees nothing but obstacles in the *not me*.'[11]

Pauline had also reviewed William Bell Scott himself. She had published brief comments on a couple of his paintings in the review of the 1852 Edinburgh exhibition that she wrote for *The Scotsman*. She saw in these works 'a certain fire and poetic feeling, which attracts and interests us, in spite of the mistaken system on which they are painted. The want of models and close study is glaringly apparent.'[12] Bell Scott took this to heart: when he later received commissions from the Trevelyans, he painted faithfully from nature and used live models for every figure.

But it was through his poems that he became a personal friend of Pauline. He was immensely serious in his pursuit of excellence in art; in 1854 he had travelled to Nuremberg in order to study Albrecht

Dürer's methods in his own city, and later in the same year he published his *Poems by a Painter*. He sent a copy of this and his *Prince Legion* (1851; twelve plates illustrating the life of a conventionally ambitious man) to the Trevelyans by way of introducing himself. He also sent *Poems by a Painter* to Thomas Carlyle, whom he had met in the early 1850s at his home in London's Cheyne Walk (the two men were introduced by Thomas Woolner). Carlyle did not recognise the name of the author and wrote back in some irritation advising Bell Scott to stick to *printing* – he had misread the title as 'Poems by a Printer'.[13] Pauline, by contrast, paid careful attention, especially, it seems, to the book of plates:

> I took it out upon the moors one glorious day & read it among the plovers and heather, & I have read it again at home. I thought some of Prince Legion very grand, so do most people. – I'm very sorry for him, he never got fair play – he never had any choice but between unsanctified knowledge & unholy gain.[14]

In July 1855 Pauline invited Bell Scott to Wallington, and in his autobiography he described his first sight of her:

> About midday, as I approached the house, the door was opened, and there stepped out a little woman as light as a feather and as quick as a kitten, habited for gardening in a broad straw hat and gauntlet gloves, with a basket on her arm, visibly the mistress of the place. The face was one that would be charming to some and distasteful to others, and might in the same way be called rather plain or rather handsome, as the observer was sympathetic or otherwise. In a very few minutes the verdict would be understood and confirmed by the lady, whose penetration made her a little feared.[15]

On Monday 2 July 1855 Pauline recorded in her diary:

> I met Mr Scott at the door. Came to stay. He is David Scotts brother and biographer & head of the Newcastle school of design. a good artist & poet. I sat with him till luncheon. [. . .] he talked a great deal of very interesting things about the schools of design. He has met with a good many men of talent there, but no one of decided genius. he thinks it is doing good. but in the way of general improvement in taste, not of training designers for the manufactory. He says he never recommends young men to design for manufacturers for they are so ill paid & it is an uncertain thing.[16]

She found Bell Scott an attractive, intelligent and impressive figure, with his knowledge of art and his genuinely wide circle of friends in the Edinburgh and London literary and artistic worlds. He was distantly related (he believed) to Sir Walter Scott and had known members of Keats's circle, including Leigh Hunt and the painter Benjamin Haydon: of the latter he 'gave a curious painful account [. . .] of his love of display & overweening opinion of himself'. On this first visit Bell Scott and Pauline travelled round picturesque parts of the countryside near Wallington and made sketches together. A 'gibbet' provided, it seems, a particularly striking spot: (6 July 1855) 'we drove in the evening to Harwood moor – Mr Wooster & Caly [Walter] went to look for plants & Mr Scott & I sat at the foot of the gibbet & talked. He told me about various strange Germans & Orientals who lived at Newcastle & of the odd people one met with there in obscure places.' Bell Scott also talked to Pauline about his own career and ambitions:

> speaking of his great love of painting which he can only follow out in a bye way – as a pleasure – the school of design taking all his time up. He said he often felt inclined to throw up the school and follow only his painting, but when he went to London among his brother artists & Exhibitions, and saw all the jealousy & strife & struggle & misery of it he thanks God that he had a livelihood, and could keep his art as a joy & a blessing pure & clear from all such considerations. He feels the want of companions in Newcastle. So few there care about art or study it at all.

On the Saturday he made a 'sweet little sketch in my tiny book', and declined Pauline's offer to buy one of his completed 'pretty oil sketches', for fear of Ruskin's opinion. 'He said I must have something better even if I like it, he did not like the idea of Master & other seeing those things as specimens of what he could do.' Inspired by him, Pauline painted a lilac, while Bell Scott 'mixed some tint to colour our China cases dark inside light outside'.

He talked to her about his pupils, about the working-class men in Newcastle and about their problems. On 8 July Pauline recorded that he said, 'the skilful workmen in Newcastle complain sadly of the inferiority of the wives they are obliged to marry. The men all belong to Mechanics Institutes, or join clubs for reading, & get some cultivation of mind. But they don't want to marry sickly needlewomen so they are forced to take servants [. . .] who are utterly ignorant & mentally painfully inferior to their husbands.'

She determined to make Bell Scott and Ruskin friends with each other. It proved an uphill task. Bell Scott visited Ruskin in London, and Pauline wrote to him following this first meeting: 'tell me how you enjoyed your travels? and how you are now? and how you liked Mr Ruskin? & his Turners? he wrote us how much he liked you – so I hope it was mutual.' Bell Scott replied that Ruskin was:

> not a person to be quickly understood or lightly characterised, and I cannot help fearing that I have not attractions, – or at all events our first interview did not give me opportunity for coming near enough to him, – to bring out his nature in a spontaneous and confiding manner. You say indeed that he liked me, but I fancy I must have appeared too positive and too energetic and extra ecclesiam to leave a pleasant impression. He is himself a man of so fine an organisation, so subtle a taste, that one fears to wound him or shock him when one is only hearty and free.

Bell Scott was not at all a 'hearty' man by nature, but he had perhaps allowed himself to talk in the kind of rough masculine style that worked well with Rossetti and his other London friends, and which would certainly not commend itself to Ruskin. He asked whether Ruskin may be 'cruelly cold, indifferent and oblivious to all things but what his taste selects'? And reflected that Ruskin valued pictures for their 'negative' qualities, which is why he admired Turner: 'the vague becomes informed and nothing-at-all becomes infinite profusion under his clear cold eye'.

Ruskin's enthusiasm for Dante Gabriel Rossetti did not help. Bell Scott regarded Rossetti as his oldest friend and was distressed to find that Rossetti was in effect deserting him for Ruskin; the fact was that Ruskin could use his money to have Rossetti do his bidding. Then there was the matter of Bell Scott's poems: Pauline had suggested that he send them to Ruskin, which he did, 'and D.G.R. asked him [Ruskin] what he thought of the book; he pretended to be surprised it was mine'. There were Ruskin's teaching methods of finicky instruction to gifted amateurs, such as Louisa Stewart Mackenzie, whom Ruskin set to make minute copies of leaves. Bell Scott exploded: 'I could not remain silent, so I gave them a little lecture on the orthodox method of teaching and the proper objects to be used as models.' He saw it as a waste of effort: 'spending so much time niggling over a small flat object with a pen was teaching nothing'. He challenged Ruskin to defend his methods: 'I appealed to him to tell us if he had ever found any young man apply what he had thus learned to any

purpose?'[17] Ruskin's teaching methods at the Working Men's College in London's Red Lion Square were equally pointless (the copying of lichens and rough sticks): 'What astonished me was Rossetti's abetting of such frightful waste of time.' And at a dinner party in London, Ruskin innocently disparaged Bell Scott's brother, David Scott. By way of retaliation, Bell Scott imitated Turner's cockney accent and vulgar turns of phrase: 'The poisonous expression of his [Ruskin's] face was a study.'[18] Ruskin was penitent over the David Scott faux pas: (July 1855) 'I like Scott very much – but he is languid, and not to be got out – in a single chat. You never told me that he was David Scott's brother – I came out with something – (luckily not so bad as it might have been) – about David Scott in the middle of Dinner – and was very sorry.'[19]

Pauline showed no sign of resenting Bell Scott's attitude to Ruskin; perhaps she secretly enjoyed the fact that the two men were competing for her favour.

Pauline's health was such that she and Walter spent much of the winter of 1855–6 in Oxford, where she could be looked after by Henry Acland. The current of cultural life in Oxford early in 1856 was of heightened significance because the Crimean War was now coming to an end:

> Saturday 5 January 1856 a very pouring wet morning, no possibility of getting out in a.m. did some letters & helped Clara p.m. took a walk in Wadham gardens. air warm & delicious. there is a beautiful kind of Mahonia there. which turns down its leaves. and clothes the wall. to church at St Mary's [. . .] Henry [Acland] was gone to spend the night at Cuddesden. where one of the Bishop's sons is dying. C[alverley] brought news of a strong rumour of Peace, being current in London today.

Bell Scott had sent her a copy of Arthur Hugh Clough's *The Bothie of Toper-na-fuosich* (later *The Bothie of Tober-na-Vuolich* – the Gaelic in Clough's original title contained an obscene wordplay, and Clough hastened to alter it when it was pointed out to him). Walter read it aloud to Pauline, and she found it 'a thousand times better than the mawkish "Angel in the House" which I cannot care for, in spite of the Ruskins enormous admiration of it. *he* says it is one of the best signs of the age that such a poem is written!'

Pauline's sharp critical intelligence saw through the sentimentality

and banality of Coventry Patmore's poem, popular though it was (*The Angel in the House*, a sequence of poems devoted to the celebration of married love, was a great commercial success and ran through many editions). Ruskin's critical intelligence was equally sharp, of course, but he was prone to be beguiled by dramatic works in which women were depicted as sweet, submissive and adoring. And clearly he had his own reasons for endorsing Patmore's conservative view of marriage.

Pauline allowed herself to be critical of Ruskin, though giving praise where it was due. On *Modern Painters* IV, for example, when it was published in 1856:

> It is so *much* finer than the 3d indeed (except the 2nd) it is the best of all – no exaggerations – no paradoxes. no useless digressions & discussions about irrelevant matters. all good genuine hard work. Mountains have been *drawn* for the first time by him, and this is the best sense I ever read about them.

Pauline was still quite ill at the Aclands in early January, but was pleased with Henry Acland's outfit when he dressed up as Robinson Crusoe for his children's party:

> Saturday 12 January 1856 I was ill in bed all day. not able to get up even at night to see the childrens' party. When they had their cake and the characters, and snapdragons, and fireworks. the fireworks were very pretty. meantime H.A. came back & was dressed as Robinson Crusoe. He had previously sent in an admirable note to himself from Robinson saying that he would call about 'sicks oclock' – the children fully believed in him, & were delighted. He had a tender meeting with the cat, sung them a song, played on a flageolet & left them a present of colour paints & went away. they were enchanted. He came to my room to show himself. He was admirably got up. with a beard & moustache, skins of wild beats a long gun – his rabbit skin cap &c He was as good a Robinson as cd be seen. the Dean of Ch Ch & Mrs Liddell staid all the eveg H.A. came to see me.

On 17 and 18 January Pauline received her copy of Ruskin's *Modern Painters* III, and was reading it with great pleasure in the company of Walter and Mrs Acland; Walter enhanced the pleasure by reading passages from it aloud to the ladies in the evenings. We are reminded from the following diary entries of Henry Acland's constant overwork and his fragile health:

Sunday 20th January 1856 [. . .] Poor Henry A[cland] very bad with bilious headache & severe cold, ill in bed. He had to get up & go out to see a patient, which made him worse. He sat up to tea & was very doleful in the eveg [. . .]

Monday 21 January 1856 Very wet day, not out all day. drew some plaster casts of cattle, one of a Bull very good. made a chalk study of it [. . .] Henry A still ill.

Pauline was recovering and was soon well enough to go home. She had obviously benefited from her stay in Oxford, and was sorry to leave the hospitality of her friend Mrs Acland and the high professional care of Henry Acland – though it sometimes seemed that he was more fragile in health than she was.

On their way back to Wallington at the end of January she and Walter stayed in Newcastle, where they visited some friends, the Morenos, who complained 'of the thieving habits of the boys there & the dreadful immorality of Newcastle altogether'. Their journey to Wallington was made in atrocious weather:

Monday 28 January 1856 when we were about Belsay it began to snow & there was a short but heavy storm. wh ceased & the evening was lovely when we came home. found the house looking very nice. Mr W[ooster] [Walter's assistant] had made lovely nosegays [a mischievous touch, this] & the maids roaring fires all over the house – so that everything had an air of fete – and was very cheery [. . .] Peter [her terrier; Pauline doted on this dog] proved very fat [. . .] I was very thankful to be safe at Wallington again.

Her health threatened to collapse again, though, after the journey:

Monday 4 February 1856 ill in bed all day. had Doctor. Caly gave up going to N[ewcastle] as I was so ill, & sent Mr Wooster to make his excuse. I got leeches from Morpeth & was much relieved by them. But could not rise & have my bed made.

Tuesday 5 February 1856 In bed still, but better. C[alverley] read to me. got into my room in evening. they have now caught 8 rats in my store room to Peter's great delight.

It snowed so hard on Ash Wednesday (6 February) that Walter could not walk the half-mile to church in Cambo, the local village, and instead read 'a pretty Xtmas story by Dickens. in the evening the wind rose. & all night there raged one of the fiercest gales I can

remember. it was tremendous. the house trembled & shook with it.'

Reading a Christmas story in February is not very seasonal, but it clearly went well with the weather. Life in Northumberland was in striking contrast to the pressures and excitements of Oxford* or London. Yet the activities of the Pre-Raphaelites remained a lively source of interest and involvement for Pauline. Her anger with Millais over the Ruskin marriage had not died down, and she continued to score points against him:

> [Friday 8 February 1856] C[alverley] came home quite early between 9 & 10 to my surprise. he had enjoyed his meeting last night. He told me about a workman down at Shields who has set up a little School of design of his own – and wrote to Mr Scott, to Master & to Millais to ask what P[re]R[aphaelite] principles were. Mr Scott told him it was too large a question to answer in a letter, & that he would be glad to see him: J Millais wrote a very long letter, entirely irrelevant, Mr R (whom he had asked *what* people were to encourage, if engraving was not healthy work, & adding that he admired pottery) wrote him a long and kind letter.

Disparagement of Millais went hand in hand with fierce loyalty to the Master, of course. On 9 February 'Mr Wooster took a walk too long & too fast, & was ill in the evening. C[alverley] read a very abusive review of [Ruskin's] *M[odern] P[ainters]* by the scoundrel in the *Athenaeum*.' Adverse criticism of Ruskin could only come from a scoundrel. The following day, 10 February, a well-timed letter from 'dear Master' arrived as a kind of reward for her steadfastness.

Reports of the wider world continued to reach Wallington almost daily: Pauline recorded in her diary (16 March 1856) that Bell Scott had written 'desiring me to read Rob Brownings "Men & Women" he calls him "the wisest of living poets" & the only one who is not, except in rhythmical charms & a certain feeling for beauty, behind our prose writers'. The fashionable preference at this date would

*They were back in Oxford a few weeks later so that Walter could exercise his right as an MA of the university to vote for Henry Acland as Regius Professor of Medicine. Pauline witnessed the ceremony:

> very picturesque – in university elections, before the numbers are declared all the voting papers are burnt. It was quite dark when this election ended. & there was only one lamp where the Vice Chancellor &c sat, counting the votes. then a great oil tripod was brought in to the convocation house – and the mass of papers were thrown into it and blazed up. the dark old building and crowd of eager faces, anxiously watching till the papers were burned, to hear the result announced by the Vice Chancellor. was really very pretty in the blazing flickering light.

have been for Tennyson;* Browning was still a minority interest. Bell Scott's letter was full of intelligent detail, deploring Browning's title, but praising the content of his poetry in a wholly appropriate way.

A report of a meeting of the Society of Arts in London was another talking point for the Trevelyans: 'a paper was read on the progress that has been made in the application of art principles to manufacture. Mr Ruskin, Redgrave Cole &c spoke.' Ruskin's *bête noire* Sir Henry Cole (1808–82), one of the prime movers of the Great Exhibition of 1851, had become head of the Board of Trade's 'Department of Science and Art' the same year. He thus became, in a distant sense, William Bell Scott's employer.† Bell Scott was supposed to teach industrial design only. The Board of Trade 'repudiated the Fine Arts and provided us with a table of printed rules': 'no one intending to follow any of the Fine Arts professionally was admitted as a student' and 'drawing the human figure was interdicted'. Bell Scott said of this, 'I hung up the rules, and broke them by my own practice.'[21] Some of his pupils, particularly Henry Hetherington Emmerson (1831–95) and Charles Napier Hemy (1841–1917), became noted landscape, seascape and genre artists whose work demonstrates the Pre-Raphaelite influence of Bell Scott's teaching. There were no women in the School, but Bell Scott occasionally took private pupils: one of these was Alice Boyd, the talented young woman whom he met in 1859 and who in due course became his lifelong companion.

In late March 1856 William Bell Scott brought his wife Letitia to Wallington:

21 March Good friday 1856
 the Scotts arrived, Mrs S[cott] is the most extraordinary little woman I ever saw. Very plain, at least 15 years older than her husband – talking constantly in a hard, dry cutting voice pitched at a most uncomfortable

*It has to be said, though, that Bell Scott's refusal to like Tennyson's poetry had to do with his sense of the man's personality. On one of his visits to London (back in 1852) he had met Tennyson at dinner with Coventry Patmore and found him cold, distant and self-absorbed.[20] He could seldom be persuaded to say a good word for the laureate or his work.
†In Newcastle a Northern Academy of Art under the distinguished local artist T.M. Richardson had flourished until 1843. There were a number of excellent figures associated with the Academy, among them the prolific and commercially successful John Wilson Carmichael. The creation of the Government School of Design under the control of the Board of Trade in 1843 coincided with the failure of the Northern Academy through lack of funds.

tone – & so obtrusive and forward that she will not allow one a moment's peace.

It was an eventful Easter weekend. Walter set up stone decorative features in the garden, which are still there and very prominent:

Monday 24th March 1856 a cold day. Caly got workmen to set up his druidical stone, & the dragon's heads &c on the lawn & wanted Mr Scott & me to settle where they should be. so we went out & it was arranged (and very well they looked afterwards) it was a difficult job setting up the larger stone, and took a good many men & a horse. Mr Scott remarked on what a different scene its first raising by the Druids was.

Pauline had another bout of illness after the Bell Scotts had gone; it is not clear whether this was caused by 'the dreadful woman his wife'. Despite the social awkwardness of Mrs Scott, Pauline pursued her objective, which was to discuss with Bell Scott the great scheme for the decoration of her central hall.

Bell Scott wrote to her after the visit with a full sense of the importance of what had happened:

[27 March 1856]
My dear Lady Trevelyan,
 I have begun to realize the full meaning of our conversations at Wallington since returning to the cool regularity of Newcastle, and to feel more and more delighted with the idea of the great histories and decorations you have proposed, and with the way of life I have chalked out for myself with the mansion 'quite palatial' at Cambo, between which and London I could divide my time after a preliminary 'year (or half year) of consolation' abroad learning German and walking the palaces and galleries of Venice and Rome. The scheme of the whole saloon in arrangement of colour and intention of pictures must be cleared up first thing, then the particulars will be arranging themselves in my mind, and compositions taking shape on canvas while the actual decoration is partially proceeding. I see in vision Cuthbert teaching the good folk *from the window* of his hermitage on Farne as recorded, and Bede in his old chair, worthy inky-fingered soul. Besides there are subjects for little pictures I could do at Cambo 'the early plough' for instance which has long been breaking the mental clods with me – the sunny misty morning and the breath rushing white out of the horses nostrils, the crows catching that *early* worm whose foolishness has become proverbial. I hope providence will not allow any dark hand to

rise between me and all this; – if I was not a poor desponding wretch, though secreting my despondency as the wicked do poison, I would at once give up the appointment I hold here, although it is considerably lucrative.

The 'dark hand' he had most to fear was, of course, Ruskin's. Pauline instructed Bell Scott to write to Ruskin for advice about the decoration of the hall. It must have galled him to have to do this, but he wrote in detail and added an illustrative 'memorandum', which seems not to have survived. The letter itself gives details that relate closely to the way the hall looks now, with panels 'occupied by pictures' separated by pilasters painted with full-size upright native plants: 'as the foxglove the bulrush corn of different kinds, &c.' Between the upper pilasters the second tier of spandrels were to be 'filled, although less densely either with foliage like those below or arabesques'. This last (the foliage or arabesques) was not carried out; instead the second tier shows scenes from the Battle of Chevy Chase (added after Pauline's death). The tone of Ruskin's reply was not encouraging:

> I am quite *vowed* to idleness for a couple of months [. . .] and cannot think over the plan you send – for I am as much in a fix as you are about interior decoration – but incline to *All Nature* in the present case [. . .] – So get on – that I may have plenty to find fault with – for that, I believe, is all I can do.[22]

This could not have commended or endeared itself to Bell Scott, but at least it did not look like excessive interference.

Bell Scott's letter of 27 March continued to ruminate on the question of whether to resign from the School of Design:

> However there is a certain manly feeling in helping forward of many young men although by drudgery, and if I gave up the school, the endowment will be certainly withdrawn and the new system carried out. Whether this would be real misfortune to the locality or not is by no means certain, but it would be so viewed by the committee and others here.
>
> I have got the elevations from Mr Dobson [the architect] to aid in deliberating over the saloon. He seems to have a notion of having his finger in it, but I am glad to think from what you said, that you will agree in doing with a moderate amount of assistance from that quarter.[23]

Bell Scott was exaggerating in his own mind the extent of the munificence on offer, writing as though he would become in effect a part of Walter's and Pauline's household. Pauline tactfully dissuaded him from resigning his teaching job: 'I think nobody has any business to say a word – pro or con – about your giving up the School of D. people know their own affairs, as no *outside* person can know them. I hardly know which to wish for you. it seems to me a noble vocation enough.' Walter was never as keen on Bell Scott, either as a person or as an artist, and it is likely that any plan for him to move out to Cambo was quickly nipped in the bud by a realistic private dialogue between the Trevelyans. Courteous disagreement about Bell Scott's work characterised much that Pauline and Walter said to him, and to each other, over the years. Pauline tended to get her own way, and in these contests the artist himself always came third. For example, the painting of Cuthbert does not have the saint preaching from a window, but instead displays Pauline's love of the open air, and the painting of Bede does not have the saint sitting in his chair.*

On 29 March 1856 Pauline wrote to Bell Scott recording the meeting they had had over Easter, when plans for the decorative scheme were first made. She was quick to establish the lines of demarcation between his sphere of action and that of John Dobson:

> I am very glad you are thinking over our plans for the Hall. There is *no especial hurry*. so you may take plenty of time to mature them. Sir Walter does not wish or intend Mr Dobson to meddle or make in the affair. it will never do to have divided counsels. we will look at the room in the station, there are plenty of good colour decorations in Paris.

Plans for the hall advanced steadily during the summer, and Bell Scott was introduced to more of Pauline's friends: the Collingwoods were rather grand local gentry, and Henry Acland had come up for a break from his exhausting duties in Oxford:

> [Saturday 3 May 1856] Mr Scott and I & C[alverley] discussed the plans for painting the Hall. which are now taking some form & shape. & promise to be very beautiful. The Colling[woo]ds were very much delighted with Mr Scott

*There survives at Jarrow in Bede's church a medieval chair still referred to affectionately as 'Bede's chair'; presumably Bell Scott planned to use that. The chair cannot be authentic as it was made after Bede's lifetime, but that was not known when Bell Scott was working on the painting.

[Sunday 8 June] Henry A[cland] told me about his long interview with Jenny Lind [the celebrated singer] & her deep interest in moral social & religious questions – he was quite delighted with her.

Bell Scott and Henry Acland 'took to each other very much'. They agreed about the current state of fine art in London: 'They both think Millais pictures this year inferior to the past & that he is giving up his principles & painting for money.' That Acland liked him was a tribute to Bell Scott's power to charm, when he chose. His good looks, light Scottish voice and serious manner enabled him to make himself agreeable and he was increasingly an habitué of the house, now that he had been taken on for the decorative scheme. Work proceeded steadily despite Pauline's periods of illness, which she never allowed to impede her. She and Bell Scott were clearly happy with each other:

[Friday 4 July 1856] Mr Scott proceeded to have the pilasters scrubbed down with soap & water to prepare them for painting on. we went to the garden before dinner & looked for plants to draw. settled to being with blue Iris & crimson papaver bracteatum
 [Saturday 5 July] Doctor came very badly out of sorts consulting him He brought a whole team of dogs with him. the colours Mr Scott had ordered came from Ncastle & he immediately tried the first experiment on his iris & he found that there would be no difficulty at all about the color on the stone. the oil does not run & the colour has all the purity of fresco [. . .] I began a great passage of preparation for a station [i.e. a design] on another pilaster.

Pauline's use of the word 'station' recalls her visits to her beloved Italy, where in every Roman Catholic church the pillars in the nave, typically, were decorated with the Stations of the Cross, and it is another mark of her deep piety that she should include a prayer in her private diary to mark the point at which she personally started work on the painting of the pillars in the hall: '& we worked all the afternoon – & so the painting of the Hall was begun. "Prevent us [i.e. lead us] O Lord, in all our doings".' It was a sacred project, and with the old familiar phrase from the Book of Common Prayer, Pauline called for divine leadership and guidance.

Friends arrived on 7 July just as she was getting seriously to work 'at my poppies'. These visitors appeared 'between 2 & 3 o'clock a horrid hour to come & it was a pouring wet day'. Her sister Mary Hilliard was pressed into service: 'got Mous to take care of the

horrid company while I worked at my poppies a little'. The following day Pauline and Bell Scott were painting flowers on the pilasters in the central hall, while Alfred (the heir to the baronetcy) played the organ and guests, children* and workmen went about their various pursuits:

> Tuesday 8 July 1856 Mr Scott & I painting in the Hall. where, what with Alfred [Trevelyan, Walter's nephew] thundering all day on the organ and the children rowing & people playing at Bagatelle, the noise was deafening. Mrs Monteith came and sang beautifully. Mr Monteith read to us. Some of Ruskin on 'Mountain Glory' after luncheon drove with the Monteiths to N[ether] Witton [home of the other Northumberland branch of the Trevelyans] where Mrs M talked about the [Roman Catholic Church] her religious notions seem very funny. she joined the church of Rome at 12 years old. but did not really care about it. & thinks now that one religion is as good as another. C & Robert [Monteith] took a walk. In the evning we had music & Robt read some more of Ruskin to us.[24]

The Monteiths were Roman Catholics and close family friends. Many years later a younger Monteith would marry one of Alfred Trevelyan's daughters (who would be brought up in the same faith). From Bell Scott's point of view, this cheerful family day was a mixed pleasure, since there was to be no escape from the Master. Even if Ruskin was not actually present, Pauline's guests and relations were eagerly discussing him, deferring to him and reading aloud from his works.

Walter tended to rub Bell Scott up the wrong way. He was crisp and direct about his dislike of 'masks' in the proposed designs for the lower tier of spandrels in the hall: 'I do not like the corner *mask* at all –? why should we have an ugly thing before our eyes if we can have what is agreeable to look on – which we might there'; and he placed a total embargo on '*horrible masks*'. Instead of the masks, the Trevelyans persuaded Bell Scott to paint medallion portraits of famous Northumbrians, from Hadrian to George Stephenson. Walter also complained about anachronism: Cuthbert was not as yet a 'Saint' (at the dramatic date of the painting) and should not be described as one in the inscription. (Pauline, however, invariably referred to the painting as 'St Cuthbert'.)

*Mous's children, including little Constance Hilliard, who was later to enchant Ruskin.

Given how prickly Bell Scott was about unsolicited advice, there was scope for further trouble when Benjamin Woodward, of Deane and Woodward, came to stay. Pauline knew him both through Acland's Oxford Museum and through his Ireland-based friendship with Walter's nephew, Alfred. The house was already animated by two lively personalities, Thomas Woolner and Alexander Munro.* Pauline noted in her diary that Woodward was quite different: 'very nice looking but dreadfully delicate – very pleasing and gentle & gentlemanly in his manners but shy & very silent. quite a contrast to our two sculptors.'

He and Bell Scott could well have clashed, but that risk was averted: (6 October 1856) 'Mr Woodward made sketches & satisfied himself about some points in the decoration of the hall. coming round to Scotus' [Bell Scott's] opinion, wh is comfortable – dined early. Scotus & Mr Woodward went away afterwards.'[26]

One of the functions of her many letters to Bell Scott was to pass on pleasing gossip about her cultural life:

I had a most jolly day or two in London. Mr Woolner took me to Maddox Browns & Rosettis – and to the Brownings to see Rosetti's picture of Dante & Beatrice. [This was the watercolour *Dante's Dream at the Time of the Death of Beatrice*, 1856; the same subject became a large oil painting in 1871.] I was quite enchanted by Rosetti. he is a most fascinating person – & *such* fine things as I saw! – the Brownings were delightful, particularly Mr Browning, now I have seen what sort of man he is, I understand a great many things about his poetry that bothered me before.

Her diary gives more detail: Woolner had 'brought a most kind message from the Brownings to say they would be very glad to see us – & showed us Rosettis picture & a note from Rosetti about going to his house'. The Brownings captivated her:

they are both very charming people – he is short with a very fine pictur-esque face – delicate mouth, noble brow & eyes. fine curly hair & beard. he is very handsome. he has a wonderfully smooth ivory throat. Mrs B is short & almost deformed & lots of very nice dark hair she is very

*She had visited Alexander Munro's studio in London and became rather sentimental about him: 'so dark and handsome and poetic and poor'.[25] Munro was sculpting his portrait medallion of her for the hall.

gentle & amiable in her manners the child is a little bright haired long curled creature like a medieval angel child very fine in expression. almost all the talk was about art & pictures & Rossetti – R Browning talks a great deal & is so bright & caring & natural it is delicious I feel that after this sight of him I shall understand much more of his poetry.

And when they made their private visit to Rossetti's studio, Pauline took careful and detailed notes: 'watercolour of Love showing Dante Beatrice as she lies dead – a bed in a recess (wooden) wooden roof. with glimpses of Florence – two angels – or female figures/no wings – lift a veil above her strewn with pale pink flowers she lies with her long hair strown about her – Love [an angel] (in luminous deep blue – lake – & red wings) kisses her face – & passionately draws Dante along.' This was the first state of *Dante's Dream at the Time of the Death of Beatrice*; in the 1871 version the 'luminous deep blue' was replaced by a loud red, which Pauline would not have liked so well. She wanted to acquire this painting, but it had already been promised to Miss Ellen Heaton of Leeds, one of the most enthusiastic and generous patrons of the Pre-Raphaelites. Pauline's account of the painting is passionately detailed: a good artist could reproduce a recognisable sketch of the work from her prose and the pencil sketch in the diary.

The other Rossetti works that she saw and wrote notes on included: 'The Passover kept in Joseph's house', 'S John Baptist fastening on the sandal of Xt' (which had been promised to Ruskin) and 'Country girl & lover – Calf in the car – Etching of S Graal – Mariana in the south'. Pauline was bowled over by his talent: 'Rosetti has the truest & deepest feeling for beauty. & the most wonderful invention.' The 'Country girl & lover – Calf in the cart' was a sketch for the great unfinished social realist painting *Found*, inspired partly by Holman Hunt's *The Awakening Conscience*.* Ruskin's lavish praise for the Holman Hunt painting, in which a kept woman struck by remorse rises from her lover's lap and will leave him, stimulated Rossetti's

Found was later promised to the Newcastle collector James Leathart, but in the end this generous patron despaired of the painting ever being finished, and it never became his property. At this period Leathart, a Newcastle lead manufacturer, was one of the most important patrons of contemporary art in England. He was also a friend of Pauline's. He had built himself a substantial house, Brackendene, in Low Fell, overlooking what was at that time a picturesque valley below Gateshead (now disfigured by an industrial estate). He filled his house with paintings and with his substantial family (the Leatharts had fourteen children; many of them figure in a major painting by Arthur Hughes). William Bell Scott had brought Leathart and Pauline together, and

interest in the theme of the 'fallen woman.' Holman Hunt's was the first famous painting to depict a prostitute, Rossetti's the second.

Woolner had established himself as a second cicerone for Pauline, after Bell Scott, and it was good that Bell Scott was not jealous about this. Elizabeth Barrett Browning, the most famous woman poet of the century, attracted Pauline as an inspiration and a role model rather than as a person, but Pauline was genuinely sorry for her suffering from consumption. As with the Tennysons, Pauline was 'lionising'; she was keen to persuade the Brownings to stay at Wallington:

> Mrs Jameson spent last evening with me [Anna Jameson (1794–1860), the celebrated art historian and a great friend of Elizabeth Barrett; she was also an acquaintance of Louisa Stewart Mackenzie's family] – she was with the Brownings the night before they left England & has heard from them twice. Mrs B was coughing dreadfully. they are at Florence by this time. [. . .] we *did* entreat the Brownings to come & see the Border Land – they said they should like it much. & would do it, if ever it were possible. but her health cuts their summer visits to England very short. but I don't quite despair.

In Oxford with Henry Acland she visited the private collection of Thomas Combe, the University Printer at Oxford University Press and a major patron of the Pre-Raphaelites. A Christian subject by Holman Hunt (not one of his most celebrated paintings) received a great deal of attention from Pauline. The persecution of a Roman missionary by druids reflects the sympathy that she was to show with Rome all her life, despite having pulled back from the brink of conversion some ten years earlier. The painting is Hunt's *A Converted British Family Sheltering a Christian Priest from the Persecution of the Druids,* which had been slow to sell until Combe acquired it:

> a (RC) missionary hunted & wounded & exhausted, is received and succoured in a native hut, apparently that of a poor Fisherman. the

it was he who advised Leathart (very well) on his purchase of paintings. At its height, Leathart's collection included major works by Rossetti, Burne-Jones, Millais (including the 1855 master-piece *Autumn Leaves*), Ford Madox Brown and Arthur Hughes. Leathart encouraged other wealthy men of the region, including Sir William Armstrong, the armaments manufacturer, to collect the Pre-Raphaelites and their followers; the effects of Bell Scott's advice and Leathart's patronage, then, were beneficent and far-reaching. Sadly, the Leathart collection did not stay in the North-East. In the 1880s financial problems in the lead business forced Leathart to sell a number of works, and after his death in 1895 his heirs disposed of the bulk of his remaining collection.

women are supporting him and one brings some water, a youth is removing from his clothes the thorns that have caught there. a man looks out to watch the pursuers another takes down the bow & arrows for defence. outside are seen a crowd gathered before the doors of an Idol temple where the priest of the Idol is setting them on to kill some Christians. some of the crowd are already pursuing & attacking them. this is a very noble picture. there is no affectation, nor exaggeration. the faces are handsome enough – nothing remarkable. the color is good & the bits of foliage & still life are gloriously painted. The sentiment is as fine as can be.

Hunt had begun this painting in 1849 as a competition piece, entered for a Royal Academy Gold Medal. The theme for 1849 was 'Act of Mercy'. The painting is about the civilising effect these Roman missionaries have had upon the British. A fisherman and his family are sheltering the priest in their hut. The benefits that the British have already received are shown in the fisherman's cultivation of grapes and wheat for wine and bread – the converted Romans have taught him and his family how to do this. In the background of the painting a second Roman priest has been captured by the druids and is about to be murdered in a grisly and spectacular manner. There is a striking similarity between the narrative in this painting and that in Woolner's *Civilization*, where the mother teaching the Lord's Prayer to her son is sharply contrasted with the murderous druidical practices taking place in the scenes carved round the sculpture's base. It seems certain that Holman Hunt's representation of the civilising effect of Christianity helped inspire Pauline to propose the theme for the sculpture. The painting had also prompted the kind of detailed debate over historical accuracy that Sir Walter enjoyed. When it was objected that the druids long predated the earliest Christian missionaries, Holman Hunt triumphantly found a Roman historian whose Latin text seemed to show that this was not an anachronism.

Pauline also immediately and intuitively admired Holman Hunt's *The Scapegoat* and was to remain loyal to this extraordinary painting, despite the general public's indifference to it:

> Here is Hunts new picture just arrived of the Scape Goat. He painted it in Palestine, and the landscape is a wonderful PR study of the shore of the dead sea, with the mountains beyond it & in front the site of the accursed cities with the ghastly white of the soil covered with bitter salts.

She drew her own rapid sketch of the painting. The outline in her diary captures the essential shape of Hunt's composition with striking accuracy:

> The poor fainting goat with its piteous eyes is just ready to sink with hunger and exhaustion, it is deeply pathetic it sinks at every step in the salt crust. not a tree no a blade of grass is visible, here and there a skeleton of some dead creature & one withered branch of a tree – the colour is most intense & bright the sunset purples and some on the mountains. the clear green & gold sky & red clouds. the dead dull green of the dead sea. and the colour of the long haired goat are purity itself – it is too painful & true – but for people who require very strong things to rouse their emotions it may be very useful. it is very awful & typically very affecting –

Pauline was out of step with her 'Master' over this. When the painting was first exhibited in London, Ruskin wrote that it was 'in many respects faultful, and in some wholly a failure'. He praised the fidelity of the landscape: 'Of all the scenes in the Holy Land, there are none whose present aspect tends so distinctly to confirm the statements of Scripture as this condemned shore.' But he said that, as a consequence of his 'intensity of feeling', Holman Hunt had forgotten 'the requirements of painting as an art', and that the goat itself displayed 'no good hair painting, nor hoof painting'. Morally, though, Ruskin's view was that the intention of the painting was 'honourable', 'deep and sure'.[27]

Bell Scott's dislike of Ruskin remained obdurate. Pauline tried to get him to review one of the volumes of *Modern Painters*, but it would have been temperamentally difficult for Bell Scott to say anything polite about Ruskin in print. Pauline was not doing anything unusual, though; it was common practice among the Victorians for writers and their friends to seek to secure favourable reviews through their networks. William Michael Rossetti was always willing to puff friends' performances, sometimes reviewing the same work in several different periodicals. Pauline asked Bell Scott about him: 'I have forgotten in what papers it is that [William Michael] Rossetti writes the art criticism will you tell me?' The answer was that he wrote for several, and he reviewed *Modern Painters* IV admiringly in *The Spectator* on 17 May 1856.

Pauline was delighted by another Roman Catholic subject, *Convent Thoughts* by Charles Allston Collins (1828–73, brother of the novelist

Wilkie Collins; he later moved away from painting altogether). This was a painting that she defended from Ruskin's carping in his letter to *The Times* of 13 May 1851.[28] She regretted that Combe had bought it before she had the opportunity to bid for it: 'a picture I long to have. the nun is very charmingly painted & her face is beautiful in expression. the garden, the flowers, the pond & the lilies [. . .] are lovely, I had no idea before how great Collins really is.'

By this date the early public hostility towards the Pre-Raphaelites had died down. Much of that visceral reaction of 1849 and 1850 had been fuelled by resentment of the growing confidence of the Roman Catholic Church, and by the belief that the Pre-Raphaelites were Roman Catholic sympathisers. On this Pauline was of course at odds with mainstream upper- and middle-class opinion, since she had wavered over conversion herself and remained very sympathetic to the Oxford Movement. But Ruskin's advocacy had made it respectable for Protestants to admire the Brotherhood.*

Among the many studios that Pauline and Walter visited was that of Ford Madox Brown (1821–93), Rossetti's sometime teacher and the friend and contemporary of Bell Scott (and a painter with whom Bell Scott's work was often compared). Pauline found a lot of good qualities in Brown's work, but she was discriminating and judicious:

> – saw a large shaped [She drew an oval round the word 'shaped' to indicate the shape of Brown's painting] landscape [i.e. Pre-Raphaelite] scene Hampstead with the autumn tints just coming on the trees & the sun rich & bright over some red roofs in front. it is very well painted. but the subject wants interest. [Walter recorded that he saw this Hampstead landscape on the same visit, but in his diary entry he could recollect neither the name of the picture nor that of the artist] a little water colour – of the flat fields near the head of Windermere. with a number

*To remind ourselves of how things were before Ruskin's interventions in *The Times*, we have only to go back to Dickens's attack on Millais in *Household Words* in 1850. The painting that attracted Dickens's attention was Millais's *Christ in the House of His Parents* (1849). Dickens was provoked into a transport of rage: the Christ figure was 'a hideous, wry-necked, blubbering, red-headed boy, in a bed-gown; who appears to have received a poke in the hand, from the stick of another boy with whom he has been playing in an adjacent gutter'. When she reviewed this painting at the Royal Scottish Academy Exhibition of 1852 Pauline called it 'the most wonderful and daring picture that ever appeared on the walls of an exhibition room.' She conceded that the boy was 'wry-necked' but she praised the painting's ability to 'bid us love and reverence humanity in its lowest and most repulsive form.'[29]

of black cattle, pleased me more. saw again his 'Baa lambs'. the baby
is charming. Also the drawing the Prisoner of Chillon. which is
wonderful and a beginning of a picture of Work people – & idle people
contrasted and a drawing (w colour) of Cromwell riding over his farm,
& meditating on the wickedness of the age. I did not like the face but
the rest was fine. the horse admirable. there was an oil sketch of a baby.
one of his own, a most charming thing, quite admirable for color &
light.

Ruskin greatly disliked Ford Madox Brown's Hampstead Heath
scene, *English Autumn Afternoon, Hampstead – scenery in 1853*. On
meeting Brown at a gathering at Rossetti's in 1855, Ruskin asked:
'What made you take such a very ugly subject, it was a pity for there
was some *nice* painting in it.' Brown's reply was simply, 'Because it
lay out of a back window.'[30] Ruskin ought to have felt somewhat
chastened by this, since Brown was scrupulously following the
teaching that the Pre-Raphaelites had gained from Ruskin himself –
namely, that the artist should pursue visual truth above all else and
should therefore not reject anything that lay before him. But he could
never bring himself to admire anything by Brown.

About Holman Hunt's *The Awakening Conscience* Ruskin wrote
a letter to *The Times* on 25 May 1854: 'Examine the whole range of
the walls of the Academy [. . .] there will not be found [a picture]
powerful as this to meet full in the front the moral evil of the age in
which it is painted; to waken into mercy the cruel thoughtlessness of
youth, and subdue the severities of judgement into the sanctity of
compassion.' For Ruskin, compassion was the point: 'The very hem
of the poor girl's dress, at which the painter has laboured so closely,
thread by thread, has a story in it, if we think how soon its pure
whiteness may be soiled with dust and rain, her outcast feet failing
in the street.'[31] In other words, when her rich lover had become bored
with her, she would become a street prostitute, and the onlooker
would feel corresponding pity. This was a misreading: the painting
was a companion piece to Hunt's famous *The Light of the World*.
In that painting, with its text 'Behold, I stand at the door and knock',
the human heart is closed to Christ's teaching. In this one, by contrast,
the fallen woman experiences revelation and redemption. With his
lifelong immersion in the Bible enabling him to identify the signifi-
cance of the many allusions in the painting, Ruskin responded
passionately, and accurately, to the religious teaching of *The Light
of the World*: 'For my own part, I think it is one of the very noblest

works of sacred art ever produced in this or any other age' (letter to *The Times*, 5 May 1854).[32]

Rossetti's *Found* echoes Ruskin's reading of *The Awakening Conscience* in that it calls for compassion for the fallen woman. Pauline took such subjects in her stride. She wrote more in her diary about Rossetti's religious subjects, especially those taken from Dante, but in the case of *Found* she clearly recognised what the contemporary subject was and simply recorded the facts in her diary. 'A village girl has come to the city to work as a prostitute, and her lover, a young farm worker, has come to find her. He has brought with him a calf, which he is taking to market.' The calf trapped in its net marks the helplessness and vulnerability of the young woman: prostitution is an equally fatal web.

Rossetti's painting and the accompanying poem 'Jenny' were both in part inspired by William Bell Scott's poem about a prostitute, 'Rosabell'. Bell Scott was later to claim that Rossetti had given scant acknowledgement to the stimulus he had received from 'Rosabell'.

Pauline habitually wrote to Bell Scott about her many friends, as in the following letter about Loo, Ruskin and Rossetti. It would certainly have made him jealous to be forced to accept that these other friendships were more intimate than his own, though he would have taken a certain sour pleasure in her strictures on Rossetti's work:

[November 1858, Seaton, near Axminster]
 Your letter to Sir Walter is just come. & has made me more than ever ashamed of myself. but what with not being well. & being very busy, I really have not been able to write. I sat down to do it yesterday, & was interrupted. being here is no holiday for me. for the lace people come from morning till long after dark entreating me to buy their work & give them orders. and I get no time to myself. – we had a pleasant fortnight in Suffolk with fine weather and old friends. certainly the country about Ipswich is most beautiful. with a noble river and well broken ground. old oaks and fallow deer. and the old grey churches with flint ornaments. we were only three days in London besides a Sunday. so it was no use leaving an address at Mr Woolners. because we were going away. and we were staying in a friends' house & could not go about as much as we liked & what time I had was much occupied with Miss Mackenzie, she and Lord Ashburton are going to Egypt for the winter. so I was anxious to see as much as I could of her. she was in good spirits. and I hope & trust it will prove a happy marriage.

He is thoroughly kind, good, generous, and highminded; a true gentleman in all his ways but not at all clever or strong in character. –*

Was she teasing Bell Scott when she pretended to think that he took a friendly interest in Ruskin?

Mr Ruskin dined with us one day. I never saw him look better. and he was very happy and in a good humour. he is busy finishing some copies. for schools. and getting on with his Swiss Towns. did you see his little lecture at Cambridge? it is very nicely done. I also saw Rossetti, he wrote to say my drawing was done. or all but done. I think it is a *very* fine thing. as grand and deep in feeling as any thing he has done. and I cannot help feeling very glad that he has done that instead of another of the 'Blue Closets' – 'Tunes of the 7 Towers' or other subjects which really have no meaning except a vague mediaevalising which is very chivalrous and fine once in a way but not what one wants to see him spending years of life upon. However, he'll come out of that phase. He is gone to Oxford, I suppose by this time, to begin his new fresco. as I hope you'll see my picture soon. I shan't say any more about it. but I hope you'll like it very much.

The medievalising in Rossetti's paintings at this date was, indeed, often annoyingly vague, and coexisted with non-narrative or early symbolist paintings that displayed luscious sensuality. Rossetti found plenty of buyers for works like the *Blue Closet*, in which an ample model (Rossetti's mistress, Fanny Cornforth) invites the (male) onlooker to a close encounter in her brilliantly coloured and stiflingly enclosed space. There is no story; instead there is delighted anticipation. At last, in 1858, Pauline acquired Rossetti's *The Virgin in the House of St John* (also known as *Mary in the House of St John*). Ownership of this work was not arrived at quickly, because Rossetti had already promised it to Ellen Heaton. In the end Pauline offered a higher price and acquired the original work, and Miss Heaton agreed to buy a replica.[33] Rossetti was now a prosperous artist, selling both to those who liked narrative and sacred paintings and to those who enjoyed frankly sexual representations of beautiful women.

*Loo's marriage to Lord Ashburton, in November 1858, was in reality a source of pain to Pauline in several different ways. She was worried for her friend's reputation (unkind gossips had labelled Loo an opportunistic gold-digger), and she was hurt that the news about the marriage reached her indirectly through a third party (see Chapter 8 below).

Pauline was able to report progress with the Woolner sculpture on 26 January 1859:

> Mr Woolner has set up our group in the clay – in *the rough* at present. but it has got on a good deal. He is trying to get a lady beautiful enough to sit for the head. and has not yet found any one up to the mark. he expects to have to combine the beauties of several – He has determined to make the child a boy – not a girl – which I think is an improvement – He is ill with a virulent cold – poor Mr Munro is better. but still very bad with weakness & remains of rheumatism. I wish he was out of that damp part of London & that horrid cold place.

The sculptors were still in harmony with each other; Pauline was delighted with her Rossetti painting; and Woolner's famous group was already available in clay, although his success and his need for money meant that the Trevelyan group was much delayed. In the meantime the quest for the perfectly beautiful woman was perhaps a pretext, although he did find her eventually.

CHAPTER 6

The Wallington decorative scheme

Our own age is the only one for us; it is the last and the best.

Pauline's marriage of art and architecture at Wallington has a moral thrust: the history of Northumberland set out in Bell Scott's paintings is a narrative that leads to, and is crowned by, Woolner's intensely moral sculpture of a mother praying with her child. The title, *Civilization,* is self-explanatory: the Romans, the Danes, the border reivers and the industrial strength of the Victorians have led to this perfect human being reared by his perfect mother. The central medieval iconic image of mother and child finds its Protestant flowering in this image. At the foot of the main staircase, and in striking contrast with the Woolner group, stands Munro's image of lovers in medieval Catholic hell, the adulterous Paolo and Francesca.

As it stands now, Wallington is a proud record of the North-East's history in its paintings, and of its workmanlike ingenuity in John Dobson's design. It was important for Pauline that the major contributors, Dobson and Bell Scott, were both local and that she was making use of local craftsmen and native plant and animal life. She had come to love Northumberland and Newcastle, and immersed herself in the life of the place. The harshness and bleakness, and the hard lives lived by many northern workers, contrasted in her mind with the lush opulence of Somerset.

While the Wallington scheme was brewing, the city of Newcastle suffered a major disaster. Pauline's compassionate nature was immediately engaged, and she wrote on Sunday 8 October 1854:

> The accounts of the fire are appalling. It began in Gateshead in a flax mill. then spread to a store of sulphur salt petre in naptha belonging to the chemical works which blew up with an awful explosion & and threw over all the buildings near. the place was crowded with spectators. they cannot tell how many are buried in the ruins, the burning fragments were blown right across the river setting fire to the ships & to Newcastle in several places – 500 people are said to be missing, it

is to be hoped this is an exaggeration there have been about 100 wounded dug out – & 20 ladies (yesterday morning) but the fumes of sulphur prevented much digging, and made some parts quite un-approachable.[1]

There was a personal tragedy caused by the disaster, which brought it very close to home: (11 October) 'Heard that poor Dobson has lost his only son in the fire, he was killed by the explosion, and was so disfigured he was only known by the keys in his pocket.' On 13 and 14 October (the Friday and Saturday) she and Walter went to Newcastle to see the ruins. On the Gateshead side of the River Tyne the surviving buildings stood 'in great shapes of rubbish still smoking with fumes of sulphurous vapour & shells of buildings standing gaunt & bare & rent & blackened'. On the Newcastle side, the Quayside, 'they were busy pumping the water out of the burnt houses which had been drenched by the engines in other places. they were still jumping out of the smoking ruins. some houses looked as if they had been bombarded from the other side of the water.' There was some comfort to be drawn from the relatively light casualties: if the explosion had happened during the working day, 'the loss of life would have been 100 fold as much for the very large proportion of offices & warehouses there would have been full of people whereas at dead of night they were nearly empty'.

The fire destroyed most of the medieval buildings on the Quayside, which until that day had been the most colourful and characteristic part of Newcastle. The heart of the city's life had been here, with chandlers, coopers and all the other purveyors of equipment for shipping cheek by jowl with brothels and ale-houses. Today few early buildings survive on the Quayside; some of those that do remind us of the place's riotous past (a pub called the Cooperage, for example, signals both business and pleasure in its name).

The time-honoured crossing between Newcastle and Gateshead, the Tyne Bridge,* had ensured that life was focused on the water-front, though it was already somewhat usurped by Stephenson's great engineering achievement, known as the High Level Bridge. This was a split-level road and rail bridge, which brought the railway line from the South to Newcastle when the great railway station, designed by John Dobson, was built in 1849. The twelfth-century castle, from

*The Tyne Bridge that Pauline knew was in fact an eighteenth-century reconstruction, following a disastrous flood, of the original medieval bridge.

which Newcastle takes its name, had been brutally sliced in half to accommodate the new railway. The fire definitively shifted the focus of life in the city from the Quayside to the new city centre, which had been magnificently transformed by John Dobson and Richard Grainger in the 1820s and 1830s.

The erasure of the historic Quayside did not bother the citizens overmuch. Pauline was doing something uncharacteristic of the temperament of the North-East by seeking to record its history. The cycle of paintings commissioned from Scott was to illustrate the history of Northumberland and was to vindicate the art teaching of Ruskin and the example of the Pre-Raphaelites. The paintings were to be on canvas, executed in Bell Scott's studio in Newcastle, exhibited at the Literary and Philosophical Association next door to Bell Scott's School of Design, and then moved into their positions in Wallington. The subjects were to alternate between the stories of famous individuals (St Cuthbert, Bede, Bernard Gilpin and Grace Darling) and 'general' subjects illustrating key moments of Northumbrian history (the building of Hadrian's Wall, invasion by the Danes, the life of the medieval border reivers and finally, in 1861, the success of Victorian Tyneside manufacturing and industrial life). Bell Scott did much of the scene painting on location: thus, for the Cuthbert painting, he took a boat out to the Farne Islands and spent several days painting the background to the figures; for *The Danes Invade Northumberland* he spent a considerable time staying in uncomfortable lodgings at Tynemouth in order to record the sea accurately; the keep of Newcastle's Norman castle served as the setting for *The Spur in the Dish*; and he spent several cold days in Brancepeth church in County Durham painting the background to the story of Bernard Gilpin. All the figures take friends, acquaintances, family members and servants of the Trevelyans for the models, and were painted in Bell Scott's studio in Newcastle.

This great scheme – the rebuilding and then the decoration of Wallington – is the narrative background, or spine, to the years 1853–61 in Pauline's life. The foreground contained regular periods of illness, frequent and excited visits to Edinburgh, Oxford and London, and continuing intellectual curiosity.

In the winter of 1856, from Marshall Thompson's Hotel (one of Walter's uncomfortable 'temperance hotels' where he preferred to stay when he was in London), Pauline broached Woolner's

commission for the Hall. Her tact in unfolding this matter to Bell Scott was masterly:

> Sir Walter has settled to give up having plants in the Hall & we are to have a bit of sculpture there. which we have asked Mr Woolner to undertake, – we have laid our three heads together about a subject. but quite in vain. but there is no hurry. it is so difficult to find a sculpturesque subject. pray think it over. it ought to make a crown & centre of all that the pictures tell – it must be either life size or *half* life size. Mr Woolner says nothing intermediate will do in sculpture – *please* tell me if life size figures wd interfere with the paintings? Sir Walter seems to incline to having either a simple life size figure, or a group of two – but he does not care, I think. You will think of it, I hope; & we will talk it over.[2]

Bell Scott had taken up a luke-warm offer from Ruskin to paint one of the pilasters at Wallington and had secured a firm promise from him. Pauline was very pleased: 'It would be delightful to get Mr Ruskin to do a pilaster. As the idea of his painting was his own spontaneous proposal I don't doubt he will do a bit & he said he would prefer a stone pilaster.' And she begged Bell Scott to repair damage (caused by a paint spill) to the pilaster she had painted with Canterbury bells, before Walter could see what had happened: 'I don't want Sir Walter to have a vexation about it. just put 'yes' or 'no' or 'I will' or 'I won't' at the top of your next letter & I shall know what it means.' She worked in some careful flattery. Bell Scott had had pleasing notices in the local papers and Pauline made the most of them: 'Many thanks for your kind letter & for the newspapers. it is well for the Newcastle people that they are at last becoming aware that it is an honour to them to have you among them.'

St Cuthbert (as Pauline continued to call it) was completed some time before the Trevelyans saw it; indeed, Pauline wrote as though she was to be among the last to see it: 'we hear rapturous accounts of St Cuthbert from Miss Ogle [Annie Ogle, the novelist, daughter of a prosperous neighbouring family in Northumberland, who were old friends of the Trevelyans] who declares it is perfectly beautiful – I so long to see it'. And she wrote with pleasure about further subjects that were potentially dangerous when dealing with Bell Scott: the young sculptor Alexander Munro, and the detested Ruskin: 'Monday. Mr Munro has done a really lovely bust of Mrs Butler. it is less idealised than the medallion & has more of her present delicate look.

But it is most charming. He has one of Dr Acland in the clay. it is very good I think. I never saw Mr Munro look so well as he does just now.' She and Walter would shortly commission medallions of their own heads to place in niches on two of the pilasters at Wallington. 'Mr Ruskin is also in good condition & very good humour. & as much pleased as ever with his working men'; indeed, Ruskin enjoyed his teaching at the Working Men's College and was still promising to paint his pilaster. 'He says he shall positively come down in the spring & that he must paint a bit in the hall – leaves or plants or something on the stone. He is in a state of rapture over Mrs Brownings poem [*Aurora Leigh*, which Pauline equally admired once she had read it]. I have only begun it. I hope you will like it. I met William Rossetti the other night at Mrs Loudons – how beautiful he is.' It was safer ground with Bell Scott to fall back on that old favourite, the unfortunate Wooster: 'I am delighted at your amusement at the way Mr Wooster *devellopes*, like most shy people he comes out very strongly on paper.'

She had a technical problem with the holding properties of oil paint:

> I don't think it could be turpentine that makes that paint come off. I think it must be that I mixed some of it with only varnish & no oil – (that was Lofftus' [Laura Capell Lofft's] advice) – I won't do so any more. I have not done so with the ferns. Please to forgive me ('just this once' as the children say) in consideration of my utter ignorance of oil painting. I dare say it is very delightful painting on the spandrels. but I don't think I shall want to leave the pilasters when summer comes and flowers are to be had. I am too glad to make the roughness &c of the stone a sort of shelter & excuse for my incompetence but it will be very nice to have a spandril in winter time.

It was then her turn to scold, since Bell Scott failed to acknowledge the greatness of Tennyson:

> I don't think you are quite fair to Tennyson – He ought not to be judged by Gardeners daughters or Lockesley Halls – but by In Memoriams. I suspect you don't read *In Memoriam* as much as it deserves. it seems to me to grow greater & deeper every year. & to say more & more to one's soul. I quite agree with you about the idle way in which people read poetry. How *very* few grown up people really study it – they run through it, as they wd a novel. talk about it at dinner parties for a week or so, & there an end. I fancy they are exceptional minds to whom

poetry is anything more than an intellectual amusement. & that of Browning can never be popular with idle people.

This is subtly flattering scolding, since it identifies Bell Scott as one of the few initiated readers who really can read poetry. *In Memoriam* spoke 'more & more to one's soul' because Pauline read it as a Christian poem rather than as an elegy or a love poem. It was as though she had access to one of Tennyson's working titles for the poem, 'The Way of the Soul'. The poem also deals intelligently with geology and often shows a painter's eye for carefully observed natural detail, so it was entirely to be expected that Pauline would respond to it with passionate enthusiasm.

January 1857 in London meant further agreeable contact with Benjamin Woodward, and a visit to Sir Robert Smirke's new British Museum building:

The new reading room which they are building [. . .] is a great court covered in, with a dome. the largest in Europe except the Pantheon which is two feet larger. the roof is finished, it is painted pale blue. the groins & moulding in gold. it is said to have been the largest gilding order ever given in London. the gold leaf cost £1000. the proportions are pretty. *everything* is of iron & it is all warmed with hot water. Round it are double passages lined with fire proof book cases 4 stories of these it will hold immense quantities of books.

It was characteristic of Pauline to take a great interest in the Museum site's population of stray cats: ' – several thin cats came to us as soon as we entered the new building & followed us every where. but would not leave the building, though they seemed very hungry, they get nothing on Sundays. for they live on the scraps which the workmen give them from their dinners'. There was further contact with Woolner, a visit to 'poor Louisa [Stewart Mackenzie], who is very ill', to the National Gallery and to a photographic exhibition: 'about 700 photos many very good the large French one is the best of cloud effects the foliage is exquisite and the rocks and buildings'. Since Harrow, Walter had been a friend of William Henry Fox Talbot, the famous British pioneer of photograpy, and photography was a favourite pursuit for Walter and David Wooster at Wallington.

Back in the North on 9 January Pauline was able at last to see the first complete painting of the Northumbrian cycle. The Pre-Raphaelite treatment of sea and landscape was exactly what she had

hoped for: 'Mr Scott came we went with him & saw his S Cuthbert. with which we were delighted – it is far finer than we expected, all the figures are good, the King is excellent – & the Saint also. the open breezy daylight – the rippled glancing sea are delightful.'[3]

In *King Edfrid and Bishop Trumwine persuade Cuthbert to leave his seclusion on the Farne Islands and become Bishop of Hexham 684*, Bell Scott had to prove himself, and he worked slowly and anxiously on the painting between June and December 1856. The work gave him an opportunity to create a beautiful seascape, to demonstrate to Pauline that Turner was not the undisputed master of sky and water, and to prove that he could faithfully record details of the natural world as Ruskin had ordered. The models were neighbours or employees of the Trevelyans: the hermit Cuthbert was modelled by a local clergyman, and the figure in the centre of the composition, Theodore, was Mr Thomas Gow, a very important figure in the Trevelyan family because he was Walter's agent. As a total abstainer, Walter had closed down the only public house in the local village, Cambo, and the building became for some forty years the home of the invaluable Gow and his family. Correspondence with him and annual accounting with Mr Gow feature prominently in Walter's diary.

The hermit is seen digging a little plot of ground on his island when the royal deputation arrives to offer him the bishopric. The King is visibly importunate, and the hermit or sage is deep in meditation. An eider duck (a bird common on the Farne Islands and the north Northumberland coast, but rare elsewhere) waddles in the foreground, and this, together with the onions and other humble vegetables that the sage is cultivating, gives an unintentionally folksy feel to the composition. A waggish contemporary called the canvas 'roast duck, sage and onions'.

Pauline noted that 27 January 1857 was a red-letter day: 'St Cuthbert was put up in the Hall. It looked beautiful and the figures not at all too large – the colour and tone admirably suited to the Hall – it is very satisfactory – we had not the difficulty we had feared in fixing it.' (Walter and Wooster seem not to have shared her excitement over the painting; instead they were out taking photographs in the snow.)

'Not at all too large', 'very satisfactory': was Pauline persuading herself that she was not slightly disappointed? Bell Scott's figures in all the Wallington canvases are rather prominent in relation to the

landscapes or interiors in which they are placed. One effect of this is that the delicacy of (especially) his sea painting can be overshadowed.

The project continued with decorative details on the pilasters. All Pauline's friends expressed delight with Bell Scott's painting and with the appearance of the whole scheme. Pauline felt that her initiative was vindicated.

[28 January] Began to paint holly leaves – Scotus [Bell Scott] inventing Trellis work for the pilasters – there were many heavy snow showers today – & it became so deep that I did not like going to dinner at L Harle but C[alverley] made me go – Mr Wooster went with me – we got there without trouble. nothing could be more beautiful than the deep fresh fallen snow [. . .] Mr Wooster's [cold] became very bad, he stood out in the snow today making photographs – and got chilled. He made some good negatives – C was too ill with the gout, to go out – he and Scotus staid at home together –

She remained buoyed up about the paintings:

Feb 3 heard from Scotus. who sent me a nice letter from Maddox Brown [. . .] full of admiration for St Cuthbert of which Scotus had sent him a photograph.

Pauline reassured herself about the quality of the work and quoted favourable opinions eagerly in her diary: 'Maddox Brown [Ford Madox Brown] & [Dante Gabriel] Rossetti are wildly enthusiastic about Scotus' St Cuthbert & think Scotus one of the very first of English painters.'

Ruskin came to paint his pilaster, as promised: he declined to paint the Annunciation lily that Pauline had for him and insisted instead on painting humble plants: wild oats, wheat, cornflowers and yarrow. Bell Scott sneered at his selection. The pilaster remains unfinished, possibly because Ruskin made a mistake about his humble plants. He thought he had selected oats and corncockles for his pilaster, but in fact he was painting cornflowers (which are blue), and not corncockles (which are reddish-purple). When this was pointed out to him, he lost his temper with the pilaster and would not go on.[4] His painting is delicate and beautiful, though, and was rightly admired by Louisa Stewart Mackenzie and Pauline, while Bell Scott glowered impotently in the background. To Bell Scott, the pilaster embodied

everything that annoyed him about Ruskin's teaching methods at the Working Men's College:

> where they utterly repudiate copying and the ideal. Here every student has a piece of rough stick hung up three inches from his face, to copy, and after two or three sticks they are encouraged to draw the human figure and face in the same manner. The mind being thus uninfluenced, and the taste untrained by the antique or rules of art you cannot believe what hideous things are produced as pictures of children or other of God's creatures that sit to them. The sticks however [. . .] are excellently done.[5]

Cultural activities continued: a visit to the Bell Scotts to see some Blake illustrations, and a series of lectures in Newcastle delivered by the novelist William Makepeace Thackeray:* (27 February) 'eveg to Thackeray's last lecture. crowd tremendous. heat stifling. lecture admirable. the way in which the subject of George IV was treated was most dextrous. C[alverley] called on Thackeray today but he was at Carlisle.'

It was natural and inevitable that Pauline and Walter would try to get Thackeray as a house-guest. The lion-hunting was innocent and habitual to her, for she just loved to meet and talk to brilliant men. Walter wrote to Thackeray on 28 February to invite him to Wallington following his lectures. He did not come; how much did Pauline expect that he would?

It is in Pauline's diary, on 15 March 1857, that a mystery crops up, like an inexplicable fallen tree lying across an open road:

> heard today from Capt Roberts of my father's death at Saint Helena – on the 2nd March – of dysentery – he sunk from weakness – without pain – and sensible to the last. Capt R buried him in a military manner – with a flag for a pall – in an old cemetery on a neighbouring island – he seems to be a kind man, & to have done all he could in the best way I wrote to Hugh and the others.

What had happened to her father? Had he gone into voluntary exile because of debt (the most likely explanation) or was it something more culpable? Pauline went to Edinburgh to order her

*The lectures were published in 1860, to great acclaim, as *The Four Georges*.

mourning and became ill again. Bell Scott came to visit, and her inseparable dog – the increasingly smelly and bad-tempered Peter – was with her. Her father's distant, lonely death intensified her sense of her own illness, loneliness and need for love. Peter played an important part in the restricted life that she was now leading:

> Dear old Peter who we brought with us here is so delighted at having us all to himself again & being rid of the young dogs. He does not know how to show his love sufficiently. He will not leave me now I am ill. even for walks and chicken bones. dear old dog.

The painting that opens Bell Scott's narrative sequence at Wallington is a general account of the building of Hadrian's Wall, the great project (constructed in the first and second centuries AD) that stretched from sea to sea for some seventy-five miles in order to mark the northern limit of the Roman Empire. The Wall was probably designed in Rome by men who had never seen the site, and in all likelihood was considered more as a monumental and prestigious structure than as an actual defence against the inhabitants of Scotland. Bell Scott shows the Caledonians north of the Wall behaving aggressively, but in reality they were no match for the Roman legions along the Wall – and they knew it. Hadrian's Wall remains one of the most important Roman sites in Europe, although little of the original structure still stands. Many miles of it were deliberately destroyed in the eighteenth century as a matter of crass expediency. The Jacobites, it was thought, were in danger of success in the 1745 rebellion. In order to ensure their defeat, the English demolished much of the Wall, flattened it, put rollers over the cut Roman stones and turned it into a road. It is still known as the 'military road', and cuts across Northumberland from Newcastle to Housesteads, which was a substantial Roman camp and barracks. At Housesteads, because the Wall followed the line of a natural crag, the road was diverted into the second Roman line of defence, the *vallum* or rampart, and for several wonderful miles of spectacular beauty beyond Housesteads the Wall has survived.

It was Housesteads and the crag and loch beyond it that William Bell Scott chose for this painting, *The Romans cause a wall to be built*. The setting is very faithful – any modern visitor to Housesteads and Craig Lough would recognise it. The painting of landscape and sky is confident and spacious. Bell Scott then filled his scene with

figures, all carefully faithful portraits of contemporary people. A centurion, who occupies much of the central space of the painting, is rebuking an idle British workman who is taking time out to play at dice. The centurion is a lean, stern young figure, a convincing embodiment of authority in detailed Roman armour. He was modelled from John Clayton, of Chesters, who was Town Clerk of Newcastle. Behind him another dark-haired Roman officer was based on a celebrated antiquarian, Dr John Collingwood Bruce, who was the contemporary authority on the Wall. The Wall divides England from Scotland, and the Caledonians on the right of the painting are attacking the Wall with slingshot and rough spears. Bell Scott worked very fast and with great enthusiasm, and the painting was completed by June 1857.

Bell Scott had used Hadrian's Wall as a subject on an earlier occasion. In 1843 he had made a cartoon of *The Free Northern-Britons Surprising the Roman Wall between the Tyne and the Solway* and submitted it for exhibition in the competition to paint frescoes in the newly completed Westminster Hall. (This work is now in the National Gallery of Scotland.) In that work he depicted the Romans as the enslavers of British liberties, so that the politics of the piece was against progress and in favour of conservative nationalism. The Wallington painting is on the side of progress, and so was Bell Scott's biography of his brother. In her review of that biography (in *The Scotsman*, on 6 April 1850) Pauline quoted and approved this passage:

> Our own age is the only one for us; it is the last and the best: the product of any former does not answer the wants of this. Every great work has been characteristic of the age that gave it birth: judge you what is the character of this age. The days of strong passion and individual exertion have passed away; even the representation of these in art is, perhaps, past.[6]

Because 'St Cuthbert' had been finished out of chronological sequence, Bell Scott's next task was another 'general' subject: it records the many invasions suffered by Northumberland between the seventh and ninth centuries. *The Descent of the Danes* (also known as *The Danes Invade Northumberland*, painted from January to June 1857) uses Pauline herself as model. She is the figure in profile at the top of a group of terrified British in flight from the coast. At

her feet is her dog Peter, and the child in her arms is Walter's niece Evy Faussett, whom Walter and Pauline had effectively adopted.*

No history of the North-East could leave out the great figure of Bede, and Bell Scott painted the death of the great historian and theologian in *Bede finishes his work and dies at Jarrow May 26 734* (painted from June to December 1857). Bede has just finished dictating his translation of St John's Gospel. The subject gave little opportunity for Pre-Raphaelite treatment of the natural world, and instead Bell Scott followed the Brotherhood's treatment of Christian themes in works like Rossetti's *The Girlhood of Mary Virgin* and Holman Hunt's *The Light of the World* by loading the canvas with emblematic details. A dove (representing Bede's soul) flies out of the window, an hourglass marks the passing of his earthly life and a snuffed-out candle symbolises its extinction. The painting is dark and solemn. This is no doubt appropriate to its subject, but it would benefit from being lifted by some light in the adjacent paintings.

The following painting in the sequence, however, was again an interior scene. *The spur in the dish warns the border chief that the larder needs replenishing* (painted from August 1858 to January 1859) is imagined as taking place in the twelfth century, and the setting, a Norman castle, is the keep of the castle from which Newcastle takes it name. The story is a well-known border legend of a reiver, or warrior chieftain, who lived by pillaging his neighbours' herds. From her reading of Lockhart's *Life of Scott*, Pauline knew the version based on one of Sir Walter Scott's ancestors, 'Auld Wat of Harden' (?1550–1631), whose wife Mary Scott, 'the Flower of Yarrow', would have been the chatelaine in the painting. Walter Scott of Harden and his followers would ride out and rustle cattle from their neighbours, or from the English over the border, and conceal the spoil in a deep glen near the old tower of Harden. When the last bullock from this store was slaughtered and eaten, the lady would place on the table a dish which, when uncovered, was found to contain a pair of clean spurs: a hint to the riders that they must go out on another expedition.[7]

*Walter's sister Helena Caroline Trevelyan (1815–98) had married the Revd Bryan Faussett, but divorced him in 1849. The affair was regarded in society as scandalous, but Walter and his siblings supported their sister in her action. She subsequently married a Trevelyan cousin, Walter Blackett Trevelyan, of the branch of the family that lived (and still live) at Netherwitton in Northumberland. Walter's great-uncle, Walter Trevelyan (1743–1819), had married Margaret Thornton of Netherwitton. In Pauline's time Raleigh Trevelyan (1781–1865) had inherited Netherwitton. Pauline found Helena herself a dull person, but was fond of the Faussett children. For some years Walter and Pauline provided them with a home and looked after them.

Bell Scott wanted Walter to be the model for the central figure of the chieftain, but he declined. Mr William Henry Charlton, a substantial landowner whose family was (and still is) based at Hesleyside, one of the major houses on the upper Tyne, modelled for the chieftain. He had good reason to do so because in another version of the ballad, the story is about his own family: William Henry Charlton proudly displayed in his house what he believed to be the original spur.*

Several other members of William Charlton's family appear in the painting. Local gossip has it that Charlton chose his tenant farmers on the principle that the ones with really attractive wives had priority, and that he then liked to exercise a Northumberland equivalent of *droit de seigneur*. The beautiful woman presenting the spur on the dish is said to be one of his many mistresses selected in this way. Bell Scott wrote to Pauline about the first of the models whom Charlton offered him:

[21 October 1858] Mr Charlton as you see from the enclosed has a lady in his view for the Mistress in my picture – indeed I had guessed as much from what he said at our first interview, only I concluded it would be Mrs Charlton he meant, and I thought how awkward it would be if the offer were made and after all I should have to find a flaw in the diamond or spoil my picture.

William Charlton became enthusiastic about the painting and offered several young women for the role of the 'mistress' (including, of course, the one finally chosen). Bell Scott wrote to Pauline in comic despair:

Mr Charlton came with two men and two dogs, all to go into the picture [*The spur in the dish*]. Telford one of them now lives at Gateshead, but the other (his gamekeeper) had come in on purpose with the dogs. That day and the next I was hard at work you may be sure to get them done and let them home again. Then Mrs George came next morning, a lady Mr Charlton wished to sit for the mistress in the picture because she was a Shaftoe. She is not the lady he expected from York who does not seem to be coming – and on the whole I was not sorry Mrs George had to leave Newcastle so soon she could not give me any time, as she is not a very good model for the character although real Northumbrian.

*A younger son of this family was Dr Charlton, a friend of Pauline and of Henry Acland, who had established Durham University medical school (later to become the nucleus of what is now Newcastle University).

Yesterday I had a note from Mr C[harlton] telling me [he] was going to ride 20 miles for another model who will he expects come in on Tuesday, and he is indeed ready for anything to get the picture right and identified with his country [. . .]

Affectionately yours W.B. Scott

The preoccupation with the models became an obsession partly for the perfectly good artistic reason that Bell Scott wanted to lend coherence to his eight paintings: 'To see the same characters reappear is always interesting whether in story, poem or picture, and in the Bernard picture there must be two opposing sets or families in the little church.' Northumberland families were rooted, very old and all related to each other, and he wanted to convey this. But the flow of offers from the irrepressible Mr Charlton was unstoppable. One of Bell Scott's letters to Walter (21 November 1858) was clearly a cry for help: were the Trevelyans unable to keep their friends under control?

Mr Charlton has been unwearying about the 'Spur in the Dish'. At one time he brought in 3 men, 1 lady and a dog all at once. I began to be ashamed of giving him so much trouble and expense, he would not say and very likely did not know what the expense had been but I could arrive at the railway expenses and prevailed on him to let me pay them, as I have always to pay models.

The painting was becoming over-theatrical, and Bell Scott's account of the way it progressed indicated why this was:

My picture goes on apace. Mr Charlton is about leaving this for a while with all the family if Mrs C is well enough, so he came today for an hour to allow the head to be finished – had he not been leaving, it would have been much better had he delayed till the canvas was covered and the picture about done, but as it is I hope the head will be considered so far satisfactory, not only for the sake of the portrait but as it is the principal point in the picture. The expression I have tried for is suspense and inquiry. The lady stands opposite holding the pewter platter pretty high that she may see how he takes the joke before she plants it on the table. He on the other hand has been ready with his carving knife and seeing from her expression that there is something strange going forward rises partially from his seat.

It was time for a narrative painting about a single figure: *Bernard Gilpin makes peace along the borders, takes down the glove in*

Rothbury Church which had been set up as a challenge between the warring families 1570 (painted from January to August 1859). Bernard Gilpin (1516–84) was a famous Church of England clergyman, the rector for many years of Houghton-le-Spring, at that date one of the wealthiest livings in the diocese of Durham. Gilpin had been an uneasy Roman Catholic under Queen Mary and believed that he was in danger of being burnt at the stake for heresy; the succession of Elizabeth effectively saved him. He was a man of huge physical courage, famous in Northumberland for preaching tours designed to put an end to the feuds between the families of the lawless border brigands. By sheer force of eloquence he prevented two armed gangs from attacking each other in Rothbury church, and at another Northumberland church he personally took down the glove that had been placed as a challenge by one of these factions. Bell Scott's painting, notionally set in Rothbury church, combines these two stories. In it Gilpin takes down the glove and intervenes between the factions. Walter Trevelyan is the figure reading the lesson; a young local farmer is the owner of the glove; W.B. Scott is the figure in the helmet; and David Wooster is the figure on the far left.

There was sharp disagreement over this painting: the Trevelyans both wanted more fresh air in the paintings and had hoped that the Gilpin picture would display their beloved Northumberland country-side. Bell Scott was vexed, writing (on 24 February 1859):

My dear Sir Walter
 Many thanks for your note, although it has quite unsettled my ideas on the scheme of the Bernard Gilpin picture, so much so that I now write, to lay my view on the subject before you, and shall suspend work till hearing again. For the last month I have thought over it, and for these two weeks have been sketching and planning it, and now have it fairly drawn in white chalk on the canvas and have begun painting. The idea of making it an open air scene never suggested itself, and if, on reconsidering, you wish me to adopt that plan of design you so well describe, but wd appear to me to be liable to certain quite serious objections to be mentioned afterwards – I shall at once try it and work upon. there is very little done on the canvas yet of course.

Bell Scott went on to play his strongest card, authenticity: the original anecdote of Bernard Gilpin had the events all taking place inside a church, and it would be unfaithful to his source to change the setting. His opinion prevailed, and the result is somewhat

claustrophobic. It was not what the Trevelyans had wanted, but they acquiesced. Bell Scott particularly hoped for a genuine red-haired Northumbrian as a leader of one of the violent border factions who appear in *Gilpin*. Alfred Trevelyan, heir to Walter's baronetcy, was one possibility, while Swinburne was another. Because Swinburne was a personal friend, Bell Scott felt betrayed when he left the North without warning and was therefore not available as a model. 'Algernon's going off so soon is quite a disappointment,' he exclaimed. 'Must I give him up? Is he gone already? I must have a red haired Northumbrian in my picture, and if not him, then some one you don't know.' Eventually he settled for a farmer called Charleton, whose farm, Lee Hall, was near Hesleyside, home of the William Henry Charlton who had appeared in *The spur in the dish*.* Bell Scott was particularly pleased with Charleton, a red-haired, aggressive, young and wholly typical local figure.

From a sixteenth-century subject, the sequence of paintings now moved rather briskly to a nineteenth-century story: *Grace Darling* (painted from January to October 1860). Grace Darling was the daughter of a lighthouse keeper. She and her father saved the survivors from the wreck of a steamer, the *Forfarshire*, on the Farne rocks on 7 September 1838. Alice Boyd, Bell Scott's companion, is the prominent figure in the foreground. In this painting the Trevelyans were at last getting some of the Pre-Raphaelite treatment of sea and sky that they had hoped for. Bell Scott was particularly pleased with the sea painting in this canvas:

> [3 September 1860] I myself privately believe that a storm was never so well painted before nor the earnest simplicity of the sailor character so well rendered. Of course it is easy to make abysses of lamp black and white, and put boats by the half dozen toppling over in various directions for the sake of composition where no boat could live for a minute, as Turner and other cockneys have done, but to depict not merely a possible storm but a real and convincing one is another sort of matter. [And later he writes] Of course when I praise my pictures I mean to be jocular, so don't expect so much that you will be disappointed even if it is really like the real thing.

The last painting was completed in 1861 and is clearly the most important of the cycle: *In the nineteenth century the Northumbrians*

*The variation in spelling dated only from the eighteenth century: it was the same family.

show the world what can be done with iron and coal, abbreviated as
Iron and Coal (January to June 1861). Bell Scott visited Stephenson's
railway-engine works to see a locomotive wheel being forged to give
him his central action, but the painting as a whole is a composite
showing the Tyneside industries: an Armstrong gun barrel and a shell,
a locomotive wheel, barges carrying coal, a train crossing Robert
Stephenson's newly completed High Level Bridge. One of the men
wielding the hammers (the figure on the left) is drawn from Charles
Edward Trevelyan, who in due course inherited Wallington.

Iron and coal is a resonant title, which explicitly links the painting
to the English School of geology: William Buckland had written that
iron and coal were part of the dispensation of Divine providence.
They 'increase the riches, and multiply the comforts, and ameliorate
the condition of mankind' and were placed conveniently for these
purposes as 'part of the design, with which they were, ages ago,
disposed in a manner so admirably adapted to the benefit of the
human race'.[8]

The most moving and personal of Bell Scott's paintings at
Wallington is not part of the cycle: it is his portrait of Pauline
Trevelyan painted in 1865, the year before she died. What we see is
not a conventionally beautiful woman, but a slight figure with an
upturned nose and a tightly drawn hairstyle. However, the whole
canvas is irradiated with the artist's love for the subject. Pauline comes
alive in this painting as she does not in Alexander Munro's distin-
guished bas-relief medallion of her (also at Wallington) and in
photographs.

The length and detail of Bell Scott's letters demonstrate his anxiety
about his paintings and about the appearance of the whole scheme.
On 14 August 1857 he wrote to Walter angrily resisting the proposed
display of 'stuffed birds' in the Hall:

Will you please thank Lady Trevelyan for her notes. she says I approve
of the stuffed birds being set into the hall instead of the gallery – and
I write expressly to say that I don't do so at all, – this is entirely wrong,
the artistic unity of the hall will be broken and in spite of the finest
stuffing it will take a Museum character. John Hancock [celebrated
local naturalist] and I have had disputes on the subject of stuffed Birds,
I do not remember expressing approval of the Hall for his works, but
I have felt a desire to keep off the question with him. He has ideas of
Bird-stuffing as fine art which make him try always to put his stuffed
birds with the painting & sculpture departments of public exhibition.

Wax works & preserved animals are not and I hope never will be considered equal companions for the simple forms of imitation so decidedly removed from nature, painting and sculpture. I hope you will think over the arrangement again, at the same time I would not have interfered, as it seems as if I were selfish – a dog in a manger – but that Lady Trevelyan expresses herself as if *I* had favoured the change you seem to have in view.

His moods could swing very sharply. Some of the paintings were exhibited publicly before being hung in the Hall. For Bell Scott this was very important, and the Trevelyans readily and generously agreed. But when *Bede* was hung in Edinburgh at the Scottish Academy, it was 'put in the very worst place that the rooms afford', as he lamented to Pauline on 14 February 1858: it was in 'that small side place half dark you may recollect, and there it was high up & sloped forward. The day was very dark, and I confess to you the shock was more than merely humiliating and painful.' Meanwhile the quarrel with Hancock over those hateful stuffed birds was not quite over. On 16 December 1858 he wrote: 'The group of birds is still in the Lit and Phil but I understand John Hancock speaks of getting it out to Wallington.'

The hapless Wooster continued to serve as comic relief when Bell Scott was feeling upset or neglected, or both. In March 1859 he complained about the fact that Trevelyans were still on their travels: 'Wallington is to be left to Mr Wooster, and even he, poor man, with his 'ed like to split has left it too. Here is the middle of the 3rd month of the year and no word of Sir Walter & you in these spring days such as you never saw before in Northumberland.' Bell Scott was impatient for Walter to model for the reader in the Gilpin painting: 'I have purposely made an opening for Sir Walter's portrait in this picture; and hope he will sit – this Bernard Gilpin picture is the only chance we have of him commemorated in the series now, at least I don't think the 19th century picture will afford a proper opportunity.'

There can be no doubt that Bell Scott was more than a little in love with Pauline. Rossetti teased him with a limerick suggesting that she was equally in love with him:

> There once was a Lady Trevillian
> Whose charms were as one in a million.
> Her husband drank tea
> And talked lectures at she,
> But she had no eyes but for William.[9]

In May 1859, however, Bell Scott met another, more serious love. Alice Boyd, from a family of substantial Scottish gentry, was now in her thirties. She lived with and nursed her fatally ill brother and had been suffering from a depressive illness. She came to Bell Scott to learn to paint as a kind of therapy. This was the woman who was to make his marriage to Letitia bearable: 'I have got acquainted with such a delightful new friend! Miss Boyd of Ayr Shire who came to me about learning to paint, and whom I have in a friendly way been doing my best to make an artist. She can scarcely walk about, so weakly, but full of spirits, and enthusiastic about the new pleasure she has discovered in painting. Such an amiable good soul she is, and such a sweet candid expression she has!' Alice Boyd had lifted his mood so much that he could write playfully about Rossetti's neglect of him: 'Is he to be pressganged into the British Navy and sent to fight for Italian liberty? [. . .] I have a dozen times been angry with him, and then he does something kind – sometimes not exactly wanted – that counterbalances.' And he could even manage to be moderately nice about Ruskin: 'Have you read Ruskin's "Two Paths"? A book of most delightful criticism and charming writing, which might just as well have been called the "morning Star" or the "Four Elements".'

Trouble over the paintings continued: Walter had disliked the armaments included in *Iron and coal* and he was cool about the proposal to paint a fresco of the battle of Chevy Chase (subject of the most famous of the border ballads) on the upper walls of the central saloon. Walter was a leading expert on the history of Northumberland and on the border ballads, and he could reasonably have been expected to accept that the border wars were inevitably part of that history, but at this stage he was resisting. Bell Scott wrote to him about all this on Friday 28 March 1860:

It is a great pity – (it seems to me) that none of our pictures in Wallington represents the struggles between the two nations at Chevy Chase or elsewhere. And about the Armstrong gun & shell. Do you think there is a true analogy between these and a gin palace &c as you hint? The gin palace is by no means characteristic of the Tyne. If a painter were illustrating low life in London he could not ignore the gin palace, the same as in illustrating the manufacturing industry of the Tyne, we cannot ignore the Iron Works and inventions, especially the latest invention. If you were writing or having written a History of England would you omit the greater part of it? If so, what would be the result? The

united action of men in the shape of war is no doubt a legitimate outcoming of human nature, part of the necessary experience and education of Man in Time, which no doubt he will outlive and it is to be hoped he will not need many more centuries to do so. But to ignore anything is not to annul it, to ignore facts seems to me to be shutting one's eyes against so much more knowledge necessary to make up our judgement correctly. Fortitude, endurance, heroism, selfsacrifice, and so on, are no doubt parts of war as well as the destructive passions, and the Armstrong gun & shell are simply engineering inventions.

Walter was paying – and paying handsomely – for the whole scheme, so he felt entitled to have his opinion. But with further persuasion, both from Pauline and from James Leathart, whose opinion Walter was bound to respect, Bell Scott prevailed. He was permitted his Armstrong gun and shell and he was allowed to paint Chevy Chase on the upper walls. His confidence in *Iron and coal* continued to waver, though, because even he felt that by the time he was finishing the painting he had packed too much narrative into it:

The 'Nineteenth Century' is drawing towards a close. Heaven knows whether it is the best or not. I hope it is. The canvas is as full as it can hold. Every thing of the common labour life and applied science of the day, is introduced somehow, besides a mottled sunbeam done so realistically that the flies are beginning to buzz in my studio [. . .] P.S. I know you will punish me for my 'conceit' about the sunbeam. One must have one's joke even if one has to pay for it.

The later friendship with Ruskin

> I have long lamented the mistaken economy of your parents in
> not paying the extra 2d a week for 'manners' when they sent you
> to school.

The end of his marriage to Effie precipitated frantic behaviour in
Ruskin, as though he got onto the upper arc of his manic depres-
sion, or bipolar disorder, and stayed there in desperate flight. He
wrote to Pauline on 24 September 1854 (from Paris):

> I am rolling projects over and over in my head: I want to give short
> lectures to about 200 at once in turn, of the Sign painters – and shop
> decorators – and writing masters – and upholsterers – and masons –
> and brickmakers, and glassblowers, and pottery people – and young
> artists – and young men in general, and school-masters – and young
> ladies in general – and schoolmistresses – and I want to teach
> Illumination to the sign painters and the young ladies; and to have prayer
> books all written again; (only the Liturgy altered first, as I told you) –
> and I want to explode printing; and gunpowder – the two great curses
> of the age.

He was going to set up his own museum (he did in due course
do this, when he created the St George's Guild Museum at
Sheffield):

> A room where anybody can go in all day and always see nothing in it
> but what is good: and I want to have a black hole, where they shall see
> nothing but what is bad: filled with Claudes, & Sir Charles Barry's
> architecture – and so on – and I want to have a little Academy of my
> own in all the manufacturing towns – and to get the young artists –
> preRaphaelite always, to help me – and I want to have an Academy
> exhibition – an opposition shop – where all the pictures shall be hung
> on the line; in nice little rooms, decorated in a Giottesque manner; and
> no bad pictures let in – and none good turned out and very few alto-
> gether – and only a certain number of people let in each day – by ticket
> – so as to have no elbowing.[1]

Now that he was a bachelor again, Ruskin needed to find new projects and to immerse himself in a circle of friends. One way to achieve this was to volunteer to teach at the Working Men's College. This institution, founded in Red Lion Square by F.D. Maurice, the Christian Socialist, was patronised by Carlyle and enjoyed the services of Ruskin, the greatest critic of the age; of Rossetti, now Ruskin's principal ally (as he thought) among the painters; and of Edward Burne-Jones, the most brilliant of Ruskin's younger disciples.

As a further step to re-enter the world of painters, Ruskin sent two more letters to *The Times*, this time specifically defending two of Holman's Hunt's most celebrated paintings, *The Light of the World* and *The Awakening Conscience*. The first of these letters begins with a rhetorical move familiar from his defence of Turner in 1843 – he is championing a misunderstood and traduced work of art: 'I watched the effect [*The Light of the World*] produced upon the passers-by. Few stopped to look at it, and those who did almost invariably with some contemptuous expression, founded on what appeared to them the absurdity of representing the Saviour with a lantern in his hand.' As an Evangelical immersed in the Bible since the age of three, Ruskin is able to put such irresponsible spectators right. He points out that Holman Hunt has quoted 'Behold, I stand at the door and knock' to accompany the painting, and then gives his reading: 'On the left-hand side of the picture is seen this door of the human soul. It is fast barred: its bars and nails are rusty; it is knitted and bound to its stanchions by creeping tendrils of ivy, showing that it has never been opened. A bat hovers about it; its threshold is overgrown with brambles, nettles, and fruitless corn [. . .] when Christ enters any human heart, he bears with him a twofold light'[2] (these are the light of conscience and the light of peace). We know that Ruskin's decoding of the painting is exactly as Holman Hunt intended. With the second painting, however, he misses the point that it is a companion work to the first. The Ruskin whose social conscience was already stirring in *The Seven Lamps of Architecture* reads the painting as social abuse that elicits compassion. The fallen woman is leaving her heartless upper-class lover and runs the risk of becoming a common street walker. But Hunt's picture is Christian, not social, and it depicts the moment of Christian revelation in contemporary life. The artist is not actually much interested in how the redeemed woman will make a living once she has put her rich lover behind her. Pauline saw this more clearly

than Ruskin, and indeed was more discriminating about Holman Hunt's work in general than he was (we have seen that she disagreed with his reservations over *The Scapegoat*).[3] Pauline warmly endorsed the opening of Ruskin's pamphlet, *Pre-Raphaelitism* (1851), especially the comments on work: 'In order that a man may be happy, it is necessary that he should not only be capable of his work, but a good judge of his work.' This chimed favourably with everything she felt about her artists and sculptors, both at Wallington and at Oxford.

The former Pre-Raphaelites were not about to include Ruskin within their inner circle. They saw him as a source of money and patronage, but kept him at a distance. Ruskin's need to exercise power and to force his writers into intimate relationships with himself was so strong that he made extravagant claims for another woman, Elizabeth Siddal (1834–62), who in due course became Rossetti's wife. Ruskin befriended her largely, it seems, in order to strengthen his hold on Rossetti. In 1855, the year in which Pauline's own involvement with the Pre-Raphaelites became serious and committed, Ruskin persuaded Henry Acland to give Elizabeth Siddal medical attention (something that greatly overworked and conscientious man could well have done without). He wrote to Acland's wife about Siddal's impending visit to Oxford: 'These geniuses are all alike, little and big. I have known five of them – Turner, Watts, Millais, Rossetti, and this girl – and I don't know which was, or which is, wrong-headedest.'[4] He was pressing several points: that Lizzie was a genius (clearly she was not); that he was an intimate and brother of the young Pre-Raphaelites (they did not think so); and that he had the right to tell them what was in their best interest as artists (Rossetti, in particular, consistently resented that aspect of Ruskin's patronage). Ruskin was lonely. Millais had proved treacherous; Rossetti and Lizzie were now to replace him.

Pauline's good sense was a restraining influence. Perhaps if she had lived longer, we would have been spared some of the wilder judgements that Ruskin made in the 1870s and 1880s.*

It was characteristic of Ruskin's relationship with Pauline that he wanted to share with her some of the most important of his own

*There were some female favourites in these decades – most notoriously the children's book illustrator Kate Greenaway and the American dilettante Francesca Alexander – whose work was championed for reasons that had more to do with Ruskin's temperamental and emotional needs than with his probity as a critic.

discoveries as he learnt and grew as a critic. There was an intellectual communion with her which was second only to that with his own father, as far as one can tell from the surviving letters. In September 1849 he had gone to the Louvre in Paris and stood before Paolo Veronese's *The Marriage at Cana*. He wrote in his diary as follows:

> I felt as if had been plunged into a sea of wine of thought, and must drink to drowning. But the first distinct impression which fixed itself on one was that of the entire superiority of Painting to Literature as a test, expression, and record of human intellect. [. . .] I felt assured that more of Man, more of awful and inconceivable intellect, went to the making of that picture than of a thousand poems. I saw at once the whole life of the man – his religion, his conception of humanity, his reach of conscience, of moral feeling, his kingly imaginative power.[5]

A letter to Pauline in 1859 revisited this sensation in the presence of the painting. It is significant that it was to her, this retiring and steady friend in the North, rather than to one of the young lions among his London painters, that Ruskin sent this deeply personal observation:

> I always go straight to Paul Veronese, if I can – after leaving Chamouni; this time I had very nearly cried: the great painting seemed so inexpressibly sublime – more sublime even than the mountains – owing to the greater comprehensibility of the power. The mountains are part of the daily, but far off, mystery of the universe – but Veronese's painting always makes me feel as if an archangel had come down into the room, and were working before my eyes. I don't mean in the *piety* of the painting, but in its power [. . .] The Titians and Giorgiones are all very well – but quite *human*. Veronese is *super*human.[6]

In his Edinburgh lecture on 'Pre-Raphaelitism', Ruskin articulated what Pauline certainly recognised as a central tenet both of his teaching and of her own belief and practice:

> Pre-Raphaelitism has but one principle, that of absolute, uncompromising truth in all that it does, obtained by working everything, down to the most minute detail, from nature, and from nature only. Every Pre-Raphaelite landscape background is painted to the last touch, in the open air, from the thing itself. Every Pre-Raphaelite figure, however studied in expression, is a true portrait of some living person.[7]

And what did her learn from her? Pauline (with Walter) taught Ruskin a good deal about the most responsible way in which authority could be exercised. Ruskin was always conscious of being middle-class, not a real gentleman scholar of Christ Church, and yet the young hereditary aristocrats who were his fellow students repelled him somewhat. Later he formed unwisely snobbish friendships with, for example, Lady Mount Temple. Pauline was the reverse of all that. Ruskin accurately identified her as a woman like Jane Carlyle – a woman of high power, as he put it. Although she had married the heir of great estates, but was herself the daughter of a poor clergyman, she certainly saw life in terms of intellectual and spiritual qualities rather than land and money. She valued good breeding, but like Jane Austen she valued intelligence equally. From her example Ruskin could have learnt (perhaps did learn) about stoicism, obligation, responsibility, good husbandry and the need to recognise a woman as an intellectual equal.

Over the failure of his marriage, Pauline proved absolutely loyal. On 8 May 1854 Ruskin wrote to her: 'I received your little line with deep gratitude – fearing that even you might for a little while have been something altered to me by what has happened.'[8] In her diary she wrote that Ruskin should probably never have married at all, but in correspondence with him she did not waver. She had been very friendly with Effie, but was prepared to take Ruskin's side completely after Effie had left. Ruskin's continuing letters to Pauline show how fully her (lost) letters to him expressed support. He wrote from Geneva on 5 June 1854:

> Your kind letter – received last night – was one of great comfort to my father & mother as well as to myself. So far from drawing back from sympathy – and distrusting my friends – I never felt the need of them so much. I am only afraid of their distrusting me. For indeed that young wife – in Effies position, should leave her husband in this desperate way, might well make the world inclined to believe that the husband had treated her most cruelly. It is impossible for people not to think so – who do not know me, and though I am as independent of the world as most people, I am not used to be looked upon as Effie will make some people look upon me – and I am very grateful to my unshaken friends.

He worked in the observation that Effie had flirted with other men throughout their married life together, and that he had not attempted to stop her:

I had no capacity for watching flirtations – I might as well have set myself to learn a new science, as to guess at peoples characters and meanings. I should never have had any peace of mind, if I had been always thinking how far Effie was going – with this person or that. I knew her to be clever – and for a long time believed she loved me – I thought her both too clever – & too affectionate – to pass the bounds of what was either prudent for herself or kind to me. I also was induced to believe that her influence over several young men whom she got about her was very useful to them.[9]

Despite Millais's involvement with Effie, Ruskin had for a while tried to continue some kind of friendship with him (Millais briskly rebuffed him). Ruskin was genuinely astonished that Millais should fall in love with someone as 'commonplace' as Effie, the 'Scotch wife', and in this letter to Pauline spoke of it as a failure of good sense. With regard to Effie herself, he complained not so much of the flirtations as of the complete lack of sympathy and of intellectual common ground:

She is such a mass of contradiction that I pass continually from pity to indignation – & back again – But there was so much that was base and false in her last conduct that I cannot trust to anything she ever said or did.

He declared that he loved Effie, but that she was contemptuous and mocking:

She never praised me nor sympathised in my work – but always laughed at me – I can bear being laughed at as well as most people – but it is not the way in which a wife is likely to increase her husbands regard for her. Finally she drew from my affection all she could – and was perpetually demanding more – and trying to shake me in my settled purposes & principles. No wonder that a cord – so hardly strained, should seem to hang loose sometimes.[10]

While still in pain over his marriage later in the year, he admired the stoicism with which Pauline and Walter confronted problems of their own: they had both been ill, and on top of that one of Walter's brothers had killed himself (for reasons that remain obscure: this was Edward Spencer Trevelyan, 1807–54). Ruskin wrote to Pauline from Paris on 24 September 1854:

We are all most truly sorry for Sir Walter, and for you. Poor Sir Walter has indeed had much to suffer – first in his anxiety about your health – and then when you were getting better these bitter sorrows striking him again and again – like the Northumberland rain beating on his bare forehead as we crossed the moor [in June 1853]. You are both of you good people, and I think that must be the reason you have so much to suffer – you would have been too happy, but for such things as these. Men must have sorrow in this world; and it takes hard blows to make them sorrowful when they are good.[11]

The relationship between Pauline and Ruskin had changed. The 'Master' was now a wounded hero, and Pauline's love for him was strengthened by the vulnerability that he displayed. They were increasingly open with each other: Pauline allowed small jokes at Walter's expense, and Ruskin dared to disagree fundamentally (though with grace and wit) with some of Walter's beliefs. He did fully agree with Walter's opposition to warfare, though, and was astonished by Pauline's support for the Crimean War. War with Russia had been declared by Britain earlier in the year, and Pauline took the conventional view that it was a noble opportunity for the British to prove themselves a heroic rather than merely a prosperous nation. 'I hope you are insane about the War,' she wrote on 11 December 1854. 'You are perverse enough to say that you don't care about it, just out of malicious wickedness. Pray don't. It is such a wonderful thing and will do everybody such a quantity of good, and will shake up the lazy luxurious youth of England out of conventionalism and affectation into manhood and nobleness.'[12] Sydney Dobell's poems, which she had read and praised, argued the same view of the Crimean War.* 'No one has yet succeeded in laughing England's chivalry away!' she declared resonantly. A whole Romantic brew of King Arthur, Walter Scott and Tennyson lies behind that statement. Ruskin could not take it.

He was more comfortable with her on the question of alcohol. To Walter, alcohol was simply an abominable social evil while Ruskin, as a wine merchant's son, could agree with Pauline that the occasional drink would be good for Walter, writing on 3 June 1855:

*Dobell's narrative poem 'Home, Wounded', for example, praises a returning soldier for his chivalrous sacrifice for his country, and tenderly traces his recovery in the care of his brother. Pauline admired this poem.

I am sorry I was not in town when Sir Walter came up. I was a good deal surprised at his thinking it possible to introduce that Maine law [absolute prohibition of alcohol, introduced in the state of Maine in 1851] among us: I have no opinions or judgement on such matters myself – having no knowledge – all I feel about it is that there is a certain poetry in Beer – and a peculiar, racy, Shakespearean odour of non-sanctity in a Tavern which I should be sorry to lose, for my own share – which consists in grave contemplation of said taverns from the opposite sides of roads – I have still a certain Sir Tobyish sympathy with the Cakes & Ale, which makes me believe in their Perpetuity.

In her reply, on 5 July 1855, Pauline tactfully ignored the bit about the odour of non-sanctity (though she certainly agreed with it) and instead glanced indirectly at Walter's frugal lifestyle, with a reminder that as his wife she was forced to observe the habits of the border reiver country (the theme of Bell Scott's painting, *The spur in the dish*):

Sir Walter has just been to London again about a railway bill & is only now come home – that's the way wives are treated – and what was worse he carried off the key of my stores room & we were reduced to great distress for food, but fortunately I found an opportunity of stealing some tea & sugar which in these Border counties is the natural way of supplying ones household wants.

Ruskin had to get over his feelings about Millais. In his *Academy Notes* (his commentary on the Royal Academy summer exhibition, published annually between 1855 and 1859, and resumed much later in 1875), he displayed an exhausting and stressful degree of objectivity in 1855 and 1856, giving excessive praise to the Millais paintings of those years. Millais's indifferent painting of a fireman rescuing a child from a burning building, *The Rescue* (1855), was hailed as 'the only great picture exhibited this year',[13] and his much better painting *Autumn Leaves* (1856) seemed to be almost beyond Ruskin's powers of praise: 'By much the most poetical work the painter has yet conceived; and also, as far as I know, the first instance existing of a perfectly painted twilight.'[14] The praise of Millais was in a sense made necessary by Ruskin's 'programme' in the *Academy Notes*, since he was using the *Notes* to mark the victory of the painterly revolution that he himself had championed – that of the Pre-Raphaelites – over the old Academicians: the visitor to the Academy

exhibition 'can no longer distinguish the Pre-Raphaelite works as a separate class:'

> Between them and the comparatively few pictures remaining quite of the old school, there is a perfectly unbroken gradation, formed by the works of painters in various stages of progress, struggling forward out of their conventionalism to the Pre-Raphaelite standard. The meaning of this is that the battle is completely and confessedly won by the latter party; that animosity has changed into emulation, astonishment into sympathy, and that a true and consistent school of art is at last established in the Royal Academy of England.[15]

It was a victory for Ruskin's teaching. But from 1857 he no longer needed to go on pointing to Millais's work as part of this victory, and could instead start punishing him for haste and carelessness. Forbearance and nobility in his dealings with Millais were now replaced by naked aggression. Millais's work had always shown 'promise', but even in *Autumn Leaves*[16] there was 'slovenliness and imperfection [. . .] which I did not speak of, because I thought them accidental'. But now the truth must out:

> As it is possible to stoop to victory, it is also possible to climb to defeat; and I see with consternation that it was not the Parnassian rock which Mr Millais was ascending, it was the Tarpeian. The change in his manner, from the years of 'Ophelia' and 'Mariana' to 1857, is not merely Fall – it is Catastrophe; not merely a loss of power, but a reversal of principle: his excellence has been effaced.[17]

The immediate occasion for this was *Sir Isumbras at the Ford*, which indeed is not a good painting (though what we see now is not what Ruskin saw, since Millais altered it substantially after reading Ruskin's critique). A knight carries two peasant children over a stream on a huge, ungainly horse. This painting was greatly disliked by the critics, some of whom were inclined to blame its shortcomings on Ruskin himself. A contemporary cartoon in cruel parody of the painting has Millais riding a donkey – the donkey is 'J.R. Oxon', thus Ruskin himself – with Rossetti (on Millais's lap) and Holman Hunt (clinging on behind) as the two peasant children.

Ruskin was still seen in the popular imagination as the critic who had created the careers of Millais, Rossetti and Holman Hunt. By turning on Millais in his writing, he was in a sense punishing his

own progeny. He gave short shrift to *The Escape of a Heretic* ('an example of the darkest error in judgement'). He then extended the attack to give a more-in-sorrow-than-in-anger general rebuke to this prodigal who had so betrayed the ideals that he once embodied. Ruskin closed by throwing down a challenge that was also a valediction. Relations with this once-beloved young genius were now, in effect, severed:

> It seems to be within the purpose of Providence sometimes to bestow great powers only that we may be humiliated by their failure, or appalled by their annihilation; and sometimes to strengthen the hills with iron, only that they may attract the thunderbolt. A time is probably fixed in every man's career, when his own choice determines the relation of his own endowments with his destiny; and the time has come when this painter must choose, and choose finally, whether the eminence he cannot abdicate is to make him conspicuous in honour, or in ruin.[18]

Although Ruskin could never like Bell Scott, he willingly gave advice on the decorative scheme for Wallington. He saw the Trevelyans often in London and Oxford in 1856, and the following year he visited Wallington again, partly to see the Bell Scott paintings as far as they had progressed. He made two visits, on 14 July for a few days on his way to Scotland (where he travelled with his parents and Henry Acland) and again on 17 and 18 September.

He interrupted the *Academy Notes* in 1859, but continued to visit the Royal Academy exhibitions every year and often referred to them in his letters. In May 1860, for example, shortly after the opening of the Royal Academy exhibition, he wrote to tease Pauline (as he often did) about the Northumberland climate:

> There's a beautiful picture of your county in spring the exhibition – It's all white – except the sky – which is black, and – Stop – I think I can draw it
> A.B. sky
> C.D. an amusing road
> F.G. a snow drift
> T. a tree, growing

(The painting was possibly *A Rustic Path: Winter* by Andrew MacCallum.[19]) Ruskin loved to play with the idea that the Northumberland 'spring' comprised snow and ice until the middle of June.

The *Academy Notes* had been hugely influential. In 1858 Ruskin had complained about the lack of paintings of blossom: 'How strange that among all this painting of delicate detail there is not a true one of English spring! – that no Pre-Raphaelite has painted a cherry-tree in blossom, dark-white against the twilight of April.'[20] The painters acted on this hint all too assiduously. By 1859 he was complaining of an excess of paintings of blossom in the Academy. That year's exhibition gave him further opportunities for slaps at Millais, both in the Preface and the *Notes* themselves. In the Preface he remarked breezily that traditional contributors, both Academic and Pre-Raphaelite, were either absent or 'indolent' (Millais was clearly the latter),[21] while good new artists were coming up to eclipse them (Millais would be squeezed out by more serious young competitors). On Millais's own paintings, Ruskin was both grand and harsh. While *The Vale of Rest* was still 'great', though 'ugly' and 'crude', *Spring* (normally known as *Apple Blossoms*) was mere prettiness, 'fierce and rigid', with 'petals, as it were, of japanned brass', which contrasted tragically with the 'lovely wild roses and flowers scattered on the stream in the Ophelia' (Millais's major Academy painting of 1852). 'There is,' Ruskin proceeded, 'I regret to say, no ground for any diminution of the doubt which I expressed two years since respecting the future career of a painter who can fall thus strangely beneath himself.'[22] This was followed by a sonorous elegy for the career of a potentially great artist who had fatally abused his talent (and neglected Ruskin's clear teaching):

> The power has not yet left him. With all its faults, and they are grievous, this is still mighty painting: nothing else is as strong, or approximately as strong, within these walls. But it is a phenomenon, so far as I know, unparalleled hitherto in art history, that any workman capable of so much should rest content with so little. All former art, by men of any intellect, has been wrought, under whatever limitations of time, as well as the painter could do it; evidently with an effort to reach something beyond what was actually done: if a sketch, the sketch showed a straining towards completion; if a picture, it showed a straining to a higher perfection. But here, we have a careless and insolent indication of things that might be; not the splendid promise of a grand impatience, but the scrabbled remnant of a scornfully abandoned aim.[23]

Ruskin was continuing to publish and lecture on art during the 1850s, and Pauline was constantly pressing him to come and give

lectures in Newcastle (the invitations were formally from Bell Scott, and the venue would have been his College of Art and the adjacent Literary and Philosophical Society). Ruskin promised to visit and lecture in the spring of 1858, but then withdrew the promise because an invitation to give the same lectures a little later in Glasgow was withdrawn. Bell Scott was very put out. Ruskin wrote to Pauline in December 1857:

> After all the mischief you have ever known of me, can you imagine such a thing as my not coming this spring? But the Glasgow people don't want me – and say that in April they could not get an audience, and therefore I've not written any lectures – & can't therefore read them at Newcastle. I did not know the Glasgow people had altered their minds till lately – a day or two ago, but I thought it very likely they might & so wrote no lectures. Even with this additional time I shall not get all done that I wanted to do at the National gallery [where he was working on the thousands of sketches and watercolours left by Turner], before the London season fairly sets in. Its no use making any excuses. I know you'll call me all manner of names – so I must leave you to select them. I'm going to write to Mr Scott.[24]

In 1858 a momentous event took place in Ruskin's life. He had become friendly with the family of John La Touche, a landowner and Dublin banker. Mrs La Touche visited the Ruskins (John Ruskin and his parents) at Denmark Hill to see the Turners, and she brought with her her daughter Rose, then a child of ten. Ruskin fell helplessly in love with this girl, and his relationship with her was to trouble him for the rest of her short life (she died in 1875). Pauline did not get to know of Ruskin's obsession with Rose La Touche for a while (it was being openly discussed between them by 1861), but the turmoil that Rose caused him affected all aspects of his life from their first meeting.[25] Ruskin was capricious about appointments and negligent to the point of rudeness over his correspondence, and this got worse as the obsession with Rose took hold. Pauline wrote to him on 2 May 1859: 'You never answered my last note when I wrote & offered to come to Denmark Hill, which was not pretty of you. But I have long lamented the mistaken economy of your parents in not paying the extra 2d a week for "manners" when they sent you to school.'[26]

Did Pauline never become irritated by the infantile side of Ruskin? His frustration over Rose caused him to make arch and clumsy

flirtatious remarks about a whole range of girls and young women, as in this letter of January 1860 about Pauline's sister 'Mouss' Hilliard: 'I'm very glad it's your sister – Is she as nice as you – and less saucy? My father says he's so glad there are two.' And then there was Ruskin's favourite posture, that of the irresponsible child who cannot be expected to know how to behave:

> My mother says she thinks you really were a little displeased with me for not having written to you for so long. It is no wonder if you were, but the fact is I never care much at present to talk to any of my friends – not thinking that I shall give any pleasure – I have been in bad humour with most things and see no use in complaining.

But beneath the banter there was a serious theme at this date. In 1858 Ruskin had turned away from Evangelical Protestantism in his famous 'unconversion' at Turin. 'I am much changed in many things since you first put up with me,' he told Pauline, and this was one of the major ones.[27] The religious question was regularly touched upon in their letters. Ruskin's tone was usually teasing, but underlying it was their tacit mutual acknowledgement that they could not agree on religious matters. He was becoming increasingly agnostic. He teased her about naming her dog after the first Pontiff within the Roman Catholic dispensation:

> I was so very glad to hear that dear crossgrained Peter was well: – I've always been afraid to ask for him lest I should make you cry – and I thought you were ever so much milder lately from not having been encouraged by him in a Captious disposition.
>
> Talk of High Church principles & call your dog Peter: I wonder where you expect to go.[28]

In 1859 he had stopped writing the *Notes*, but to Pauline he reported that the painters were all slavishly following fashions dictated by him in previous years. The excess of blossom in Millais and others in 1859 was now replaced by an ugly plainness and a seeming abandonment of Pre-Raphaelite truth in nature altogether, 'just like people knocking their heads together in a door way and then standing bowing – to let each other go in first'.[29] The Pre-Raphaelite impetus seemed to have run its course. In any case Ruskin was too busy with the completion of *Modern Painters* to continue with the *Notes*. And one strong impetus for the *Notes* (the need to sort out

his feelings about Millais) had become less urgent, now that he could convince himself of Millais's failure as an artist. Not, of course, that Millais's failure was commercial, but for Ruskin and Pauline that was part of the point. Greedy provincial Effie, they both believed, was driving Millais to paint quickly for money in order to fund her lifestyle.

Ruskin suffered from depression for much of 1859–61, and he supposed that his anger would show in his face. Pauline had a photograph of him, which he disliked, and which he compared in a letter of 1 January 1861 with the portraits that had been made of him: 'I cannot think what it is that has made me so very ugly.' It must have been, he concluded, because he had never been loved: 'I never have had any of my kindly feelings developed – (my best friends taking delight in Tormenting me – like some people I could name).' Pauline had told him that the savagery in his nature was not shown in the portraits of him by George Richmond (two of which had been made in 1857). Ruskin was self-deprecating about his savagery, which was 'savagery against evil', but 'just as ugly as if it were savagery against good'.[30]

'Some people I could name' referred to Rose la Touche. In September 1861 Ruskin was staying with Rose (now thirteen) and her family at Harristown in Ireland. He wrote to Pauline about his weakening of faith, and promised to read Thomas Aquinas on her advice. She hoped it might restore his convictions. 'I will look at Aquinas – when I read next anything of the kind, but no book – however good, can do me much good. It is the course of (so called) "Christanity" in the world which I am watching and from which I reason.' The La Touches were indulging him in their house by allowing him to ignore adult company and spend his time playing with their children: chess with Rose and then reading Scott's *Marmion* to her. Rose's company had put Ruskin in a better mood, and he tactlessly made it plain that his infatuation with her was supplanting his relationships with wiser friends (including Pauline herself):

I don't think I shall get into quite so sulky a fit again, for some time at least – but I don't think that the change of thought & belief has anything to do with temper. The manner of expressing it may be. The change itself is steady and progressive. Rose can always preach me, if she takes it into her little golden head, back into second-volume temper

– but not into second-volume convictions [that is, he could recover the peaceful and even tone of the second volume of *Modern Painters*, but not its spiritual convictions].[31]

It was obvious to Pauline that his love for Rose had become danger-ously obsessional. He wrote on Saturday 28 December 1861, on his way to Switzerland:

> The little work that I'm now good for, goes on a good deal better by lake Lucerne than it would have done, if I had been within a walk of my little Wicklow blossom – What will she say to me now – that I'm half Heathen & half nothing, and can't talk about good things any more! However – I'll take care and not hurt her by letting her see why. Seriously – it is sorrowful work enough this, turning oneself upside down, like a cake on the hearth – when one is within seven years of fifty – Partly because it is worse confusion – and still more because it is hard to lose ones hopeful thoughts of death just when one is growing old.

Ruskin was preoccupied with his fiftieth birthday (which was in fact eight, not seven, years in the future) because Rose appeared to have made some kind of promise to him about the possibility of becoming engaged to him once she was eighteen and marrying him when she reached the age of twenty-one. That would be in 1869: Ruskin would be fifty by that date. Having to wait so long drove him to howls of frustration: 'Such a dreadful book I could write,' he wailed, about his passion for Rose.[32] In his pain he forgot or ignored the fact that the woman to whom he wrote was herself in constant poor health, had been close to death several times already, and was closer to fifty than he was. Pauline did not have 'hopeful thoughts of death', but quite the reverse; she had plenty to live for and wanted, in her courageous pragmatic way, to make the most of her life. What did she write back in response to this naked exposure of his lethal passion for Rose? His next letter to her gives no clues about that. Perhaps she ignored the topic completely and steered carefully away from his obsession to safe neutral topics such as the American Civil War, over which Ruskin merely felt impatience. 'I should like to beat them, if beating would do them good, & they had fair play.' But Americans were 'made of the bad sort of stuff' that would not be shaped by beating. She was being excessively militarist again, as she had been over the Crimean War: 'All our English ideas about war and its legitimate causes are

more like those of schoolboys than of men – and you shouldn't encourage them in such.' Ruskin refused to take sides over the American Civil War. (His father, by contrast, sympathised with the slave-owing Southerners, largely because they resembled English gentlemen.)

Pauline was also a friend of Francis [*sic*] Strong Pattison (1840–1904), again the wife of a much older husband. Francis Pattison was an accomplished painter. Like Pauline, she called Ruskin her 'Master'. He had admired her early work and encouraged her to train as an artist, but he disapproved of her choice of training (at the School of Art at South Kensington). He encouraged her to go into art history rather than practical painting.

In 1861 Francis Strong, aged just twenty-one, married Mark Pattison, a difficult and reclusive Oxford don who had just been elected Rector of Lincoln College. At the time of the marriage Pattison was forty-eight and seemed much older, 'withered in appearance and if intellectually fresh and vigorous, yet preternaturally crabbed in spirit'.[33] This mismatch was one of the sources for the ill-fated marriage of Dorothea Brooke and Mr Casaubon in George Eliot's *Middlemarch*. Through a historical benefaction to Lincoln College, the Rector was something of a local dignitary in Northumberland, and he and his wife made several visits to the county. They probably met the Trevelyans in 1862 when Pattison and his wife stayed at Bamburgh Castle (where the Rector of Lincoln had his own rooms). In 1864 they stayed as guests of the Trevelyans at Wallington. Francis painted one of the pilasters in the Hall and at the same time Pauline painted a successful and richly coloured portrait of this strikingly beautiful young woman. (It is now in London's National Portrait Gallery.) When he retired from the School of Art and visited Wallington in September 1864 to say farewell, Bell Scott met Francis and wrote about her to Alice Boyd:

[She was] about 25 but looks quite between the girl and young lady, a beauty, with her hair *en toupée* like the Queen Anne time, with two loose ringlets hanging from the back of the arms in front of the shoulders. She is tremendous in anecdote and conversation and is considered at Oxford as a pet. Very clever [. . .] She is made up in every possible way, and is the dislike of all the women I fancy. Lady T. I have found out hates her like brimstone, and so do I. She is so pretty, so clever, so brilliant in conversation, knows so many celebrities and is so artificial and heartless, she is a kind of monster.[34]

At the time of this visit, Ellen Heaton – the celebrated and generous Leeds patron of the arts who had competed with Pauline for one of Rossetti's paintings – was also staying at Wallington. Bell Scott had met her at the British Institution exhibition in Newcastle the previous year, as he told Alice Boyd on 6 September 1863: 'a rather pretty little woman in spectacles, very well dressed, full of chatter and as it turned out possessed of discrimination'.

Pauline may have had reservations about Miss Heaton, but there is no evidence at all for Bell Scott's view of Pauline's attitude to Francis. Pauline was fond of this beautiful and much-oppressed young woman.* She admired Francis's independence of spirit (like her adored Loo, Francis was willing to stand up to Ruskin) and could reflect comfortably on the contrast between her own marriage to an older man and her friend's: Pattison was an arid bully while Walter, however wilful and eccentric, was fundamentally generous and considerate.

Ruskin's continuing insensitivity over the topic of death did at last provoke Pauline to rebuke him. He treated the death of Prince Albert in 1861 as though the Queen's genuine and desperate grief was something that could be brushed aside: 'I think all your heads are turned about the queen & her loss – Anything more disagreeable to the nation than that it should so much miss such a man, I never heard of – For the queen – I believe she will get on very well.'[36] For Pauline, fear of widowhood was not a joke but a recurrent reality: Walter (much older than she) was often ill, and her beloved Loo also had a much older husband who was regularly sick. Pauline had clearly rebuked Ruskin for dealing lightly with a serious and painful matter. On 13 January 1862 he wrote: 'I have a dim recollection in reading your letter, of the sort of feeling that it used to be, to be ashamed

*Although she lived in a university city, Francis felt she was excluded from its intellectual life (because she was a woman) and regarded Oxford as a 'hole'. The later story of Francis Strong has interesting twists: within a few years she became an active opponent of the moral content of Ruskin's art teaching. In a review of his first lecture as Slade Professor at Oxford she wrote: 'Art is neither religious nor irreligious, moral nor immoral, useful or useless; if she is interpreted in any one of these senses by the beholder, is she to bear the blame?'

Long after Pauline's death, Francis was widowed and married Sir Charles Wentworth Dilke, with whom she had for many years shared an interest in radical politics and French art. As Emilia Francis Dilke, she became a well-known art historian and renewed her friendship with Ruskin. In 1887 he wrote to her affectionately: 'I thought you always one of my terriblest, unconquerablest, antagonisticest – Philistine – Delilah powers! I thought you at Kensington the sauciest of girls – at Oxford the dangerest of Don-nas.' [35]

of oneself, in the days when one was – but its so long ago that perhaps I'm mistaken, after all.'[37]

By 1860 Ruskin had turned to his important political essays in *The Cornhill Magazine*, later published as *Unto this Last*. Ruskin's father, John James Ruskin, dutifully sent the relevant issues of *The Cornhill* to Pauline and Walter, but his loyalty to his son was greatly strained by these pieces. As he said ruefully in one of his letters to Pauline, the essays were an attack on the merchant class and therefore on John James himself. Further, he was distressed both by the hostility of the reviews that his son's essays received, and by the editor's timidity in the face of this onslaught. Thackeray (editor of *The Cornhill*) was anxious to distance himself from Ruskin's opinions:

> So to relieve him [Thackeray] from the Opprobrium of seeming to approve of anything kind liberal or just towards the Working Classes I let my Sons initials go to the end of the article. The Times some time ago expressed surprise that Dr Guthrie & Mr Ruskin whom they allowed to be both men of Genius should be such perfect Innocents in Political Economy – so I presume we shall have the Slaughter of the Innocents.[38]

Pauline was inclined to agree about the political economy.

Ruskin was delighted that Pauline had commissioned a house in Devon from his favourite architect, Benjamin Woodward. The house was at Seaton, near Axminster, Walter's seaside property. The Trevelyans wanted something highly decorative in the Gothic style and the result, 'Calverley Lodge', had a striking patterned exterior with sandstone squares set into flint to form a chequerboard pattern. The roof, chimneys and windows were all Gothic. However, tuberculosis had been undermining Woodward for many years (since his first involvement with Acland's Museum in Oxford) and in 1861 he died. Had he lived, Walter would have had the whole sea-front of Seaton rebuilt to Gothic designs.[39]

Illness was carrying off some of her friends and was continuing to plague Pauline herself, while three men who were in different ways important to her – Ruskin, his father and Walter – all lamented their own illnesses extensively and with little restraint (Walter in particular suffered acutely from gout and rheumatism). Pauline seldom

referred to her own suffering, but in her letters to Ruskin she expressed
a great deal of concern about her husband and about Ruskin himself.
From her sister's house, Cowley Rectory, near Uxbridge, she wrote
to Ruskin on 20 October 1862:

> Sir Walter has been very unwell lately, and we have come south for him
> to see Doctors & get his Turkish Baths, which do him more good than
> anything. I wonder whether they would do you good? Drive away the
> indigestion, and put Political economy out of your head.[40]

John James Ruskin is the largely unsung hero of the story of John
Ruskin: a man of dignity and probity who dearly loved his brilliant
son, even when Ruskin's behaviour was puzzling or distressing him,
and who throughout his son's adult life (until John James's death in
1864) gave him unswerving personal and financial support. Ruskin's
career was only possible because of his father's wealth and generosity.
The friendship with the Trevelyans was one that John James valued,
as he valued all relationships with the gentry or aristocracy.

But Ruskin could be cruel to his parents. In the summer of 1862
he was so exasperated by his father's dominance that he decided to
set up house independently in Switzerland. He wrote to Pauline from
Milan on 20 July 1862 expressing his frustration with his father and
enlisting her support in his struggle with the old man:

> I know my father is ill – but I cannot stay at home just now, or should
> fall indubitably ill myself also, which would make him worse. He has
> more pleasure if I am able to write him a cheerful letter than generally
> when I'm there – for we disagree about all the Universe, and it vexes
> him – and much more than vexes me. If he loved me less – and believed
> in me more – we should get on – but his whole life is bound up in me
> – and yet he thinks me a fool – that is to say – he is mightily pleased
> if I write anything that has big words and no sense in it – and would
> give half his fortune to make me a member of parliament if he thought
> I would talk – provided only the talk hurt nobody & was in all the
> papers.
> This form of affection galls me like hot iron – and I am in a state
> of subdued fury whenever I am at home which dries all the marrow out
> of every bone in me. Then he hates all my friends – (except you) – and
> I have had to keep them out of the house.

There was probably some truth in this last accusation. John James
certainly disapproved of Ruskin's generosity to Rossetti and Lizzie

Siddal, and was inclined to see the Burne-Joneses too as parasites. It was, of course, John James's money that his son spent on these artists. Ruskin needed to buy friendship, and Rossetti (who had no conscience over money) was always willing to be bought. It was hard for John James to understand his son's aching desire to re-create the old male comradeship of his artist friends following Millais's defection.

Part of the trouble, though, was that Ruskin was in constant torment because of Rose La Touche's behaviour. Her parents had offered him a cottage on their estate in Ireland, but had later with-drawn the offer because their neighbours among the Anglo-Irish gentry were gossiping about Ruskin's inappropriate relationship with Rose. 'I must have a house of my own,' wailed Ruskin. 'The Irish plan fell through in various – unspeakable – somewhat sorrowful ways. – I've had a fine quarrel with Rosie ever since – for not helping me enough.' Throughout his miserable association with Rose La Touche he blamed her for not defending him more strongly to her parents, and for not being unequivocal about her feelings for him. Still, even in a letter that touches on such painful themes, he is able to raise his spirits enough to tease Pauline about her dogs. Peter (her favourite dog) had had to be put down, and Ruskin asks: 'Haven't you got a new dog yet? Peter used to write part of your letters for you I fancy – they've been a little stupider since he died.'[41]

John James's letters to the Trevelyans about John were quite guarded, though his hurt was all too apparent. He wrote to Pauline on 16 August 1862, thanking her for some lace sent to his wife (who had had a fall; she was quite disabled thereafter). His own health, he said sadly, had been damaged by 'our Son's change of plan'. Ruskin had greatly upset them both by deciding not to come home:

> He has again over worked himself painting Frescoes & writing Political Economy [John James always regarded this as a sad abuse of his son's talents] & felt so unwell on reaching Geneva, that he has taken a House there for a month to rest himself & to try how he would like continued Residence there. He has intended having a house abroad for many a year but it has not the less taken us by surprise his stopping short now when we made sure of seeing him [for his mother's birthday on 2 September].[42]

Pauline knew how strong-willed Ruskin was, and she could see how much provocation he had from his parents. Nevertheless, she

chided him about his plans. She wrote from Wallington on 21 August 1862:

> Have you really set up that dreadful house in Switzerland which I always used to hope would blow over? However it is no good even 'wishing' for other people; everyone knows their own affairs best and I trust now you really are at peace you will get well.

She remarked very accurately on what was certainly a central characteristic of Ruskin, his sheer contrariness or perversity when confronted with opposition to his will:

> I have such faith in your perverseness that I have no doubt when you don't live in England, and have nothing more to do with it, you'll begin to like the poor old country and think she was not so bad after all. And also that having satisfactorily got rid of all your friends, set up your hermitage, locked the door, & thrown the key down the well, you will begin to think you like us, and that we are not so bad after all.

And she reacted to his rather tactless joke about her dog by turning the joke against him:

> Indeed it's very true I'm stupider a good deal since Peter died but I can't get another Peter. I have got a dog who is a great beauty – a thorough-bred Skye with lovely hair [the new dog's name was Tiny] and a most amiable disposition, but he is a good gentle sort of dog, well behaved and not amusing. I want a quaint surly old fellow like Peter who takes his own views of things, and likes & dislikes people vigorously. Besides Peter was so like you.[43]

Ruskin responded obstinately from Switzerland in October 1862, 'if I could only find a house to my mind, it would amuse me to arrange things in it – but I have not yet been able to'; and 'My polit. econ goes on too – slowly but nicely, and everything I am able to read is noted for future use in that – which if I live will become my main work.'[44] He knew full well what Pauline would think about that.

Although she was only three years his senior, Pauline became increasingly parental in relation to Ruskin. When John James wrote to her complaining about his son's plans to live in Switzerland, and upset about the way Ruskin's work was being received, Pauline was affectionate and reassuring. Ruskin's misery and depression were

lifting: 'I hope when he comes you will find him really better. I have got a nice letter from him this morning, with much the same account as yours really more cheerful & like himself than usual. I wish he had been going to pay his visit to you at a brighter time of year.'[45]

On 5 March 1863 John James wrote to Pauline with reports of his adored son and with responses to kind enquiries from the Trevelyans about his own and his wife's health:

> Mrs Ruskin remains a fixture to Bed or Chair – in less pain but with less Sleep [. . .] My Son writes he finds the cold [in Switzerland, where Ruskin was still living] so extremely disagreeable that I have some hopes of his postponing if not abandoning his Scheme of making Switzerland his home [Ruskin did indeed abandon the scheme].

John James was engagingly clumsy on what he perceived as the class barrier between himself and the Trevelyans. As a wine merchant, he was condemned against his will to be a natural enemy of Walter's beloved campaign for Temperance:

> I venerate & admire Sir Walter's disposition to labour for the benefit of our Race and even go with him in his views of waterdrinking though I have sold more Sherry last year than ever I did in my Life. I cannot help this – I would join in any crusade against Gin but that some of my best Correspondents have a wing of their Establishment devoted to the sale of this Article. I am sickened at the sight of the Streets. Wretchedness caused by the sale of Spirits & go in heart with all attempt to arrest the evil Consequences of the Sale of this poison.[46]

Ruskin, by contrast, hoped that Walter would be reading Horace on the pleasures of drink ('I am sorry for Sir Walters rheumatism – it serves him right for not believing his Horace and being jolly').[47] Pauline privately concurred: 'I quite agree with you that he wd be better of more stimulants. His Doctors always tell him so – but he is obstinate, like the rest of your weak sex.'[48] The remedies that Walter tried included Turkish and 'Galvanic' baths, but never any alcohol.

For the benefit of their health the Trevelyans visited the Auvergne for part of the summer of 1863, returning to Wallington in good time for Ruskin's visit in August. Despite ill-health and travel Pauline continued to busy herself with the sale of lace made by her lace workers in the west country; Ruskin's mother interested herself in

this and had been buying lace from Pauline for several years. These purchases were the peacable and comforting theme of some of John James's letters to Pauline during 1860–63.

Ruskin never stopped working, however much his private life was in turmoil, and at this date he was finding relief from his anguished feelings about Rose La Touche in the friendships that he had made with the girls of Winnington Hall School, near Manchester. In his letters to Pauline he referred regularly to his flirtations and games with them. To modern sensibilities, his accounts read oddly, but there is an absolute unconsciousness and innocence in all this. He travelled from Winnington to Wallington early in August 1863, having made an excuse to Pauline for keeping a promise to stay at Winnington, and rearranging his visit to Wallington. He wrote to Pauline, 'As I have a remnant of character still to lose at Winnington – and none at Wallington, I think it will be best to keep my word to the schoolgirls – who still believe it a little.'[49] His enthusiasm for Winnington was unbridled, as he wrote on 8 August: 'the girls are out of doors all day at some mischief or other – (what it is called a "School" for, I can't think) and looking mightily pretty glancing in & out among the trees by threes and fours'.[50] The semi-erotic tone was kept up in later letters to Pauline about the girls at the school, as on 25 August 1863: 'I'm so glad you miss me a little – so do I you & Con [Constance Hilliard, 'Mous's daughter and Pauline's niece] – though I've some nice Lily's and Isabelles and May's here to tempt me to inConstancy.'[51]

Ruskin arrived at Wallington on 11 August; it was his first visit there for six years, and the anticipation was intense. The physician John Brown was staying and William Bell Scott had also been summoned. Bell Scott hoped that Ruskin would talk to him about his paintings and that he might secure the commission to decorate the upper part of the Hall, but found that he had to spend time with one of the Miss Percevals, who wanted to learn to paint. She had a dull brother, the future Lord Egmont, a 'cub of seventeen', he wrote to Alice Boyd, who 'never said a word to anyone all the time I was there'. John Brown (1797–1861) was part of Pauline's Edinburgh circle, and one of her closest friends in the North. Through Pauline, he became a close friend of Ruskin, who treated him as a father figure of exceptional wisdom, sanity and loyalty.

The dearness of Wallington was founded, as years went on, more deeply in its having made known to me the best and truest friend of my life; *best* for me, because [as a Scot] he was of my father's race, and native town [Edinburgh]; *truest*, because he knew always how to help us both, and never made any mistakes in doing so – Dr John Brown [. . .] we walked together, with little Connie [Constance Hilliard], on the moors: it dawned on me, so, gradually, what manner of man he was.[52]

Brown did not fully reciprocate this admiration. His surviving letters in which he refers to Ruskin show that his judgement of the critic fell well this side of idolatry. He and Pauline would regularly agree with each other that Ruskin's opinions (especially on religious matters) were extravagant and silly. But Pauline loved and respected Brown, who immortalised Pauline's dog Peter in his celebratred essay about dogs, 'Rab and his Friends'.

In the following letter to Loo, Pauline clearly thought that friendship with Brown would have been good for her too, and she was justifiably pleased to be invited by Brown to write reviews for a quality journal:

> I forget if I have told you of mine & Mr Ruskin's great friend here Dr John Brown? you would delight in him as much as I do – well this said Dr J.B. propounded to me some time ago his opinion that it was my duty to put some studies into the exhibition here, because Mr Ruskin says the landscape people here don't study half enough & that they ought to do large light & shade things of the same sort as mine – I told him I would do nothing of the sort while Mr Ruskin was away, but he persisted beseeched? and teazed so that I was obliged to consent at last, he promising to take all the blame if the 'maestro' does not approve the proceeding.

The most vexing part of this stay, for Bell Scott, was the spectacle of Ruskin enchanting the company. As he wrote to Alice Boyd on 13 August 1863, Ruskin was 'very good and sweet and kind to everybody, myself included, dancing to amuse little Constance Hilliard, and playing at Croquet standing behind the ball before him like a woman, so I suppose one ought to be delighted with him: yet he is a little nauseous'.[53] On 16 August Bell Scott heard 'something concocting' in the morning, and he went up to Pauline's private room to find 'a sweet scene. Lady T and Dr Brown sitting in a wrapt almost devotional attention opposite a row of Turner drawings Ruskin carries about with him, displayed on chairs, the thin figure of the

critic moving fitfully about seeing that they were properly exhibited, and pointing out the "wondrous loveliness" of each. Of course I joined in and cried "Oh, what a glorious treat!"[54]

Ruskin's father died in March 1864, which prompted a cluster of intimate letters to Pauline, and a little later, when his mother was beginning to get over her grief, he returned to the relentless theme of Rose (letter of mid-April 1864): 'Rosie's so ill – you can't think – her mother sent me two photographs yesterday – and she's so wasted away not that there was ever much of her to waste – but there's less, now – & the face full of pain – and she looks about thirty five.'[55]

For much of the summer of 1864 Pauline was in Somerset, staying by the sea on Walter's property at Seaton, where her beloved Loo also had a house. She then went back to Nettlecombe and prepared for the 'Grande Fête and Bazaar' at the South Kensington Museum in aid of the Female School of Art. She had been devoting herself to selling Honiton lace made by Somerset villagers. Her commitment to this philanthropic project benefited the lacemakers and their families and made their work famous. Ruskin became an intermediary in the lace business.

The background to all this was Ruskin's preoccupation with Rose and his need to divert himself with other girls. He clung to the hope that Rose might be willing to become engaged to him when she reached the age of eighteen (which she would on 3 January 1866). At times his excitement about this overshadowed all else. It was obvious to Pauline that he was in a dangerously excitable state over the girls of Miss Bell's school at Winnington Hall. Pauline's niece, Constance Hilliard, was among the girls who excited Ruskin. Pauline put up with all of this, as Ruskin wrote: 'I walked to the Crystal palace yesterday – and the third person I met was Miss Con – papa and mama being the two first. I was pleased, but Con is not growing properly – I like Mr Hilliard more & more, and your sister – for a woman, is well enough';[56] 'I've been having such a game at blindmans-buff [with the girls at Winnington Hall] the ones that have their hair tight let it loose – and the ones that have it loose tie it into knots – and they put on each other's brooches and bracelets – and they plague me out of my poor little halfwits';[57] 'Lily and Isabelle have been rolling me round the room on the floor, and pulling my hair over my eyes, and curling it afterwards';[58] 'the girls are so pleased with my lecture on girls that they've kissed me all to pieces – the

prettiest of them make their lips into little round Os for me whenever I like'.[59]

May 1865 found Ruskin harking back to his other perversity – namely that he was now an economist, not a critic. He had refused to give a lecture on poetry at Oxford: 'I hate Oxford – and I don't know anything about poetry. I only know political economy.'[60] This brilliant, grumpy man who knew nothing about poetry was appealed to by one of the greatest poets of the age, Swinburne, as a judge of poetry. Lord Houghton, Swinburne's influential and in many ways dangerous friend, encouraged Swinburne to show the manuscript of *Poems and Ballads* to Ruskin, and others, before venturing to publish the poems. Pauline was worried that the sexual content of the poems would do Swinburne's reputation harm (which indeed turned out to be the case). Ruskin, by contrast, defended the poems' 'power of imagination and understanding', and he continued to support the volume after publication. The publisher was so shocked by the public abuse that the volume received that it was withdrawn. Ruskin remained staunch.

The miserable relationship with Rose continued to haunt him. He believed that Pauline had had enough of hearing about Rose. He was wrong: what Pauline felt was not impatience, but deep anxiety. Ruskin wrote to her in detail about the agonising relationship at the end of December 1865:

> I fancied you didn't care about Rosie or I should have told you of her sometimes. She is very terrible just now – for at least she has lost nothing in the face, except spoiling her lips a little with winter and rough weather. (for she's out all day long:) and she's tall, and the kind of figure I like best in girls just now [. . .] I'm to have her to take down to dinner on her birthday next week.[61]

The birthday was Rose's eighteenth birthday – and thus, because of the understanding about marriage that Ruskin believed still existed between them, a day of intense disquiet and painful excitement. He gave a dinner party for her (with his mother and his cousin Joan Agnew) and on the same day, or soon afterwards, he proposed marriage. On 2 February 1866 he wrote to Acland that Rose 'asked if I would stay yet three years, and then ask her – for "She could not answer yet."' Rose's parents, who had been increasingly troubled by Ruskin's friendship with their daughter, made it clear that in their

view she was to be free to consider other suitors. In his bitter disappointment, Ruskin felt it imperative to get away, and he planned a continental tour: Joan Agnew and Pauline's niece, Constance Hilliard, were to accompany him. Pauline decided that she and Walter would join the party and travel with them.[62]

CHAPTER 8

Louisa Stewart Mackenzie

Your conduct requires explanation. 'I pause for a reply.'

Corfu had only briefly been Loo's home. In 1843 her father was relieved of his post as Commissioner (partly because of that same Evangelical proselytising that had so offended Pauline) and by September of that year he was dead, following an injury on the homeward journey. Mary Stewart Mackenzie was a widow (for the second time) with six children. She had to sell property to survive. She had inherited the Mackenzie seat, Brahan Castle, near Dingwall, north of Inverness. This huge, cold and dilapidated mansion stood in one of the most beautiful parts of Scotland, and it became the one place of stability for Loo.* Loo's world was different from her mother's. Her mother knew little beyond the conventional world of the grander Scottish gentry. Loo, by contrast, as a direct result of Pauline's influence, grew up to love the company of artists and intellectuals.[1]

Ever since their first meeting in 1842, when Loo was just a child, she and Pauline had become permanent fixtures in each other's lives. At times their letters to each other read as though their mutual love was satisfying to the exclusion of all others, including Walter and such suitors as were addressing themselves to Loo. Loo urgently needed to make a good marriage but on the whole she was cool about men, and from the first years of her adult life she and Pauline loved to mock the oafishness, selfishness, stupidity and general unsatisfactoriness of the hapless males who fancied themselves as partners for Loo. In an early letter that she wrote to Loo, Pauline noted the excitement of some Dingwall worthies over Loo's imagined prospects:

> Miss Emilia [. . .] – seized hold of me – & whispered – 'oh my dear he's here! – have you seen him? – do talk to him about Brahan' – I asked who she meant – 'why Lord Reidhaven to be sure – don't you know

*The castle has been demolished, but a medieval tower and a number of cottages and farm buildings (all part of the Mackenzie estate) survive. The setting is magically beautiful and one can see why Loo and Pauline loved to escape there whenever they could.

him –? Lord Reidhaven come here – come here *directly*' so up he came kilt and all – & she introduced him to me – & told him I was just come from Brahan &c &c – as soon as he was away – 'well dear – *will* he do? – do you think he'll do? – I am so thankful *you* have seen him, it's one step gained at any rate' – in the afternoon Miss Jane Cumming the eldest went on with the same subject, & told me she had been giving him a great deal of motherly advice about matrimony – &c – & a great deal too long to write. the three ladies are so fond of him. they say he has plenty of talent &c in him – which only wants a clever wife to bring it out. and that wife must be you say they, so you must consider your-self engaged darling – if you are to sell yourself, better do it for rank than for l.s.d. and besides he is young & well behaved and a gentleman – don't cut me when you are a Countess, or I shall break my heart. & thrash Miss Emilia Miss Jane & Miss Sophia, all round [. . .] I shall long for a letter from my darling Loo. Calverley sends his dear love – & with a thousand kisses from me I remain ever your loving sister PJT.

Lord Reidhaven, kilt and all, clearly made no headway on this occasion, and Pauline did not need to get out the horsewhip for these particular well-meaning neighbours, but there were to be plenty of other unsuitable suitors and intrusive busy-bodies to be seen off. Loo needed protection from herself and from most of those around her, for she was unwise, untutored and feckless, and Pauline took on the task of guiding and educating her. As a diligent and natural reader herself, Pauline was always pressing good books on Loo and asking searching questions about her reading. The truth was that Loo read far less than Pauline and had in general a less inquisitive and cultured outlook on life, although she came to like the company of well-educated people and enjoyed *buying* culture by lavishly patronising artists. Pauline also wanted to share with Loo her knowledge of the artists whom she admired and whose talents she encouraged.

Moments of happiness with Loo had to be caught where they could. Pauline's sharp nose for the absurdities of well-meaning but obtuse gentry yields diary entries that are as funny as Jane Austen's set pieces. They were shared with Loo, and the relationship between the two women became like the sisterhood of Jane and Cassandra. Pauline recorded the cheerful monologue of a Mr Lindsay Carnegie, whom she had sat next to at dinner. Mr Carnegie had found the panacea for all social problems:

'and that is?' – 'Why – *guano* Ma'am! To be sure – *guano* will regen-erate society – if properly & sufficiently used – *guano* will do it – and

nothing else can' when I asked him how this miraculous improvement was to come about, he told me that when the whole of the country is properly manured, then every one will be rich & happy, and no one will have occasion to quarrel. consequently every one will agree – this he proved by the fact that the people who were put in the black hole of Calcutta, had lived together as neighbours, all their lives, in perfect harmony – because they were comfortable – but no sooner were they shut up together in acute distress than they fell to quarrelling at such a rate that 16 duels were fought the day they were set at liberty – then he told me how a cargo once came in to the port of Arbroath purporting to be pure whale blubber & he posted off in a hurry & bought I forget how many tons & made a glorious dunghill ('gad ma'am – *I wish you had seen it*') but behold 9 tenths of it melted away into water & left only a film – but when there was a little bit of pure blubber – to see the splendid hot smoking manure it made would have done one's heart good – 'The thing I should like best in this world, the *most glorious* thing would be, to man a whole fleet & fetch dead seals & manure the country – 'gad with one seal – real good fat seal I would make you a heap of good hot manure as big – yes – as big as this dining room.'

Among Pauline's greatest pleasures was that of 'having got leave from Caly [Walter]' to go off on her own with Louisa and stay in a cottage on the Brahan estate for a few days.

Early in 1853 Pauline had a most enjoyable stay in London, where she was able to bring Ruskin and Loo together. Ruskin did not particularly warm to Pauline's exuberant young friend. She was too handsome, forceful and Scottish for his taste (part of his growing resentment of poor Effie had to do with her Scottish accent). But he put up with Loo for Pauline's sake. In late April Pauline and Loo went together to see Ruskin's collection at his parents' house in Herne Hill (not the smaller house in which he lived unhappily with Effie). John Everett Millais was there too. 'My Master showed us lots of beautiful things. some of Millais' drawings – admirably clever – a drawing of Turner still on its mounting board (Margate). whereby one can trace from its first touch to its last a most beautiful, interesting thing – he showed us what Turners sketches were like.'

On 2 May she and Loo went to have stereoscopic photographs (a fashionable novelty) taken of themselves by Monsieur Claudet 'for Caly & Dr John Brown. Claudet as usual was very careful & did them very nicely. They had to be often repeated before they would answer.' The problem was that Loo would not sit still. Alphonse Adolphe Claudet (1797–1867) was one of England's first professional

photographers. He set up his business in London in 1841, and within a few months his portraits were in demand both in 'Society' and among the newly rich.[2] Pauline and Loo then went on to the Royal Academy exhibition: 'it was very crowded. Saw [Holman] Hunts lovely picture of *Our English Coasts* strayed sheep feeding among brambles & flowers and the top of a cliffs most divine colour. His *Claudio & Isabella* is a perfect thing of the very highest class.' And at the theatre in the evening (this was a crowded day) they saw a new play by Robert Browning, which Pauline thought a failure. She observed acutely that however beautiful Browning's poetry was, he did not know how to write for the stage.

Two days later came a significant visit: 'May 4 1853 fetched Loo, & went for Mrs [Anna] Jameson [the art critic], who took us to see Lord Ashburton's pictures, statues &c, a very noble collection.' The immensely wealthy Lord Ashburton was married to one of the most famous hostesses of the day, the fat, ugly and intelligent Lady Harriet. She was a notoriously successful lion-hunter, gathering round her all the poets and painters who were Pauline's friends, as well as giants such as Tennyson and Browning whom Pauline would have liked to have secured for her own circle. Lady Harriet had so captivated Thomas Carlyle that he more or less abandoned his hapless wife, Jane, because of his infatuation. Carlyle called Lady Harriet his 'glorious Queen' and the 'lamp of my dark path', while to poor Jane she was 'an evil spirit' and a 'malignant elf'.[3] Loo was undoubtedly impressed by this evidence of wealth beyond her wildest dreams. Was she already planning a wealthy marriage for herself?

By June 1853 – the date of the famous visit of Ruskin, Effie, Millais and his brother to Wallington – Loo was still short of money, so Pauline simply paid her fare in order that she could join the Wallington party. Pauline kept Loo and Ruskin together as much as she could during the visit in order to promote the relationship, which was still sticky. Loo's antics (climbing like a tomboy and driving like a highwayman) would not have helped, but she had the tact to allow Ruskin to advise her on her drawing. Loo's drawing lessons with the 'Master' continued on subsequent visits: she had a lot of natural talent and Ruskin slowly came to recognise this.

Like Ruskin, Walter found Loo somewhat overpowering, but he was glad to accompany her on rides and outings because he shared her love of vigorous exercise. For most of this holiday, though, she was with Pauline, who could never tire of her exuberance. When the

Ruskin party had gone on to Scotland, Pauline was left contentedly with Loo looking out at the sky and the evening light from the windows of her house, 'through which the wide rolling moorlands looked perfectly beautiful'.

Pauline was encouraging the writing ambitions of a friend and neighbour, Annie Ogle. Annie was a deeply embedded native of the place – Augustus Hare in his guide to Northumberland listed the Ogles as among the eleven surviving Northumberland families who dated back to William the Conqueror. There was a village named after them, and an ancestral castle, but in Victorian times they lived at Kirkley Hall, a country seat close to Newcastle and within reasonable reach of Wallington. Miss Ogle's novel, set in a dull country house in Northumberland, displays the self-sacrifice of a pair of high-minded and virginal young lovers. Pauline got Loo to read the manuscript. The two friends found it 'charming', and promoting Annie Ogle subsequently became something of a cause for them. When finally published (under a male pseudonym), this novel* was a commercial success and attracted surprisingly respectful attention from the Poet Laureate, no less. Tennyson enjoyed all kinds of fiction and had a voracious appetite for it: often he would have slack periods in his own writing, when he would occupy the time by reading two new novels a day. Annie's novel has a certain melancholy and naïve charm, but not much else, as Bell Scott wrote to William Michael Rossetti: 'You once mentioned Miss Ogle's novel *A Lost Love* – I am afraid in spite of Tennyson's eulogium you would not find much in it except a certain freshness belonging to a first book and an absence of the professional novel-writing style.'[4]

On 2 July 1853 the Trevelyans and their servants (and Loo) all moved out of Wallington and into the Garden House in the grounds, in order to allow John Dobson and his men to carry out the work on the new central hall. The servants were particularly quarrelsome and difficult over this process. A maid called Adams 'strode majestically about haranguing concerning her own comfort', and 'Old Jane the dairy maid who is to be left – in the dirt and discomfort [of the big house] was the only person who was good tempered'. Pauline hung all the drawings that Millais had made on his recent

A Lost Love by 'Ashford Owen' (London: Smith, Elder, 1855). Annie's opening account of the landscape near Newcastle (which is 'three miles off') is decidedly depressing: 'Flat fields, red-roofed cottages, a coal-pit, and the straight lines of two plantations, were the principal features of the country.'

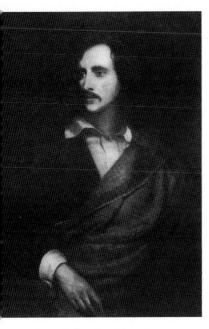

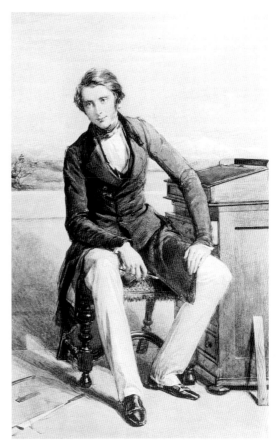

Walter Calverley Trevelyan
as a young man

John Ruskin, 1843

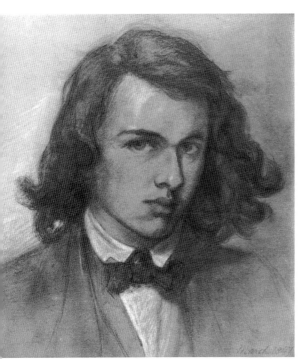

Dante Gabriel Rossetti,
self-portrait, 1847

'*Mr Whewell on tides*'. Page from Pauline's diary about a meeting of the British Association in Newcastle. New scientific discoveries prompt a visit from Lucifer: Pauline has decorated her fantasy with a drawing of the Devil holding a pitchfork

Two of Pauline's water-colour sketches: *Icicles* and *Storm on a Beach*

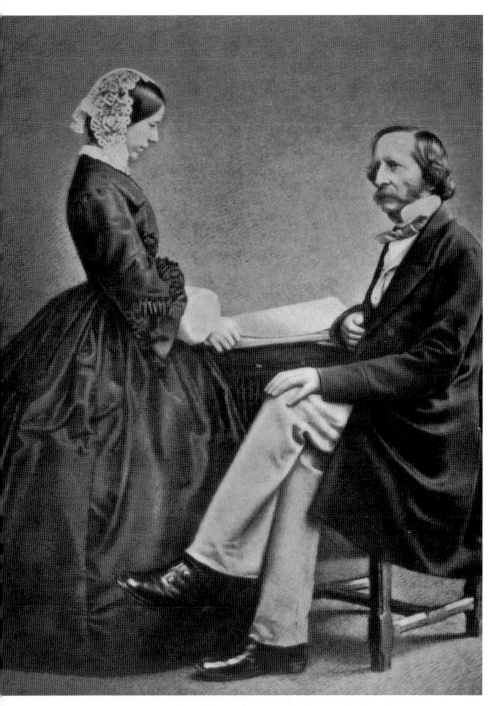

Pauline and Walter Calverley Trevelyan photographed in about 1863

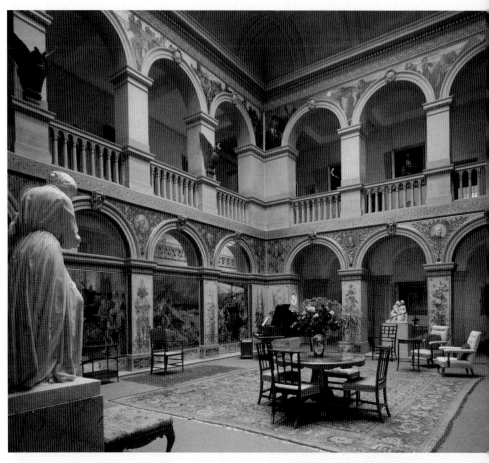

The magnificent Central Hall at Wallington, designed by John Dobson of Newcastle and built in 1853-4. In 1856 Pauline commissioned her protégé, William Bell Scott, a local painter in the Pre-Raphaelite tradition, to decorate the Hall with canvases and murals showing scenes from the history of Northumberland

William Bell Scott,
portrait in oil, 1877

Thomas Woolner, sketched by
Dante Gabriel Rossetti in 1852

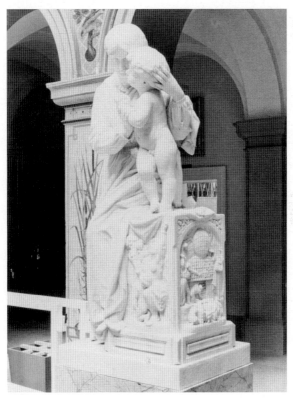

'*Civilization*', sculpture by Thomas Woolner, commissioned by Pauline,
and installed in the Hall at Wallington in 1868, after her death

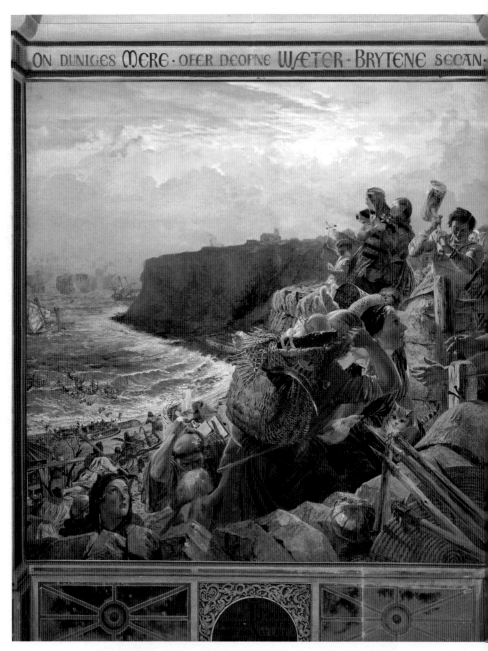

ON DVNIGES MERE · OFER DEOPNE WÆTER · BRYTENE SECAN·

'*The Descent of the Danes.*' In this canvas, William Bell Scott
made a portrait of Pauline Trevelyan: she is the woman in profile at the top of the
cliff, and at her feet is her favourite dog, Peter

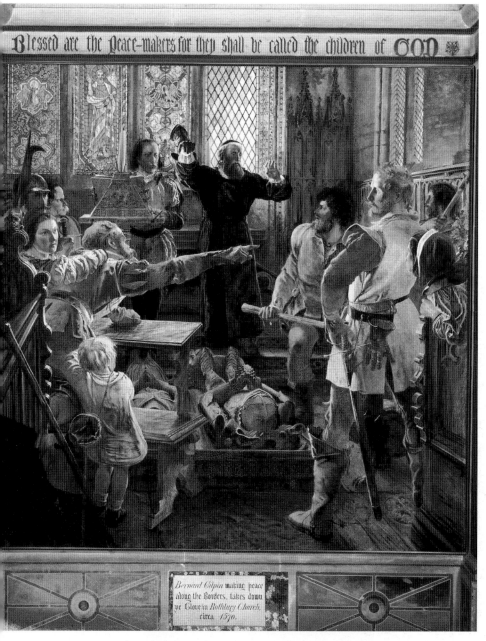

Blessed are the Peace-makers for they shall be called the children of GOD

Bernard Gilpin making peace along the Borders, takes down ye Glove in Rothbury Church, circa 1570.

'*Bernard Gilpin makes peace along the borders*', one of the
canvases for the Hall at Wallington. The painter, William Bell Scott, used his patrons
and their friends as models. Walter Calverley Trevelyan is the figure at the lectern;
Bell Scott himself is wearing a helmet on the extreme left; and David Wooster is the
moustached figure in profile next to him

Ruskin teaching Louisa
Stewart-Mackenzie to
draw, in Pauline's parlour
at Wallington

Algernon Swinburne,
Northumberland
neighbour and intimate
of Pauline. Portrait by
William Bell Scott

visit so that they showed to advantage in the Garden House and then left the servants to their bickering in order to spend a few days by the sea: 'posted to Newcastle got to Roker between 8 & 9 in the evening'.

Roker was a seaside resort on the north-east coast near Durham, now effectively a suburb of the city of Sunderland. It had striking rock formations, including a famous natural arch (which has since collapsed) and was a sufficiently notable place for Pauline to feel it worth taking her friend for a holiday. When Pauline and Loo bathed there, they would have encountered a good deal of coal on the beach. Coal travelled constantly by sea from the Tyne to London and anyone on Roker beach would have seen these cargoes heading south. 'Sea coal', spillage washed up on the beach, was the perquisite of the poor, and would be collected by the cottagers after every high tide. So as seaside resorts go, this was a fairly rough one, but in holiday mood Pauline was indifferent to comfort or fashion. This spartan holiday was perfect, from her point of view, because Loo was sharing it. On 7 July her beloved terrier, Peter, 'got worried by a fierce cruel dog. who hurt him a good deal'. By the following day 'Peter was better afternoon walked on the shore'. A neighbour of whom she was fond, William Henry Charlton (who was later depicted in Bell Scott's *The Spur in the Dish*) took them out into the bay in a fisherman's boat to see the salmon nets.

Their last day at Roker was 9 July: 'Loo bathed I could not. left Roker at 4 and to Newcastle by train – waited there about an hour then on to Morpeth where we left dear L to proceed north & we came home – had a pleasant drive but we had scarcely got home when heavy rain came on Found the little garden house very snug & tidy & the maids had recovered their tempers and it was all comfortable.'

Pauline was always too gentle to manage her servants well. Wallington, when they moved back into it, required a lot of servants and later, as Pauline's health failed and Walter's eccentricities became more marked, it was easy for these rich, frail people to be taken advantage of by their employees – and they were.

A letter of 1853 reports the great benefit in health that she and Walter had gained from a holiday on the coast north of Berwick, and how much Pauline regretted not being able to travel further north to visit Loo at Brahan Castle near Dingwall; this was an opportunity Pauline would never miss if she could possibly avoid

it, but Wallington and its duties called. There is an interesting and striking reference to Sir Edwin Landseer (1802–73), who by this date had become unfashionable as a painter and knew that his day was done. Now in his fifties, he was somewhat disabled and was drunk more often than not, but he was nevertheless very rich and might well have been a desirable prospect for Loo. But in due course he was to find himself played off against an even richer admirer. The letter is characteristic of Pauline in the vivid descriptions she gives of the people and places that she visited, and in the impatience that she expresses with boring social duties. The curse of being an intelligent upper-class woman in the nineteenth century was that so much of one's time was wasted with the tyrannical codes of social obligation: 'calls', house-guests, and the like. This is reflected in an undated letter (probably from 1853) from Stirling, when Pauline and Walter were making a Scottish tour but did not have time to get as far as Brahan Castle to see Loo: 'I must go & return visits of cruelly kind people who have found us out here. Calverley has washed his hands of it & gone for a walk with Peter. so good bye.'

She spent as many holidays as possible with Loo. For example, in May 1855 she, Walter and Loo were in Berwick (again, not an obviously fashionable or comfortable resort) on the border between Northumberland and Scotland. It was vigorous holiday, which included some climbing: 'walked up a hill to the south & got a very fine view of Cheviot two of its high parts covered with snow! it was very pretty in the misty sunshine.' On Saturday 19 May she wrote: 'dined early [. . .] then Loo rode & I walked [from Berwick] along the riverside with Calverley to where a stream joins the Tweed. the views all the way were glorious. especially of the great bridges seen between them then to a still pond with willows in which I drew.' Pauline was immersed in the scenes that she witnessed: 'It was pretty to meet lots of bairns, every one of whom had handfuls of primroses or daisies carrying home to cheer some little dark room in dirty Berwick. I rode home by another way, very pretty too.' Although dirty, humble Berwick was an agreeable setting for her love for Loo: 'Eveg Loo & I to church at Berwick I walked a little way along the road to the south; a fine evening with a glorious twilight effect. the gulls too were diving close to the shore. It was beautiful to watch them wheeling about and plunging in the blue waves. picked up sea weeds for Loo.' Walter did not disturb them

much: he had recently acquired a microscope and spent a good deal of time happily collecting ditch-water to examine the microscopic life forms swarming in each drop. In the evening he read Scott's *Redgauntlet* to the two women.

While they were in Berwick, news came echoing the fallout from the previous year's great scandal, the Ruskin divorce: (20 May 1855) 'Had a note from Agnes Loudon. who heard from J Millais himself that he is to marry E. Grey (!!) next month. I am sorry for him.' Pauline was ill from 24 May for several days, but as always made light of her own illness and was disproportionately worried about Loo, who suffered an 'eruption on her shin'.

Loo had great hopes of marriage to one William Stirling, whom she adored; when that did not come about, Landseer was a prospect for a while, but when Harriet, Lady Ashburton (object of Carlyle's misplaced infatuation) died in May 1857, another possible bridegroom became available.

In the summer of 1857 Loo stayed at Wallington again. She had not mentioned Lord Ashburton to Pauline, who still thought of Loo as penniless. She appeared to be surviving in London with little money (she was actually being courted by the smitten peer) and Pauline offered to pay her travelling expenses:

> It seems you are not growing prudent in your old age – however I don't at all see why this disturbance in the Exchequer should keep you from coming here. You must exist somewhere & you would be more economical here than in most places: and you *must* allow me to pay your journey here – as I have not been to London this year I have committed very few extravagances, & can very well afford to give myself the great pleasure of your visit, and I shan't think it at all sisterly of you , if you make objections to such an arrangement; so just let me know what day you will come.

Pauline had a particular reason for wanting Loo to visit in 1857. Bell Scott was still looking for good models for the Northumbrian cycle of paintings, and 'I want Mr Scott to make a study of you to put you in one of our pictures. now don't say no to my request. but come to me like a good old thing.' Ruskin came to stay as well, and William Bell Scott made a skilful and agreeable sketch of one of Loo's drawing lessons with Ruskin: the 'Master' looks serious and solicitous, like the excellent teacher he was, and Loo appears

preoccupied, but still strikingly beautiful. She was clearly working hard.[5]

The good old thing was being secretive, and when Pauline did learn of Loo's engagement, it was in a manner that was decidedly hurtful:

> Feb 3 [1858]
> My Darling
> Pray read the enclosed, & put me in a position to answer the questions – 'how did they first meet'? & 'when is the marriage to be?' I always thought you & [the author of the enclosure, whose name is illegible] were kindred spirits. but Calverley & I both think it rather hard that you should have taken her so deeply into your confidence, before us, your conduct requires explanation. 'I pause for a reply.'

Loo had taken the most important decision of her life and had not told her closest friend. 'I pause for a reply' is still affectionate, but is not meant as a joke.

There was lively gossip, not unnaturally, about Loo being an adventuress taking advantage of an ageing man's vulnerable emotional state. William Bingham Baring, the second Lord Ashburton, was fifty-nine, suffering from gout and in frail health. On their wedding day (17 November 1858) it was obvious to everyone that Loo (now aged thirty-one) was not marrying out of romantic passion. Pauline was genuinely distressed that Loo should have to put up with calumny, but she also wished to remind Loo that she, Pauline, had always been absolutely loyal to her, and that by contrast Loo had been displaying surprising lapses of loyalty to Pauline. Perhaps Loo's confidence in the friendship was like that of a thoughtless adolescent in a long-suffering parent: Pauline's feelings were simply of no consequence to Loo if she was having to deal with emotional storms of her own. Loo was too self-revolving to care much about other people's feelings, and was capable of hurting her most loyal friends.

Loo's marriage was so obviously the action of an ambitious young woman with expensive tastes attaching herself to a man of huge fortune that talk spread like wildfire. Loo was upset, though she could scarcely have been surprised. Pauline loyally tried to comfort her: 'I am truly grieved, my dearest love, that you have such painful things to bear. Any sort of calumny must give one pain at the time, though one *knows* that one will live it down. that is sure in the end.'

The 'calumny' came from some of the oldest and most respected of Pauline's and Loo's friends. Jane Carlyle felt that the speed with which Loo established herself in the widowed Lord Ashburton's favour violated all known bounds of decency. She recalled witnessing the reaction of Harriet Ashburton's mother (Lady Sandwich) to the news that her son-in-law intended to marry Loo:

> I have not recovered from the shock. Lady Sandwich handing me a letter said 'Read that, I thought you would like best to hear it from me.' The letter was in Lord Ashburton's hand – first words caught my eye 'I have proposed to Miss Stewart-Mackenzie and she has accepted me.' No doubt of that if she had the chance.

Jane Carlyle had loathed the first Lady Ashburton for the good reason that her husband had been infatuated with her. But despite this, she declared war: 'I shall never like the new Lady Ashburton – she is full of affectation and pretension if not pretence.'[6] This was unfair. Loo did not go in for affectation; she was clear and direct about what she wanted.

Pauline's letters to Loo soon recovered their normal friendly and gossipy tenor: 'Gerald Massey's lectures were worth hearing & I liked him much better than his poems.' Gerald Massey (1828–1907) was an extraordinary example of Victorian energy and self-reliance. The social reformer Samuel Smiles applauded Massey in *Self-Help* (1859) as a working-class hero and a fine example of self-help at its best. One of the many children of a canal boatman, Massey had been brought up in extreme poverty. From the age of eight he had been a silk worker, straw plaiter and errand boy, but in adolescence he embarked on an ambitious programme of self-education and began writing political verse on the suffering of the poor and the value of education. His first volume was published in 1848 when he was twenty. London in the 1840s seethed with working-class discontent, and Massey joined the Chartist movement and from 1849 published a radical newspaper written by working men, entitled *The Spirit of Freedom*. The volume that made his reputation as a poet of labour and of the people was *The Ballad of Babe Christabel and Other Poems* (1854). His political poetry was stirring stuff:

> Fling out the red Banner! its fiery front under,
> Come, gather ye, gather ye, Champions of Right!

And roll round the world, with the voice of God's thunder,
 The Wrongs we've to reckon, oppressions to smite.
They deem that we strike no more like the old Hero-band,
 Victory's own battle-hearted and brave:
Blood of Christ! Brothers mine, it were sweet but to see ye stand,
 Triumph or Tomb welcome, Glory or Grave!

 ('Song of the Red Republican')[7]

Tennyson and Ruskin praised Massey and he was popular among other poets. His lectures would have been recommended to Pauline by Sydney Dobell, the consumptive 'spasmodic' poet whom she had met in London. By the time she heard him lecture, Massey was a celebrity, fêted – rightly – in liberal circles as an authentic working-class radical voice.

Jane Carlyle's indignation over Loo's engagement was short-lived. She softened considerably, especially after Loo had presented her elderly husband with a baby daughter. Henceforth Jane decided that Loo was to be loved and cherished. She had far more to complain about in Thomas Carlyle's persistently outrageous selfishness than in any misjudged or hasty behaviour from the warm and impulsive Loo.

Lord Ashburton longed for a male heir. Loo did her best but all she could manage was her adored Mary or 'Maysie', born on 26 June 1860. 'Mary' was for Louisa's mother, and the baby's second name, 'Florence', was for Florence Nightingale, who had formed an attachment to Loo some years earlier. There was some sadness for Pauline Trevelyan in the fact that there was never any suggestion that the baby might be named after her, given that she was a far closer friend than Miss Nightingale, and that she had loved and protected Loo ever since she was a teenager.

Loo decided to build herself a large spectacular house on a site adjacent to the Trevelyans' house at Seaton. It was all her initiative, because Lord Ashburton was now in very poor health and simply allowed her to pursue this enthusiasm using his money. She bought the land for the house from Walter. She and Pauline corresponded about it:

> Calverley has written to his man of business about selling the bit of land. as soon as I can walk up there, I will go and fix the exact spot. There is one field – just the size for our two cottages & half acre

domains & I will sketch the view from your marine palace that is to be – I did so wish for you last night, when the full moon rose over the sea – I thought what good it would do you to see it. with the tremulous water rippling in the light [. . .] It would be a great delight & interest for me when I am here if Mary [Loo's baby] were here. and I shall get her to be fond of me then. as it is, she will never get to know Aunt Pauline except as a sort of a nuisance who takes Mammy's attention from Baboo sometimes. I think it is generous of her to be even as friendly as she is.

Loo, who was capable of arrogance and thoughtlessness on a grand scale, chose to assume that a larger piece of Walter's land than had been agreed was actually hers. This generated a stiff breeze and a series of remarkably crisp letters from Walter, with Pauline sending loving and emollient letters on the side to try to keep the peace:

My darling. I wish you would not think it possible that I could ever love you less. I am very sorry you and Calverley are bothered about the measurements of your bit of ground. I have no doubt if you were both there you would settle it in five minutes. But the most minute trifles look important on paper [. . .] I hope nothing will keep us from having next winter together. I am quite as desirous of it as you can be. And if anything prevents it, it would be a very serious grief to me. I never much expected that our cottage would be ready to live in by the autumn – but I don't care the least about accommodation if I get the sea air and the sunsets. And with your dear society in addition, any place would be a palace to me.[8]

A second pregnancy, in 1862, ended in miscarriage: Loo sobbed inconsolably. Her mother died shortly after this disaster, and there is a very sombre photograph of Lady Ashburton in full mourning, in late 1862, looking far from pleased with the hand that life had dealt her, despite her dazzling social consequence and her splendid fortune. She had come to love her husband, but she could do nothing to arrest his declining health. He died on 23 March 1863 after an illness of some eighteen months, which made his death, when it came, seem both inevitable and overdue. Loo was now a very rich widow of thirty-seven with a small child to look after. She had clearly reaped one of the rewards of a marriage for which she had openly and deliberately planned.

With substantial wealth at her command and no husband to

control her, Loo now became more impulsive and extravagant than ever. Pauline was one of the few people who could manage her, and in the early spring of 1866 she planned a holiday in Europe with both Loo and Ruskin, both of whom needed her to look after them in their different ways. Loo had been seriously ill (with cholera). Characteristically, Pauline worried about Loo's health and ignored her own. Loo should not attempt to stay in 'our dear Auvergne' because 'the inns are very bad and you would be too uncomfortable'. Instead of travelling through France, Loo was to sail directly to Italy with her baby and join them at Lake Maggiore: 'it would be delicious to meet you & Mary in that lovely land. Mr Ruskin wants to go there & will not go alone. the matter is not quite settled but even if his part of it falls through there is no reason why we should not go. as we know that country very little – and to meet you wd be worth anything to me.' To be with Loo in Italy, where she had been so happy, and to have her friend's 'dear society' – Pauline's hopes and spirits were lifting so confidently that it was as though the act of writing this letter was restoring her shattered health. In reality, she was never to see Loo again.

The widowed Loo, handsomely set up though she was, with her comfortable houses in London and in Scotland, found that life was increasingly lonely. In 1869 this celebrated widow sought out a much more celebrated widower – Robert Browning – and the reason for her enthusiastic pursuit of the great man and her coercive invitations to stay with her in Scotland must have become clear to him before too long. *The Ring and the Book*, the culmination of Browning's career, was published to great acclaim in 1869, and in the same year Loo made it explicit to him that she hoped he would propose marriage. He responded in such a manner that she misunderstood him (Browning could be just as oblique in prose as he sometimes was in poetry), and when she had to accept that he did not intend to marry her, Loo felt betrayed. She became wildly importunate, bombarding the unfortunate poet with passionate messages, and generally making a public spectacle of herself.

Browning really had no intention of changing his routine. He had his son, Pen, to care for, and Pen was worryingly feckless and self-indulgent. Further, Browning's devotion to Elizabeth Barrett had been so absolute that no other woman was ever likely to find a place in his heart. His first concern was to ensure Pen's future,

and after that his intention was to go back to Italy and live out his life there among all the associations of his marriage to Elizabeth. The only possible marriage for him would have been to a woman who had loved Elizabeth as much as he had loved her himself.

CHAPTER 9

Thomas Woolner, sculpture and patronage

You are to do something for the centre of the hall – you are to
put the finishing crown upon the work.

When Thomas Woolner left to seek gold in Australia in 1852, Rossetti
wrote him long narrative letters, which are of great interest now
because they show how the members of the original Brotherhood
remained in touch with each other, and how the circle of friends was
expanding:

> [1 Janary 1853] I date this from my new rooms at Blackfriars, but it
> is written Arlington Street, where Hunt and Stephens have just left,
> having dined with us, and spent the New Year's evening. Hunt has just
> returned from a Christmas at Oxford, jollier than ever, with a laugh
> which answers one's own like a grotto full of echoes. Stephens smiles
> as of old, as cordially as the best but with a shade of nicety – the
> philosopher of reluctance. We have been amusing ourselves since dinner
> with trying to sketch heads from memory.[1]

The sketches ('scratches and caricatures') included Woolner
himself, William Holman Hunt (asleep), James Hannay and Rossetti.
He wrote again on 8 January to describe another meeting (the
previous day) of the group of friends: 'I had a gathering here last
night, at which almost every one was present – neither was
Woolnerius utterly absent: the daguerreotype being set open over the
mantelpiece.'[2] On 12 April he and their friends made sketches that
they sent to Woolner, and Rossetti described how the other members
of the brilliant Rossetti family joined him in writing poems: William's
was 'inscrutable', Christina's was 'intense', his own was a friendly
sonnet addressed to Woolner. He also seized the opportunity to mock
Ruskin:

> McC [McCracken of Belfast, one of Rossetti's patrons] sent me a
> passage from a letter of Ruskin's about my Dantesque sketches exhib-
> ited this year at the Winter Gallery of which I spoke to you in my last.
> R goes into raptures about the colour and grouping which he says are

superior to anything in modern art – which I believe is almost as absurd
as certain absurd objections which he makes to them. However, as he
is only half informed about Art anything he says in favour of one's
work is of course sure to prove invaluable in a professional way, and I
only hope, for the sake of my rubbish, that he may have the honesty
to say publicly in his new book what he has said privately. [. . .] It now
seems that Ruskin had never seen any work of mine before, though he
never thought it necessary to say this in writing about the PRB.[3]

Rossetti took care to include Bell Scott in the Brotherhood when
writing to Woolner on 22 April 1853:

I have forgotten to give you news of Scott. He has been in town once
since July last, and then made his stay with us at Camden Town for a
week or two. Part of this time the poor stunner was laid up, and I hear
has continued more or less unwell ever since. He has not yet published
his poems though I believe he is getting them under way. He has sent
a picture of 'Fair Rosamond' in 3 compartments to the Academy.[. . .]
I should not forget to say how much Scott always talks of you and
wishes to be remembered to you. No one I know will enjoy your journal
more than he.[4]

'Stunner' was normally reserved by the young men for beautiful
young women such as Lizzie Siddal or Jane Morris, and it is a mark
of Bell Scott's striking good looks as a young man that he was the
male 'stunner' among the Brotherhood.

Woolner's log of his journey home from Australia in 1854 (on a ship
called *The Queen of the South*) reminds us that Ruskin was still
potent in the minds of the Brotherhood. Alone in his cabin, early in
August 1854, Woolner was reading the work that had guided the
Brotherhood from its beginnings in 1848:

Last evening I had a read at Ruskin's first vol. of Modern Painters and
derived much pleasure from the wisdom of the principles enunciated
and the forcible grace of the language they are expressed in. I am
convinced the work must do an incalculable amount of good, for it
states truths hitherto but dimly understood by many fine artists and
totally disregarded by the bulk – I see no evidence of unjust bias in the
author, not more than his propositions justify, and I apprehend no man
can be too fond of nature and truth. Artists and critics object to this
book the same way that unhealthy people object to the physician's
injunctions to take exercise and face the pure air of heaven, but if they

wish to enjoy long life they must do as they are recommended [. . .] it delights me the downright hearty way he cuts up and exposes the igno-rant conceits and tameness of the over-lauded old masters as much as it pleases me the keen, magnificent exposition of Turner's greatness and the delicate beauties of minor landscape artists.[5]

Although it yielded no gold, Australia had in fact done much for Woolner's self-reliance, and his best years (1855–65) coincided with the flowering of Pauline's ambition as a patron, so the two were well matched. He worked hard on the most famous of his friends, the Tennysons, with a view to making medallions and busts of them both, and he succeeded in persuading Acland, Ruskin and the Trevelyans that he was the right sculptor for some of the statues of philosophers and scientists that adorn the Oxford Museum. At the same time Woolner was becoming increasingly hostile to Ruskin. He did not acknowledge this in his letters to the Trevelyans, but in his correspondence with Emily Tennyson, the poet's wife, he spoke his mind. He was angry with Ruskin for 'cutting up' (condemning in print) Holman Hunt's great painting of that year, *The Scapegoat*:

[28 May 1856] I should like Ruskin to know what he never knew – the want of money for a year or two; then he might come to doubt his infallibility and give an artist working on the right road the benefit of any little doubt that might arise. The little despot imagines himself the Pope of Art and would wear 3 crowns as a right, only they would make him look funny in London![6]

In any case, the connection with the Oxford Museum was not one that brought in any money, as Woolner wrote to Emily Tennyson in August 1856: 'The Statue of Bacon is for the New Museum Oxford: but it is not a thing I can well be congratulated upon, for 2 or 3 more such commissions would lodge me in prison for debt.'[7]

Woolner passed on some welcome nutritious gossip:

I heard a good thing Carlyle said upon the party-giving propensity of many persons: he was talking as he generally does against the dreadful state of the present age, when someone coinciding said 'yes, the age *is* dreadful, I believe if even Christ were to appear we should crucify him again.' 'You are quite wrong Sir,' said Carlyle, 'quite wrong: you would hunt him to death by Lionising.'[8]

Woolner visited Wallington in September of that year, and wrote to Emily Patmore, wife of the poet Coventry Patmore:

I left London last Sunday early by steamer for Newcastle, arrived there on Monday night, arrived here Wednesday morning. The Trevelyans are charming persons. Sir Walter a grave dignified man; very kind and hospitable, and of wide experience in all scientific matters and general knowledge. Lady Trevelyan is full of life and splendid geniality. I could almost agree in [William Bell] Scott's extravagant praise, that she was 'the best woman in the whole world'. Such a place! such copses and woods and bullrushy ponds with water-hens, etc. Such gardens with old rich brick walls encrusted with romance and peach trees and apple trees – one 76 feet from tip to tip. O, such a place to luxuriate in! I should have called to see you before I started but was working till the last hour. I am so indolent I can scarce bring myself to spare time to write even if I had anything to say.

Bell Scott knew that his own friendship with Pauline was now open and trusting – it had come a long way since the inhibited early days of his first meeting with her in 1855 – but he still could not speak his mind to her about Ruskin. Mutual dislike of Ruskin was a reliable area of common ground with Woolner, although he too watched his step when talking to Pauline.

The relationship prospered. The Trevelyans visited Woolner in London in December 1856 and he worried (in a further letter to Emily Tennyson) about Pauline's health, 'so weak and delicate', but predicted that 'some day they will give me an order to make something for their grand hall at Wallington'.[9] This indeed came about, and much more quickly than he had expected. Within a few days Bell Scott was writing to him to say how pleased he was that Woolner's introduction to the Trevelyans had borne fruit in this way:

My Dear Woolner,
 I have just learned by a letter from Lady Trevelyan that you are to do something for the centre of the hall – you are to put the finishing crown upon the work – the jolliest piece of news I have heard from a long time.[10]

And Pauline wrote to Bell Scott about Woolner:

I have been reading Mr Woolner's poem. some of it is very fine. and there is a great deal of himself in it – but doubtless you will have seen,

or heard most of it. I was in some hopes that the Tennysons would have come to Wallington when we returned – but that has had to be given up. & they have gone back to the Isle of Wight to receive some guests.

Thomas Woolner had sought recognition as a poet as well as a sculptor since the early days of the Brotherhood. He had pungent views about poetry (as he did about most things) and had to tread carefully since he loathed one of Pauline's favourite poets, the 'spasmodic' Sydney Dobell. The spasmodics were not manly enough for Woolner. 'What a ghastly school of spasmodic idiots who blaspheme in rhyme this age is producing!' he wrote to Bell Scott: 'It is as one who has been addicted to stimulants and grown old. Feels horrible nervous twitches about his carcase: each of these poets [he was thinking of Sydney Dobell and Alexander Smith] is an ugly spasm on the face of the British Nation: they ought to be allayed.' His ballad, 'My Beautiful Lady', could have been the subject of any of a number of paintings by members of the circle. It was published in *The Germ* in 1850. It has a pleasingly inventive rhyme scheme:

> I love my lady; she is very fair;
> Her brow is white, and bound by simple hair;
> Her spirit sits aloof, and high,
> Altho' it looks thro' her soft eye
> Sweetly and tenderly.
>
> As a young forest, when the wind drives thro',
> My life is stirred when she breaks on my view.
> Altho' her beauty has such power,
> Her soul is like the simple flower
> Trembling beneath a shower.[11]

The poem that Pauline refers to in her letter has the same title, *My Beautiful Lady,* but is in fact a medley, strongly elegiac in tone, reminiscent of Tennyson's *Maud* and *Locksley Hall*. Woolner had sent her this poem well before publication. He was a close friend of Tennyson and in this long poem, published in 1863, pays him the compliment of close imitation. Just as 'O that 'twere possible' was originally published in 1837 and reappeared in 1855 as a central lyric in *Maud*, so Woolner's original ballad reappears in full as the centrepiece of a tragic narrative about a young wife who has died, and her bereft husband's attempts to find redemption in hard, ambitious work. There is a clear parallel

with part of the plot of *Maud,* where the protagonist goes off to fight (and probably to die) in the Crimean War in order to get over the death of his childhood sweetheart. Despite its derivativeness, Pauline was right to enjoy this poem. As an elegy it belongs to a long tradition. Here, for example, it suddenly sounds as though it is visiting both Dante (as mediated by Tennyson in *In Memoriam*) and Donne's *The Expiration* ('So, so, break off this last lamenting kiss/Which sucks two souls, and vapours both away'):

> I shrunk from searching the abyss I felt
> Yawned by; whose verge voluptuous blossoms belt
> With dazzling hues: – she speaks! I fall and melt,
> One sacred moment drawn to rest,
> Deeply weeping in her breast:
>
> Within the throbbing treasure wept! But brief
> Those loosening tears of blessed deep relief,
> That won triumphant ransom from my grief,
> While loving words and comfort she
> Breathed in angel tones to me.
>
> Our visions met, when pityingly she flung
> Her passionate arms about me, kissing clung,
> Close kisses, stifling kisses; till each wrung,
> With welded mouths, the other's bliss
> Out in one long sighing kiss.

And when the speaker looked back on his loss, years after his wife's death, the poem offered a remarkable condensed narrative of England. It resembled the heroic passages in which peace between the sexes is restored in Tennyson's *The Princess,* and it paralleled the way figures such as James Anthony Froude and, later, Charles Edward's grandson, G.M. Trevelyan, would come to write English history. This is a versified and simplified 'Whig view' of the national story:

> My spirit saw
> This Island race two thousand years ago
> In simple savagery, controlled by priests
> More fell and bloody than the wolves that howled
> At midnight round their monstrous altar-stones,
> Scenting the sacrificial human blood.

Whereas now, in the splendid present, the poet felt bound by gratitude to work creatively towards national glory by making magnificent sculptures:

> How could I
> Here feed on this accumulated wealth,
> Like senseless swine on acorns of the wood
> And own no wish to render thanks in kind?[12]

Woolner was surely right to acknowledge to Bell Scott that he was not primarily a poet. The fact that he had attempted poetry at all was Tennyson's fault: 'the truth is Poetry is not my work in this world, I must use, not make it' and 'the verses have brought away an odour from the spice islands of Tennyson'.[13] The most interesting feature of his ambitious poem was its bearing on the monumental sculpture for Wallington, *Civilization*, which also expressed the Whig view of history. The mother teaching her son to pray was the embodiment of all that was enlightened about the modern world, while around her feet Woolner carved examples of 'simple savagery', with druids engaging in human sacrifice and similar atrocities.

A quite different poet, and this time a really major one, visited Wallington in 1857. Like the rest of her family, Christina Rossetti was a close friend of the Bell Scotts, and she came to visit William and Letitia in Newcastle. She recorded this visit in some of her poetry, notably in 'Goodbye' (which she wrote on the train back to London) and in 'Up-Hill.' The pain in these poems has prompted speculation that she was for a time in love with William Bell Scott and that he toyed with her affection – but this is no more than speculation. Bell Scott and his wife were showing ordinary civil hospitality to a friend who needed a change of scene and would benefit from getting out of London for a while.

Christina Rossetti's visit to the North-East lasted some three weeks. Bell Scott took her to meet Thomas Dixon, of Sunderland, the 'cork cutter' (manufacturer of corks to the wine trade) to whom Ruskin's series of open letters, *Time and Tide by Wear and Tyne*, was addressed. The party went out for a picnic, as Christina recalled in a poem:

From Newcastle to Sunderland
Upon a misty morn in June
We took the train: on either hand
Grimed streets were changed for meadows soon.

Umbrellas, tarts and sandwiches
Sustained our spirits' temperate flow
With potted jam, and cold as snow
Rough-coated sun-burnt oranges.

It was natural that Bell Scott would want to take Christina to Wallington as well; he was eager to show this Pre-Raphaelite poet the site for which his eight paintings had been commissioned. Christina was suitably impressed by the magnificence of Pauline's new central hall. As the owner of a D.G. Rossetti watercolour, Pauline was delighted to meet the sister of the famous Pre-Raphaelite painter and soon warmed to Christina Rossetti for herself. Christina sat rather silently at luncheon (she was overawed by the magnificence of Wallington, and by Walter's cordial but detached and decidedly patriarchal manner), but afterwards she was taken round the house and gardens by Pauline and loved the experience. She also loved Peter, Pauline's bad-tempered and smelly old dog, and to be fond of Peter was a reliable channel to Pauline's own affections.[14] The two became friends and exchanged letters agreeably for some years. Christina's letters to Pauline, which have survived, were somewhat angular and guarded, but she was clearly doing her best to pass on friendly news about her brother Gabriel and his circle.

In 1861 Elizabeth Barrett Browning died. Pauline was too modest to be referring to herself when she spoke of the paucity of great women in the world on Saturday 6 July:

Heard of Mrs Browning's death this day week at Florence – great women are so few that the world feels poorer & women feel smaller for her loss. I think a great deal of the golden haired boy & the grief it must have been to her to leave him. I do hope his Father will have sense to send him to school or he will be quite ruined.

The public at large saw Christina Rossetti as the obvious successor to Mrs Browning. Pauline seems not to have seen the situation that way, despite the fact that she knew Christina quite well and was reasonably fond of her. One might have expected Pauline's huge regret

at the death of Elizabeth Barrett Browning to have been followed by pleasure at the sudden emergence of Christina Rossetti after 1862, when the success of *Goblin Market* caused her to be widely hailed as the next great woman poet. But Pauline seems not to have been much interested in, or impressed by, Christina's poetry.

Concern about Walter's health, mild teasing of Wooster and gossip relating to the 'Master' were meanwhile becoming staples of Woolner's chatter:

> Feb 10 [1857] I am grieved to hear that Sir Walter is unwell again; why could not you prevent him running such a great risk? I hope now he is well again. I think considering what feeble attempts his are, Mr Wooster needed not to catch a cold in his ardour for photography. the amount of pleasure that they will give to others will scarcely compensate the sore eyes, sore nose, the sans comfort in everything he has to endure [. . .]
>
> [Ruskin] begins to look very old and more odd looking than ever: his forehead looks stronger and the eyebrows show raggedy, hanging overmuch like Peter's [Pauline's dog]: and as he delivered his address he sneered most extraordinarily, I suppose with the energy of his intention. He means to remember and write out his speech, so that mankind may know.

He was intelligent and informative about Carlyle,* and very acute on the way in which the painters of the former Brotherhood, having carried all before them with Ruskin's support, were now encountering a backlash or counter-attack, and about the Indian Mutiny.

Reference to the Indian Mutiny had tragic resonance for Pauline and Walter. In May 1857 sepoys of the Bengal army shot their British officers and marched on Delhi to restore the last Mughal emperor, Bahadur Shah, to power. Violence spread down the Ganges valley and the siege of the British garrison at Cawnpore became a symbol of the whole struggle. After nineteen days the garrison surrendered to Nana Sahib, who ordered that all the prisoners should be executed: these included Anna Halliday, the daughter of Walter's sister Emma Wyndham, together with her husband and children. Sir Henry

*Carlyle was engaged in his Herculean struggle with his life of *Frederick the Great*: 'He talks of it with great pain and says that he often thinks seriously that it will kill him before it can be finished.'

Havelock recaptured Cawnpore and inflicted brutal and systematic reprisals, but he was unable to hold the city. He died later in the year at Lucknow. In the meantime his punishment of the people of Cawnpore had shocked liberal opinion in England. Despite the death of his niece and her family, Walter Trevelyan was among those who condemned Havelock's revenge. He wrote a thousand-word open letter entitled 'Indian Mutiny and Massacre', which he had printed and circulated among his friends. England, he protested, had forgotten that it was supposed to be a Christian country. For Woolner to be commissioned to create a sculpture group called *Civilization* was therefore consonant with Walter's profound belief in the need for an essentially Christian foundation for British life at both the political and the personal levels.[15]

In 1860 Pauline was fired by the enthusiasm of one Captain Snow, and by his discussion of the lost explorer, Sir John Franklin of the Antarctic, to mount her own campaign for an expedition to set out in search of his ships, *Erebus* and *Terror*, and their crews. The chivalrous and romantic spirit that had fired the Arthurian decoration of the Houses of Parliament and the Oxford Union seemed to be embodied in this courageous and adventurous man. Sir John had set out with his two ships to find the North-West Passage from the Atlantic to the Pacific. The expedition was planned to take two years. After three years the British Government sent out further expeditions to search for the lost explorers; evidence was found that Franklin and some of his men had died, while the fate of the other explorers remained unknown.

Sir John's widow, who was a friend of the Trevelyans, funded an exploration to discover what had happened to the expedition (Walter and Pauline contributed to the expenses). Pauline was also stimulated to take an interest in Franklin by Swinburne, who planned to write a poem about the explorer for a competition. A prize would be awarded for a poem on a topical theme to be read at the meeting of the British Association in Oxford later that year (Pauline and Walter would be there, of course). The expedition funded by Franklin's widow had returned and there could be no doubt that the crews were dead, but a lecture given in Newcastle by the Arctic explorer W. Parker Snow persuaded Pauline otherwise. She decided to support Snow in mounting a second expedition to the Arctic, and she and Walter subscribed £50 each, and then she canvassed her

friends. This was a somewhat feverish quest. In June 1860 she wrote to Bell Scott:

> Yesterday I sent you a paper about Captn Snows Search – he is to lecture at Newcastle on the 19th & collect subscriptions – now I do conjure you by all you believe in – by *misty* philosophy by gooseberry pie – & tobacco smoke – & anything else equally sacred to you – do go – do make other people go – do puff – do ventilate the subject & try to get people to take an interest in it if they don't care for the Records & Journals there is always a chance of finding some of the Franklin people alive & if they don't care for either they may be moved by the thought of our old Flag going first round the world by the Arctic Route. & not leaving that triumph to the odious Stars & Stripes. which will be before us as sure as fate if we don't mind. – now pray do try what you can to help us. I have set my whole heart on this Search – read the *Saturday Review* of this week about it please.

Through the Trevelyans, Snow was invited to speak at the British Association meeting; Walter wrote to the Prince Consort, subscriptions came in, and the expedition was planned for 1861. But Snow turned out to be a bankrupt rogue and the plan came to nothing.[10]

Meanwhile *Civilization,* so enthusiastically commissioned from Woolner in 1856, had not progressed. Pauline did not seem too put out by the delay. In her letters to Bell Scott she joked about it, instead of expressing the vexation that would certainly have been justified. From the seaside at Seaton in August 1860 she noted that Woolner worked on her sculpture when he had nothing better to do. She reported on Benjamin Woodward's designs for some further 'sea side houses here' (these were not built because of Woodward's early death) and, with no trace of embarrassment, teased Bell Scott cheerfully and affectionately about his mistress and his supposed laziness: 'I suppose it was all sunshine while you were with Miss Boyd [. . .] what are you doing now? smoking and getting fat in your new studio? – I expect to find you fearfully fat and stupid when I come home.'

But unlike Woolner, Bell Scott made reliable progress with his commissions: 'is Grace Darling finished? Is she fearfully & wonderfully ugly?' This was another sly tease; Bell Scott replied that Grace Darling could not be seen in detail because she was a distant figure in a boat, but that the figure based on Alice Boyd was fully present in the foreground of the painting. He boasted that he was 'a great

marine painter', more skilful than Turner, and duly got teased about that as well: (October 1860) 'no doubt you ought to be. considering your love of the sea – and yr passion for voyaging upon it. so that you are a sort of a fat peacable sea King. not like that "Cockney Turner" who used to go a voyage when ever he could – and had himself lashed to the masts to watch storms when they came.' She had more serious news to communicate, though: Swinburne had failed to win the Newdigate Prize for an original poem at Oxford, and his grandfather, her old friend Sir John Swinburne of Capheaton, had died:

> I am afraid we shant see much of poor Algernon in the north now dear kind Sir John Swinburne is gone – what a loss he is – it seems ridiculous to feel as if a man of 98 had died too soon. but he certainly has. for he enjoyed life & added to the enjoyment of many other people.

Pauline had been struggling with oil painting, but without Bell Scott to help her it was not a success:

> I took advantage of some five days to try and make a little oil study of plants out of doors – you basely never kept your promise of shewing me how to do it. so of course I got in many troubles – hang the oil colours!! why do they look so bright & strong & jolly & then in two or three days they go in and are all dim & dingy? it seems to want varnish must it wait for a year till its quite hard before it is varnished?

Her funny letter about Grace Darling contains a serious point about Bell Scott's use of light:

> I like Grace Darling and it isn't nearly so ugly as I expected. – I think it is one of the best of the lot in point of composition & I think both the sea & the sky are capital. one thing which chiefly troubles me is, that I have been watching the stormy rosey dawns at Seaton lately. when days broke after a rough night. and everything that faced the day break was dyed fiery red. so why these people. even those who look straight at that red dawn – are made as pretty coloured as ever – I can't understand – one would think you had invested a fortune in antibilious pills, that you are set on painting all mankind as ready to die for want them. I'll never believe these people looked that colour. never – the woman might – being screened by the others. but the sailor looking out – it is impossible that he should – Sir Walter likes the picture greatly better now he sees it up.

Bell Scott was obviously able to take quite a lot of teasing when she wrote about his (excess) weight and the 'horrors' that he had painted:

> Did I tell you about the winds wrenching up & breaking one of the glass domes at Wallington & sending it crashing down into the Hall – it came just on the table where the painting things live – fancy if any stout party had been mixing his pallette there! there was no great damage done – but the breaking of that nice white pallette you gave me – which has been a most favorite possession of mine ever since – unhappily no harm came to Bernard Gilpin or any of the other horrors on the walls.

Pauline rebuked Bell Scott for being too self-regarding to see the greatness of Turner's paintings: 'but you were disgusted, & discontented & had a clamorous and absorbing "Ich"'. Indeed she was right: his self-centredness, his clamorous and absorbing Ich, both propelled him to work hard (Rossetti was constantly amazed and perhaps intimidated by the speed with which Bell Scott completed the Wallington paintings) and made for his prickly inability to get on with people and advance his own career where it mattered.

She knew that Bell Scott felt slighted and hard done by in his relationship with Ruskin and, in particular, that he resented Ruskin's refusal ever to praise his work. His touchiness about this in the end taxed even Pauline's patience, judging by the content of her letter to him of 18 August 1863:

> I will tell you exactly what he tells me about [the paintings] [. . .] He thinks they are in the highest sense of the word great works, and he thoroughly admires them, and he says that he does not believe that we could have got them so well done, take them all by all, by any other living man [. . .] but he does not enjoy them, because the colour is not pleasant, and one colour is left quite uninfluenced by another, and the unnecessary bits of ugliness and vulgarity annoy him as cruelly as they annoy me – (perhaps worse, though I doubt it). You might have compassion on us and alter some of the *little* disagreeables – but I dare say you won't.[17]

Bell Scott was hurt.

The truth is that the settings and landscapes of the Wallington paintings are painstaking and often beautiful, but that the figures placed in these settings do not show Bell Scott at his best. After he

arrived in Newcastle in 1843 he painted some beautiful small water-colours of the city: the medieval approach to the Black Gate of the twelfth-century castle, and the medieval houses at the centre of the Bigg Market, both painted in about 1846; and there is a fine undated oil painting of the Crown of Thorns, which is a remarkable feature of St Nicholas's Cathedral. These have an additional importance in that they are good records of how the city looked before much of its medieval heart was cleared away to make room for the railway; this carved a route right through the castle, separating the Black Gate from the Keep with astonishing brutality, and causing most of the old buildings round the castle to be swept away in order to create an approach for the railway to Dobson's new station (built in 1846–50) and Stephenson's High Level Bridge, which carried the railway south to Durham and London.

The Trevelyans were strong advocates of railways: Walter's phil-anthropic attitude was that they were a democratising force and that they established social cohesion in the nation at large. So he person-ally promoted, and contributed substantially to, the building of a branch line between Morpeth and Scots Gap, near Wallington. For Pauline, the opening of John Dobson's railway station at Newcastle in 1850 (the first and most beautiful of those splendid monuments to Victorian enterprise) brought London and its culture to her doorstep. In the summers of the 1850s and 1860s the stream of southern visitors to Wallington was continuous, to her great delight. Bell Scott, like Ruskin, hated the railways (although, also like Ruskin, he always travelled by train when it suited him). Many of his letters to Pauline mournfully record the damage that Walter's enthusiasm was doing to the scenery of Northumberland. Surprisingly, though, he says little about the destruction of medieval Newcastle, although his paintings of it speak for themselves. Surprisingly, too, he seems never to have discussed any of this with Ruskin, though it would have provided welcome common ground between the two men.

It was unlikely that Ruskin would admire Bell Scott's work at Wallington, if only because he could not bring himself to enjoy the work of Ford Madox Brown, whom he admired in other ways. The greatest of Bell Scott's paintings at Wallington, *Iron and coal*, is a very deliberate piece of social and political realism. The painting most closely comparable to it is Ford Madox Brown's *Work* (1852 and 1856–63 – it was exceptionally slow to complete, even for Brown). *Work* praises the dignity of labour and displays F.D. Maurice, founder

of the Working Men's College (at which Ruskin and Rossetti taught in the 1850s), and Thomas Carlyle, Ruskin's close friend and adoptive father (and later a good friend of Pauline). Yet Ruskin would never commend Brown's painting. He wrote to Ellen Heaton on 12 March 1862:

> Do not buy any Madox Brown at present. Do you not see that his name never occurs in my books – do you think that would be so if I *could* praise him, seeing that he is an entirely worthy fellow? But pictures are pictures, and things that aren't aren't.[18]

The Wallington scheme had been widely and favourably reviewed, and it had the effect of altering national attitudes to regional art. William Michael Rossetti wrote in *Fraser's Magazine* in November 1861:

> Nothing can be more appropriate to the case than such a pictorial county history. It is as truly and as valuably historical as the 'national' historical arts, admits of and demands variation for each several country and district and furnishes endless material of artistic, local and general popular or human interest, not forestalled nor likely to be forestalled otherwise. Were such an idea to spread every part of England might become an artistic centre of direct and special interest to those settled on the spot, and certain to present to the visitor something new and high in aim at least, if not in result.[19]

In 1855, the year in which Pauline had conceived the Wallington scheme, a local journalist wrote in despair that the 'fine arts in Newcastle appear literally to be dead and buried', and that with the growing prosperity of the people of Newcastle and Sunderland came a growing ignorance of art and a preference for 'champagne and claret'.[20] By 1862 that opinion had significantly changed. The Wallington scheme was recognised as an innovation of national as well as regional significance, and it was widely reviewed in the national press. The paintings were exhibited in London before finally being hung in Wallington. The only comparable (though not closely comparable) recent decorative scheme were the frescoes of Arthurian subjects painted by Rossetti, Burne-Jones, Morris, Prinsep and others in Dean and Woodward's new Gothic Union building at Oxford in 1857. Bell Scott's Wallington paintings prompted similar decorative schemes elsewhere in the country, such as the cycle of twelve historical paintings

for Manchester town hall (depicting episodes in the history of Manchester from Roman times to the recent past) undertaken by Ford Madox Brown in the 1870s, and the later decorative scheme commissioned for the Scottish Portrait Gallery.

It was never going to be possible for Pauline to have Thomas Woolner's undivided attention. He loved to know the rich and famous, and was especially proud of his friendship with Tennyson and his circle. At the same time he was well liked by William Bell Scott (which was not easy), by the Rossettis (much easier) and by most of his fellow artists. His personality attracted a great many people, men and women alike. Like any prudent and penniless artist, he worked to ingratiate himself with those visibly higher up the ladder of fame and success.

The relationship between Woolner and Pauline developed into the kind of mild flirtation that characterised Pauline's friendships with clever men. He felt confident enough to tease her about her failings as a correspondent: (5 August 1860) 'Your letters are like fine summers in England, grateful and pleasant when they come but which are not very frequent'; and he continued to tax her patience with his narrative poem: 'if you would like me to send it to you I will do so: only you must tell me exactly where I must address it, as this is the only copy I have; and if it were lost I should lose my years of labour; and I have no time to make another copy'. Pauline was too polite to retort that if he had not wasted his time on poetry, he would have made more progress with her sculpture. 'I have been working at your group for a long time now, and I think I shall soon be satisfied with the composition, and when I am the finishing will not take me long. It seems an almost incredible circumstance that sculptors should be standing still for want of marble: but that is the case with others beside myself.'

Pauline was resigned to the fact that other commissions would be put ahead and that hers would be fitted in: 'Woolner can't get a block of marble at present to do the Fairbairn children,' she wrote to Bell Scott in August 1860, 'so he has been working on our group.' She could have added 'at last', but did not. Constance and Arthur Fairbairn had been born deaf and dumb, and this sculpture was commissioned by their parents. It is striking, bringing out the gentleness and uncertainty of the two children and the gestures with which they tried to communicate.

As social facilitator, Woolner was second to none: holidaying in Cornwall with Tennyson and Palgrave, he seized the opportunity to suggest to the Tennysons that they should stay with Pauline at Wallington – Pauline's own earnest desire. And he was happy to join in the strangely open running joke that all Bell Scott's friends enjoyed with each other about his relationship with Alice Boyd:

> [25 August 1860] As for W.B. Scott's charmer Miss Boyd. I know nothing of the sweet creature; all I can say is that I hope Mrs W.B. will be jealous and keep her husband in order due. What right has such a grave old philosopher as he to flirt with pretty girls?

The Tennysons remained elusive:

> [26 September 1860] I am sorry the Tennysons are not going to you this year [. . .] I have heard her [Tennyson's wife] say how much she should like Alfred to know you and Sir Walter. When I was with A.T. at the Scilly Isles he was grumbling that he had to go home to enter-tain guests: he was always asking me questions about Sir Walter, and seemed to take a great interest in him: I think that the Trevelyan Legend of the White Horse fascinates rather and makes him wish to see the descendant of such a favoured man.

This romantic legend gave timeless and supernatural ancestry to the original Trevelyans. The founding Trevelyan was said to have escaped on his white horse from Lyonesse, or Atlantis, as that myth-ical kingdom sank off the Cornish coast. A variant of the story has it that he had swum his white horse to the coast of Cornwall from St Michael's Mount. (A fine tapestry at Wallington illustrates this.) The story was of a piece with the legends of King Arthur from which Tennyson took subjects throughout his life (from 'The Lady of Shalott' to 'The Last Tournament' in *Idylls of the King*).

Woolner regarded Lizzie Siddal, Rossetti's mistress and now his wife, as vulgar, and he assumed (rightly) that Pauline was in agree-ment with this. The new Mrs Rossetti, married in 1861, was: 'rather good-looking in the face and exceedingly graceful in figure; but most unattractive in manners, that is, she never spoke'. Meanwhile Edward Woodward, architect of the Oxford Museum, whom Pauline greatly liked, was known by all his friends to be dying. Woolner wrote to Pauline 'I hope Woodward will come to you, and I hope you will not fail to impress on him the necessity of personal care; for he is so

excessively delicate, and above all things he ought not to work too hard, which I fear he is apt to do. If we lose him there is no other to supply his place.'

Woolner's breezy contact with the world of the arts was some compensation for the delay in his work on the sculpture. A long, gossipy account of Browning described the widowed poet's sadness now that he lived alone. He 'was chatty and almost cheerful till something however distant touches near the dark place of his memory.' Woolner had a ruthless sense of who mattered and who did not. A less important, but far more recent and shocking, loss gets tucked in hastily at the end of his letter: 'I dare say you have heard of the death of Rossetti's wife – she took an overdose of laudanum – was buried yesterday.' Woolner also reported that Ruskin, 'the dictator', was subject to extreme mood swings. Indeed, his account indicates the manic-depressive or bipolar disorder from which we now know Ruskin was beginning to suffer in these years, partly because of his helpless infatuation with the Irish child, Rose La Touche:

> The last note I wrote I told you how old and nearly shrivelled he looked. to my astonishment last Monday night he looked like a youth. perfectly blooming: I believe these sudden changes are common to nervous sensitive persons. but I never saw anything like his case.

A tense episode for Woolner involved the commission for a bust of Lord Macaulay. He lobbied the Trevelyans for help in securing this commission for himself, and was enraged by the possibility that it might go to a fashionable sculptor of the day called Carlo Marochetti: 'The Baron [Marochetti] has maltreated so many of our great men that I should like to rescue our historian from his merciless fingers.' The Charles Edward Trevelyans initially preferred Marochetti's work, but proved open to persuasion.

As Woolner became more successful, so his letters became more comfortably self-regarding:

> [14 April 1862] Lady Ashburton [Loo] and Browning came to me today, she said my group was the most beautiful piece of sculpture she had ever seen by anyone in her life, and that she would rather be the make of that than of all the other statues in England together. Browning said the workmanship was equal to the finest antique. So you see that is something like praise, and I naturally bow to such appreciation. Lady

Ashbtn is exceedingly anxious to see your group and I have promised to let her know when she can go & see it.

In the summer of 1862 Pauline had at last met the Tennysons, in London, partly through Woolner: 'I had heard from Mrs Tennyson of your meeting which pleased me greatly, and I hope with you that it is a beginning of many and not the one solitary event of the kind.'

On the subject of marriage, Woolner took Pauline very much into his confidence, as though she was a kind of mother to him as well as to the other young men (such as Swinburne) who actually needed mothering. He was pursuing a young woman whose wealthy family were not pleased: (March 1863) 'It seems to me that parents treat men if rich as though they were gods, but if not rich as if they were of no more account in their aspirations and their lives than so many pieces of dead wood or pebbles on the road.' In June 1864, however, Woolner was able to announce his forthcoming marriage: 'I had terrible work with the parents: did not think me religious enough.' Loo, he reported happily, was taking a close interest in his marriage: 'Lady Ashburton says August will do for me.'

By 1865 Pauline was in such poor health that a full social life was no longer an option, and she enjoyed living vicariously through other people's accounts of what was going on in the world. Woolner continued to oblige.

[12 December 1865] I gave your messages to Mrs Tennyson who expressed her thanks for your kind remembrances. We had the sea in great glory at Freshwater, and so tortured were the waves they realised Shakespeare's expression of 'yeasty waves' – one of the few times of my life that I have seen the water so [. . .]

A copy of the 3rd edn of my poems came to me last evening, which Macmillan has got ready I suppose with an eye to Xmas.

Even Pauline must have been running out of patience with Woolner's poems by this time. And she was never to see her group completed. Woolner continued to take on other commissions for the busts of great Victorian men. On 4 April 1866 he wrote:

I am now finishing off the Lord Macaulay, and when this is done I want

to finish off your group, and now write to know if it will be convenient for you to have it when completed home at Wallington. It should have been done long ago.

Civilization was finally finished in November 1866. By then Pauline was dead.

Algernon, the adopted son

The *unmanly* monomania he has of raking up from history and
the haunts of the devil all the wicked stories that give rise to the
horrible accusations

Pauline's friend Algernon Charles Swinburne, born in 1837, is now
acknowledged as one of the greatest poets of his age and a defining
figure of the radical and heady 1860s, when art was proclaiming its
independence of morality. Unlike her other friendships with geniuses,
though, that with Swinburne began for reasons to do with the genial,
old-fashioned and courteous life of the Northumberland gentry. The
Swinburnes were the great ancient aristocratic owners of Capheaton,
the nearest significant country house to Wallington. The immensely
long-lived Sir John Swinburne, who had been born a Roman Catholic
in 1762, found it expedient to be received into the Anglican Church
as a young man and had been one of Walter's distinguished prede-
cessors as High Sheriff of Northumberland (among many public
offices), had serious literary and intellectual interests and was a friend
of poets and painters (including Turner). He was also a long-standing
friend of Pauline and Walter.

Algernon Swinburne was the oldest child of Sir John's second son,
Captain (later Admiral) Charles Henry Swinburne, and his wife Jane
Henrietta Ashburnham. The Captain was a martinet and did not
understand his oldest child: Algernon was odd-looking, undisciplined
and in constant trouble with his father. By contrast, his mother adored
and indulged him, and her famously soft and beautiful voice,
Swinburne would later say, had given him his earliest sense of the
beauty of lyric poetry. His childhood home was at Bonchurch, on
the Isle of Wight, where he early on developed his abiding love of
the sea (surrendering to its violence and becoming roused to visionary
exultation by its extent were to become recurrent motifs in his major
poetry). William Sewell, the old adversary of Newman whom Pauline
had so disliked at Oxford in the 1840s, was a neighbour of the
Swinburnes on the Isle of Wight and tried to encourage Algernon in

his writing of poetry; this was an uphill task, as Captain Swinburne firmly discouraged this aspect of his son's talent. Not surprisingly, the young Swinburne loved to get away from the parental home and his favourite place for holidays was his grandfather's house in Northumberland. Little Algernon became famous among his northern circle for his physical daring: a small red-headed figure would be seen riding in all weathers over the wildest Northumberland moors or swimming when the North Sea was at its most violent.

Captain Swinburne sent his son to Eton, thinking that the discipline, the company of more normal boys and the steady application to work would be good for him. A contemporary at the school, his cousin Algernon Mitford (later Lord Redesdale), remembered 'what a fragile little creature he seemed' when he first arrived at Eton:

> His limbs were small and delicate; and his sloping shoulders looked far too weak to carry his great head, the size of which was exaggerated by the tousled mass of red hair standing almost at right angles to it.

Swinburne's intellectual life at Eton was enthusiastic and unorthodox. Redesdale remembered him as a solitary, strange boy, constantly reading in the boys' library: 'perched up Turk- or tailor-wise in one of the windows [. . .] with some huge old-world tome, almost as big as himself, upon his lap, the afternoon sun setting on fire his great mop of red hair'.[1] He responded passionately to some of the Greek and Latin poets who comprised the staple of the school's syllabus (especially Sappho and Catullus) and he read Marlowe, Webster and as many others of the Elizabethan and Jacobean dramatists as he could find, as well as Victor Hugo's *Notre Dame de Paris* and *Lucrèce Borgia*. Algernon had been writing poetry since early childhood, and now ambition drove him to write full-length Elizabethan dramas, as well as a mock-Augustan occasional poem to record a royal visit to the school.

Intellectually, then, Eton suited him and served him well. At the same time there was a great deal of violence, both random and institutional: physical bullying from the older boys and systematic beating (usually with the birch) from the tutors. The beatings became associated for Swinburne with extreme physical excitement, so that by late adolescence sexual pleasure was inextricably associated with pain. This was to become a dominant obsession in his adult life.

He left Eton early – it has never been clear why, but Swinburne

and institutions did not get on, and it seems likely that his parents had been persuaded to remove him. After Eton he spent some considerable time back in Northumberland being prepared for Oxford by the Revd John Wilkinson, curate of Cambo, the village owned by the Trevelyans (it stands next to Wallington and is part of the estate). William Bell Scott befriended Algernon at about this date, and remembered him aged about seventeen 'riding a little long-tailed pony at a good pace towards the village' and looking like a small boy, 'but for a certain mature expression on his handsome high-bred face'.[2] Swinburne had known Pauline since he was a child, but now he became a personal friend and would ride over to Wallington with the latest French novel in order to praise it to her. This peaceful interlude for the young man ended, though, when the old family friend Dr William Sewell, now Warden of Radley, invited Swinburne to continue his preparation for Oxford down at Radley College, partly as a pupil and partly as a member of his household. Sewell's prominence in the Oxford Movement made this a welcome suggestion to Swinburne's parents, who hoped at this date that Algernon might enter the Church (astonishing though that may seem in the light of subsequent events). Swinburne was still reading avidly: the whole of Tennyson, especially the newly published *Maud,* and the complete works of Thomas Middleton (Swinburne was later to be the first scholarly editor of Middleton). But Sewell and Swinburne fell out, as might have been expected; Swinburne's conspicuous religious scepticism and disdain for all convention were seen as a danger to the boys of Radley, and he was asked to leave.

At Balliol College, Oxford, he encountered an intellectual equal in Benjamin Jowett, the Professor of Greek and great translator of Plato, who would in due course become a close and indulgent friend of the poet. The other friendships Swinburne made at Oxford were lasting and important. By shared enthusiasm and energetic association with their pursuits, he became, in effect, an honorary Pre-Raphaelite in 1857. Rossetti, Burne-Jones, Morris, Prinsep, J.H. Pollen and Arthur Hughes – all fired by Tennyson's Arthurian poetry to decorate the Oxford Union debating chamber with Arthurian murals – adopted Swinburne. Because of his blazing red hair he was their 'dear little Carrots' and he in turn idolised Morris, Rossetti and Burne-Jones as a trio of geniuses. In 1858 he read Morris's dark, powerful account of the punishment of the adulterous queen, *The Defence of Guenevere,* and hailed it as another Arthurian master-

piece. It stimulated him to write a number of Arthurian poems himself. The interests and the companionship of these men acted as a major stimulus to the poetry and plays that he wrote in the 1860s.

Swinburne was never going to be a conventional undergraduate. In terms of real intellectual development he gained hugely from the university, but on the whole he did not engage with his formal studies. He failed his first-year examinations (because he was reading Browning's *Sordello* instead of revising his classical texts) and struggled through the syllabus in his second year. By November 1859 Balliol was becoming exhausted by Swinburne: he had repeatedly flouted all the rules and ignored the college's warnings, but the immediate cause of his leaving Oxford was a fall from a horse. He felt unable to recover in time to sit his examinations and withrew from Balliol without taking a degree.

His writing accelerated after leaving Oxford: some of the lyrical writing of 1859–60 was to appear in due course in *Poems and Ballads* (1866) and he was also writing plays (some very good ones) based on Jacobean tragedies. He spent the winter of 1859–60 at Capheaton and Wallington, then plunged himself into literary and artistic London. A pattern seemed to be developing – intense stimulus in London alternating with security among the people he loved in Northumberland – but this was upset by the death of his grandfather in September 1860. From that date Capheaton ceased to be his home; his future visits to Northumberland would be to stay with the Bell Scotts or with Pauline. In London his closest friendships were with the Rossettis: William Michael and especially Dante Gabriel and his wife Lizzie Siddal. Swinburne dined with the D.G. Rossettis the night before Lizzie's sudden death from an overdose of laudanum in February 1862. This was in fact suicide, though the Rossetti family concealed this, for obvious reasons. It was a disastrous event for Rossetti himself, and one from which he never fully recovered.

Rossetti and Swinburne became increasingly close following Lizzie's death. Bell Scott and William Michael Rossetti invited them as travelling companions on a tour of Italy in the summer of 1862. Rossetti had never set foot in his father's country; but he had lost Lizzie so recently that, after much discussion of the plan, he and Swinburne decided not to go; indeed, Rossetti was never to visit Italy. He and Swinburne stuck together, and by November of the same year they were sharing a house, Tudor House, in Cheyne Walk, Chelsea.

The revolutionary Swinburne was a supporter of Italian republicanism, of Irish home rule and of Shelleyan atheism, and by 1861 he was associating with a new, and dangerous, friend who was outside the Rossetti and Trevelyan circles. This was Richard Monckton Milnes, Lord Houghton, the author of the biography of Keats that had stirred the young Pre-Raphaelites in 1848. Milnes was far too raffish a figure for Pauline, but had she known his poetry she would have liked it: literate meditations on his travels in Greece and Rome, published in 1854 as *Memorials of Many Scenes*. And she would have endorsed the modest attitude to the role of the biographer set out in his *Keats*: 'It was best to act simply as editor of the life which was, as it were, already written. I had not the right, which many men yet living might claim from personal knowledge, of analysing motives of action and explaining courses of conduct; I could tell no more than was told to me [. . .] The biography of a poet can be little better than a comment on his poems.'[3]

Milnes kept a secret library of erotica at his Palladian house, Fryston Hall in Yorkshire, and was especially interested in flagellation. Swinburne found this irresistible. He had not been able to read the works of the Marquis de Sade, but he knew about him by reputation and made a point of praising him. (One William Hardman, who heard Swinburne on de Sade in D.G. Rossetti's company in 1861, said that the sodomy, murder and cruelty were too much for his friends, 'who received Swinburne's tirades with ill-concealed disgust, but they behaved to him like to a spoiled child'.[4]) Swinburne's intelligence and humour did not desert him, though. When he was able to borrow de Sade's *Justine* from Milnes, he found it hilariously absurd and devoid of erotic sensation. He wrote to Milnes on 18 August 1862 asking, 'is this all?' De Sade had made the radical mistake of taking 'bulk and number for greatness [. . .] You tear out wombs, smash in heads, and discharge into the orifice. Après? You scourge and abuse your mother and make dogs tear off her breasts, etc. Après? Suppose you take your grandmother next time and try wild cats by way of a change?'[5]

Friends saw Swinburne as torn between a bad and a good angel, the sensual *enfer* of Milnes, his library and his circle of libertine friends, and the gentle and protective role that Pauline Trevelyan played in his life. In fact, Milnes himself tried to restrain Swinburne as far as drink was concerned, but on the subject of sex Milnes gratified Swinburne's appetites. Late in 1862 Swinburne spent some six

to eight weeks at Fryston Hall, absorbing Milnes's library and displaying his talents excitedly to his friends. He told Pauline nothing about this visit beyond the bare fact that it had taken place, and by the winter he was in Northumberland again, staying with the Bell Scotts and then travelling on from Newcastle to Wallington for Christmas. Tradition has it that in January 1863 he brought a new novel by Balzac to Wallington and was praising it to Pauline when Walter arrived unannounced and threw the novel onto the fire on the grounds of its indecency. Swinburne rescued it from the flames, stalked out of the house and went straight to the Bell Scotts' house in Newcastle. Bell Scott and Letitia had indeed invited Swinburne to come back to them after his Wallington visit, but not as early as 5 January. They were not expecting him and were about to take a brief New Year holiday by the sea at Tynemouth. Since he now had no other home in the North, Swinburne accompanied them, and spent a few days in Tynemouth reciting his poetry to them as the three friends walked by the sea. The quarrel with Walter, though, was soon made up. Walter and Swinburne had much in common, after all: they loved Northumberland and were good walking companions for each other. Swinburne went back to Wallington and travelled with the Trevelyans down to London on 18 January.[16]

Back in London, the Cheyne Walk household was expanding to include William Michael Rossetti and the novelist George Meredith. The arrangement – four men sharing a shabby but very large ancient house by the river – did not last long, partly because Rossetti moved his mistress, Fanny Cornforth, into the house and Swinburne felt this was an affront to Lizzie's memory; but partly also because Swinburne was drinking a great deal and was subject to fits of extreme violence and excitability. The stories, if true, are of wild adolescent behaviour: he stripped naked, slid down the banisters and chased their friend, the painter Simeon Solomon, round the house; he threw poached eggs at Meredith as a way of settling a literary disagreement; he smashed Rossetti's precious blue and white china; and so on. In the summer of 1863 Meredith moved out, but Swinburne continued to share the house with Rossetti for another year.

In the summer of 1864 Swinburne's friendship with Rossetti came under severe strain, for reasons that are not clear; it seems likely that Swinburne was failing to contribute his share of the rent to the house on Cheyne Walk. Whatever the reason, Rossetti in effect threw him out. Swinburne reacted frostily: 'I had not understood our common

agreement to be so terminable at the caprice of either party that one could desire the other to give place to him without further reason alleged than his own will and pleasure,' he wrote.[7] Untidy and undisciplined though life at Tudor House had been, it did at least give Swinburne a kind of framework. After this he lived temporarily at various London lodgings, stayed for long periods again with Monckton Milnes (now Lord Houghton), and drank and indulged himself even more thoroughly. At the same time he was establishing his fame in literary London as poet, dramatist, critic and sensation. In 1865 his father decided to sell the Isle of Wight family home and, with Capheaton closed to him, Swinburne felt increasingly like a man with no base and no family. His correspondence with Pauline Trevelyan (among the fullest and most famous of Swinburne's letters) dates from this period. He needed the security of a house like Wallington, and he spent a good deal of time back in Northumberland in the summer of 1865, staying some of the time with the Bell Scotts and moving on to visit Pauline. But there was a dark side to his northern visits, in that he also spent a lot of time at Fryston Hall with Lord Houghton. Swinburne was addicted: the poetry – the most startling, brilliant and uncompromising work published in England in the 1860s – was fuelled by drink, pornography, flagellant sessions with London prostitutes and in general by a life of excess.

In the 1860s Swinburne's revolutionary poetry was seen by intelligent and literary young people (especially at Oxford and Cambridge) as heralding another Shelley. Swinburne himself embraced Shelley as a model, and he was also very enthusiastic about Byron, another aristocrat whose lifestyle was criticised and whose poetry had been seen as obscene and dangerously radical. Swinburne was regarded by those sympathetic to him as a defiant, fearless, crusading atheist and humanist who was also an effortless and brilliant craftsman, eclipsing even Tennyson's formidable technical skills. He was also impressively learned. *Poems and Ballads* uses sex as a political instrument. Stirred by the scandalous success of Charles Baudelaire's *Les Fleurs du mal* (published and then prosecuted in 1857),[8] Swinburne writes about lesbianism, sadomasochism and the deep connections in human psychology between sex and death in a way that had never been seen in Victorian poetry. The themes were embedded in received literary sources, especially Greek myth, in such a way that many readers were

successfully baffled. Most contemporaries just did not notice, for example, that the hugely popular lyrical narrative, 'Itylus', was actually an oblique retelling of a Greek story about rape, cannibalism, incest and infanticide. The story (from Ovid's *Metamorphoses*) is barbaric: Tereus, King of Thrace, married to Procne, rapes his wife's sister, the beautiful Philomela, whose tongue he cuts out that she might not betray him. Philomela makes a woven picture of the outrage, and Procne avenges the deed by killing Itylus, the son of her marriage to Tereus. The child's flesh is cooked and served to the unwitting father. Procne then completes her revenge by revealing to Tereus that he has just eaten his own son. She is transformed into a swallow and her sister into a nightingale. As a nightingale, Philomela sings, lamenting the dreadful story to Procne; but as a swallow, Procne has forgotten her actions and is now an innocent and oblivious creature.[9]

In Swinburne's letters of 1861–6 there is a painful contrast between the erotic letters, enthusiastically painting scenes of flagellation, that he is writing to Monckton Milnes and the letters that he is writing to Pauline at the same time, pleading absolute innocence of all the charges levelled against him by rumour. There is a certain ruthlessness in the fact that some of the letters of which Pauline would most have disapproved were actually written to Milnes while Swinburne was staying under her roof at Wallington (27 December 1862 and 2 January 1863, for example). Bell Scott heard worrying reports about Swinburne's activities, but his conviction was that Swinburne nourished his own reputation for sexual excess because in reality he was impotent. On 14 November 1865 Bell Scott wrote to Alice Boyd:

> I had such an astounding letter the other day sent me by a lady who had received it from a person insisting that she should cease at once to consider A.S. a friend, accusing him of the most monstrous crimes and vices [. . .] You know I don't believe in his wickedness even when he asserts it himself, so I wrote a long letter saying so and that I knew others thought the same, but fully admitting the *unmanly* monomania he has of raking up from history and the haunts of the devil all the wicked stories that give rise to the horrible accusations. I gave a solution of the character too, – a solution I am not alone in believing, that the word unmanly may be physically correct.[10]

Bell Scott was by this time the recipient of all and any family gossip from Pauline: On 28 December 1863 she wrote from Seaton to say

that her sister 'Mous' Hilliard had been ill, but was now better – 'the London Drs say it is an affair of digestion & will be cured with a little patience. the pains are already less frequent & much less severe' – while 'Mrs Carlyle has been at deaths door – literally, she is now for the first time – said to be a little better. Mr Carlyle had a dreadful fright about her.' And there was routine teasing about Bell Scott's weight: 'to wish that "your shadow may never be less" would be unkind – now that you are enjoying retired leisure, you'll grow enormous, I'm afraid.'

Her anxieties over Algernon could always be freely discussed with Bell Scott. In September 1865 she wrote to him:

> Algernon has repeated & read to me some *very* fine things, *splendid I think* – & one which I cant endure I thought at first that he was a great deal improved in himself – but I am afraid that was a mistake. he is as touchy in his vanity & as weak of temper as ever – the way he goes on at Browning &c is too silly. and I see, with other people, that he is out of humour the moment he does not get as much admiration as he wants. it is such a pity. I wish he was more manly.

Still, manly or not, he could write major and distinguished work, as she had acknowledged when *Atalanta* was published earlier in the year (March 1865): '*what* a grand poem *Atalanta* is! it seems to me most beautiful & of the very highest kind of beauty. I am astonished & delighted with it – Lets hope the public will appreciate it. they are stupid animals if they don't.'

Atalanta in Calydon had established Swinburne's reputation. The myth on which the play is based is complex and cruel: Althaea, Queen of Calydon, has dreamt that her son Meleager will survive in battle and live to a ripe age if she preserves a particular 'brand' – a piece of firewood. Meleager leads a violent life because the goddess Artemis is intent on punishing the kingdom of Calydon for its failure to honour her. One of Artemis's visitations takes the form of the ravages of a wild boar. Meleager and the Atalanta of the title (the maiden whom Meleager loves) hunt the boar. Artemis permits it to be killed because Atalanta, unlike Meleager's family, honours her. In his love for Atalanta, Meleager proposes to present the dead boar to her: this provokes the jealousy of his two uncles (brothers of Althaea) and, in an ensuing fight, Meleager kills them both. Transported with rage and grief, Althaea avenges her dead brothers by ending her son's life: she burns the sacred 'brand' on which his existence depends.

214

Swinburne's waywardness and sensationalism were reined in by his Greek models for the work, and the rhythms and energy of *Atalanta* are consistently powerful. The songs of the Chorus are justly famous:

> When the hounds of spring are on winter's traces,
> The mother of months in meadow or plain
> Fills the shadows and windy places
> With lisp of leaves and ripple of rain;
> And the brown bright nightingale amorous
> Is half assuaged for Itylus,
> For the Thracian ships and the foreign faces,
> The tongueless vigil, and all the pain.
>
> Come with bows bent and with emptying of quivers,
> Maiden most perfect, lady of light,
> With a noise of winds and many rivers,
> With a clamour of waters, and with might;
> Bind on thy sandals, O thou most fleet,
> Over the splendour and speed of thy feet;
> For the faint east quickens, the wan west shivers,
> Round the feet of the day and the feet of the night.[11]

Pauline could enjoy it without hesitation because its obvious sensuality was disciplined by its sources. She took in her stride the fact that the world of *Atalanta* is one in which an arbitrary and violent deity acts destructively out of pique, and where 'God' is 'the supreme evil', a cruel force implanting love in human beings for murderous ends. She recognised that Swinburne's Greek models, Euripides in particular, also saw the gods and heroes of the ancient world in the same bleak and unsparing light.

It is greatly to Pauline's credit that she protected and loved Swinburne and never deserted him. The relationship was close and loving, and often mischievous. When Swinburne was a schoolboy and undergraduate, he and Pauline played with the idea that he was another woman rather than a young man, and they would get up female conspiracies between them. Swinburne was a brilliant female impersonator in charades and the like ('I once played Mrs Skewton to admiration'). He wrote to Monckton Milnes on 10 February 1863 (the immediate subject was an injudicious advertisement in a newspaper for a governess 'willing to give corporal punishment'; this brought out Swinburne's flair for farce):

Ah heaven, to run back but four years [i.e. to 1859 or so]! would you believe that at the time I did quite well (that is, I was a credible being – I don't say attractive!) in female attire, and should have been invaluable on a pinch of theatrical necessities? It is a lamentable truth that Lady Trevelyan had then a dark project of passing me off upon Madame Sand[12] as the typical miss anglaise émancipée and holding the most ultra views; we made up no end of history about it, and infinite adventures for the British Mademoiselle de Maupin. I saw the likeness then done the other day at Wallington [Pauline's drawing of Swinburne as a woman] and howled over it. Such is life. Now alas! had I that chance left which my majority bereft me of, quelle chance! The wildest flattery of friendship could not now aver that even shaving and rouge would make a presentable girl of me.[13]

Pauline felt able to say of some of his work that it was immature and needed rewriting; she particularly felt at liberty to be rude about his tragedies. But she recognised that Swinburne was a major and brilliant poet. Both she and Ruskin had a high opinion of his writing, and in this they were both ahead of their time. William Bell Scott, on the other hand, was worried by Swinburne's drinking, wildness and general aberration from the norm. He wrote to Pauline in November 1865: 'With all his boasting of himself and all his belongings he is very sensitive about society, and I certainly think you will do him the very kindest of actions if you can touch his sensibility on his vanity – a little sharply. Of late he has been much excited, and certainly drinking. Gabriel and William Rossetti think he will not live if he goes on as lately without stopping.' He hinted to Pauline that Swinburne might be homosexual ('he suffers under a dislike to ladies of late') and complained of the cold, perverse attitude to sexuality displayed in *Chastelard*, 'the total severance of the passion of love from the moral delight of loving or being loved, so to speak, and the insaneness of the impulses of Chastelard'.[14]

Chastelard shocked the reviewers as well. *The Athenaeum* was inflamed both by its sexuality and by its anti-theism. The language of the characters was 'inherently vicious', and would offend 'not only those who have reverence, but those who have taste. We decline to show by quotation how often the Divine Name is sported with in scenes which are essentially voluptuous.' The reviewer was in schoolmaster mode: 'We hope, should we meet Mr Swinburne again, that he will be able to exhibit Vice without painting a Monster, and to

give us a higher type of knightly devotion than an infatuated liber-tine.'[15]

Chastelard is an effective pastiche of the dark Jacobean writers whom Swinburne had been reading with such enthusiasm at Eton and Oxford. The play sharply contrasts the open hedonism of Chastelard, the French sensualist, with the cold orthodoxy of the Scots surrounding Queen Mary. The Queen herself is equally 'French', an irresponsible sensualist who likes her sexual relation-ships flavoured with a strong dash of sadism. One of her ladies watches her as she chatters with her doomed lover at his execution. The victim flushes with perverse pleasure immediately before his head is struck off:

> Now his eyes are wide
> And his smile great; and like another smile
> The blood fills all his face. Her cheek and neck
> Work fast and hard; she must have pardoned him,
> He looks so merrily. Now he comes forth
> Out of that ring of people and kneels down;
> Ah, how the helve and edge of the great axe
> Turn in the sunlight as the man shifts hands –
>
> (Act V, scene iii)[16]

Pauline was troubled by the sadomasochism here, but Swinburne was being faithful to his Jacobean models: compare Thomas Middleton's great tragedies. In *The Changeling* and *Women Beware Women* Middleton ostensibly displays wrongdoing in order to chas-tise it, but he clearly assumes that his audiences will share his pleasure in the spectacle of cruelty and depravity.

Late in 1865 Swinburne got to hear that Pauline was worried about his excesses, and in December he wrote her in quick succession some wholly characteristic letters: (4 December 1865) 'I cannot express the horror & astonishment, the unutterable indignation & loathing, with which I have been struck on hearing that any one could be vile enough to tax me, I do not say with doing but with saying anything of the kind to which you refer. The one suggestion is not falser than the other.' (Tuesday 5 December) 'Six hours ago, I was so utterly amazed, horrified, agonized & disgusted, that I could hardly think of anything but the subject of your letter. Now I can hardly think of anything but your inexpressible kindness in writing.' This is dizzying and disin-genuous stuff, and Pauline knew that he was behaving childishly and

was probably lying. But, as always with Swinburne, she did the decent thing and took his protestations at face value:

> [6 December 1865] Your letter is a great comfort to me – I am so very glad that you disclaim indignantly any such talk as is attributed to you – now that you know how people take things up, you will be more guarded in future. I am sure I suppose when men get together and take what Walter's protégés call 'alcoholic stimuli' they are apt to say more than in their wiser moments they wd like to remember, and their listeners may carry away dim notions that much more was said than ever was uttered. Perhaps some of the solid older heads among your friends would tell you loyally if you ever lay yourself open to misconstruction if you ask them about it.

After politely agreeing that Swinburne must in reality have been leading a 'retired studious life', as he claimed, Pauline came to the point: 'do be wise in which of your lyrics you publish – do let it be a book that can be really loved and read and learned by heart, and become part and parcel of the English language & be on everyones table without being received under protest by timid people.' In other words, tone down some of the sexually explicit lyrics that Swinburne was collecting for publication.

Swinburne countered this by pointing out that 'no two friends have ever given me the same advice', and by quoting Ruskin's support for his work:

> Two days ago Ruskin called on me & stayed for a long evening, during which he heard a great part of my forthcoming volume of poems, selected with a view to secure his advice as to publication & the verdict of the world of readers or critics. It was impossible to have a fairer judge. I have not known him long or intimately; & he is neither a rival nor a reviewer. I can only say that I was sincerely surprised by the enjoyment he seemed to derive from my work, & the frankness with which he accepted it.[17]

Ruskin indeed admired both the poetry and the poet, but he clearly also felt some alarm. On 6 December 1865 he wrote to Pauline saying that he had heard Swinburne read 'some of the wickedest and splendidest verses ever written by a human creature', and that 'he mustn't publish these things. He speaks with immense gratitude of you – please tell him he mustn't.'[18] 'These things' were the scandalous verses that gave *Poems and Ballads* (1866) its outrageous reputation.

Against Pauline's advice, Swinburne went ahead and published, but by the time that happened Pauline was dead.

Her great affection for Swinburne is well attested. In 1916 George Otto Trevelyan wrote to Edmund Gosse, who was researching his biography of Swinburne (published in 1917):

> Pauline, Lady Trevelyan, was a woman of singular and unique charm; quiet and quaint in manner, nobly emotional, ingrainedly artistic, very wise and sensible, with an ever-flowing spring of the most delicious humour. No friend of hers, man or woman, could ever have enough of her company; and those friends were many and included the first people of the day in every promise of distinction. She was Algernon Swinburne's good angel; and (to quote one of his letters,) he regarded her with 'filial' feelings. It was a very real and permanent misfortune for him that Pauline Trevelyan died in middle life in the summer of 1866; and sad it was for me too, since she was a second mother to me, who was so rich in that blessing already. Widely, and almost absurdly, different as we two young men were, Pauline Trevelyan was catholic enough to be in sympathy with both of us. [. . .]
>
> My sole recollection is of hearing him, more than once, reciting poetry to the ladies in the Italian saloon at Wallington. He sat in the middle of the room, with one foot curled up on the seat of his chair beneath him, declaiming verse with a very different intonation and emphasis from that with which our set of young Cantabs read Byron and Keats to each other in our college rooms at Trinity. That is the beginning and the end of what I have to tell.[19]

In due course Swinburne would fall out with most of his friends. He quarrelled with Dante Gabriel Rossetti and with Lord Houghton, and he wrote a ferocious account of William Bell Scott after his death. The last of Swinburne's close friendships was with Theodore Watts-Dunton, the solicitor and novelist who initially came into Swinburne's life when the poet needed to be rescued from a blackmailer, and thereafter saved Swinburne from his alcoholism and took him off to live in Putney for the last thirty years of his life. It is easy to say that Watts-Dunton saved Swinburne's life but destroyed his talent; but this is a caricature of the truth. Swinburne continued to write and publish. It seems more truthful to say that living with Watts-Dunton restored to Swinburne the kind of security that he had had as a child and young man when he was always protected by his father, by his schoolmasters at Eton or by Benjamin Jowett. Swinburne was always attaching himself to older men; Watts-Dunton was the last of the series.

Like Gautier, Baudelaire, Rossetti, Pater, Symonds and Wilde, Swinburne heralded the future. Pauline died before she could see that, while Ruskin, clearly, understood. His letters in effect hail Swinburne as an apostle of the new. Ruskin's account also recognises that Swinburne is an embodiment of, and revival of, the most extreme energies of the Romantic movement – the energies of Shelley, Blake and Byron.

Pauline Trevelyan's three histories

Could I but stand again on youth's green shore

Pauline's love for Scott's novels, Tennyson's poetry, Ruskin's Gothic, Rossetti's painting, the Arthurian decoration of the Oxford Union and the wild, bracing countryside of Northumberland are expressions of a passionate engagement with all that we mean by the word 'romantic' (in both its cultural/historical and its more general and popular senses). The components of her early story – her clergyman father's diminishing means, the frosty relationship with an intrusive stepmother and, later, the tense mutual hostility that existed with some, at least, of Walter's family – feel as though they are drawn from that tough late eighteenth-century world of the middling gentry that Jane Austen had observed with such sharp distaste. With her devotion to literature and the arts, to poets and poetry, and to painters and painting, she rescued herself from that world.

She also rescued Walter; this diffident, generous and philanthropic man certainly loved his wife and was willing to be led by her. It was Pauline's decision that they should live in Northumberland; her preferences that shaped their social worlds in Edinburgh, London and Oxford; and her vision that transformed Wallington into a marriage of architecture and fine art. By 1860 the Trevelyan marriage was solid and comfortable, like one of the exceptionally well-built and ingeniously fitted horse-drawn carriages in which Walter liked to travel, and they accepted each other. Walter's eccentricities and prejudices remained lovable, although to a less tactful and skilfully intelligent wife they would have become maddening. Walter in turn (with exceptions, like the moment when he threw Swinburne's French novel into the fire) worked to accept and accommodate those of his wife's friends whom he found it hard to understand.

They were a well-established and devoted couple, the distinguished gentleman and his brilliant, diminutive and determined wife, who attended the meeting of the British Association for the Advancement of Science in Oxford in the summer of 1860. This was one of the

major events in the history of intellectual, theological and scientific life in the nineteenth century. The famous debate over evolution took place in the Museum (Pauline's, Ruskin's and Acland's great creation) on Saturday 30 June.

Since Walter was a prominent member of the British Association Committee, Henry Acland had invited him to chair the natural-history section. Walter declined, much to Pauline's disappointment. Had he accepted, his equanimity would have been strained to breaking point – he would have had to control one of the most violent public quarrels in the history of science. *The Origin of Species* had been published six months earlier. Darwin's theory of natural selection did not appear in the title of section meeting on that Saturday, but a Professor Draper, from New York, was scheduled to speak on Darwin and social progress. Participants were aware that Samuel Wilberforce, the Bishop of Oxford, would attend. Wilberforce's hostility to Darwin's thesis was well known, and the numbers trying to pack into the lecture hall were so great that the event had to be moved to the library, a large (if awkwardly shaped) space on the first floor of the building. About a thousand people were packed into the room. Draper spoke for an hour; he was quite unable to hold his audience, which was waiting for Wilberforce's performance. Doing what he saw as his absolute moral and professional duty, namely defending the Church, Wilberforce barely attempted to address them, but instead devoted a good half-hour to a brutal direct attack on Darwin. Thomas Henry Huxley, Darwin's pupil and champion, then spoke in Darwin's defence. Wilberforce made a clumsy joke, asking Huxley whether it was from his grandfather's or his grandmother's side that he was descended from an ape. Huxley's response was as follows:

> If then, said I, the question is put to me would I rather have a miserable ape for a grandfather or a man highly endowed by nature and possessed of great means & influence & yet who employs these faculties & that influence for the mere purpose of introducing ridicule into a grave scientific discussion I unhesitatingly affirm my preference for the ape.[1]

In retrospect we can see that the laughter following this famous riposte marked a watershed. That very peculiar Oxford and Cambridge institutional position, whereby geology was closely bound to the established Church, was now superseded. The link was broken;

the Church was now in bad-tempered but inexorable retreat. For the Trevelyans this was painful, since all their friends among the geologists had been of the 'English School'. With the rest of the scientific community, they had to adjust to the reality of this shift in authority.

The adjustment came slowly. Darwin's most vocal opponents included some of the people with whom the Trevelyans had associated closely in the past, such as Roderick Murchison, Louis Agassiz (now Professor of Geology and Zoology at Harvard) and Adam Sedgwick. John Phillips, the curator of the University Museum and one of Walter's steadiest and most reliable correspondents on geological matters, was also an opponent of Darwin. He was a devout Anglican and in 1860 he used his authority as the newly appointed Professor of Geology at Oxford to publish *Life on Earth,* in which he made a valiant attempt to discredit Darwin's science by denouncing natural selection, insisting on the separate creation of the species and tracing the universe to a single benevolent creator. Sir Roderick Murchison, one of the grandest and least self-effacing of gentleman scientists, took the view that his own published work had already disproved Darwin's theory, but that Darwin had not bothered to attend to it properly:

> My geological postulates, if not upset, destroy his whole theory [. . .] His assumption of the Lyellian theory, that causation never was more intense than it is now, and that former great disruptions (faults) were all removed by the denudation of ages, is so gratuitous, and so entirely antagonistic to my creed, that I deny all his inductions, and am still as firm a believer as ever that a monkey and a man are distinct species, and not connected by any links, i.e. are distinct creations.[2]

Darwin wrote to Lyell about Murchison's position to say: 'How singular so great a geologist should have so unphilosophical a mind.'[3] Darwin's thesis survived, and Walter and Pauline gradually changed their views. Pauline admired Huxley for his oratory and conviction, and indeed for his dark good looks. In due course she and Walter overcame their own and their friends' scruples to agree that Huxley and Darwin must be right.

Legends wove themselves about the Trevelyans during the 1860s. The spritely and mischievous Augustus Hare, for example, was a guest at Wallington when researching his *Handbook for Travellers in Durham and Northumberland* for the enterprising publisher John Murray.[4]

He was fond of the Trevelyans and his colourful record is worth preserving, but he somewhat misrepresented them:

> Such a curious place this is! and such curious people! I get on better with them now [this was Hare's second visit], and even Sir Walter is gruffly kind and grumpily amiable. As to information, he is a perfect mine, and he knows every book and ballad that ever was written, every story of local interest that ever was told, and every flower and fossil that ever was found – besides the great-grandfathers and great-grand-mothers of everybody dead or alive. His conversation is so curious that I follow him about everywhere, and take notes under his nose.

While Hare made no allowance for the fact that Pauline was in poor health, he still gave a flavour of how her personality could appear to a relative stranger:

> Lady Trevelyan is equally unusual. She is abrupt to a degree, and contra-dicts everything. Her little black eyes twinkle with mirth all day long, though she says she is ill [. . .] She never appears to attend to her house a bit, which is like the great desert with one or two little oases in it, where by good management you may possibly make yourself comfort-able. She paints foxgloves in fresco and makes little sketches à la Ruskin in the tiniest of books – chiefly of pollard willows, which she declares are the most beautiful things in nature [. . .] The more one knows Sir Walter and Lady Trevelyan, the more one finds how, through all their peculiarities, they are to be liked and respected. Everything either of them says is worth hearing.[5]

Hare also had it that the house was bitterly uncomfortable and that Walter was a miser. Both descriptions were completely untrue. Walter devoted large sums of money to local amenities like his beloved railways and to improvements on his estate, as well as to public proj-ects like the Oxford Museum. As hosts the Trevelyans were certainly high-minded and not sybaritic, but Pauline insisted that wine should be available for guests (Walter would not touch it himself). Walter was a philanthropist: he believed in excellent management of his estates, looked after his farms with deep pride and built warm and well-drained cottages for his workers. He and Pauline were intensely depressed when they heard of workers elsewhere in the North-East suffering, whether through negligent managers or just cussed bad luck. The plight of the miners trapped by the blocking of the mineshaft at New Hartley pit, 16 January 1862, was noted in appalled detail in Pauline's diary:

January 18 1862 Relays of miners mostly voluntary working day &
night at the risk of their lives to dig out the debris from Hartley pit &
get to the poor people – They can hear them also, working, & shouting
from were they are buried. they have horses, corn & oil to eat & there
is a spring of fresh water if they can get to it.

Sunday January 19 1862 The people are still heard in Hartley pit.
The work goes on but the amount of digging required is enormous.
Many thousand people go there daily.

Tuesday 21 January We can think of nothing but the 215 poor fellows
buried in Hartley coal pit, & the brave men who are working to deliver
them. Very little hope today of their being alive owing to foul gas.

In fact the number of dead in the New Hartley pit disaster was 204
men and boys, some of the boys being as young as 10.

Meanwhile Pauline's long and fruitful association with William
Bell Scott was about to change radically. The national management
of the Art Schools was changed in 1862 and Bell Scott, appointed
under the previous system, was offered redundancy (with a pension),
which he accepted with some hesitation in 1863. At about this date
he suffered a nervous illness that caused him to become totally bald,
and he took to wearing a wig. From 1864 he divided his time between
London and Penkill in Scotland. He was commissioned by Henry
Cole to design stained-glass windows for what is now the Victoria
and Albert Museum in London, worked as an examiner in the
London Art Schools and did a good deal of freelance editing of
literary texts. He was able to buy a substantial house, Bellevue, in
Chelsea. For the last eight years of his life he was disabled by angina,
and was nursed faithfully by Alice Boyd until his death at Penkill in
1890.

The Building of the New Castle, now in the Literary and
Philosophical Society in Newcastle, was painted by him in response
to a commission from the School of Art and his friends in the city,
who had got up a subscription; it was a kind of farewell gift to him,
completed in 1865. An excellent watercolour sketch for this lively
painting is in the Laing Gallery in Newcastle. There are also Bell
Scott's strong northern paintings of the 1840s and 1850s; some excel-
lent sketches taken from a long-deferred visit to Italy with William
Michael Rossetti, which took place after he had finished the

Wallington cycle; and his portraits of Pauline and Walter, both at Wallington. His 1860 portrait of Swinburne, in many ways the best extant image of the wayward poet, hangs at Oxford in his old college. Balliol had learnt to honour its rebel poet, much as University College had learnt to honour Shelley.

For most of his life William Bell Scott was a much less self-regarding and vindictive figure than the sick man whose *Autobiographical Notes* were edited for publication after his death. When the *Notes* appeared, Bell Scott was seen as having betrayed various friendships, especially those with Holman Hunt, Rossetti and Swinburne. He had loved and protected Swinburne and remained steadfastly loyal to the poet throughout the uproar following the publication of *Poems and Ballads*. A less volatile and fiery tempera-ment than Swinburne would have seen the *Notes* as the work of a disappointed and ailing figure, and would have balanced Bell Scott's undoubted friendship in life against the comments that appeared in the book. But Swinburne called Bell Scott a 'lying, backbiting, driv-elling, imbecile, doting, malignant, mangy old son of a bitch', and 'a man whose name would never have been heard [. . .] but for his casual and parasitical association with the Trevelyans, the Rossettis and myself'.[6] Bell Scott did himself no service with his *Notes*. A question about this difficult man raised by William Michael Rossetti's daughter, Helen Rossetti Angeli, is this: why was he so genuinely loved by his friends?

> He was neither good-natured, nor caustically witty in his ill-nature; he does not appear to have been particularly unselfish, or even loyal in friendship, to judge by his treatment of Gabriel. And yet he must have been lovable, for a number of people loved him. He was a popular companion and ever welcome crony. I was a child when he died and do not remember ever seeing him, but his name was familiar to me as that of a dear and valued friend of the family.[7]

Pauline certainly loved him: her porcupine, her Sea-king, her grumpy old Scotus. And he certainly loved her; while others are berated and punished in his *Notes*, Pauline is recorded with absolute devotion.

Bell Scott carefully considered the tension between the life of a country house in the North and the life of London, on which he had turned his back for most of his life. The Trevelyans could make extended visits to London, Oxford or Edinburgh, their three favourite

cities, whenever they felt like it, but there is a sense in which they, too, had chosen provincial as against metropolitan life when they decided to make Wallington rather than Nettlecombe their home. Bell Scott spoke for his patrons as well as for himself when he explored both the losses and the gains of this situation in a passage from his autobiography:

> If a man, artist, *litterature* or other, with a specific professional object, lives in the country, he may live a higher life than in town, but out of daily collision with other men, his fellows in literature or what not, he ceases to strive as they do for the objects they value. He sees better because he takes a bird's-eye view of the battle, and finds that many things struggled for are not worth having. The game is not worth the candle.[8]

It is important to remember that not all of the decorative scheme at Wallington is Bell Scott's work. Pauline painted seven of the pillars in the Hall herself, and she recruited friends to paint the others. Francis Strong found solace from her wretched marriage by coming up to Wallington to paint a pilaster, and the wife of W.G. Collingwood painted two more. Of the remainder, one is by Ruskin, one by Arthur Hughes, two by Bell Scott and two by Laura Capell Lofft.

Pauline had been stoical about her own sufferings for most of her adult life. In the late 1840s her problems were seen as gastric. A report by a Mrs Wagstaff of Leighton Buzzard, written in 1850, indicates the kind of advice that she was receiving. Mrs Wagstaff said that Pauline was suffering from 'stomach disease'; there was a 'fullness of the stomach' and a 'torpid liver'; if the condition was allowed to continue untreated, 'The Heart will become diseased'; 'The spine is naturally weak, and has given rise to the deranged state of the stomach'; 'The sea air would be of service to her'; she should eat 'little but often'. Mrs Wagstaff continued, 'I can prescribe' (and, of course, charge for) 'some Homeopathic Medicine' (to 'act on the nervous system'.)[9]

By 1864–5 Pauline was disabled most of the time, propelled by Walter around Wallington in a wheelchair and spending long periods down in her beloved Seaton: she always loved the sea, and at Seaton there was also the invaluable draw of Loo's company. Loo liked to entertain lavishly, and a host of notable people from London would

visit her at Seaton – it was in this way that Pauline became a close friend of the Carlyles. The winter of 1865–6 was a difficult one for her, and the pain was more or less constant; nevertheless early in 1866 she was devising what seemed like the perfect holiday with the three people she loved best in the world, Walter, Loo and Ruskin. The plan was contrived jointly with Ruskin, who urgently wanted distraction from the misery he was suffering over his desperate relationship with Rose La Touche. Through his many visits to Wallington he had become friendly with (indeed, possibly attracted to) Pauline's niece Constance Hilliard, 'Mous's' daughter, and he also enjoyed being with his young cousin, Joan Agnew, who by this time was an indispensable part of the Ruskin household.*

Loo was capricious and unreliable, as Pauline well knew. Pauline should not have trusted her; but up to the last moment before the spring holiday of 1866 she believed that Loo would join them at Lake Maggiore. She wrote what would be the last letter of her life to Loo on 17 April 1866 from the Hilliards, full of happy plans and anecdotes about dogs and Loo's baby, mingled with quite serious observations about parliamentary reform and the unrest in Europe. Pauline was serenely unbothered by the prospect of Europe going up in flames while she travelled through it. She wondered whether 'a Prussian Austrian war & a row in Venetia wd interfere with us. but I shd think not', and proceeded sedately with her plans: 'I don't quite know when we shall get to Lago Maggiore. but if you send me your address I will write often. Mr Ruskin wishes for short days journies as much as I do. & the two girls [Joan Agnew and Constance Hilliard] will find everything delicious.' Pauline talked as well about arrangements in their respective houses at Seaton while they were travelling: 'I am sorry Seaforth Lodge [the house that Loo had had built] is not to be let because I think the furniture fades & spoils almost as much standing unused, as if it were in use – of course in our cottage everything is taken down & covered up.'¹⁰

Presumably when Pauline, Walter, Ruskin, Constance and Joan set out in April 1866, Pauline knew that she might not survive. She was probably feeling so wretched that any diversion was welcome, and it

*After Ruskin's mother died in 1871, Joan moved to Brantwood, Ruskin's house in the Lake District, and somewhat later on she married Arthur Severn, the painter, and moved him into the house as well. She and Arthur had a large family, and all the Severns continued to live with Ruskin; after his death in 1900 she inherited Brantwood, together with the bulk of Ruskin's very substantial estate.

seems likely that in her stoical way she had decided that she would rather die quickly doing something she enjoyed (travelling) in the company of people she loved, rather than go on with the lingering pain in familiar and safe surroundings. Walter's diary tells the day-to-day story of the expedition. The two men of the party, Walter and Ruskin, took the women first to Boulogne, on 24 April, and then to Paris for a few days' sightseeing. At first Pauline seemed perfectly fit and able to walk in the sunshine and enjoy the pleasures of the city. However, on 28 April she became ill and by early May, still in Paris, was suffering persistent diarrhoea and vomiting. Walter called in a doctor, who prescribed 'Kreuznach water' and an infusion of green walnuts.

Despite a 'better night' on 1 May, Walter wrote to Loo the following day with what was in effect a warning that the holiday might come to a premature end. He was clearly not expressing his worst fears in this letter, though:

> You will I am sure be grieved to hear that the reason that *I* write to answer your last letter to dearest Pauline, is that she is much too weak to write to you herself [. . .] I consulted a doctor here – who has given her medicine, which has been of use – & advice which will I hope benefit her in the future [more infusion of walnuts?] – he had given us hope that she would be well enough to travel on yesterday or today – but she is I am sorry to say, by no means so [. . .] she is however decidedly, tho slowly, improving.[11]

Walter's diary reported further sightseeing as though he was using it to rehearse reassuring conversations and activities with which to keep Pauline's mind away from her condition. They visited Sens and Dijon, but on 7 May: 'My dearest Pauline frightened me with such an attack of illness that she was obliged to be carried to the station & fortunately the train having to wait there more than an hour, she had time to recover sufficiently, lying down in the seat, to go on to Pontarlier'; there she was carried from the train to a carriage to convey them to the hotel.

Pontarlier was slightly more comfortable than Dijon, because it was higher and cooler, but Walter was clearly beginning to panic and badly needed Ruskin's support. He stayed up all night feeding Pauline small spoonfuls of arrowroot, but the diarrhoea and sickness were relentless. On 11 May, still at Pontarlier, he wrote: 'God Grant a favourable result to our attempt to go to Neufchatel!' Ruskin, who

had gone ahead to Neuchâtel in Switzerland, had arranged an invalid carriage on a special train. Pathetically, Walter regretted that Pauline could not enjoy the travelling as much as she normally did: 'P was carried on a chair to the station & then laid in the carriage & thank God we got safe to N thro some fine scenery, which P unhappily could not see – got comfortable quarters at the Bellevue & I sent for Dr Regnier, who prescribed for P & I trust will benefit her.' On 12 May at Neuchâtel he raised her head so that she could see a rainbow from her bedroom. The following day, by force of habit, Walter was still making notes on the view, despite the fact that his wife was clearly dying:

[13 May] day cold & no view of Alps. In the afternoon dearest Pauline's symptoms of approaching death became unmistakable, in failing pulse, coldness and difficulty of breathing, brought on by diminished action of heart & from about 3 pm she gradually sunk till she expired about 10.45 p.m. I hope without much suffering, but most heartrending to see the efforts for breathing, which [. . .] continued long after other parts were cold & dead. Thus have I lost one of the best of wifes and of friends, who has been a blessing to me more than 30 years.

Not surprisingly, Walter reproached himself for having been:

persuaded to bring her abroad, when she was not in a fit state to travel, and tho perhaps with her organic complaints she could not have expected a long life – yet it was shortened I have no doubt by the fatigues of travelling – the last thing she admired was a splendid rainbow the day before her death, to which I drew her attention from her bed – & it was touching to see how enthusiastically she admired a view of the alps, which she was able to see from her couch in the sick carriage in which she came from Pontarlier – oh here were a mind & a character combined, such as are rare – her intellect, when not interrupted by suffering, always working for her own improvement or for the good of others. She had much bodily suffering, but was most patient and cheerful under it all, and so uncomplaining, that even of those about her few would know how much she suffered.[12]

Arrowroot, spa water and infusion of green walnuts – the autopsy conducted by the Swiss doctor in Neuchâtel showed just how wide of the mark these recommendations had been:

Autopsy on Madame Trevelyan

15 May 1866 I was instructed by Mr Trevelyan and conducted the autopsy on the corpse of his wife who had died on 13 May in the evening at Neuchâtel, following very heavy diarrhoea which she had had intermittently and from which she had suffered for some 15 days consecutively before the final crisis. It was accompanied by heavy vomiting. She was unable to keep food down and when I saw her 3 days before her death she had yellow diarrhoea and violent vomiting. She was very distressed, her facial appearance had changed, her tongue was dry but cyanosed, her pulse was very rapid and she was sweating heavily. There did not seem to be swelling of the stomach. An enormous tumour filled the abdomen behind and above the pubis. The sick woman retained her faculties and her intellect right to the end.

An elliptical incision from one side of the abdomen to the other including the gastric region revealed a cluster of tumours adhering to the intestines and to the abdominal wall. Immediately behind the pubis was a very large tumour [or cluster of tumours] which may have taken some 15 years to grow to their present size. A peritoneal tumour was so well developed that it could not be detached. Around the womb was a growth consisting of a cluster of some 12 to 15 tumours between the size of a plum and an orange, some of these adhering too securely to be excised. The hypertrophied womb contained a well developed fibrous tumour the size of a child's head. [The stomach, by contrast, showed some ulceration, but was not the cause of death.][13]

The autopsy showed that Pauline had died from the final stages of ovarian cancer, from which she had been suffering for a long time. Given the various phases of ill health that she suffered in the late 1840s before the drastic and horrible surgery that she underwent in Edinburgh in 1851, it seems likely that 'fifteen years' was a conservative estimate and that the cancer actually dated back some twenty years before the date of her death, aged just fifty.

Nobody was to know when the holiday began that Pauline would last only three weeks. Walter reproached himself for agreeing that she should travel. It is striking that he did not reproach Ruskin. It was Ruskin's tormented condition over Rose La Touche that had caused him to propose this tour. He needed young girls about him: Joan Agnew and Constance Hilliard. Pauline was not blind to his neediness and his miserable emotional frustration. She may well have felt that the security of her niece Constance ought not to be entrusted to a man in a state bordering on the manic, which Ruskin clearly was, even if there were level-headed servants in attendance. But

perhaps Walter's guess in his diary is the simple truth: she had had enough of the pain and wanted to do something ill-advised and physically stressful in order to hasten her own end. She was conscious, charitable, selfless and dignified to the end.

Ruskin reported that Swinburne was on her mind:

> About one oclock – nine hours before her death, she asked me very anxiously what I thought of Swinburne – and what he was likely to do and to be. (She had been very kind to him in trying to lead him to better thoughts). And I answered – that she need not be in pain about him – the abuse she heard of him was dreadful – but not – in the deep sense, moral evil at all, but mentally-physical and ungovernable by his will, – and that finally, God never made such good fruit of human work, to grow on an evil tree.[14]

This letter was passed on to Swinburne's parents and gave them considerable comfort.

Ruskin did care deeply for Pauline, and Walter's testimony shows that his attempts to help in the last few desperate days of her life were greatly appreciated. Ruskin was at Pauline's deathbed by invitation: Walter did not want to be alone with her as she died. On 15 May Ruskin wrote to his mother:

> Before she lost consciousness, Sir Walter and I were beside her, he holding her left hand and I her right. I said to Sir Walter that I was grateful to him for wanting me to stay: 'I did not think he had cared for me so much.' 'Oh' he said, 'we both always esteemed you above any one else.' Lady Trevelyan made an effort, and said 'He knows that.' Those were the last conscious words I heard her speak: then I quitted her hand, and went to the foot of the bed and she and her husband said a word or two to each other – low; very few. Then there was a pause – in a few minutes she raised herself, the face wild and vacant, and said twice, eagerly (using the curious nickname she had for Sir Walter of 'Puzzy') 'That will do, Puzzy, that will do.' And so fell back – slightly shuddering – a moment afterwards she said 'Give me some water.' He took the glass and I raised her; as I did for all her medicine; – she drank a little, but had scarcely swallowed it when a violent spasm came in her throat, and her husband caught her as I laid her back on the pillow; and then the last struggle began – I went to the foot of the bed and knelt down, and he held her: the spasm passed through every form of suffocating change, and lasted for upwards of an hour, each new form of it getting fainter, but all unconscious, though terrible in sound – he saying softly to her sometimes,

'Ah, my dear' – I rose in a little while, thinking it must be too dreadful to him, to assure him it was unconscious – He said, Yes, I know it. Then I went back to the foot of the bed and stayed, till the last sobs grew fainter, – and fainter – and ceased, dimly and uncertainly – one could not tell quite when. At last he raised the hand which had fallen; and laid her head back; and took the candle and called me to look at her.

And so it ended.[15]

After Pauline's death in 1866, the marriage between Walter and Laura Capel Lofft, which took place in 1867, was a memorial to the woman they had both loved. Laura did not share Pauline's enthusiasm for Bell Scott, though. Once the Battle of Chevy Chase murals were completed in the upper part of the Hall, Laura put a stop to any further commissions for Bell Scott; for his part, he was glad to keep his distance from her. He wrote crossly to Rossetti on 27 June 1868: 'I got all my Chevy Chase pictures up at Wallington very much sooner than I expected, and as the new Lady Trevelyan is eaten up by envy jealousy and all uncharitableness I got away as fast as possible.'[16] The second marriage was in its own way strong and enduring. A mark of how closely the second Lady Trevelyan's life was intertwined with that of her husband is the fact that Walter died on 23 March 1879 and Laura died of a heart attack the following day.

The decision taken nearly twenty years earlier to leave the Wallington estate to Sir Charles Edward Trevelyan (and in due course to the dark and captivating Otto) ensured, by the subsequent unfolding of events, that the house would become the property of the nation. The seventh baronet, Sir Alfred Trevelyan, although still heir to the Trevelyan properties at Nettlecombe and to a substantial fortune, bitterly contested the will. Walter had left the house and estate to Charles Edward, but the contents of the house to Alfred. The enraged new baronet therefore carried off much of Pauline's art collection and many of the books. Pauline's central creation, though – the space enclosed and glazed by Dobson, and the narrative of the history of Northumberland in Bell Scott's canvases and of the Battle of Chevy Chase in his frescoes – remained intact. However, Pauline's prized Rossetti painting, *The Virgin in the House of St John*, is no longer there.

Sir Charles Philips Trevelyan, eldest son of George Otto and a committed and radical socialist, announced his intention of giving Wallington and its estates (at that date more than 11,000 acres) to

the National Trust in 1934, on condition that he could live there during his lifetime, and that members of the Trevelyan family could continue to reside there. The deed of settlement was signed in 1941 and Wallington became the property of the National Trust on Sir Charles's death in 1958. As a consequence of this munificent gift, Pauline's vision is now permanently and safely preserved and is available to all visitors who are willing to pay a small entrance fee or to become members of the National Trust. Pauline would have been delighted by this development.

In her short life Pauline Trevelyan had engaged passionately with three great historical narratives that were major preoccupations of intellectual Victorians: the history of the earth as displayed by the study of fossils, minerals, glaciers and the like; the history of mankind as given in the Bible; and the history of the world in which she lived as displayed in works of literature and art. It would be quite natural to attend only to the third of these and to focus exclusively on her relationships with artists and writers, given that she was such a patron of the arts; that she wrote and painted herself and was an extremely acute art critic; that she was a friend of John Ruskin, the Brownings, the Carlyles, the Rossettis, Algernon Swinburne, Thomas Woolner and Alexander Munro, and a warm acquaintance of other giants of the age, including Tennyson; and, of course, that she was the most important single patron of William Bell Scott. But Wallington was also conceived as that archetypically Victorian instrument of instruction – a museum – and invites comparison with Acland's great museum at Oxford. Wallington told the history of civilisation in a particular place (Northumbria from the Romans to 1861), while the Oxford Museum told the history of the earth before civilisation, as well as providing the teaching centre in the university for the modern natural sciences, especially medicine. The natural world is God's Book, and this is reflected in the ecclesiastical Gothic style of the Oxford Museum. It thus continued the accommodation between the Bible and science that we have identified as a peculiar feature of the English School of Geology. It is a rich and much-appreciated irony that this tactful and conciliatory building was the setting for the nineteenth century's most explosive encounter between science and religion, namely T.H. Huxley's public humiliation of Samuel Wilberforce.

If the decorative scheme at Wallington was Pauline's major achieve-

ment as a patron, her personal achievements as writer and artist should not be overlooked. As a poet she worked within the conventions of her day, while as a critic she was extremely acute. One of her lyrics takes on an additional poignancy in view of her early death. Her defeated painter in 'The Dying Artist' would gladly take up again his austere quest for distinction and immortality if he could live his life again: 'Could I but stand again on youth's green shore.'[17] But although her published work as poet, critic and essayist is of lasting interest, her best writing is in her diary and her letters. This life, in so far as it was literary, was largely a private life. The diary reveals a potential novelist capable of brilliantly acute observation and satirical comedy of a mordant and memorable kind. The Trevelyan sister-in-law like a 'fattish vampire' and the genteel passenger to France who wishes that the sea would leave off 'swelling' are memorable comic vignettes, and we can assume that in her lifetime gems like these had only two readers, Walter and Loo.

Pauline Trevelyan, then, was both peripheral and central, a figure who was in the mainstream of high Victorian cultural life in London, Edinburgh and Oxford, but was also the creator of a house that was itself a major work of art, where the attraction was that of a retreat surrounded by beautiful wild countryside, a place in which friends with more turbulent and stressful lives, such as Acland, Ruskin and Swinburne, could find calm and refreshment.

THE TREVELYANS: A CONCISE FAMILY SCHEME

Trevelyans were known in the fourteenth century.

John Trevelyan, High Sheriff and MP for Cornwall (d. 1492) was the first Trevelyan to own Nettlecombe.

His eldest son was Sir John Trevelyan (d. 1522).

The baronetcy was created in 1661: SIR GEORGE Trevelyan, 1st Bt of Nettlecombe (d. 1671).

His eldest son was SIR JOHN Trevelyan, 2nd Bt of Nettlecombe (1670–1755).

His eldest son was SIR GEORGE Trevelyan, 3rd Bt of Nettlecombe (1707–68). He married in 1733 Julia Calverley, daughter of Sir Walter Calverley. It was through Julia Calverley that Wallington, formerly the property of the Blacketts, became a Trevelyan property.

His eldest son was SIR JOHN Trevelyan, 4th Bt of Nettlecombe and Wallington (1735–1828), Sir Walter's grandfather. He inherited Wallington from Julia Calverley's brother, Sir Walter Calverley Blackett (1707–77), who added the surname Blackett.

His eldest son was SIR JOHN Trevelyan, Walter's father and Pauline's father-in-law, 5th Bt of Nettlecombe and Wallington (1761–1846). He married in 1791 MARIA WILSON (1771–1851), daughter of Sir Thomas Spencer Wilson, 6th Bt of East Borne, Sussex. (Her sister, Jane Wilson [d. 1844], married the Rt Hon. Spencer Perceval; her other sister, Margaret Elizabeth Wilson [d. 1851] married Charles George Perceval, 2nd Baron Arden.)

The children of Sir John Trevelyan and Maria Wilson were:

- Two who died in infancy.
- Maria Jane Trevelyan (1796–1860), married in 1828 the Revd Noel Thomas Ellison, rector of Nettlecombe.
- SIR WALTER CALVERLEY Trevelyan, 6th Bt of Nettlecombe and Wallington (1797–1879), married in 1835 PAULINA JERMYN JERMYN (1816–66), and in 1867 Laura Capel Lofft (1804–79).
- Julia Trevelyan (1798–1884), unmarried (never able to accept Pauline as a member of the family).
- Raleigh Trevelyan (1800–14).

- Arthur Trevelyan (1802–78), married in 1835 Elizabeth MacKay (Arthur was Pauline's favourite among her husband's siblings).
- Emma Trevelyan (1804–57), married in 1830 Alexander Wadham Wyndham. Walter was greatly distressed by this sister's early death.
- Edward Spencer Trevelyan (1805–54), married in 1830 Catherine Anne Forster. This brother committed suicide for reasons that remain unknown.
- Alfred Wilson Trevelyan (1807–30), married in 1830 Mathilda Margaret Royce.
- Beatrice Trevelyan (1809–98), married in 1830 Ernest Augustus Perceval, her first cousin on her mother's side (captain in the 15th Hussars and son of the Rt Hon. Spencer Perceval).
- Laura Agnes Trevelyan (1812–99), married in 1836 the Revd John Woodhouse, rector of Nettlecombe.
- Helena Caroline Trevelyan (1815–98), married in 1837 the Revd Bryan Faussett. The marriage ended in divorce. Pauline was fond of the children of this marriage and often looked after them at Wallington (Evy Faussett is the child in Pauline's arms in Bell Scott's painting *The Descent of the Danes*.) Helena Faussett's second marriage was to Walter Blackett Trevelyan (1821–94), the grandson of Walter Trevelyan (1763–1819), a brother of Sir John, 4th Bt (and therefore great-uncle of Sir Walter Calverley Trevelyan, Pauline's husband). He had married the heiress of Netherwitton in Northumberland (close to Wallington), and the Netherwitton house and estate are still owned by that branch of the Trevelyan family.

Alfred Wilson Trevelyan's posthumous son, SIR ALFRED WILSON Trevelyan, 7th Bt of Nettlecombe (1831–91), was a Roman Catholic – his mother's faith. It was partly for this reason that Sir Walter decided to split the Trevelyan estates and leave Wallington, which was not entailed, to his cousin Charles Edward Trevelyan. Sir Alfred had six daughters, but no sons, so the title did not pass to his descendants.

Sir John, 4th Bt of Nettlecombe and Wallington, had ten children: Sir John, 5th Bt (Walter's father), was the oldest son, and the third son was the Ven. George Trevelyan (1764–1827), Archdeacon of Taunton and Canon of Wells. The fourth of the Ven. George's seven children was the exceptionally talented SIR CHARLES EDWARD

Trevelyan, 1st Bt of Wallington (1807–86). He married Hannah More Macaulay (1807–73), sister of Thomas Babington Macaulay.

His son was the Rt Hon. SIR GEORGE OTTO Trevelyan, 2nd Bt of Wallington (1838–1928), who married Caroline Philips.

His oldest son was the Rt Hon. SIR CHARLES PHILIPS Trevelyan, MP, 3rd Bt of Wallington (1870–1958), who gave Wallington to the National Trust. His wife was Mary Katharine Bell, and they had seven children – the heir was SIR GEORGE LOWTHIAN Trevelyan, 4th Bt of Nettlecombe and Wallington (1906–96), the Nettlecombe title having reverted to the Wallington line.

George Otto's other sons were:

- Robert Calverley Trevelyan (1872–1951), poet and writer.
- Prof. George Macaulay Trevelyan (1876–1962), historian and Master of Trinity College, Cambridge.

BIBLIOGRAPHY

(Archive sources are listed in the Preface.)

Acland, Henry Wentworth. *Memoir on the Cholera at Oxford in the year 1854, with considerations suggested by the epidemic.* London: John Churchill, 1856.

Ashton, Rosemary. *Thomas and Jane Carlyle: Portrait of a Marriage.* London: Chatto & Windus, 2001.

Atlay, J.B. *Sir Henry Wentworth Acland, Bart. K.C.B. F.R.S. Regius Professor of Medicine in the University of Oxford. A Memoir.* London: Smith, Elder, 1903.

Batchelor, John. *John Ruskin: No Wealth but Life.* London: Chatto & Windus, 2000.

Bell Scott, William. *Autobiographical Notes of the Life of William Bell Scott,* ed. by W. Minto. London: Osgood McIlvaine, 1892.

Bell Scott, William. *Chorea Sancti Viti; or, Steps in the Journey of Prince Legion. Twelve Designs.* London: [Newcastle upon Tyne printed], 1851.

Bell Scott, William. *Poems by a Painter.* London: Smith Elder, 1854.

Blau, Eve. *Ruskinian Gothic: The Architecture of Deane and Woodward, 1845–1861.* Princeton: Princeton University Press, 1982.

Buckland, William. *Vindiciae Geologicae; or the Connexion of Geology with Religion Explained.* Inaugural address, Oxford, published by the university, 1820.

Buckland, William. *Reliquiae Diluvianae, or Observations on the Organic Remains contained in Caves, Fissures and Diluvial Gravel and on other Geological Phenomena attesting the action of an Universal Deluge.* London: John Murray, 1823.

Buckland, William. *Geology and Mineralogy considered with reference to Natural Theology,* 2 vols. London: William Pickering, 1836.

Bullen, J. B. *The Pre-Raphaelite Body.* Oxford: Oxford University Press, 1998.

Chambers, Robert. *Vestiges of the Natural History of Creation.* Edinburgh: W. and R. Chambers, 1884.

Church, R.W. *The Oxford Movement: Twelve Years 1833-1845*. London: Macmillan, 1891.

Cunningham, Valentine (ed.). *The Victorians: An Anthology of Poetry and Poetics*. Oxford: Blackwell, 2000.

Darwin, Charles. *The Voyage of the Beagle*. Ware: Wordsworth Classics, 1997.

Davidoff, Leonore, and Hall, Catherine. *Family Fortunes: Men and Women of the English middle class, 1780–1850*. London: Hutchinson, 1987.

Desmond, Adrian, and Moore, James. *Darwin*. London: Penguin, 1992.

Faber, Geoffrey. *Oxford Apostles: A Character Study of the Oxford Movement*. London: Faber, 1933.

Faulkner, Thomas, and Greg, Andrew. *John Dobson: Architect of the North East*. Newcastle upon Tyne: Tyne Bridge Publishing, 2001.

Faxon, Alice Craig. *Dante Gabriel Rossetti*. London: Phaidon, 1994.

Fleming, G.H. *John Everett Millais: A Biography*. London: Constable, 1998.

Fredeman, William. 'The Letters of Pictor Ignotus: William Bell Scott's Correspondence with Alice Boyd, 1859–1884', *Bulletin of the John Rylands Library*, 58 (1975), 66–111.

Fredeman, William. 'The Letters of Pictor Ignotus: William Bell Scott's Correspondence with Alice Boyd, part 2', *Bulletin of the John Rylands Library*, 58 (1976), 306–52.

Girouard, Mark. *Life in the English Country House*. New Haven: Yale University Press, 1978.

Girouard, Mark. *The Return to Camelot: Chivalry and the English Gentleman*. New Haven: Yale University Press, 1981.

Green, V.H.H. *Oxford Common Room: A Study of Lincoln College and Mark Pattison*. London: Edward Arnold, 1957.

Haines, Robin. *Charles Trevelyan and the Great Irish Famine*. Dublin: Four Courts Press, 2004.

Hare, Augustus. *A Handbook for Travellers in Durham and Northumberland*, 2nd edn. London: John Murray, 1873.

Hare, Augustus. *The Story of My Life*, 6 vols. London: George Allen, 1896–1900.

Heffer, Simon. *Moral Desperado: A Life of Thomas Carlyle*. London: Weidenfeld & Nicolson, 1995.

Hewison, Robert (ed.). *Ruskin's Artists: Studies in the Victorian Visual Economy*. Aldershot: Ashgate, 2000.

Hilton, Tim. *John Ruskin: The Early Years*. New Haven: Yale, 1985.

Hilton, Tim. *John Ruskin: The Later Years.* New Haven: Yale, 2000.

Holmes, Richard. *Coleridge: Darker Reflections.* London: Flamingo, 1999.

Howarth, O.J.R. *The British Association for the Advancement of Science: A Retrospect 1831–1921.* London: The British Association for the Advancement of Science, 1922.

James, William. *The Order of Release.* London: John Murray, 1947.

Lang, Cecil Y. (ed.). *The Swinburne Letters,* 6 vols. New Haven: Yale University Press, 1959–62.

LeMahieu, Dan L. *The Mind of William Paley: A Philosopher and His Age.* Lincoln, Nebraska: University of Nebraska Press, 1976.

Lockhart, John Gibson. *Memoirs of the Life of Sir Walter Scott,* 10 vols. Edinburgh: Cadell, 1839.

Lutyens, Mary. *Millais and the Ruskins.* London: John Murray, 1967.

Lyell, Charles. *Principles of Geology,* 4th edn, 4 vols. London: John Murray, 1835.

Marsh, Jan. *Christina Rossetti: A Literary Biography.* London: Pimlico, 1994.

Marsh, Jan. *Dante Gabriel Rossetti: Painter and Poet.* London: Weidenfeld & Nicolson, 1999.

Martin, Robert Bernard. *Tennyson: The Unquiet Heart.* Oxford: Clarendon Press, 1980.

Milnes, Richard Monckton. *Life, Letters and Literary Remains of John Keats,* 2 vols. London: Edward Moxon, 1848.

Morrell, Jack, and Thackray, Arnold. *Gentlemen of Science: Early years of the British Association for the Advancement of Science.* Oxford: Clarendon Press, 1981.

Morton, John L. *King of Siluria: How Roderick Murchison changed the face of Geology.* Horsham: Brocken Spectre Publishing, 2004.

Murchison, Roderick. *The Silurian System: Founded on Geological Researches in the Counties of Salop, Hereford, Radnor, Montgomery, Carmarthen, Brecon, Pembroke, Monmouth, Gloucester, Worcester and Stafford, with Descriptions of the Coalfields and Overlying Formations.* London: John Murray, 1839.

Nockles, Peter B. *The Oxford Movement in Context: Anglican High Churchmanship 1760–1857.* Cambridge: Cambridge University Press, 1994.

O'Dwyer, Frederick. *The Architecture of Deane and Woodward.* Cork: Cork University Press, 1997.

Paley, William. *Natural Theology or Evidences of the Existence and*

Attributes of the Deity collected from the Appearance of Nature. London: R. Faulder, 1802.

Pevsner, Nikolaus. *Northumberland.* Harmondsworth: Penguin, 1987.

Quinn, Peter. 'Picturing Locality: Art and Regional Identity in the North East of England, 1822–1900'. Unpublished Ph.D. dissertation, University of Sunderland, 1997.

Quinn, Peter James. *Picturing Locality: Art and Regional Identity in the North East of England, 1822–1900.* Ph.D. dissertation, University of Sunderland, 1997.

Reynolds, Joshua. *Sir Joshua Reynolds' Discourses,* ed. by Pat Rogers. Harmondsworth: Penguin, 1992.

Rooksby, Rikki. *A.C. Swinburne: A Poet's Life.* Aldershot: Scolar Press, 1997.

Rossetti, William Michael (ed). *The Germ: The Literary Magazine of the Pre-Raphaelites* (facsimile). Oxford: Ashmolean Museum, 1979.

Rupke, N.A. *The Great Chain of History: William Buckland and the English School of Geology.* Oxford: Clarendon Press, 1983.

Ruskin, John. *The Works of John Ruskin* (library edition), 39 vols, ed. by E.T. Cook and Alexander Wedderburn. London: George Allen, 1903–12.

Ruskin, John. *The Diaries of John Ruskin,* 3 vols, ed. by Joan Evans and J.H. Whitehouse. Oxford: Clarendon Press, 1956–9.

Scott, Walter. *The Life of Napoleon Buonaparte,* 9 vols. Edinburgh: Ballantyne, 1827.

Secord, James A. *Victorian Sensation: The Extraordinary Publication, Reception, and Secret Authorship of Vestiges of the Natural History of Creation.* Chicago: University of Chicago Press, 2000.

Stanley, Arthur. *Life of Thomas Arnold.* London: John Murray, 1901.

Surtees, Virginia (ed.). *Sublime and Instructive: Letters from John Ruskin to Louisa Marchioness of Waterford, Anna Blunden and Ellen Heaton.* London: Michael Joseph, 1972.

Surtees, Virginia (ed.). *Reflections of a Friendship: John Ruskin's Letters to Pauline Trevelyan 1848–1866.* London: Allen & Unwin, 1979.

Surtees, Virginia. *The Ludovisi Goddess: The Life of Louisa Lady Ashburton.* London: Michael Russell, 1984.

Swinburne, A.C. *Poetical Works,* 6 vols. London: Heinemann, 1904.

Swinburne, A.C. *Chastelard: A Tragedy*. London: Chatto & Windus, 1910.

Swinburne, A.C. *The Swinburne Letters*, 6 vols, ed. by Cecil Y. Lang. New Haven: Yale University Press, 1959–63.

Thomas, Donald. *Swinburne: The Poet in his World*. London: Weidenfeld & Nicolson, 1979.

Thompson, Keith. *The Watch on the Heath: Science and Religion Before Darwin*. London: HarperCollins, 2005.

Thornbury, Walter. *The Life of J.M.W. Turner, R.A.* London: Chatto & Windus, 1877.

Trevelyan, Pauline. *Selections from the Literary and Artistic Remains of Paulina Jermyn Trevelyan*, ed. by David Wooster. London: Longmans, Green & Co., 1879.

Trevelyan, Raleigh. *A Pre-Raphaelite Circle*. London: Chatto & Windus, 1978.

Trevelyan, Raleigh. *Wallington*. London: The National Trust, 1994.

Vernon, H.M. and K.D. *A History of the Oxford Museum*. Oxford: Clarendon Press, 1909.

Walker, Vera. *The Life and Work of William Bell Scott, 1811–1890*. Ph.D. dissertation, University of Durham, 1951.

Woolner, Amy. *Thomas Woolner, R.A. Sculptor and Poet: His Life in Letters*. London: Chapman & Hall, 1917.

Woolner, Thomas. *My Beautiful Lady*. London: Macmillan, 1863.

Yanni, Carla. *Nature's Museums: Victorian Science and the Architecture of Display*. London: Athlone, 1999.

NOTES

PREFACE AND ACKNOWLEDGEMENTS

1 Walter Thornbury, *The Life of J.M.W. Turner, R.A.* (London: Chatto & Windus, 1877), p. v.
2 Arthur Stanley, *Life of Thomas Arnold* [first published 1844] (London: John Murray, 1901).

CHAPTER 1
Paulina Jermyn Jermyn becomes Pauline, Lady Trevelyan

1 *Circle*, pp. 8–12.
2 Sir Walter Scott, *The Life of Napoleon Buonaparte*, 9 vols (Edinburgh: Ballantyne, 1827).
3 Quoted by Jack Morrell and Arnold Thackray, *Gentlemen of Science: Early years of the British Association for the Advancement of Science* (Oxford: Clarendon Press, 1981), p. 541.
4 Quoted from S.T. Coleridge's essay 'On the Constitution of Church and State' in Morrell and Thackray, p. 17.
5 Quotations from her diary relating to the Association meeting are all from *Diary*, vol. 2.
6 *Circle*, pp. 13, 18–19.
7 By the Revd William Buckland, BD, FRS, FLS (London: John Murray, 1823).
8 Bodleian Library, Buckland MSS.
9 Keith Thompson, *The Watch on the Heath: Science and Religion Before Darwin* (London: HarperCollins, 2005), p. 134.
10 Quoted by O.J.R. Howarth, *The British Association for the Advancement of Science: A Retrospect 1831–1921* (London: The British Association for the Advancement of Science, 1922), p. 16n.
11 Morrell and Thackray, p. 12.
12 Howarth, p. 99.
13 Morrell and Thackray, p. 149.
14 Quoted from a letter from William Vernon Harcourt to his wife, Morrell and Thackray, p. 151.
15 Quoted in Morrell and Thackray, p. 152.
16 Thompson, p. 61. Thompson lists a number of earlier works that use the analogy, including Bishop Burnet's *Sacred Theory of the Earth* (1681); Thompson, pp. 61–2.

17 William Paley, *Natural Theology or Evidences of the Existence and Attributes of the Deity collected from the Appearance of Nature* (London: R. Faulder, 1802), pp. 1–3. See also especially Dan L. LeMahieu, *The Mind of William Paley: A Philosopher and His Age* (Lincoln: University of Nebraska Press, 1976), pp. 168ff., which notes the survival of *Natural Theology* well into the Victorian period.

18 Richard Holmes summarises Coleridge's position in *Coleridge: Darker Reflections* (London: Flamingo, 1999), pp. 71–2.

19 Charles Lyell, *Principles of Geology*, 4th edn, 4 vols (London: John Murray, 1835), vol. 1, pp. 3, 4, 243.

20 This sequence is summarised by LeMahieu, pp. 169–70.

21 William Buckland, *Geology and Mineralogy considered with reference Natural Theology*, 2 vols (London: William Pickering, 1836), vol. I, pp. 21–2.

22 Buckland (1836), vol. I, p. 9. Buckland also quotes Trevelyan's friend the Revd Dr William Conybeare, who says in his *Geology of England and Wales* that the juxtaposition of iron and coal is 'determined with a view to the convenience of its [the earth's] inhabitants'; Buckland (1836), vol. I, p. 531.

23 *Diary*, vol 35.

24 Special Collections Library, Newcastle University: WCT 260, letter on capital punishment to the Editor of *The Scotsman*, Edinburgh, 20 April 1840.

25 *Journal*, 1833.

26 Or, as a modern scholar puts it: 'To keep the Bible sacred, it must not be treated as a scientific text.' Herschel is quoted by LeMahieu, p. 169, and paraphrased on p. 167.

27 This and the related entries in 1834 are in *Diary*, vol. 2.

28 This and the succeeding entries for 1835 are in *Diary*, vol. 3.

29 W. Minto, (ed.), *Autobiographical Notes of the Life of William Bell Scott* (London: Osgood, McIlvaine & Co., 1892), vol. II, p. 257. Hereafter cited as Bell Scott (1892).

30 They will bear comparison with those that Elizabeth Barrett Browning was to write in the 1850s to her husband, Robert Browning, in *Sonnets from the Portuguese* (the Brownings were to become friends of Pauline after her meeting with them in London in 1856).

31 David Wooster (ed.), *Selections from the Literary and Artistic Remains of Paulina Jermyn Trevelyan* (London: Longmans, Green and Co., 1879), pp. 6, 7. Hereafter cited as *Remains*.

32 R.W. Church, *The Oxford Movement* (London: Macmillan, 1891), p. 91.

33 Church, p. 233.

34 Aubrey de Vere, quoted in Geoffrey Faber, *Oxford Apostles* (London: Faber, 1933), p. 32.

35 This and the related entries for 1836 are in *Diary*, vol. 6.

36 *Journal* for 1835–7.

37 *Circle*, p. 21.

38 *Diary*, vol. 10.

39 See *Circle*, p. 21.

40 This and related entries for 1838 are in *Diary*, vol. 11.

41 *Circle*, pp. 17–18.

42 Ibid., p. 20.

43 Roderick Murchison, *The Silurian System: Founded on Geological Researches in the Counties of Salop, Hereford, Radnor, Montgomery, Carmarthen, Brecon, Pembroke, Monmouth, Gloucester, Worcester and Stafford, with Descriptions of the Coalfields and Overlying Formations* (London: John Murray, 1839), revised and expanded in 1854.

44 Darwin's voyages on the *Beagle*, especially the experience of witnessing the effect of an earthquake at Concepción, in Chile, showed him that Lyell was right. Outside Concepción, mussel beds had been raised above sea level by the earthquake and the related volcanic action. Processes of this kind, extended over thousands of years, could alter the whole surface of the planet. When back in London in the late 1830s, Darwin also came to see, with Herschel, that theology and geology need not be connected. God had created the universe and then left it to get on with itself. And Herschel permitted the notion of trans-mutation. Slowly Darwin came to believe that his own findings on the Galápagos and in Tierra del Fuego permitted the notion that species do indeed 'transmute'. From 1837 he kept a series of secret notebooks about 'transmutation' (the word that was anathema to all Anglicans). Lamarck had suggested that man might be descended from the apes. Darwin began to believe that this must be true. See Adrian Desmond and James Moore, *Darwin* (London: Penguin, 1992), especially chapters 8, 15 and 16. The first meeting between Darwin and his later enemy Richard Owen is well described in this book, p. 202.

45 Quoted by Morrell and Thackray, p. 241.

46 Ibid., p. 231.

47 This famous book was first published as volume III of a joint publica-tion with the Captain of the *Beagle*, Robert Fitzroy. Fitzroy was later to condemn Darwin's work at the famous 1860 meeting of the British Association in Oxford. Fitzroy's two volumes were *Narrative of the Surveying Voyages of HMS 'Adventurer' and 'Beagle' between 1826 and 1836*, 1839. Darwin's volume (*Narrative of the Surveying Voyages of HMS 'Adventurer' and 'Beagle' between 1826 and 1836, vol. III*, 1839) rapidly became known as *Darwin's Journal of the Beagle*, and was reis-sued as a separate book by John Murray in 1845. Over the next twenty years it had steady and increasing sales. As *The Voyage of the Beagle*, its fame and sales have been continuous ever since.

48 This and related entries for 1839 are in *Diary*, vol. 13.

51 In *The Voyage of the Beagle*, first published in 1839, Darwin noted the

astonishing variety of beaks among the finches from the archipelago: 'Seeing this gradation and diversity of structure in one small, intimately related group of birds, one might really fancy that from an original paucity of birds in this archipelago, one species had been taken and modified for different ends.' He was already sensing that they had been 'modified' by the wholly secular mechanism that he was later to identify as natural selection. Charles Darwin, *The Voyage of the Beagle* (Ware: Wordsworth Classics, 1997), pp. 359, 361.

50 This and related entries are in *Diary*, vol. 14.
51 Morrell and Thackray, pp. 278–9.
52 *Circle*, p. 22.
53 Ibid., p. 23.
54 *Journal* for 1841.
55 *Circle*, pp. 24–5.

CHAPTER 2
Italy, Greece, Nettlecombe: a leisurely progress towards Wallington

1 *Journal* for Greece and Italy 1842.
2 John Gibson Lockhart (1794–1854), Scott's son-in-law, published his *Memoirs of the Life of Sir Walter Scott* in 1837–8.
3 'Lockhart's biography, while very popular, caused controversy because of the way he handled Scott's financial crash, putting much of the blame for it on to Scott's publishers, James and John Ballantyne. Lockhart had, of course, married Scott's daughter and wanted to present him as a great man. Scott himself accepted his crash with typical stoicism and did not blame others – even if they had been unwise, he recognised that he had concurred in their activities, and he was far their intellectual superior' (Claire Lamont, private letter to the author).
4 *Diary*, Kansas, vol. 21.
5 Ibid.
6 The paintings are now in the Bowes Museum at Barnard Castle, County Durham.
7 *Diary*, vol. 21.
8 *Diary*, vol. 23.
9 *Circle*, p. 28.
10 *Diary*, vol. 23.
11 Church, pp. 252–3.
12 *Diary*, vol. 23.
13 *The Works of John Ruskin,* edited by E.T. Cook and Alexander Wedderburn, 39 vols (London: George Allen, 1903–12), III, pp. 571–2. This edition hereafter referred to as *Works*, followed by the volume (in roman type) and page number. Ruskin is focusing on the sea painting, not on the horrible trade in which the ship is engaged. He gives the

information that she is a slave ship, throwing her human cargo over-
board, in a footnote.

14 Quoted in *Circle*, p. 28.

15 Letter to John Brown, quoted in Virginia Surtees (ed.), *Reflections of a Friendship: John Ruskin's Letters to Pauline Trevelyan, 1848–1866* (London: Allen & Unwin, 1979), p. 269.

16 *Diary*, vol. 23.

17 For a full discussion of this astonishing work, its anonymity, its impact and its radical intellectual and political significance, see James A. Secord, *Victorian Sensation* (Chicago: University of Chicago Press, 2000).

18 Quoted in Adrian Desmond and James Moore, Darwin (London, Penguin, 1992), p. 322.

19 *Circle*, p. 29.

20 Robert Chambers, *Vestiges of the Natural History of Creation* (Edinburgh: W. and R. Chambers, 1884), pp. 146–7. This was the first edition to acknowledge Chambers's authorship, and in it his friend Alexander Ireland published an introduction giving details of the process of composition and the secretive circumstances of its publica-
tion.

21 *Remains*, p. 8.

22 Ibid., pp. 16–18.

23 Ibid., pp. 19–21.

24 Ibid., pp. 12–14.

25 From Chambers's *Edinburgh Journal*, NS, no. 130, 27 June 1846, reprinted in *Remains*, pp. 41–6.

26 *Diary*, vol. 23.

27 *Journal* for 1845.

28 Quoted in *Circle*, p. 34.

29 Ibid., p. 42.

30 Letter to Acland of 23 December 1847 (Bodleian Library, University of Oxford, Ms. Acland Papers D72, fol 15).

32 *Circle*, p. 41.

33 *Diary*, vol. 28.

34 *Circle*, pp. 59–61; the letters are quoted on p. 61.

CHAPTER 3
The Oxford Museum

1 J.B. Atlay *Sir Henry Wentworth Acland, Bart. K.C.B. F.R.S. Regius Professor of Medicine in the University of Oxford. A Memoir* (London: Smith Elder, 1903), Chapter 7 and pp. 161–2.

2 Henry Wentworth Acland, *Memoir on the Cholera at Oxford in the year 1854, with considerations suggested by the epidemic* (London: John Churchill; and Oxford: J.H. and J. Parker, 1856).

3 Atlay, pp. 162–4.

4 Quoted in ibid., p. 107.

5 Ibid., p. 168.

6 Ibid., p. 205.

7 Quoted by Frederick O'Dwyer, *The Architecture of Deane and Woodward* (Cork: Cork University Press, 1997), p. 157.

8 Ibid., p. 153.

9 Ibid., p. 156.

10 'It was Philip Pusey [brother of Dr Edward Bouverie Pusey] who first proposed the plan of a central court roofed in by iron and glass, the idea having been suggested to him by the new gigantic railway stations.' H.M. and K.D. Vernon, *A History of the Oxford Museum* (Oxford: Clarendon Press, 1909), pp. 57–8. The Vernons' source was the mineralogist Professor Nevil Story-Maskelyne (1823–1911).

11 Carla Yanni, *Nature's Museums: Victorian Science and the Architecture of Display* (London: Athlone, 1999), p. 66.

12 Quoted in ibid., p. 52.

13 Henry Acland and John Ruskin, *The Oxford Museum* (London: Smith, Elder, 1859), pp. 69–70.

14 Quoted in ibid., p. 83.

15 Surtees (ed.) (1979), pp. 138, 139n.

16 Quoted in Atlay, p. 207.

17 Quoted in *Circle*, p. 116.

18 Augustus Hare, *The Story of My Life*, 6 vols (London: George Allen, 1896), vol. 2, pp. 349–51.

19 Robin Haines, *Charles Trevelyan and the Great Irish Famine* (Dublin: Four Courts Press, 2004), p. 6ff.

20 Ibid., p. 29.

21 Quoted in ibid., p. 30.

CHAPTER 4
The early friendship with Ruskin

1 Ruskin, *Works*, XXXV, pp. 457–8.

2 Wednesday 7th [March 1849], Surtees (ed.) (1979), p. 17.

3 *Journal* for 1837–41.

4 In the large album, plates 1–86 are all scenes from the Italian travels of 1836–8, but the last watercolour, plate 87 ('place not indicated'), is Venice, dated 30 July 1842. There are some excellent city scenes in the large album, especially of Florence, Pisa and Rome. Plates 55 (verso) and 56 are both of Rome outside the Porto del Popolo (the second one said to be by Ruskin), and 65 (verso) and 66 are both of Asturia (the second one said to be by Ruskin, but dated 15 August 1836, so it cannot be).

The small album of forty-seven plates is more interesting because it depicts Venice, Greece and Oxford and Pauline's friendships with Loo and Ruskin began during these two years (1842–3).

5 Surtees (ed.) (1979), p. 26.

6 *Works*, XXXVI, pp. 114–15.

7 Ibid. p. 34.

8 Ibid. p. 35.

9 Ibid. p. 28n.

10 Surtees thinks that this was the Rev. Osborne Gordon, a friend of Ruskin who had been one of the young tutors at Christ Church when Ruskin was an undergraduate.

11 Surtees (ed.) (1979), p. 37.

12 *Works,* XII, p. 533.

13 Ibid., p. 551.

14 Ibid., p. 552.

15 Ibid., p. 557.

16 Ibid., p. 320.

17 *Remains*, p. 89.

18 *Works,* XII, pp. 320–7.

19 Quoted by Surtees (ed.) (1979), p. 41n.

20 *Works*, III, p. 591.

21 *Diary,* vol. 28.

22 *Works,* XIV, p. 308n. His relationship with women artists is explored by Pamela Gerrish Nunn, 'The Woman Question: Ruskin and the Female Artist', in Robert Hewison (ed.), *Ruskin's Artists: Studies in the Victorian Visual Economy* (Aldershot: Ashgate, 2000), pp. 167–83.

23 Virginia Surtees (ed.), *Sublime and Instructive: Letters from John Ruskin to Louisa Marchioness of Waterford, Anna Blunden and Ellen Heaton* (London: Michael Joseph, 1972), p. 116.

24 Surtees (ed.) (1972), p. 10.

25 *Diary,* vol. 28.

26 Mary Lutyens, *Millais and the Ruskins* (London: John Murray, 1967), p. 54.

27 These letters are quoted in Lutyens, pp. 59–61.

28 Ibid., p.91.

29 Ibid., pp. 100–1.

30 *Diary,* vol. 28.

31 Surtees (ed.) (1979), p. 58. Surtees remarks of this, 'Three years earlier Wiseman had been appointed Archbishop of Westminster and a day later nominated Cardinal. In the summer of 1852 he had convened a synod to establish a new form of ecclesiastic government for Roman Catholics in England, and was now in Rome to have the decrees ratified. The Trevelyans had known him in Rome in 1836, where he had had more than a passing influence on Lady Trevelyan, and whose return there in 1842 had been partly in order to see him. At that time she may have had serious thoughts of turning to Roman Catholicism'; p. 59.

32 *Remains*, p. 79.

33 Quoted in *Works,* XII, p. xxxiv.

34 *Diary,* vol. 31.
35 Quoted in *Works,* XII, p. xxxii.
36 Ibid., p. 78.
37 Ibid., p. 157.
38 This and related entries are in *Diary,* vol. 32.

CHAPTER 5
The Pre-Raphaelite Brotherhood and William Bell Scott

1 Jan Marsh, *Dante Gabriel Rossetti: Painter and Poet* (London: Weidenfeld & Nicolson, 1999), p. 35 and *passim.*
2 Quoted in ibid., pp. 45–6.
3 Ibid., Chapter 3.
4 For an excellent modern edition of this text, see Pat Rogers (ed.), *Sir Joshua Reynolds' Discourses* (Harmondsworth: Penguin, 1992).
5 Richard Monckton Milnes *Life, Letters and Literary Remains of John Keats,* 2 vols (London: Edward Moxon, 1848).
6 Alice Craig Faxon, *Dante Gabriel Rossetti* (London: Phaidon, 1994), pp. 71–2.
7 See Mark Girouard, *The Return to Camelot: Chivalry and the English Gentleman* (New Haven: Yale University Press, 1981), especially Chapters 8 and 15.
8 Bell Scott (1892), I, pp. 291–2.
9 Pauline Trevelyan, review of *Memoir of David Scott R.S.A.* by W.B. Scott, Edinburgh, 1850. Reprinted from *The Scotsman* of 6 April 1850. *Remains,* pp. 49–60.
10 Ibid., pp. 50–53.
11 Ibid., p. 53.
12 Ibid., p. 157.
13 Bell Scott (1892), II, p. 21.
14 The quotations from Pauline Trevelyan's letters to William Bell Scott are all from the Troxell Collection, University of Princeton.
15 Bell Scott (1892), II, pp. 3–4.
16 This and related quotations from 1855 are from *Diary,* vol. 32.
17 Bell Scott (1892), II, pp. 11–12.
18 Ibid., pp. 9, 10.
19 Surtees (ed.) (1979), p. 105.
20 Bell Scott (1892), I, p. 297.
21 Ibid., p. 178.
22 Surtees (ed.) (1979) pp. 275–6.
23 Letter from Bell Scott to Pauline, 27 March 1856, Special Collections Library, Newcastle University.
24 *Diary,* vol. 33.
25 *Circle,* p. 111.
26 Ibid.

27 Ruskin, *Works*, XIV, pp. 61–6.
28 See Chapter 8 below, p. 255.
29 Charles Dickens, 'Old Lamps for New Ones,' *Household Words* (1850), p. 266, quoted in J.B. Bullen, *The Pre-Raphaelite Body* (Oxford: Oxford University Press, 1998), p. 16.
30 Quoted from Ford Madox Brown's diary, 13 July 1855, in *The Pre-Raphaelites* (Tate Gallery: Tate Gallery Publications, 1984), p. 111.
31 *Works*, XII, pp. 333–5.
32 Ibid., p. 330.
33 *Circle*, p. 140.

CHAPTER 6
The Wallington decorative scheme

1 This and related entries for 1843 are from *Diary*, vol. 32.
2 See chapter 5, note 14, above.
3 This and related entries are from *Diary*, vol. 35.
4 *Circle*, p. 132.
5 Bell Scott to Pauline, 25 August 1855. Bell Scott's letters to Pauline and Walter are in the Special Collections Library, Newcastle University.
6 *Remains*, p. 58.
7 See Lockhart (1837–8), vol. I, p. 67.
8 *Geology and Mineralogy Considered with Reference to Natural Theology*, 2 vols (London, 1836, 1837) I, pp. 67 and 536–8, quoted in Rupke, p. 236.
9 Quoted in *Circle*, p. ii.

CHAPTER 7
The later friendship with Ruskin

1 Surtees (ed.) (1979), pp. 87–8.
2 Ruskin, *Works*, XII, pp. 328–9.
3 For example, see Chapter 5 above, p. 143.
4 *Works*, XXXVI, p. 217.
5 Joan Evans and J.H. Whitehouse (eds), *The Diaries of John Ruskin* (Oxford: Clarendon Press, 1956–9), II, p. 437. See the discussion of this encounter by Andrew Tate, '"Archangel" Veronese: Ruskin as Protestant spectator', in Hewison (ed.), pp. 131–44.
6 *Works*, XXXVI, p. 176.
7 *Works*, XII, p. 157.
8 Surtees (ed.) (1979), p. 78.
9 Ibid., p. 81.
10 Ibid., p. 82.
11 Ibid., p. 87.
12 *Circle*, p. 110.
13 *Works*, XIV, p. 22.

14 Ibid., pp. 66–7.
15 Ibid., p. 47.
16 Arguably Millais's greatest painting, now in the City of Manchester Art Gallery.
17 *Works*, XIV, p. 107.
18 Ibid., pp. 110, 111.
19 Surtees (ed.) (1979), pp. 145, 146n.
20 *Works*, XIV, p. 154.
21 Ibid., p. 209.
22 Ibid., p. 214.
23 Ibid., p. 215.
24 Surtees (ed.) (1979), p. 131.
25 John Batchelor, *John Ruskin: No Wealth but Life* (London: Chatto & Windus, 2000), pp. 202–4.
26 Ibid., p. 135.
27 Ibid., pp. 140–1.
28 Ibid., p. 160.
29 Ibid., pp. 145, 146n.
30 Ibid., p. 163.
31 Ibid., p. 175.
32 Ibid., p. 182.
33 V.H.H. Green, *Oxford Common Room: A Study of Lincoln College and Mark Pattison* (London: Edward Arnold, 1957), p. 205.
34 William Fredeman, 'The Letters of Pictor Ignotus: William Bell Scott's Correspondence with Alice Boyd, 1859–1884', *Bulletin of the John Rylands Library*, 58 (1975), pp. 88–9.
35 Tim Hilton, *John Ruskin: The Later Years* (New Haven: Yale, 2000), pp. 318–20.
36 Surtees (ed.) (1979), p. 183.
37 Ibid., p. 184.
38 Ibid., p. 150.
39 O'Dwyer, pp. 531–3.
40 Surtees (ed.) (1979), p. 196.
41 Ibid., pp. 188–9.
42 Ibid., pp. 190–1.
43 Ibid., pp. 193–4.
44 Ibid., p. 199.
45 Ibid., p. 200.
46 Ibid., pp. 207, 208.
47 Ibid., p. 198.
48 Ibid., p. 200.
49 Ibid., p. 215.
50 Ibid., p.217.
51 Ibid., p. 221.
52 *Works*, XXXV, pp. 457–8.

53 Fredeman (ed.) (1975), p. 84.
54 Quoted in *Circle*, pp. 194–5.
55 Surtees (ed.) (1979), p. 231. At this time Rose was sixteen. It was during this spring, following his father's death, that Ruskin's cousin Joan Agnew came to live with his mother. In due course Joan became Ruskin's own companion.
56 Ibid., p. 234.
57 Ibid., p. 235.
58 Ibid., p. 236.
59 Ibid., p. 242.
60 Ibid., pp. 247–8.
61 Ibid., p. 251.
62 Batchelor, pp. 213–14.

CHAPTER 8
Louisa Stewart Mackenzie

1 Virginia Surtees, *The Ludovisi Goddess: The Life of Louisa Lady Ashburton* (London: Michael Russell, 1984), p. 35.
2 A number of Claudet's portraits (of people more notable at the time than Loo and Pauline) are in London's National Portrait Gallery.
3 Surtees (1984), p. 55.
4 William Bell Scott to William Michael Rossetti, 11 April 1858, Durham University Library, Special Collections.
5 This sketch is on permanent display at Wallington.
6 Surtees (1984), p. 62.
7 From *The Ballad of Babe Christabel*, 1854, quoted in Valentine Cunningham (ed.), *The Victorians: An Anthology of Poetry and Poetics* (Oxford: Blackwell, 2000), p. 632.
8 Loo's letters to Pauline are in the Special Collections Library, Newcastle University.

CHAPTER 9
Thomas Woolner, sculpture and patronage

1 Amy Woolner, *Thomas Woolner, R.A. Sculptor and Poet: His Life in Letters* (London: Chapman & Hall, 1917), pp. 45–6.
2 Ibid., p. 47.
3 Ibid., pp. 52–3.
4 Ibid., p. 57.
5 Ibid., pp. 86–7.
6 Ibid., p. 114.
7 Ibid., p. 115.
8 All letters from Woolner to Walter and Pauline Trevelyan are quoted from the Special Collections Library, Newcastle University.
9 Woolner, p. 126.

10 Ibid., pp. 126–7.
11 Thomas Woolner, 'My Beautiful Lady', in W.M. Rossetti (ed.), *The Germ: The Literary Magazine of the Pre-Raphaelites* (facsimile of the 1901 edition, Oxford: The Ashmolean Museum, 1979), p. 1.
12 Thomas Woolner, *My Beautiful Lady* (London: Macmillan, 1863), pp. 54–5, 136, 140.
13 Woolner to William Bell Scott, 13 December 1851, Troxell Collection, University of Princeton.
14 See Jan Marsh, *Christina Rossetti: A Literary Biography* (London: Pimlico, 1994), especially pp. 209–11.
15 *Circle*, p. 138, and private letter of 26 April 2005.
16 Ibid., pp. 155–6.
17 From the Troxell Collection, University of Princeton (also quoted by Surtees [ed.] [1979], p. 127n.).
18 Ruskin, *Works*, XXXVI, p. 406.
19 Trevelyan Scrapbook, Special Collections Library, Newcastle University.
20 Anon, *Sketches of Public Men of the North* (Newcastle, 1855), quoted in Peter Quinn, 'Picturing Locality: Art and Regional Identity in the North East of England, 1822–1900' (University of Sunderland, unpublished Ph.D. dissertation, 1997), p. 53.

CHAPTER 10
Algernon, the adopted son

1 Redesdale, quoted in Rikki Rooksby, *A.C. Swinburne: A Poet's Life* (Aldershot: Scolar Press, 1997), pp. 28, 30.
2 Ibid., p. 42.
3 Milnes, pp. xix, 2.
4 Quoted in *The Swinburne Letters*, ed. Cecil Y. Lang (New Haven: Yale University Press, 1959–63), I, p. 49n.
5 Ibid., p. 54.
6 Rooksby, pp. 80–81.
7 Quoted in ibid., p. 93.
8 Available to English readers as *The Flowers of Evil*, trans. James McGowan (Oxford: World's Classics, 1993).
9 Donald Thomas, *Swinburne: The Poet in his World* (London: Weidenfeld & Nicolson, 1979), pp. 78–9.
10 Ibid., pp. 92–3.
11 A.C. Swinburne, *Poetical Works* (London: Heinemann, 1904), IV, p. 249 (this edition hereafter cited as Swinburne, *Works*, with the volume and page numbers).
12 George Sand (1804–76), the French Romantic writer and mistress of Chopin.
13 *The Swinburne Letters*, I, pp. 76–7.
14 Ibid., pp. 135–6.

15 Quoted in Rooksby, pp. 122–3.
16 A.C. Swinburne, *Chastelard: A Tragedy* (London: Chatto & Windus, 1910), p. 171.
17 Trevelyan Papers, Special Collections Library, Newcastle University, and *The Swinburne Letters*, I, pp. 137–42.
18 *The Swinburne Letters*, I, p. 141n.
19 British Library, Ashley MS 5739 f427.

CHAPTER 11
Pauline Trevelyan's three histories

1 Desmond and Moore, p. 497.
2 Quoted in John L. Morton, *King of Siluria: How Roderick Murchison changed the face of Geology* (Horsham: Brocken Spectre Publishing, 2004), p. 196.
3 Quoted in ibid., p. 197.
4 Augustus Hare, *A Handbook for Travellers in Durham and Northumberland,* 2nd edn (London: John Murray, 1873).
5 Ibid., pp. 349–50.
6 Quoted in *Circle*, p. 135.
7 Quoted in Fredeman (1975), p. 69.
8 Bell Scott (1892), II, p. 70.
9 Trevelyan Papers, Special Collections Library, Newcastle University, WCT 260.
10 Ibid., WCT 331 24.
11 Ibid., WCT 331 51.
12 *Journal* for 1866.
13 Trevelyan Papers, WCT 265/33. Autopsy report on Lady Trevelyan by Leopold Reynier, 15 May 1866 (my translation).
14 *The Swinburne Letters*, I, p. 183.
15 Surtees (ed.) (1979), pp. 280–1.
16 Penkill Papers, University of British Columbia.
17 See p. 52.

INDEX